John La Farge

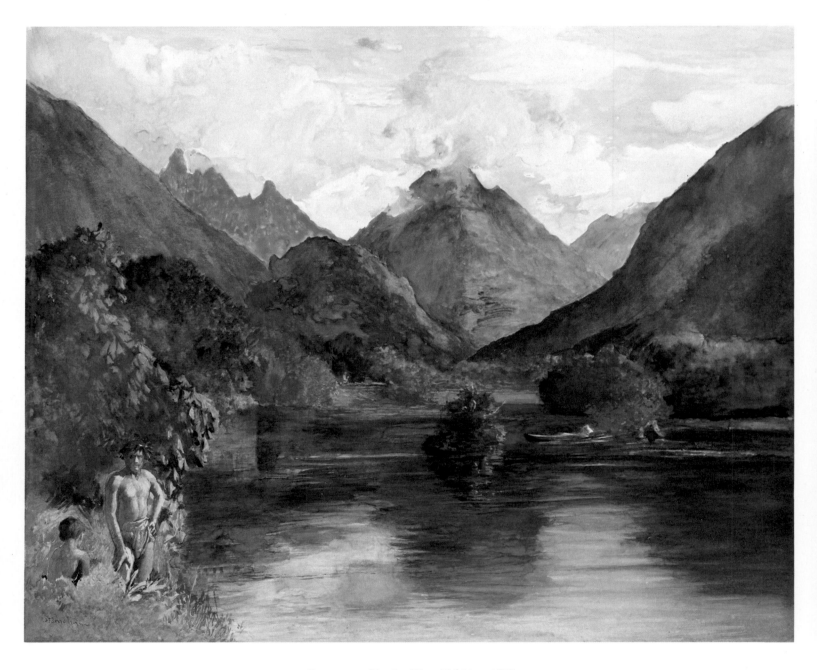

Entrance to Tautira River, Tahiti, c. 1893
Watercolor on paper
13⅜ × 21⅜ in. (33 × 54.3 cm.)
Mr. and Mrs. Willard G. Clark
W1893.1

John La Farge

Essays by Henry Adams,
Kathleen A. Foster, Henry A. La Farge,
H. Barbara Weinberg, Linnea H. Wren,
and James L. Yarnall

THE CARNEGIE MUSEUM OF ART, PITTSBURGH

NATIONAL MUSEUM OF AMERICAN ART,
SMITHSONIAN INSTITUTION, WASHINGTON, D.C.

ABBEVILLE PRESS PUBLISHERS NEW YORK

Cover
Details of *Peonies in the Wind with Kakemono Borders*, c. 1893
See plate 162

A Note about the Captions
———————

Every effort has been made to use the title given to the work when it was first
exhibited or sold; any title by which a work may be familiarly known, or by which it
was previously known, is given in parentheses. Each caption includes the number
that the work has been assigned for the forthcoming catalogue raisonné.
In those numbers, *P* refers to oil painting or encaustic, *W* to watercolor or gouache,
D to drawing, *E* to engraving, *MD* to mural design, and *G* to stained glass. The first
four digits of the catalogue raisonné number refer to the year during which primary
production of the work took place. For illustrations, the date of publication appears
in parentheses after the title of the publication.

This book was published on the occasion of the exhibition *John La Farge*,
shown at the National Museum of American Art,
Smithsonian Institution, Washington, D.C., July 10–October 12, 1987;
The Carnegie Museum of Art, Pittsburgh, November 7, 1987–January 3, 1988;
and Museum of Fine Arts, Boston, February 24–April 24, 1988.

The exhibition and publication were made possible by generous grants from
the Luce Fund for Scholarship in American Art, a program of The
Henry Luce Foundation, Inc.; the National Endowment for the Humanities;
The Foster Charitable Trust; the Smithsonian Special Exhibition Fund;
and the James Smithson Society.

Consulting Curator: Henry Adams
Editor: Nancy Grubb
Designer: Sarah Laffey
Production Supervisor: Hope Koturo

Library of Congress Cataloging-in-Publication Data

John La Farge.
"[Exhibition]: Carnegie Museum of Art, Pittsburgh; National Museum of American
Art, Smithsonian Institution, Washington, D.C."
Bibliography: p.
Includes index.
1. La Farge, John, 1835–1910—Exhibitions. 2. La Farge, John, 1835–1910—
Criticism and interpretation. I. La Farge, John, 1835–1910.
II. Adams, Henry, 1949– III. Carnegie Institute. Museum of Art.
IV. National Museum of American Art (U.S.)
N6537.L28A4 1987 759.13 86-25870
ISBN 0-89659-678-8
ISBN 0-89659-682-6 (pbk.)

First edition

CONTENTS

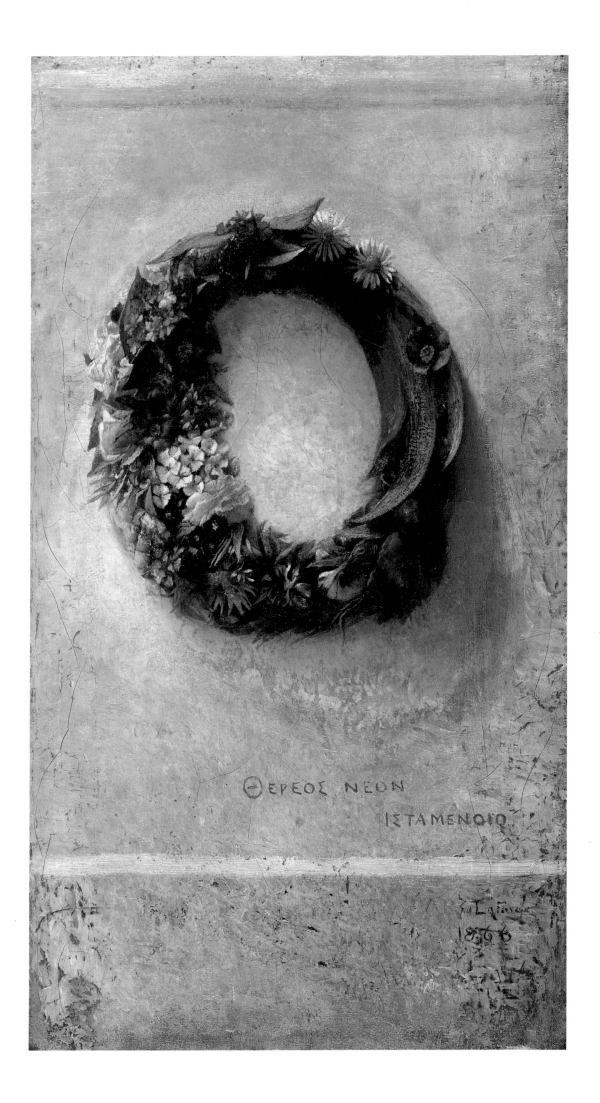

FOREWORD

The perplexing variety of John La Farge's accomplishment is perhaps best registered in the range of critical and scholarly opinion generated by his work during the past ten years. The attention, long overdue, is manifest in numerous thoughtful studies about the artist, his colleagues, and the cosmopolitan era that in many ways he helped inaugurate. Yet La Farge is not an artist whose aims are easily understood by contemporary scholars. He had a curious way of coming down on all sides of an issue; neither his life nor his art was linear or predictable, and his enthusiasms were spread across all conceivable media and widely divergent subjects. While his posthumous reputation may not rival those of two of his closest artistic colleagues, Henry James and Winslow Homer, his contemporaries regarded La Farge as a figure of greater influence and imagination.

Then, as today, some understood him as an innovator, advocating a radical approach to design and technique—indeed a whole new means of conceiving (and perceiving) a work of art. Others saw him as seeking a compromise between experimentation and tradition, borrowing randomly but prudently from the past to revitalize a faltering academic tradition. Somewhere in between we recognize another aspect of La Farge's artistic personality: his desire to escape, not only to Japan and the South Seas, but into an aesthetic arcadia that screened out a Gilded Age America. His finely wrought prisms of opalescent glass were as much an attempt to diffuse the image of a nation obsessed with material concerns as they were a means with which to create fantasies of color and light.

To summarize these views is no easy task. Nor is it possible, or even desirable, to align half a dozen productive scholars, each of whom has devoted years to his or her respective topic, to speak with a single voice. The essays that follow, therefore, reflect a diversity inherent in the creative process of the artist—and in the method chosen by each contributor to argue on behalf of one or more aspects of that process. A lesser artist might suffer from such treatment. La Farge and La Farge scholarship seem instead to have benefited;

1
Wreath of Flowers, 1866
(Greek Love Token)
Oil on canvas
24⅛ × 13⅛ in. (61.1 × 33.3 cm.)
National Museum of American Art, Smithsonian Institution, Washington, D.C.
Gift of John Gellatly
P1866.1

only a handful of nineteenth-century American artists has ever set in motion such an ambitious program of scholarly study.

Twenty-one years have elapsed since the last significant showing of La Farge's work, fifty-one years since the last major retrospective. In that time, there has been a thorough investigation of many of La Farge's colleagues but no single volume devoted to the artist's own work. The trend toward late nineteenth-century studies in recent years has made this lack even more evident, despite the fact that dissertations and articles on La Farge have appeared with increasing frequency. His name, his achievements, his involvement in a multitude of artistic issues between 1860 and 1900 have become familiar only to those with the patience and means to pursue an elusive artistic personality. This publication is designed to gather and extend our knowledge of La Farge—to provide a spectrum of current opinion and a broad base for future studies.

We are indebted to each of the six authors who has prepared an original essay for this publication and we sincerely thank Dr. Henry Adams, Samuel Sosland Curator of American Art, Nelson-Atkins Museum of Art, Kansas City; Dr. James L. Yarnall, director, La Farge catalogue raisonné project, Yale University, and museum consultant; Dr. Kathleen A. Foster, curator and director of research and publications, Pennsylvania Academy of the Fine Arts, Philadelphia; Dr. H. Barbara Weinberg, professor of art history at Queens College and the Graduate Center of the City University of New York; Dr. Linnea H. Wren, Ethel and Edgar Johnson Professor of the Fine Arts, Gustavus Adolphus College, St. Peter, Minnesota; and the late Henry A. La Farge, art historian and editor of *Artnews* from 1948 to 1973.

Several years ago, the idea of a John La Farge exhibition was proposed to The Carnegie Museum of Art by Henry Adams, then curator at the museum. Independently, a similar concept was under concurrent review at the National Museum of American Art, proposed by curator William Truettner and his colleague James L. Yarnall. Learning of each other's interest, the two museums decided to join resources in pursuit of their common goal.

We are grateful to Dr. Adams for his continuing association with the development of the exhibition as consulting curator following his assumption of new duties at the Nelson-Atkins Museum of Art early in 1985. Dr. Adams's view of La Farge—one that places rather more emphasis upon adventurous aspects of the artist's career than on his also important but more conservative achievements—has, to a significant degree, given shape to the exhibition. This is in contrast to the catalog, in which, through a variety of texts by La Farge scholars, we seek to represent the full range of interpretive opinion about this very complex artistic personality. Both Mr. Truettner and Dr. Yarnall continued to provide essential assistance, reviewing and proposing ideas for the exhibition and helping coordinate authors and essays for this publication.

The National Museum of American Art took responsibility for establishing the relations with lenders to the exhibition. Margy P. Sharpe, exhibitions coordinator, compiled the exhibition checklist, and W. Robert Johnston, registrar, with his associates, organized the packing, shipping, and insurance for the loans. The Carnegie Museum of Art was responsible for producing the catalog, and the development of this publication was directed by Barbara L. Phillips, assistant director for administration, assisted by Marcia L. Thompson, publications coordinator, and Nancy Beattie and Judith H. Schardt, manuscript typists. It has been a pleasure to work with our copublisher, Abbeville Press, where our primary collaboration on this book has been with Nancy Grubb, senior editor; Sharon Gallagher, managing editor; James Wageman, art director; Sarah Laffey, designer; and Hope Koturo, production supervisor. Among the many other individuals who have lent expertise and support to the La Farge project are Elizabeth Broun, Vicky A. Clark, Milton Porter, and Mrs. Henry A. La Farge.

We are particularly grateful to the many private collectors and institutions who, as lenders to the exhibition, have generously shared their works of art by John La Farge. It is a pleasure to acknowledge them individually in the list of lenders.

In addition to its Washington and Pittsburgh showings, we are very pleased that the exhibition will also be seen at the Museum of Fine Arts in Boston, a city that provided so much important patronage for La Farge. We thank Jan Fontein, director, and Jonathan Fairbanks, curator of American decorative arts and the staff member responsible for the Boston showing of the exhibition, as well as G. Peabody Gardner III and Theodore E. Stebbins, Jr., for their interest in *John La Farge.*

This publication has enjoyed the support of the Henry Luce Foundation, Inc., through its Luce Fund for Scholarship in American Art. Both the catalog and the exhibition have been the beneficiaries of grants from the National Endowment for the Humanities (which has also supported the preparation of the La Farge catalogue raisonné), the James Smithson Society, and the Foster Charitable Trust. We wish to thank Robert E. Armstrong, vice-president and executive director, and Mary Jane Hickey, program officer, of the Luce Foundation; Gabriel Weisberg, formerly of the National Endowment for the Humanities; the members of the James Smithson Society; and Mr. and Mrs. Jay L. Foster, Mr. and Mrs. Bernard S. Mars, and Carnegie trustee Milton Porter and Mrs. Porter, the trustees of the Foster Charitable Trust.

We are beholden to the late Henry A. La Farge, grandson of the artist, who, in addition to preparing an essay for this publication, as the author of the forthcoming La Farge catalogue raisonné thoughtfully shared a great deal of information vital to the organization of the exhibition and to the catalog. His contributions to American art in general and to the study of John La Farge in particular are of high significance, and it is with respect and gratitude that we dedicate this book to his memory.

John R. Lane
Director
The Carnegie Museum of Art

Charles C. Eldredge
Director
National Museum of American Art, Smithsonian Institution

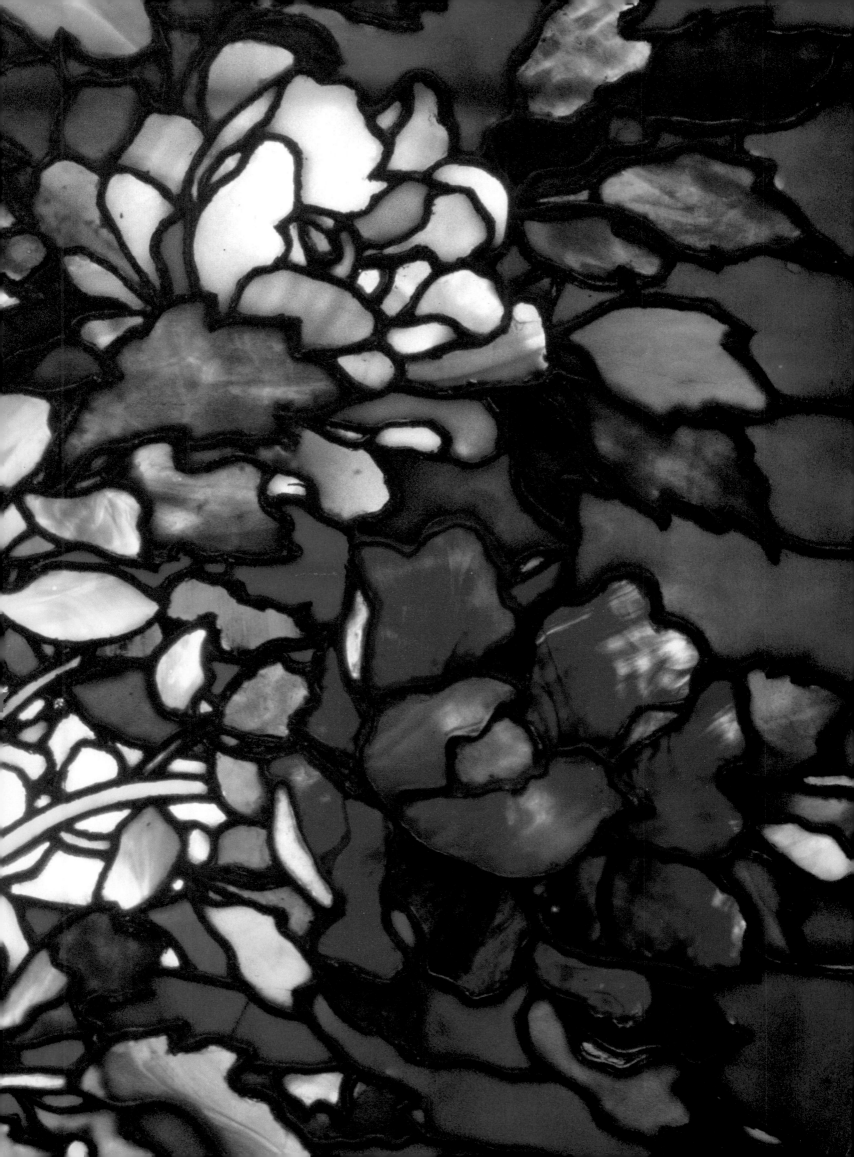

The Mind of John La Farge

Henry Adams

2
Detail of *Peonies in the Wind with Kakemono Borders*, c. 1893
See plate 162

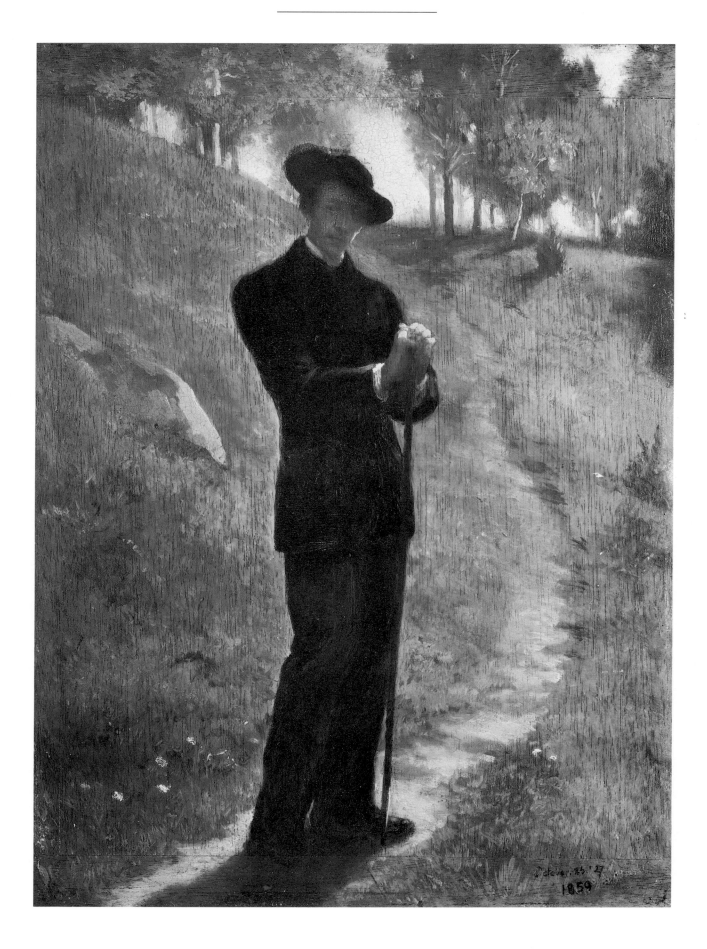

I n an age of great conversationalists, John La Farge was perhaps the greatest. "He was quite the most interesting person we knew," wrote Henry James, in remembering his Newport years.[1] "A most winning and insinuating old man," noted Bernard Berenson after his first meeting with the artist.[2] "I have heard some brilliant talkers, Whistler amongst them," wrote Royal Cortissoz, "but I have never heard one remotely comparable to La Farge."[3] Henry Adams judged La Farge the best conversationalist of his time, and even William James, who was at times offended by La Farge's slightly pompous tone, once wrote to his brother Henry, "I pine for some conversation of an intellectual character. . . . Would I might see La Farge."[4]

Not that La Farge was forceful or extroverted. He did not mix easily in large gatherings, and when he dined at the Century Club he often dined alone. A journalist reporting his lectures at the Metropolitan Museum of Art noted that he spoke quietly, in a near monotone.[5] His son John observed: "Father did not make friends rapidly. In manner he was reserved and inquiring and critical in approaching people. It was physically distressing to him to shake hands; disagreeable for him to be introduced, and always somewhat of a shock to make a new acquaintance. Yet he was singularly faithful to his friends once he had made them, loyal to the very end: in his whole life I never knew of an abandoned friendship."[6]

La Farge's elaborate verbal constructions often left his listeners breathless, for as Cortissoz noted, "La Farge was a past master of the parenthesis and he hated to let go of his collateral lines of thought."[7] Yet even William James declared that "his sentences when they do come forth are often worth the throes of concentration which attend their birth."[8] Adams was dazzled by his intellectual complexity. "In conversation," he maintained, "La Farge's mind was opaline with infinite shades and refractions of light and with color toned down to its finest gradations."[9]

La Farge could fascinate all classes of society. The journalist Viola Roseboro observed that at dinner parties the waiters would sometimes momentarily forget their tasks and stand by, expectantly, until he had brought one of his long parenthetical phrases to its

3
Portrait of the Painter, 1859
Oil on wood
16 × 11½ in. (40.6 × 29.2 cm.)
The Metropolitan Museum of Art, New York
Samuel D. Lee Fund, 1934
P1859.14

intended conclusion.[10] Edmond de Goncourt was impressed by his knowledge of Japanese prints, and the taciturn Winslow Homer found him the only person with whom he enjoyed talking about art.[11] La Farge was equally adept at charming former cannibals in the South Seas, for as Frank Jewett Mather reported: "A few years ago a party of American biologists touched at a remote Polynesian island. Seeing white men, the interpreters came running down the beach shouting, 'How is John?' The 'John' they spoke of was John La Farge, whom they had befriended during his visit to that remote area." [12]

La Farge's son John recalled:

As a child I did not understand or appreciate the conversational gifts that made him famous, yet everything that father did was intensely interesting. He was interesting to see; his person was always absolutely neat, and scrupulously adapted to whatever he was undertaking to do. He had his own kind of pen, his own kind of paper, his own distinctive way of doing everything; every gesture of his body seemed to relate to the ultimate ends of his life and work. Father in a benign mood was as fascinating as Father in an irascible one was alarming.[13]

La Farge's contemporaries, in fact, were overwhelmed by his charm; they tended to judge his art not on its own terms but as a reflection of his iridescent personality. Mather declared that "no acquaintance of his may hope impartially to weigh his long and multiform achievement."[14] Similarly, Cortissoz stated: "The La Farge to whom I would above all pay tribute is the La Farge who was, in a sense, greater than all of his works, the La Farge who was, to those who knew him, a lambent flame of inspiration. There was something Leonardesque about him, something of the universal genius. . . . When we lost him we lost a great character."[15] Henry James, in seeking to explain the power that La Farge's paintings held for him, decided that "the true source of the spell" was that he came to know them through "the eye of friendship, friendship full of character and colour."[16] Adams eulogized: "La Farge was a great man—this is rarely true of artists. Take away the brush from Sargent or Whistler, or the pen from Balzac, what have you? But La Farge . . . needed nothing but his own soul to make him great."[17]

Personal charm, however, is evanescent. When confronted with tributes such as these it is natural to pose an obvious yet vexing question: what happened to the genius that La Farge's contemporaries so applauded? What happened to the genius that so impressed not only critics such as Mather and Cortissoz but also individuals who are now themselves ranked as major figures, such as Henry and William James? Did La Farge's inspiring spirit leave tangible traces, or was it lost in the cigar smoke of after-dinner conversation?

Answering these questions is not an easy task, both because of the complexity of La Farge's achievement and because of its extraordinary diversity. La Farge had a paradoxical mind, and his work is easy to misconstrue. As Adams noted: "He had no difficulty in carrying different shades of contradiction in his mind. . . . Even a contradiction to him was only a shade of difference, a complementary color about which no intelligent artist would dispute."[18]

La Farge's work was almost encyclopedic in its variety. He bridged the major and the minor arts as well as visual and verbal modes; he dabbled with architecture and sculpture; wrote poetry, travelogues, histories, and art criticism; made easel paintings and mural paintings; drew illustrations; invented a new mode of wood engraving; worked in watercolor; completely transformed the medium of stained glass; and freely dispensed his advice to practitioners in other fields.

To have done one of these things well would have been a considerable achievement, and La Farge's work, while frequently inventive, is quite naturally not always good. Even in the media in which he most excelled his work was remarkably uneven. In stained

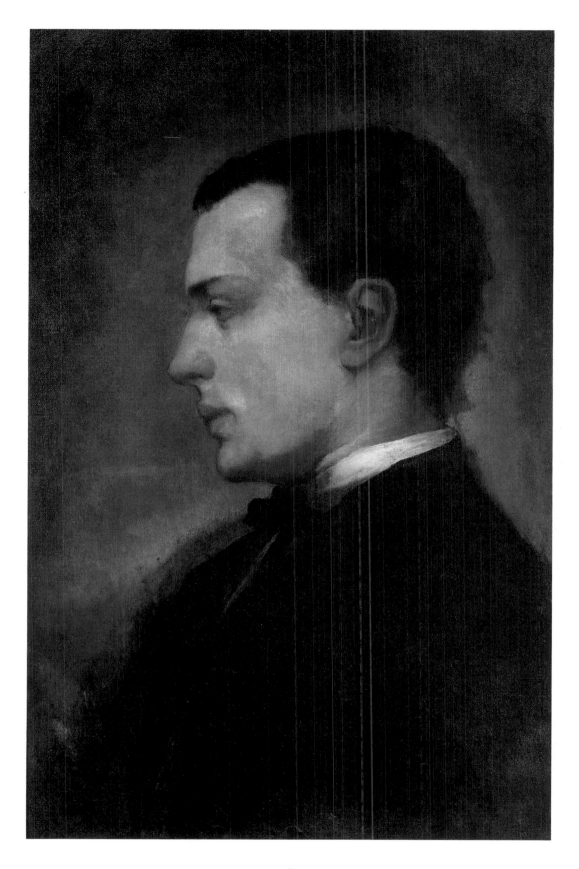

4

Portrait of Henry James, the Novelist, 1862
Oil on canvas
20½ × 13½ in. (52.1 × 34.3 cm.)
The Century Association
P1862.3

glass, for example, while he produced some resplendent windows, he also produced many that are dull and formulaic, commercial "pot-boilers" by his own confession. Consequently, he has always been a difficult artist to do justice to—one not readily dismissed as a minor figure, nor easy to recognize as a major one.

To an unusual degree, to confront the art of John La Farge is to encounter the difficult distinction between kitsch and quality, between insincere artifice and an art that is sincerely felt. Certainly all artists produce work that varies in quality. But few are so uneven and eccentric as La Farge, whose output so varied in media, quality, and artistic intention. His works are not easily reduced to a single direction or artistic purpose, and they alternate between the stale and the novel, between the conservative and the avant-garde, between the inept and the well crafted, and between the shallowly amusing and the intellectually demanding. Judging La Farge's challenging and unpredictable works entails a constant sense of risk and uncertainty. We must evaluate each piece afresh.

La Farge's Influence on Two Writers

Oddly enough, in attempting to make a case for La Farge's importance, it is easiest to start not with his own work, but with his influence on others. There are many examples, but perhaps the most striking is his impact on two major American writers, Henry James and Henry Adams. In both cases La Farge had a critical influence: without his intervention their careers would have taken very different forms. To review his impact on them may serve as a good introduction to his own artistic mind, with both its virtues and its striking peculiarities.

La Farge affected Henry James when the latter was a boy in his teens, at a crucial turning point when James was unclear about his literary ambitions and hesitant about pursuing a career as an artist. Henry James, senior, had noted of his children that "they are none of them cut out for intellectual labors."[19] It was La Farge who advised young

5
Henry Adams at Beverly Farms, 1883

Henry, still undecided between palette and pen, to become a writer. Yet he did so without disparaging his visual gifts and often declared in later years that James had "a painter's eye"—adding that few writers possessed one.[20]

"He opened up to us," James later wrote of La Farge, "though perhaps to me in particular... prospects and possibilities that made the future flush and swarm."[21] Later in life the novelist wrote to a mutual friend, "If La Farge is within hail, please tell him that I feel the loss of him, always, as one of the greatest pangs of my long exile."[22] "The writer was haunted by John La Farge," Leon Edel has noted, "and his image is preserved among those talkative, brilliantly vivid painters who pass across his fictional pages."[23]

It seems likely that James's distinctive and tortuous verbal style—with its long digressions and parentheses, its ambiguity, its tireless pursuit of nuance—was modeled to some degree on La Farge's famously elaborate conversation. Without question La Farge shaped the aesthetic direction of James's achievement by passing on his own enthusiasm for French authors. Through La Farge, James came to love Prosper Mérimée, Alfred de Musset, and, in particular, Honoré de Balzac, then just ten years dead. "Most of all," James later recalled, "he revealed to us Balzac.... To reread, even after long years, the introductory pages of *Eugénie Grandet*, breathlessly seized and earnestly absorbed under his instruction, is to see my initiator's youthful face, so irregular but so refined, look out at me between the lines as through blurred prison bars."[24]

La Farge's early portrait of James (plate 4), with its vibrant halation of pinks and greens, takes on special interest as a characterization by the first person to foresee the youthful writer's greatness. Through the slightly parted lips La Farge suggested James's perpetual appearance of incipient speech; through the priestly dark costume, with its thin white collar, he effectively evoked James's celibate pursuit of his art. It is fitting that La Farge, in turn, served as the model for an early work by the young author: he became the protagonist in one of James's earliest published stories, an entertaining spoof of Newport's artistic life titled "A Landscape Painter."[25]

La Farge's influence on Henry Adams occurred in a different manner, not at the beginning but toward the end of the writer's career, but perhaps it had even greater impact. Adams first met La Farge about 1872, when they were both on the faculty of Harvard, and Adams later watched him paint the murals of Trinity Church, an event that served as the backdrop of his novel *Esther* (1884).[26] For the first fifteen years of their acquaintance, however, La Farge did not belong to Adams's most intimate circle: he was not a member of "The Four of Clubs," the coterie of Adams's special favorites.[27] A tragedy finally brought them together: the suicide of Adams's wife, "Clover," in December 1885. Shattered by the event, Adams sought escape in a trip to Japan and persuaded La Farge to join him. While Adams disliked Japan, he enjoyed the company of La Farge, and in the succeeding decades he and La Farge remained in intimate contact. La Farge, with his combination of wit and religious faith, brought vitality and meaning into what Adams called his "posthumous life."

A second trip with La Farge, to the South Seas, in 1890–91, marked a watershed in Adams's career, the beginning of a looser and more vibrant literary style: all his most memorable works, notably *The Education of Henry Adams* (1918), were written after he had come under La Farge's sway. While La Farge had influenced the fundamentals of Henry James's technique, in this case he affected a writer whose mannerisms of diction were already essentially formed. Yet his influence was perhaps even more profound: Adams himself later noted that he "had no standard to measure it by."[28] La Farge helped bring about a subtle shift of rhythm, color, mood, and feeling: he broke Adams out of his narrow, puritanical, intellectual mode and opened his mind to emotion and sensual experience. "Adams, you reason too much!" was one of his standing reproaches.[29] It was

La Farge who first interested Adams in medieval stained glass, took him to the French cathedrals, and laid the groundwork for the most playful and delightful of the historian's books, *Mont-Saint-Michel and Chartres* (1913).

Probably no other American painter played such a role in shaping the achievement of a major American author, let alone two. This influence may alert us to some of the most salient features of La Farge's own art—its intellectuality, its deep immersion in culture, its refined sensibility. At the same time some of those qualities of La Farge's work that have always been criticized are called to mind. Both Henry James and Henry Adams were mannered and exasperating writers who have always been viewed with suspicion because of their aloofness, their compromised masculinity, and their distaste for the crudeness of American society. La Farge has similarly been attacked as snobbish, effeminate, and un-American. Fragility, delicacy, and a tremulous sensitivity characterize much of La Farge's work, and he regularly invaded realms that had traditionally been set aside for women, such as watercolor, flower painting, and home decoration. His creations possess a foreign quality, even though he grew up in the United States.

The Early Years

Most people who encountered La Farge were struck by his foreignness of demeanor. "La Farge was of the type—the 'European,'" opined Henry James.[30] "He was so 'un-American,'" mused Henry Adams, "so remote from me in time and mind, . . . that I have preferred to talk little about him, in despair of making him or his art intelligible to Americans."[31] As Henri Focillon remarked, after viewing a retrospective of La Farge's work in 1936, "to the French traveler, attentive guest of the United States, it seemed almost as if one caught the whisperings of a dual language, that of America and that of his own country."[32] Throughout his life La Farge enjoyed entertaining French visitors to these shores, such as the novelist Paul Bourget, the painters Jean-François Raffäelli and Jean-Charles Cazin, and the sculptor Frédéric-Auguste Bartholdi, who is said to have created the first model of the Statue of Liberty in La Farge's studio in Newport.[33] But La Farge spent his childhood in New York City; his European traits were derived not so much from actual experience of Europe as from his curious family background.

Jean-Frédéric de la Farge (later John Frederick La Farge), the artist's father, was born in the Charente-Inférieure, not far from Angoulême. As a young man he volunteered to join the ill-fated expedition of Napoleon's brother-in-law, General Charles Leclerc, to put down the black insurrection in Santo Domingo. Captured in an ambush, Jean-Frédéric remained prisoner for three years and then managed to escape to the United States, where he settled in New York.[34] Through shipping, real estate, hotel keeping, fire insurance, and other ventures, he soon became wealthy, and in 1833, at the age of forty-seven, he married Louisa Josephine Binsse de Saint-Victor, only sixteen at the time. Her family had been a prominent one in France, famous for its fervent Catholicism and ultraconservative views; her cousin Paul de Saint-Victor was an influential Parisian art critic.

John La Farge, the eldest son, was born in New York City on March 31, 1835, and grew up in a bewildering mix of cultural influences. French, still spoken by his parents and relatives, was his first language. German he learned from his Alsatian nurse. English he perfected when his nurse was replaced by an English governess. His parents and relatives were Roman Catholic and deeply involved in Catholic affairs; but his nurse was Lutheran, and his governess a "high church" Anglican.[35] From his earliest childhood he encountered conflicting political sentiments. Over his small bed hung a big lithographic portrait, nicely framed, of Henry V, the pretender to the throne of France. He said a

prayer for it every night and morning at the insistence of his maternal grandmother, who hoped that someday he would do something for "the cause." His father would smile at this performance but held exactly opposite views.

Books were abundant in the La Farge library, and the house was filled with pictures, many of them imported by John La Farge's uncle, Louis Binsse, who was an importer of "fancy articles."[36] La Farge took his earliest art lessons from his grandfather Binsse, who taught him, at age six, to make accurate copies of engravings. As a young teenager at Columbia Grammar School, he took lessons from an English watercolorist; a few years later he studied drawing with the landscapist Régis-François Gignoux, who had also taught George Inness.[37]

La Farge received a strict Catholic schooling at Saint John's College (now Fordham University) and Mount Saint Mary's College and then set off for Europe in 1856 to complete his education with a grand tour. He met his cousin Paul de Saint-Victor, who was an intimate friend of Théophile Gautier, Paul Gavarni, Charles Baudelaire, and the de Goncourts; he briefly studied painting with Thomas Couture; he stayed with relatives on the tip of Brittany; he visited the French medieval cathedrals; and he traveled in Germany, Belgium, and Denmark, copying drawings in the print rooms of museums. Unfortunately, his trip was cut short by news that his father was in poor health, and so he returned to the United States in the autumn of 1857, in time to attend the final illness of his father, who died of angina the following June.

His father's death had a decisive effect on La Farge's future, for it relieved him of the pressure to take up a business career and left him with a substantial inheritance. For a brief time he ostensibly studied law but actually spent most of his time reading promiscuously, sketching, and making artistic friends. With his enthusiasm for France it was natural that he would fall in with the architect Richard Morris Hunt, who had just returned from Paris after a brilliant success at the Ecole des Beaux-Arts and whose New York studio had become a center of architectural training. One day, when La Farge expressed his artistic interests, Hunt mentioned that his brother William, the painter, had settled in Newport, Rhode Island, and wished to take on pupils. La Farge followed up this lead and in 1859 moved to Newport to study painting "in a little more serious way than before."[38]

The Newport Paintings

Henry James once described the Newport of the 1860s as "the one right residence, in all our great country, for those tainted with the quality and effect of detachment."[39] In Newport, if anywhere, La Farge could meet figures (including James) whose inclinations matched his own. Newport was insular (on an island, in fact), and economically it had never recovered from the devastating effects of the American Revolution. But society there, if not splendid, had remained quaintly aristocratic and imbued with European tastes. There was, for example, an old Frenchman whom La Farge took pains to seek out, who had once been a servitor of Marie Antoinette and had lived to see the supporters of John Quincy Adams shouted down by the rabble-rousing followers of Andrew Jackson.[40] And there was the eccentric gourmet, connoisseur, essayist, and dilettante Thomas Gold Appleton, the brother-in-law of the poet Longfellow, who is said to have crossed the Atlantic forty times by 1860.[41] An indication of Newport's European accent is that La Farge's friend John Bancroft, who arrived on the scene in 1863, preferred to discuss painting in French, which he considered more precise than English in its artistic vocabulary.[42]

Like his brother Richard, William Morris Hunt was a devotee of French art, but his tastes were more avant-garde, as befitted his more impulsive and passionate temperament.[43]

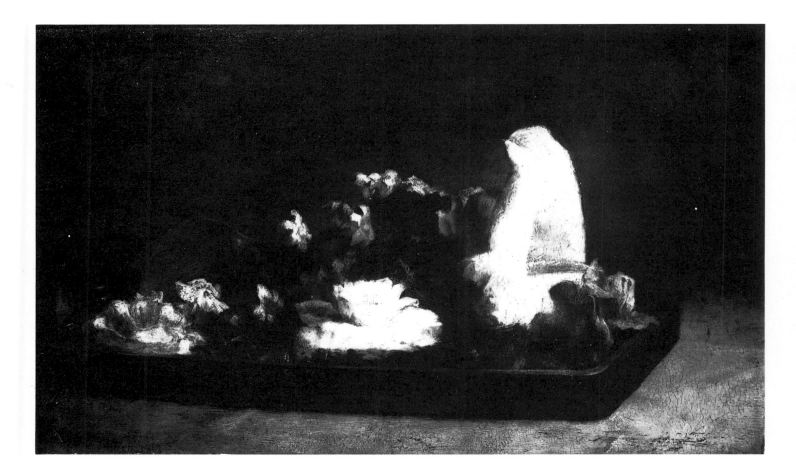

6
Calla Lily, 1862
Oil on wood
9³⁄₁₆ × 15¾ in. (23.3 × 40 cm.)
The Art Museum, Princeton University, Princeton, New Jersey
Gift of Frank Jewett Mather, Jr.
P1862.13

Originally a pupil of Thomas Couture, he had abandoned him to study with Jean-François Millet, the painter of peasant scenes. Unlike William Morris Hunt, who never broke away from the manner of his teachers in France, La Farge quickly evolved a highly original style. In October 1859, within a few months of coming to study with Hunt, he created his first masterpiece, an arrangement of silhouettes and decorative patterns titled *Portrait of the Painter* (plate 3). Here La Farge showed himself dressed in the garb of a French art student of the Latin Quarter, complete with tight black pants, broad-brimmed hat, and painter's umbrella. The face is in shadow, but the fastidious dress, the eccentric hat, the slight slouch of the shoulders, and the somewhat quizzical stance unmistakably express the figure's individuality.[44] A gentle manifesto, the painting evokes the French sophistication that La Farge aspired to apply to the American cultural landscape.

While the figure is set in a real place—a hillside near the La Farge family home at Glen Cove, Long Island, which can still be visited—the work seems to suggest a symbolic interpretation. The young man, about to embark on his career as a painter, leans thoughtfully on his furled painter's umbrella, the insignia of his profession, pausing a

moment to look backward, while the path of life winds up the hill behind him toward the sunlight and then disappears over its edge. From the beginning—as this understated self-portrait indicates—La Farge very consciously avoided the bombast of the Hudson River School, which was reaching a climax at just this time in the huge panoramas of Albert Bierstadt and Frederic Church.[45] La Farge deliberately chose scenes that were spare and unspectacular, which he painted with visible brushwork that freely discloses the artist's touch.

A major factor in La Farge's development was his enthusiasm for Far Eastern art. As a schoolboy he had read with fascination the missionary and Dutch accounts of the closed-off country of Japan. He probably first encountered the Japanese art style known as Ukiyo-e in Paris in 1856, and on his return to the United States he began seriously collecting Japanese prints and incorporating Japanese ideas into his own work. Appropriately, in 1860 he married Margaret Perry, a granddaughter of the commodore who had opened up trade with Japan. By about that date, La Farge was flattening the forms in his paintings in a decorative, Japanese manner, and he even executed some paintings on Japanese tea trays (plate 163)—thus providing tangible proof of his interest in Japanese things.[46] To a great degree, La Farge's discovery and use of Japanese art preceded that by the avant-garde painters in Europe. Under the influence of Japanese prints he introduced a whole group of new effects into American painting: the use of asymmetrical composition, the exploitation of large areas of empty space, and the use of brilliant color in flat planes.

La Farge applied his Japanese ideas to particularly good effect in his still-life paintings, which have been termed "the most beautiful floral pieces ever executed in America."[47] Before La Farge, American still-life specialists had tended to concentrate on fruit and costly objects rather than on the more ethereal loveliness of flowers. La Farge's still lifes, on the other hand, are almost exclusively flower paintings that emphasize beauty, fragility, and transience. He loved the decorative quality of flowers, painting them not as botanical specimens but as evokers of mood and of complex poetic and lyric associations. An almost indefinable Oriental quality, at once delicate and unexpected, pervades these works.[48]

As William H. Gerdts has noted, "The variety of La Farge's still-life was unequaled by any other 19th century flower painter."[49] A Greek marriage wreath, token of the transience of love (plate 1); a bowl of flowers casually placed on a windowsill (plate 13); water lilies opening in a pond in the morning light (plate 65); calla lilies floating in a Japanese lacquer tray (plate 6)—these are some of the subjects he painted with directness and an almost careless freshness. What other nineteenth-century painter would have conceived such a subject as a single cactus flower placed against the opalescence of an oyster (plate 11)? An almost unbearably poignant sense of transience and loss fills many of these paintings. Often, indeed, they carry specific overtones of death. In *Flowers in Japanese Vase* of 1864 (plate 10) not only has a petal fallen on the table but the vase itself is shaped like one of the broken-column grave markers of a New England cemetery.[50] While seemingly casual and unstructured, the compositions of these paintings were often carefully calculated. Barbara Novak, for example, described *Flowers in a Persian Porcelain Water Bowl* (plate 13) as an example of La Farge's spontaneity; but in fact, every element in the painting conforms to a geometric system, based on the rabatment of the painting.[51] Even the most awkward of these flower paintings are strangely moving. They seem like illustrations of Eugène Fromentin's dictum, which La Farge was fond of quoting, that "any work of art which has been deeply felt by its maker is also naturally well painted."[52]

As a landscape painter La Farge progressed from a Barbizon manner to one that recalls the effects of the French Impressionists. He worked outdoors, noting: "The closed light of the studio is more the same for everyone, and for all day, and its problems,

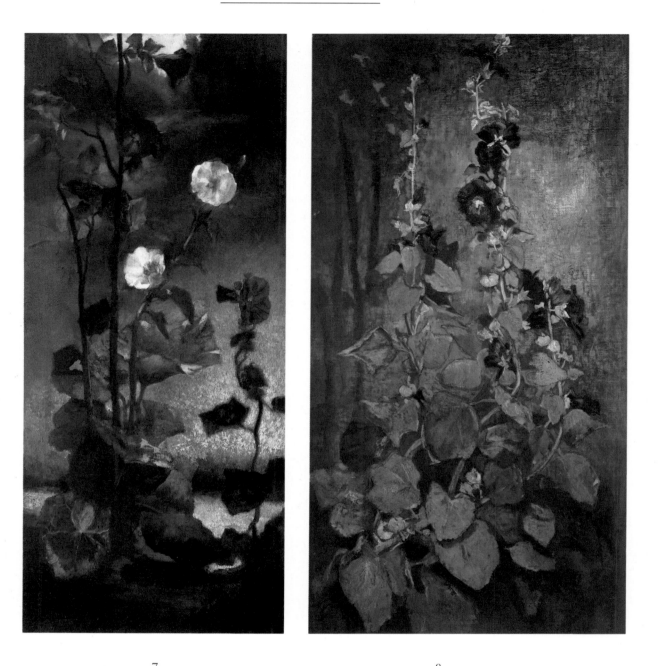

7
Hollyhocks, c. 1863
(White Hollyhocks)
Encaustic on wood
34 × 15¾ in. (86.4 × 40 cm.)
Mr. and Mrs. John M. Liebes
P1863.9

8
Red Hollyhocks,
c. 1863
Encaustic on wood
34 × 21½ in. (86.4 × 54.6 cm.)
Private collection
P1863.10

9
Agathon to Erosanthe, Votive Wreath, 1861
Oil on canvas
23 × 13 in. (58.4 × 33 cm.)
Private collection
P1861.10

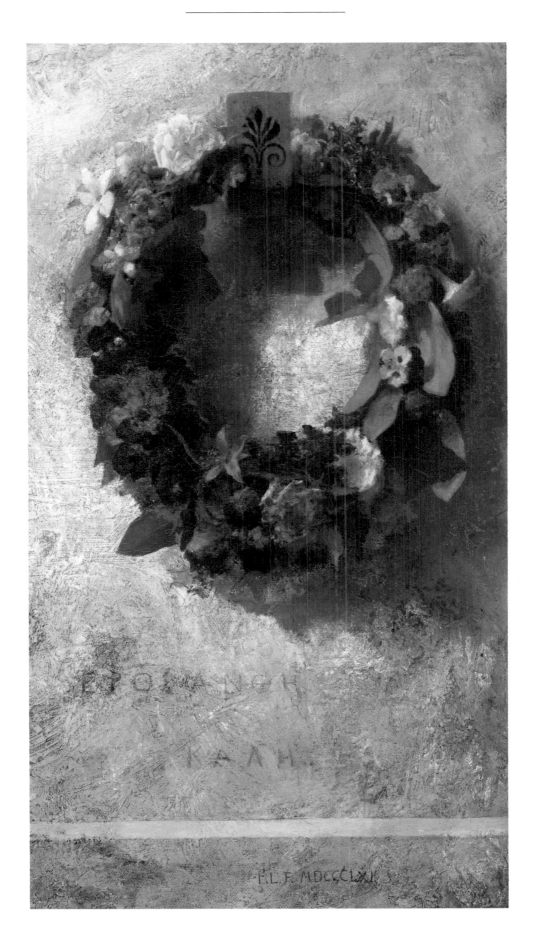

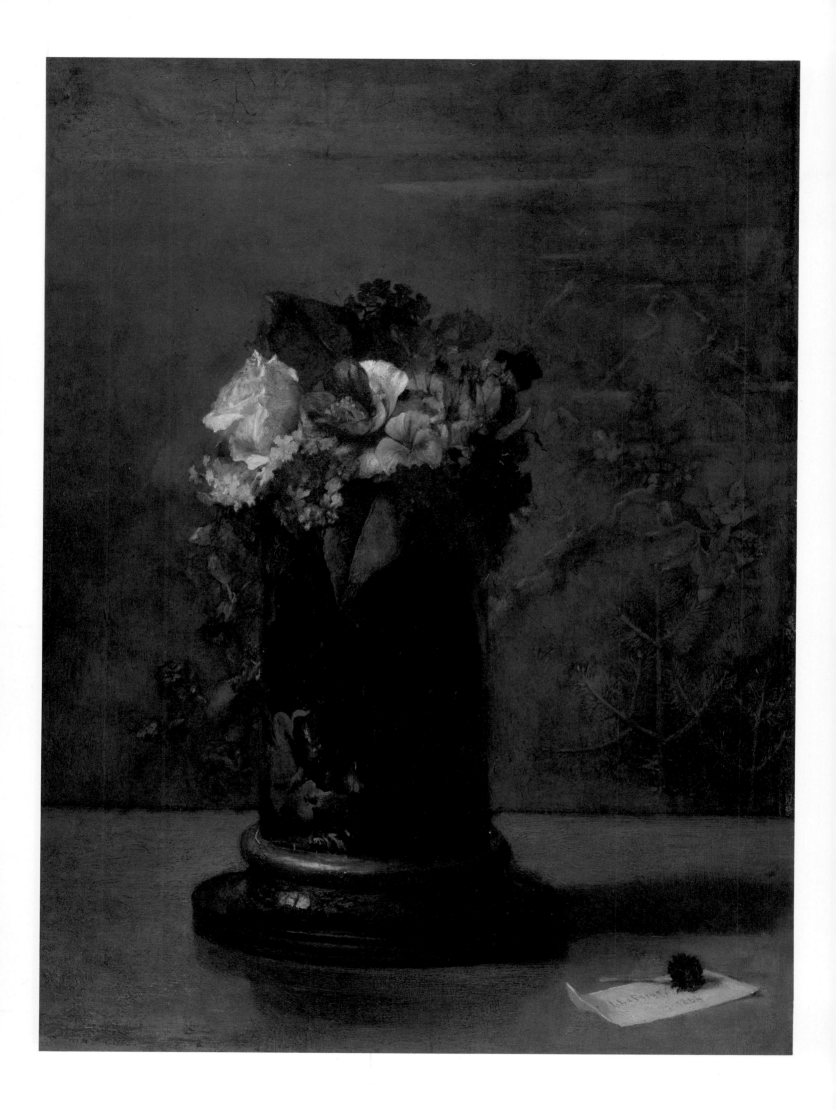

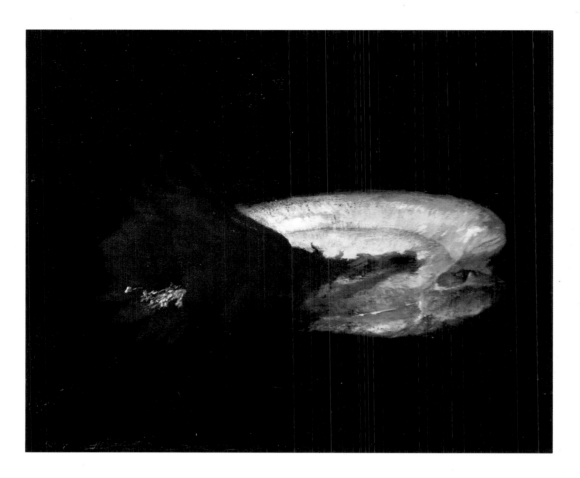

10
Flowers in Japanese Vase, 1864
Oil on wood covered with gold leaf
18¼ × 14 in. (46.4 × 35.6 cm.)
Museum of Fine Arts, Boston
Gift of Louise W. and Marian R. Case
P1864.2

11
Shell and Flower, 1863
(Cactus Flower in an Oyster)
Encaustic on wood
7¹³⁄₁₆ × 9¹¹⁄₁₆ in. (19.8 × 24.6 cm.)
Jerald Dillon Fessenden
P1863.11

however important, are extremely narrow compared with those of out of doors. There I wished to apply principles of light and color, . . . to be as free from recipes as possible, and to indicate very carefully, in every part, the exact time of day and circumstances of light."[53] The artist Elihu Vedder praised one of his early landscape paintings, now lost, for "the truth of the transmitted light through the snow-burdened air."[54]

Above all, La Farge avoided obvious formulas, choosing modest motifs and unusual vantage points and composing his paintings from color and light rather than outlines. A painting such as *Snow Storm* of 1865 (plate 15) hardly contains enough subject matter

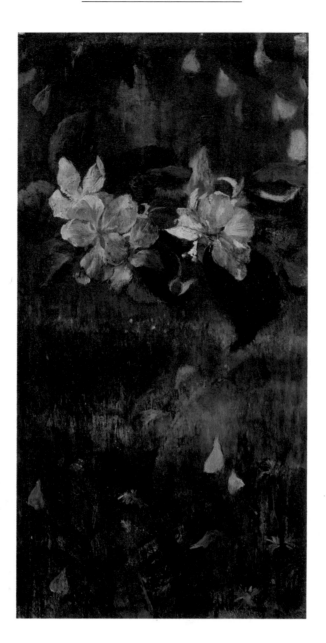

12
Apple Blossoms, c. 1878
Oil on wood
10¾ × 5¼ in. (27.3 × 13.1 cm.)
Private collection, Boston
P1878.4

13
Flowers in a Persian Porcelain Water Bowl, c. 1861
(Flowers on a Windowsill)
Oil on canvas
24 × 20 in. (61 × 50.8 cm.)
Corcoran Gallery of Art, Washington, D.C.
Anna E. Clark Fund, 1949
P1861.3

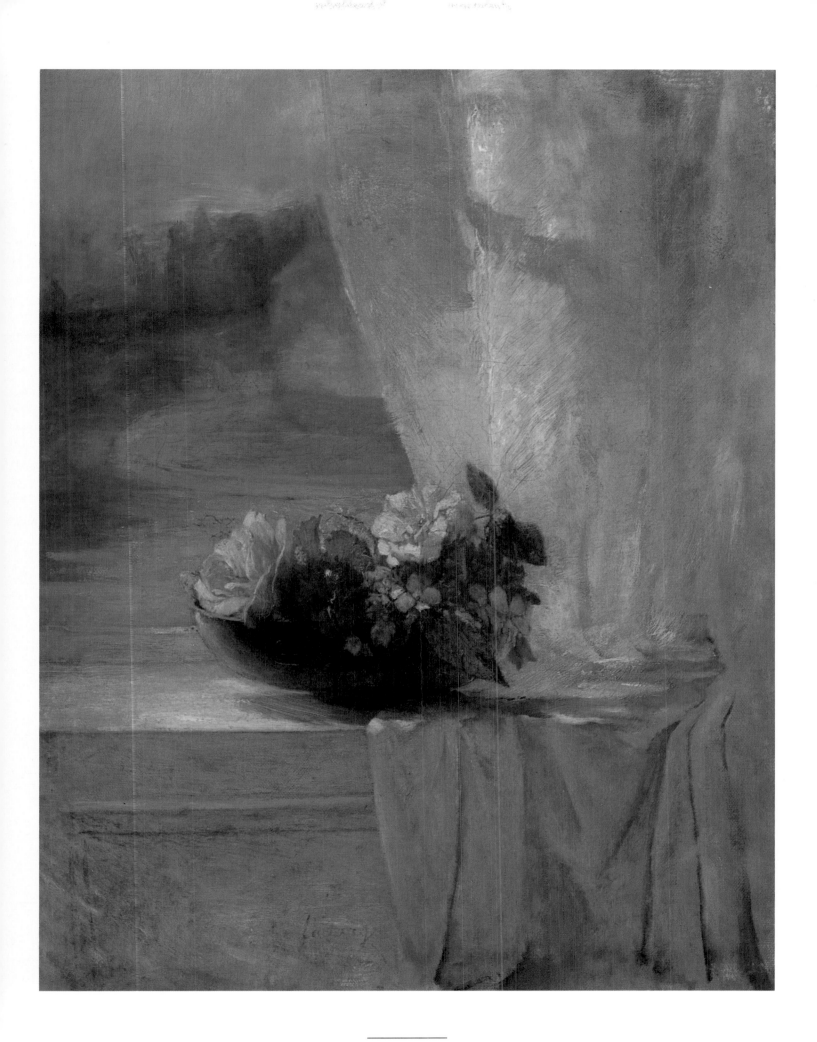

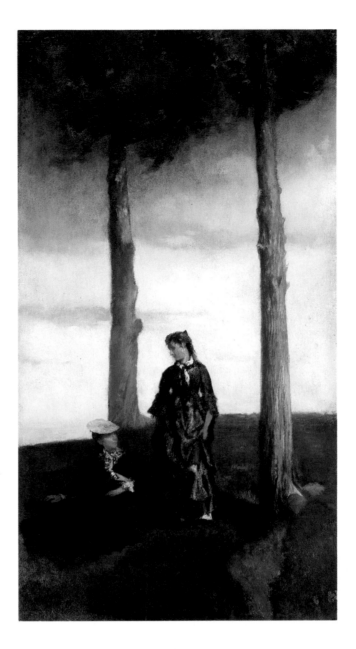

14
Hilltop, c. 1862
Oil on canvas
24 × 13 in. (61 × 33 cm.)
Museum of Fine Arts, Boston
William Sturgis Bigelow Collection
P1862.14

for a traditional picture; it shows merely a single scrub oak standing alone in a windswept field. Yet the painting does not seem empty, partly because of the stark drama of the motif and partly because of the delicacy with which La Farge handled the shadows on the snow.[55] *Clouds over Sea; From Paradise Rocks* of 1863 (plate 54) contains even less in the way of traditional subject material: only the horizontal sweep of land, sea, and sky, and a mass of cumulus clouds. In its abstraction the painting looks forward to the Nocturnes of James McNeill Whistler.[56]

La Farge brought the 1860s to a close with a group of comparatively large-scale landscape paintings: *Autumn Study. View over Hanging Rock, Newport, R.I.* of 1868

15
Snow Storm, 1865
(Tree in Snowstorm)
Oil on wood
16½ × 12 in. (42 × 30.5 cm.)
Mr. and Mrs. Glenn Verrill
P1865.1

(plate 49), *Paradise Valley* of 1866–68 (plate 57), and *The Last Valley—Paradise Rocks* of 1867–68 (plate 58). *Paradise Valley*, which was entirely painted out of doors and which depicts a scene without strong shadows through gradations of pure color, has been described as "one of the first Impressionist landscapes in this country."[57] No doubt because of the parallel with his own early efforts, La Farge was always sympathetic to the work of the French Impressionists. When Lilla Cabot Perry brought back one of Monet's views of Etretat to Boston in 1889, she found that hardly anyone liked it—the chief exception being La Farge.[58]

La Farge's paintings of the 1860s have always received mixed critical responses, on

the one hand hailed for their freshness and sensitivity, and on the other dismissed as too slight to be important. To a large degree, this variation in judgment reflects a contradiction in the critical standards that have been applied to La Farge's works. Many writers have considered a hard-edged style, one concerned with what has rather naively been termed "fact," as intrinsically American. By this standard, La Farge's paintings are clear-cut failures. If, for example, we weigh his *Flowers in a Persian Porcelain Water Bowl* against some still life by Severin Roesen, it is apparent that La Farge's forms are soft and ill defined, his textures hardly expressed, his colors anemic, and his composition distressingly empty. If, on the other hand, we compare La Farge's work with a painting by a progressive French painter of his time, say a floral piece by Henri Fantin-Latour, it is apparent that La Farge's canvas is more freely painted, less stiffly composed, less subservient to studio conventions, and more subtle in its evocation of color and light.[59] Indeed, La Farge's *Flowers in a Persian Porcelain Water Bowl* invites comparison with paintings by Whistler and the Impressionists rather than with those by more traditional French and American painters. If we condemn this piece, as it often has been condemned, as too white, too formless, too preoccupied with slight nuances of lighting and focus, we should at least be aware that we are ready to praise exactly these features in the work of European artists and that they are present in La Farge's work because of his deliberate rejection of more conventional American modes.

After the Civil War the expansive outlook of the Hudson River School was replaced by a more introspective vision, and in this development La Farge's paintings played a pioneering role. Few other American painters of the 1860s had yet adopted the free French manner of painting, and of those that had, none produced works that were so analytical, so·introspective, so concerned with the ambiguity of sensation, and so deeply imbued with a consciousness of human fragility. Reacting against the materialism of American culture and against the violence of the Civil War, La Farge sought in his paintings of common objects to evoke the spiritual dimension of human experience.

This shift has wider implications, for it marked a change not only in American painting but in larger currents of American culture. Indeed, it is worth considering the parallels between La Farge's artistic innovations and those made in different realms of expression by his two close companions of the Newport years, Henry and William James.[60] La Farge's paintings created a new relation between the artist and his subject. His paintings unite the external world with subjective inner experience to the point where subject and object, the viewer and the thing seen, merge into one. Perception ceases to lead to solid, substantive qualities but culminates instead in feelings of transition and relation—in ever-changing gradations of light, focus, interest, and emotion, in continually fluctuating perceptual nuances, which never become fixed or solid.

Henry James, in his novels, similarly transformed traditional formulas, treating narrative not as a succession of events but as successive acts of interpretation. Characters, settings, and happenings cease to be things that occur outside the onlooker but become projections of an inner mental life, reflections of the ordeal of consciousness.

It remained for William James to work out the philosophical implications of this shift. Unlike previous philosophers, he conceived ideas not as discrete entities, but as a teeming multiplicity of ephemeral, ambiguous feelings, in which qualities of transition and relation have as much significance as substantive attributes. In addition, he challenged the assumption of previous philosophers that thought and the thing perceived are different entities; consequently, he effectively eliminated the Cartesian ego. "Thought and actuality are made of one and the same stuff," William James maintained, "the stuff of experience in general."[61] Like La Farge and Henry James, William James conceived an external world that can never be absolutely separated from inner experience.

La Farge's paintings, in short, belong not simply to the history of painting but to the history of ideas. By redefining the self and the act of consciousness, they played a part in bringing about a shift from the certainties of the Victorian world view to the introspection and uncertainty of the modern sensibility.

The "Fantastic" Illustrations

La Farge's paintings of flowers and landscapes dominated his work of the 1860s, but in that decade he also produced a distinguished group of illustrations that explore very different artistic ideas. In his later years La Farge sometimes referred to these designs for wood engravings as if they were trifles, casually tossed off. His disparagement, however, is hardly convincing. His drawings were ambitious, imaginative, and altogether unique in American art of their period.

16
The Wolf-Charmer, 1867
Illustration for the *Riverside Magazine for Young People* (1867)
Wood engraving
6¹⁵⁄₁₆ × 5⅜ in. (17.5 × 13.7 cm.)
The Metropolitan Museum of Art, New York
Rogers Fund, 1921
E1867.1

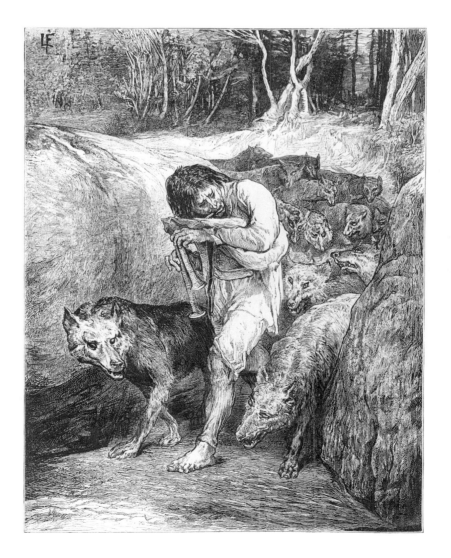

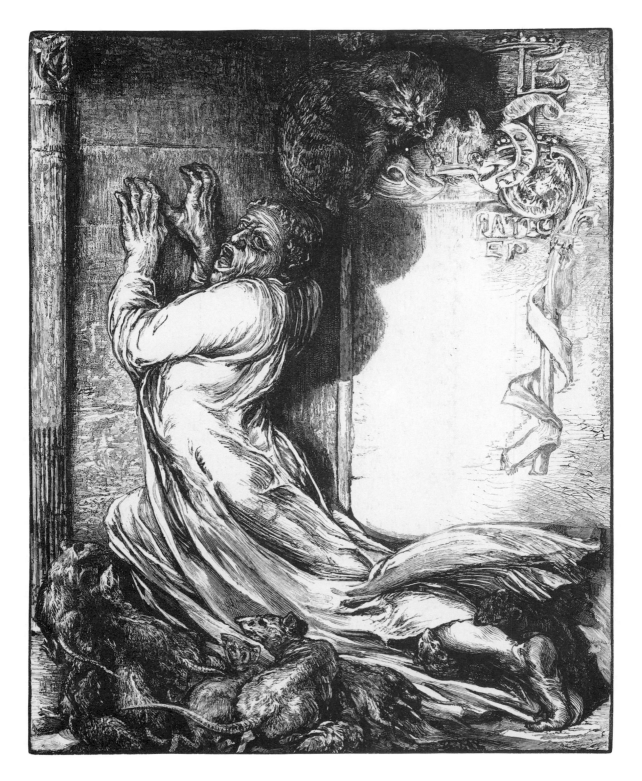

17
Bishop Hatto and the Rats, 1866
Illustration for the *Riverside Magazine for Young People* (never published there)
Wood engraving
7 × 5½ in. (17.8 × 14 cm.)
The Metropolitan Museum of Art, New York
Rogers Fund, 1921
E1866.2

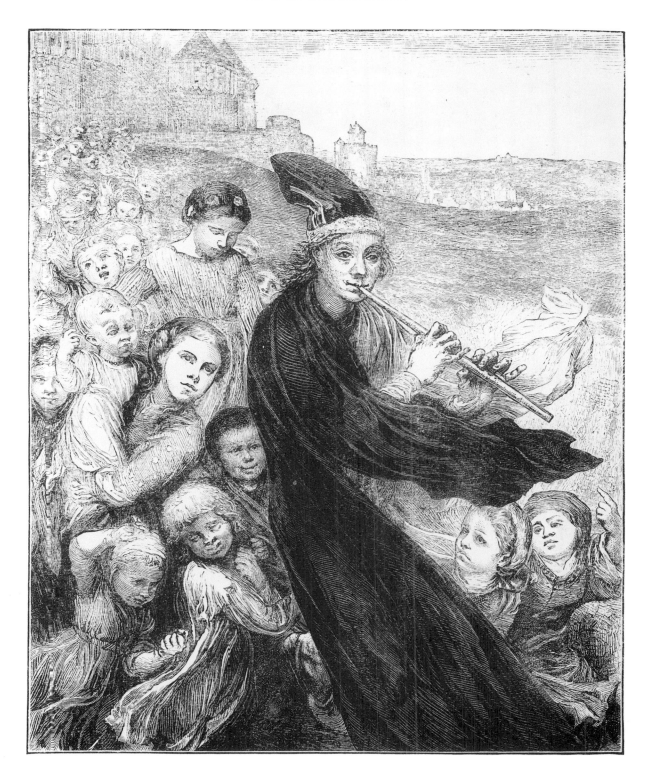

18
The Pied Piper of Hamelin, 1867
Illustration for the *Riverside Magazine for Young People* (1868)
Wood engraving
6¾ × 5⅜ in. (17.2 × 13.7 cm.)
The Metropolitan Museum of Art, New York
Harris Brisbane Dick Fund, 1936
E1868.1

Horace Scudder, editor of the *Riverside Magazine for Young People*, rejected several illustrations by Winslow Homer as unsatisfactory but considered La Farge's *Pied Piper of Hamelin* (plate 18) to be the finest piece of art to appear in his periodical.[62] His enthusiasm was shared by Dante Gabriel Rossetti in England, who sent La Farge a warm letter of commendation for *The Pied Piper*—La Farge's first notable testimony of recognition.[63] Sadakichi Hartmann, in his *History of American Art* (1902), described La Farge as the founder of the first serious school of American illustration.[64] The extraordinary impact of La Farge's designs is suggested by an incident that occurred during his visit to Japan in 1886. A Japanese court painter, one Hung Ai, who remembered La Farge's *Wolf-Charmer* illustration of 1867 for the *Riverside Magazine* (plates 16, 98), greeted him with the words, "Oh, you are the wolf man!" He then accused La Farge of having painted the work with a Japanese brush, which La Farge confessed had indeed been the case.[65]

La Farge introduced a new mood of imaginative fantasy into American illustration. Often he dealt with terrifying themes, such as danger, abandonment, strange encounters,

19
The Travelers and the Giant, 1868
(The Giant)
Illustration for the
Riverside Magazine for Young People (1869)
Wood engraving
7 × 5½ in. (17.8 × 14 cm.)
The Metropolitan Museum of Art, New York
Rogers Fund, 1921
E1869.1

20
The Fisherman and the Djinn,
1866–67
Illustration for the
Riverside Magazine for Young People (1868)
Wood engraving
6¾ × 5⅜ in. (17.2 × 14.3 cm.)
The Metropolitan Museum of Art, New York
Harris Brisbane Dick Fund, 1936
E1868.2

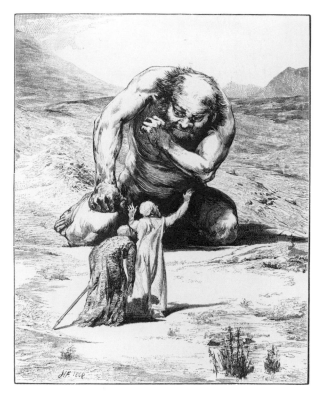

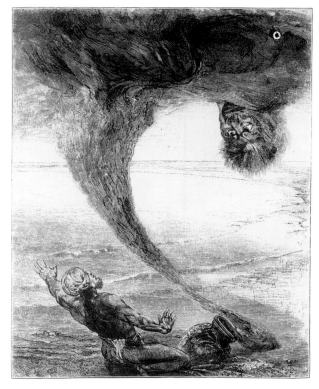

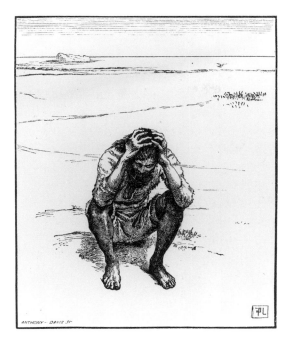

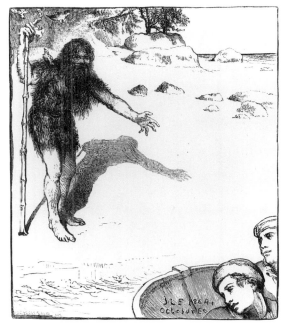

21
Enoch Alone, 1864
Illustration for *Enoch Arden* (1864)
Wood engraving
3⅞ × 3¼ in. (9.8 × 8.3 cm.)
Private collection
E1864.6

22
The Solitary, 1864
Illustration for *Enoch Arden* (1864)
Wood engraving
3¹⁵⁄₁₆ × 3⅜ in. (10 × 8.6 cm.)
Private collection
E1864.7

23
The Island Home, 1864
Illustration for *Enoch Arden* (1864)
Wood engraving
3¹³⁄₁₆ × 3¼ in. (9.7 × 8.3 cm.)
Private collection
E1864.5

and the fear of punishment—for example, Enoch Arden marooned on the desolate sands of a deserted island (plate 21), a pair of travelers confronting a giant (plate 19), or the cruel Bishop Hatto being devoured by rats (plate 17). La Farge's style was non-naturalistic, with swirling rhythms and peculiar shapes. Many of the designs had a "Gothick" feeling. Others were Japanese and grotesque, including a remarkable drawing of 1864, *The Island Home* (plate 23), for Tennyson's poem *Enoch Arden*. This was the first work in a completely Japanese style by any Western artist.[66]

In technique La Farge's illustrations were also extremely innovative. He disliked the hard, linear effect of previous illustrations and consequently created his designs in wash, much to the consternation of his engravers, who had to translate his subtle gradations of tone into linear networks.[67] Neither La Farge nor his artisans were ever satisfied with the result, but the friction between them led to a new style of wood engraving—the so-called New School or American School—which virtually eliminated modeling with contour lines to concentrate instead on tonal and atmospheric qualities.[68] Thus, as in his paintings, La Farge chose both subjects and techniques that transcended the literal and the physical, that translated mundane realities into the world of spirit and imagination.

Trinity Church and the Early Decorative Projects

Throughout the 1860s La Farge put his greatest effort into easel paintings, most rather small in scale. By the end of the next decade, however, he had virtually abandoned easel painting to concentrate on monumental decorative projects. These mural ensembles bear little outward resemblance to his earlier productions, but La Farge had learned from the French Romantic Théodore Chassériau, whose work he had admired in Paris, "that one technique serves, or might serve, as the substratum of another very different."[69]

Religious mural painting stood at the top of the traditional French hierarchy of genres, but La Farge's attraction to ecclesiastical work reflected more than a desire to practice the most prestigious of artistic modes. While at times La Farge's religious paintings may seem hackneyed and conventional, they reflected a religious faith that was deep-rooted and sincere, though often somewhat puzzling in its manifestations. The paradoxes of La Farge's approach, his ability to sustain contradictions in his mind, extended to his religious beliefs. "I never could quite make out my father's religious practice,"[70] his son John, a Jesuit priest, once noted. La Farge was proud of his Catholicism in a society that was predominantly Protestant, though he was often delinquent when it came to actually going to church. He was fascinated by alien religions, particularly Buddhism, and enjoyed the comparative study of religious practices and psychology. Though by temperament a skeptic on nearly every subject, in matters of religion he was content to accept Catholic dogma, maintaining that he must believe either "that Church or none."[71] La Farge's attraction to religious painting reflected a very personal need both to reconcile his Catholic upbringing with a Protestant culture and to discover spiritual truths in a materialistic age. In the deepest sense, in fact, La Farge was always a religious painter: even in his landscapes and still lifes he sought to express the spiritual realities that lie behind the veil of appearances.

Despite their originality, La Farge's Newport paintings brought him little public notice. It was in 1877, after he had decorated the interior of Trinity Church in Boston (plates 24, 115, 124), that he was suddenly recognized as one of America's most distinguished artists and as "the father of American mural decoration."[72] The job at Trinity was not an easy one. The entire decoration of the structure, for which there were no precedents in America, was accomplished in a hurried five months. Because of the pressured schedule the painting was started, in biting winter cold, before the roof of the church was complete.

Moreover, the work was hazardous as well as uncomfortable. Two workmen were killed by falling tiles, and the rector himself, Phillips Brooks, who had come to watch the work, was nearly flattened by a sturdy oak plank that landed within six inches of his head. Although he was troubled by some form of partial paralysis, which he attributed to lead poisoning, La Farge both supervised his assistants and took part in the painting himself. On the last night, suspended fifty feet above the church floor, he painted feverishly, stopping only a few hours before the scaffolding was removed.[73]

Although it was La Farge's first mural project, Trinity Church remains in many respects his best. He was lucky in having a magnificent building to decorate, the work with which H. H. Richardson discovered his mature style, the so-called Richardsonian Romanesque. One of the few large buildings to go up in Boston during the panic of 1876, Trinity became the most admired architectural statement of its time and has grown in stature as a landmark ever since.[74] More than that, Trinity offered unusual freedom for the painter. It was conceived as a barnlike "preaching box," which could focus attention on Phillips Brooks, the most charismatic preacher of his day. The entire interior consists of bare plaster walls, modeled on those of early Christian basilicas, almost unadorned by moldings or architectural protuberances. If left undecorated, in fact, the interior would have been quite grim. La Farge's murals, however, transformed the space into an Arabian Nights fairyland.[75]

La Farge's plans were prepared in secrecy and haste, for the church committee had already spent more than intended and was inclined to defer the issue of decoration. La Farge's presentation, however, backed by Richardson's contagious enthusiasm, won them over. They liked the grandeur of the proposal, the first unified ensemble of ecclesiastic decoration in the United States. And they liked the price, for La Farge agreed to perform the whole task for a mere $8,000, barely enough to cover the cost of workmen and materials.

La Farge's scheme for Trinity is filled with allusions to the art of different periods, particularly those that evoke an early age of faith. The dull Pompeian red of the walls recalls the wall paintings of classical antiquity. Many of the motifs are Byzantine—for example, the imitation-mosaic crosses, which resemble those in the Orthodox Baptistry of Ravenna; the jeweled crosses like those of Santa Pudenzia in Rome; the portrayal of Jonah's whale as a sea monster, a motif found in early Christian art; and the scene of Abraham and Isaac, which recalls one at San Vitale in Ravenna. Other elements seem medieval, such as the symbols of the four Gospels, which recall manuscript illuminations, and the figure of Isaiah (plate 121), whose sinuous pose seems to have been based on the carvings at Souillac. Finally, there are references to Renaissance art. Moses, for example, recalls Nicola Pisano's fountain at Perugia, and perhaps contains a hint of Michelangelo's famous statue as well.

An unusual feature of the Trinity ensemble is the studied use of asymmetry. Although La Farge had eight panels to fill in the central tower, he created only six figures, placing them on all sides of the tower but the west. This was to some extent logical, for figures on the west wall would have been largely hidden from the congregation, but no doubt it was also done to create an unexpected break in the regularity of the design. Still more random is the treatment of the vaulted surfaces of the nave and transepts, which are sprinkled arbitrarily with geometrical symbols and patterns.

The architect Henry Van Brunt perceptively noted that despite La Farge's use of Western motifs, his free compositional arrangement "shows a very intelligent study of oriental methods."[76] La Farge himself, in a speech he gave shortly after the murals were completed, noted that the work of the monuments of the past "is never like our usual modern work, which suggests machinery, that is to say the absence of personality." He

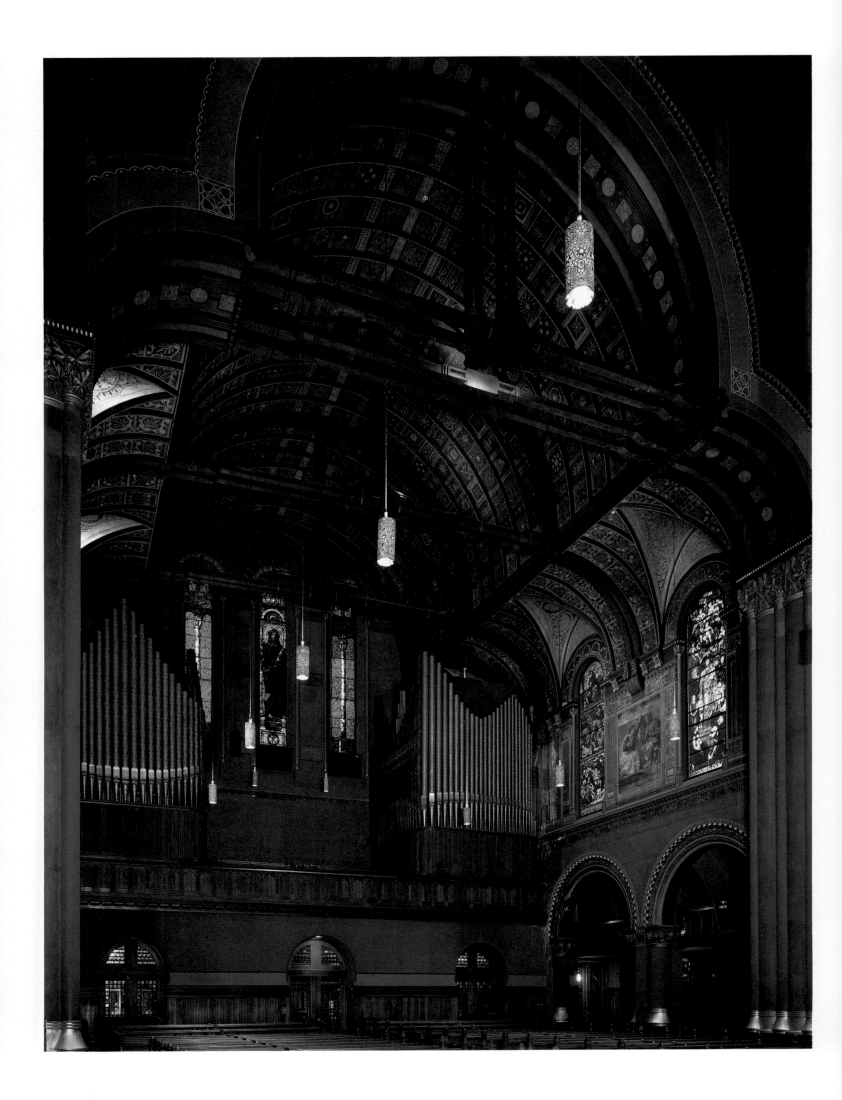

confessed, "I knew that our work at Trinity would be faulty, but this much I was able to accomplish—that almost every bit of it would be living, would be impossible to duplicate."[77]

The fascination of La Farge's scheme lies in the complexity of its interplay between flat decoration and pictorial illusionism. La Farge, with his delight in paradox, asserted the architecture by creating effects that contradict it. He painted imaginary windows in the wall, denying its weight-bearing role, and emphasized the thin colonnettes at the side, where in fact there is little structural load. Thus the structure, which in actual fact is solid, massive, and unmodulated, appears spindly and insubstantial, with walls that resemble Japanese sliding paper screens. The physical becomes floating and unreal in a manner that recalls the dematerialization of Byzantine structures. It also curiously anticipates modern architecture, in which the new materials of steel and glass made possible in actual fact the effects La Farge presented as pictorial fiction.

Trinity created a sensation: America had never seen anything like it. The sensuality of the ensemble, with its rich colors and romantic subject matter, opened up a whole new realm of experience to a public accustomed to cold, unadorned stone or the bare white interiors of New England colonial churches. The subject matter, with its self-conscious allusions to the art of the past, to the work of the early Christians, the Byzantines, the medieval craftsmen, and the followers of Raphael, evoked a world of tradition and ritual that contrasted with the lonely self-examination of Puritanism. Finally, the interplay between painting and decoration established a more complex and intimate relationship between painting and daily life. Painting had stepped out of its frame to create a complete environmental ensemble. The result brought La Farge a shower of critical acclaim. As one enthusiast wrote to the *Art Amateur*: "The art loving person who could not spend an hour, nay two, amid its rich and varied beauty, must be insensible to color."[78] More recently, Robert Berkelman has described Trinity as "one of the most satisfying interior ensembles in all American art."[79] For the next thirty years La Farge was to enjoy almost continuous praise, such as rarely is accorded living artists.

After Trinity, La Farge had little time for easel painting. He became a full-time muralist and decorator. In the crowded years between 1878 and 1886 he produced decorations for Saint Thomas Church, New York (plate 126); Church of the Incarnation, New York (plate 128); United Congregational Church, Newport (plate 132); and Brick Presbyterian Church, New York (plate 133); as well as for the Union League Club (plate 135), the mansions of Cornelius and William H. Vanderbilt (plates 136, 137), and many other private residences. These projects were too large to undertake completely on his own, so he built up a sizable shop, which included such notable artists as the sculptor Augustus Saint-Gaudens, who began his career as La Farge's assistant.[80]

In both his religious and his domestic work La Farge sought to give visual form to new impulses in American life. His ecclesiastical work reflected a trend toward more "high church" forms of religious observance and a new tendency to approach religion in emotional as well as intellectual terms. His domestic work reflected the needs of a new social creature in America, the multimillionaire. Working for such clients as the Vanderbilts, William Whitney, and the railroad magnate James J. Hill, La Farge created a decorative splendor that matched their newly won wealth and social aspirations.

24
Trinity Church, Boston, 1876–77
Nave
MD1876.1

In certain ways La Farge was well fitted to supervise decorative programs, for he had an ingenious imagination, nourished by much looking and wide reading, as well as a remarkable ability to intuit how a small sketch would look when carried out on a monumental scale. On the other hand, the organizational responsibilities of these ventures taxed his ultrasensitive nerves, and he had a deplorable business sense. Adams described La Farge's high-strung character in *Esther*:

> He was apt to be silent until his shyness wore off, when he became a rapid, nervous talker, full of theories and schemes, which he changed from one day to another, but which were always quite complete and convincing for the moment. At times he had long fits of moodiness and would not open his mouth for days. At other times he sought society and sat up all night, talking, planning, discussing, drinking, smoking, living on bread and cheese or whatever happened to be within reach, and sleeping whenever he happened to feel in the humor for it. Rule or method he had none.[81]

During the early 1880s, when La Farge maintained an arrangement with the decorative firm of Herter Brothers, who subcontracted to him, he managed to remain solvent. But when that arrangement expired he set up his own firm, which very shortly plunged into bankruptcy, under circumstances of considerable acrimony. Before that happened, however, he had established a new art form, for his work in decoration fueled his most significant artistic triumph, the creation of opalescent stained glass.

Stained Glass

La Farge's interest in stained glass dated back to his first trip to Europe, when he had studied the glass of the medieval churches. His interest was revived in 1873, when he visited England, met the Pre-Raphaelites, and discussed stained glass with Edward Burne-Jones. He first began to experiment with the medium in the mid-1870s, when he received some commissions from Henry Van Brunt. Unfortunately, good materials and good workmen were not available; although La Farge sought to enhance the depth of color and his control over it by "plating," or layering, the sheets of glass, he was unable to achieve the effects he desired.[82] Indeed, in his displeasure he eventually destroyed his major early effort, a window for Memorial Hall at Harvard done in 1876.

Then one day, while he was lying ill in bed and thinking over the problems he was having with stained glass, La Farge looked up and saw light streaming through a tooth-powder jar on the windowsill. The glass vessel, which had been intended to look like china, had been cheaply manufactured and had come out looking streaky and opalescent. La Farge quickly recognized that this was the material he needed. Opalescent glass contains opaque particles that float in colloidal suspension, and these modulate its degree of transparency or opacity and scatter light in a mysterious manner. It has a layered structure, which allows different colors to be blended in a single sheet. Thus, almost any pictorial effect can be created, making it possible to manipulate effects of color not by painting on glass but by exploiting the properties of glass itself.

La Farge's approach to stained glass differed fundamentally from that of William Morris and the members of the English Arts and Crafts movement, who sought to revive medieval stained-glass principles, materials, and techniques. Repudiating the excesses of pictorial stained glass, Morris and his cohorts sought design reform by returning to the purity of medieval principles. They rejected illusionistic effects; they admired flatness; they avoided excessive use of enamel, paint, or stain; and they let leading play an assertive role in the design, as in the best medieval work. The limitation of the English approach

was that it discouraged adventurousness and encouraged anachronism. La Farge's approach was fundamentally different, for he sought to expand rather than limit the potential of stained glass. He, as much as the English, wished to exploit the properties of glass, but rather than rejecting pictorial effects, he sought ways to make glass better express them.

Technically, La Farge was the greatest innovator in the history of modern stained glass. His key breakthrough, of course, was the discovery of opalescent glass, which made possible a host of previously undreamed-of pictorial effects. (It was quickly picked up by imitators, particularly Louis C. Tiffany, who successfully commercialized La Farge's discovery, exploiting it to produce ashtrays, vases, and lamp shades.) La Farge manufactured glass of every type: glass that was textured by rollers; glass that was folded to resemble drapery; glass that was cast in molds to assume special shapes—for example, to resemble the petals of a flower; glass that was cut or chipped into facets like a jewel; and glass that had bits of colored glass sprinkled into it in decorative patterns. These new varieties of glass suggested the incorporation of other materials, and La Farge exploited this idea exuberantly, utilizing broken bottles, slices of alabaster, bits of quartz, and even semiprecious stones. He attempted every possible contrast of texture and color, placing the brilliant beside the dull, the rough beside the smooth, sometimes creating subtle transitions of tone, other times juxtaposing complementary colors. He once described his work as "a rivalry of precious stones."[83]

Unlike previous painters who worked in stained glass, La Farge did not turn over the entire manufacture of his windows to artisans and assistants. He closely supervised every aspect of the operation, including not only the design but the manufacture of glass, the placement of lead lines, and the selection of individual pieces of glass. Thus, his vision of the possibilities of the medium was reflected in every detail of how his windows were put together. In glass, more than in any other medium, La Farge lived up to his belief that "in all of the greatest artists there is a humble workman who knows his trade and likes it."[84]

See page 42
25
The Infant Bacchus, 1882–84
Window from Washington B. Thomas house (later Henry P. Kidder house),
Beverly, Massachusetts
Stained glass
89⅛ × 44⅞ in. (226.4 × 114 cm.)
Museum of Fine Arts, Boston
Gift of W. B. Thomas
G1882.36

See page 43
26
Peonies Blown in the Wind, 1886
(Peony in the Wind)
Window from studio of Sir Lawrence Alma-Tadema, London
Stained glass
60½ × 46⅞ in. (153.7 × 119.1 cm.)
Museum of Fine Arts, Boston
Purchased from General Funds
G1886.1

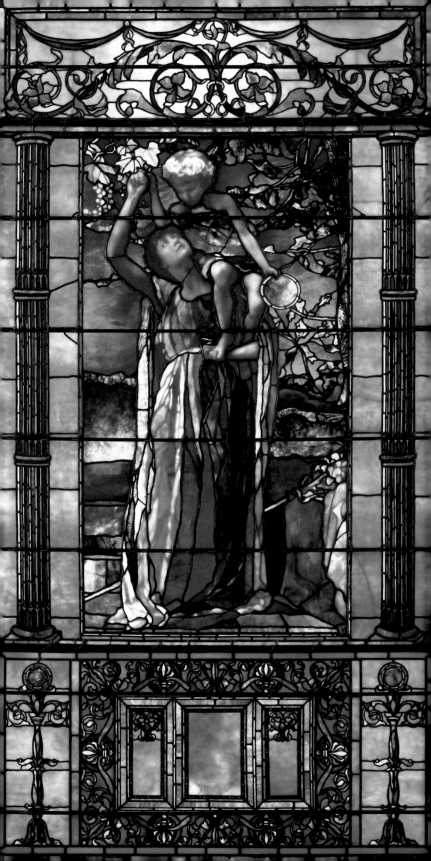

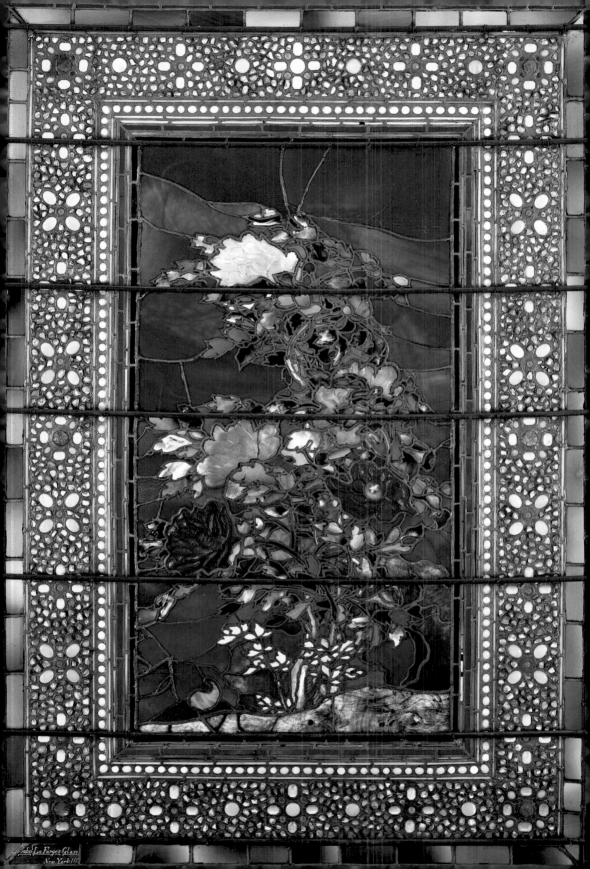

John La Farge Glass
New York/[...]

La Farge expanded the traditional subject matter of stained glass in two respects. First—a stroke of genius—he recognized that the flatness and decorativeness of Japanese design made it intrinsically suited to stained glass. Thus, he introduced into stained-glass design a whole new range of motifs from Japanese prints—for example, sparrows and peacocks; iris, peonies, and chrysanthemums; butterflies and grasshoppers; swimming carp; apple and cherry blossoms—all subjects that had never been treated in stained glass before. This innovation was so widely imitated and so fundamental to nineteenth-century stained glass and to the whole flowering of Art Nouveau that it is easy to forget that La Farge deserves credit for it. While floral windows had occasionally been made before, La Farge was the first to create elaborate, large-scale flower images in glass, and thus he was the chief originator of the Victorian floral window.

Second, La Farge took up precisely the sort of pictorial subject matter that had been rejected by the English apostles of design reform—going so far as to make copies in glass of Renaissance paintings and even basing one of his windows, *The Infant Bacchus* (plate 25), on a photograph taken at a garden party. La Farge reasoned that illusionism was the most natural expression of the nineteenth century and that to deny it would be to settle for an emasculated art, an art defined not by possibilities but by restrictions. He attempted, therefore, to reconcile illusionism with decoration—using strong lead lines and balanced arrangements of color to create an ornamental effect and to assert the double nature of his compositions as both an illusion and a flat pattern resting on the pictorial plane.

La Farge's work in stained glass is usually pushed off to the sidelines of art history and treated as a small episode in the history of the so-called minor arts. But if La Farge's glass were considered as part of the history of painting, one might propose that he was the most innovative and progressive artist working in America during the nineteenth century, the only one whose experiments significantly parallel those of the modernist European painters.[85] Indeed, his Japanese-inspired floral windows, such as *Peonies Blown in the Wind*, which he created for Sir Lawrence Alma-Tadema in 1886 (plate 26), possess many of the formal attributes of a Post-Impressionist painting: flatness, asymmetry, and intensified color.[86]

Painting with light was one of the ambitions of the nineteenth century, and it provided the basis for the influential Impressionist style.[87] La Farge's contribution lay in recognizing how stained glass could be exploited for this purpose. Previous painters who had designed for stained glass—Sir Joshua Reynolds, for example—had attempted to imitate pictures by painting in opaque black pigment on the glass or by using enamel paint, two approaches that invariably led to dull, washed-out effects.[88] La Farge, on the other hand, developed means of modeling with the rich colors of glass itself. Recognizing, as the Impressionists did, that the shadows of things are also colors, he created his shadows with sheets of colored glass. "He creates a kind of chiaroscuro hitherto unknown," Henri Focillon commented of La Farge's efforts, "a kind of nocturnal sun more brilliant than the light of day."[89] Through the use of opalescent glass, with its rich coloristic effects, through the use of plating to modify color, and through dozens of other ingenious techniques, La Farge found ways to model his designs entirely with colored glass and thus to paint with light itself.

Watercolor

Beginning in the late 1870s watercolor rather than oil became La Farge's preferred medium as a painter. Several factors led to this change: the great ease and fluidity of watercolor, which made it suited to quick sketches; the translucent brilliance of its color,

which almost paralleled stained glass; and the growth of watercolor societies and a watercolor movement, which focused new attention on watercolor and increased the market for it.[90]

La Farge regularly used watercolor to make studies for his murals and stained glass. In addition, around 1879, at the height of the watercolor craze, he devoted serious effort to the medium in a group of magnificent renderings of flowers, such as the inexpressibly subtle *Chinese Pi-tong* and the breathtaking *Wild Roses and Water Lily—Study of Sunlight* (plates 101, 103). Several of these works are technically faultless, proof that La Farge was capable of superb craftsmanship when he concentrated seriously. At the same time as these flower studies, he also produced a number of watercolors of the Newport landscape (plates 27, 28).

In many ways these watercolors—both the floral studies and the landscapes—restate the themes of La Farge's oil paintings of the 1860s. However, they also display interesting

27
Study at Berkeley Ridge or Hanging Rock, c. 1883
(Rocks at Newport)
Watercolor on paper
10½ × 13 in. (26.7 × 33 cm.)
Museum of Fine Arts, Boston
Bequest of Mrs. Henry Lee Higginson, 1935
W1883.24

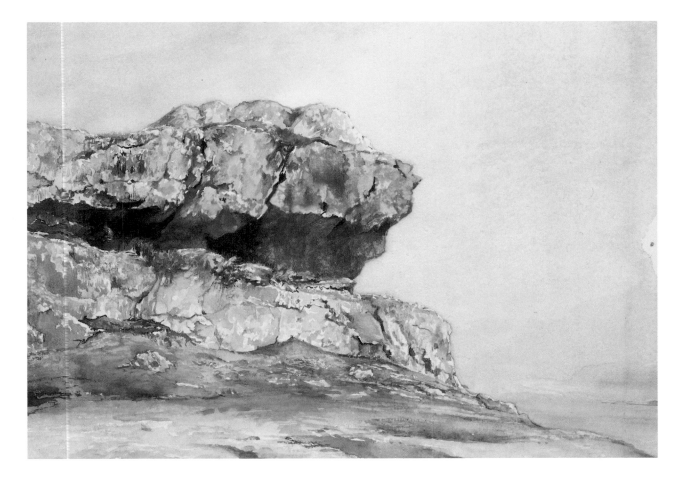

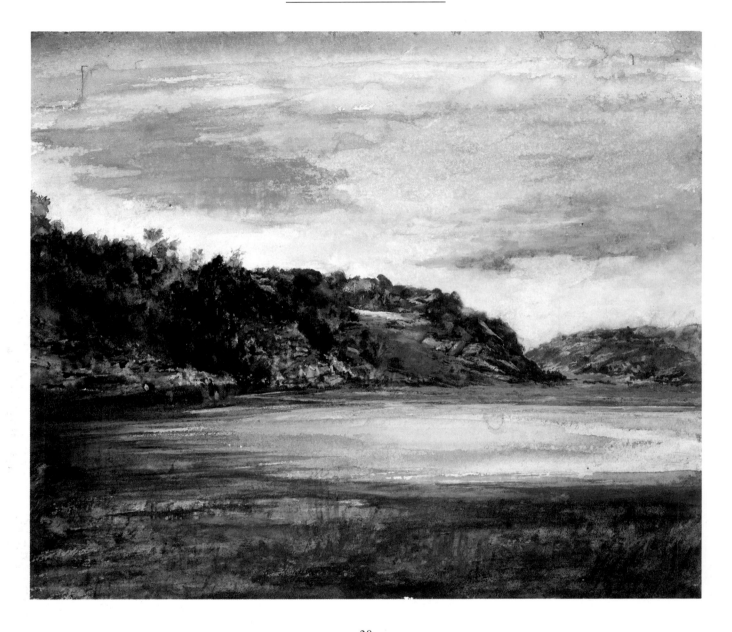

28
Paradise Rocks—Study at Paradise. Newport, R.I., c. 1883
(Green Hills and Pool)
Watercolor on paper
8 × 9⁷⁄₁₆ in. (20.3 × 24 cm.)
The Metropolitan Museum of Art, New York
Bequest of Susan Dwight Bliss, 1966
W1883.23

29
Wild Roses in a White Chinese Porcelain Bowl, 1880
Watercolor on paper
10¹⁵⁄₁₆ × 9¹⁄₁₆ in. (27.8 × 24.5 cm.)
Museum of Fine Arts, Boston
Bequest of Elizabeth Howard Bartol, 1927
W1880.2

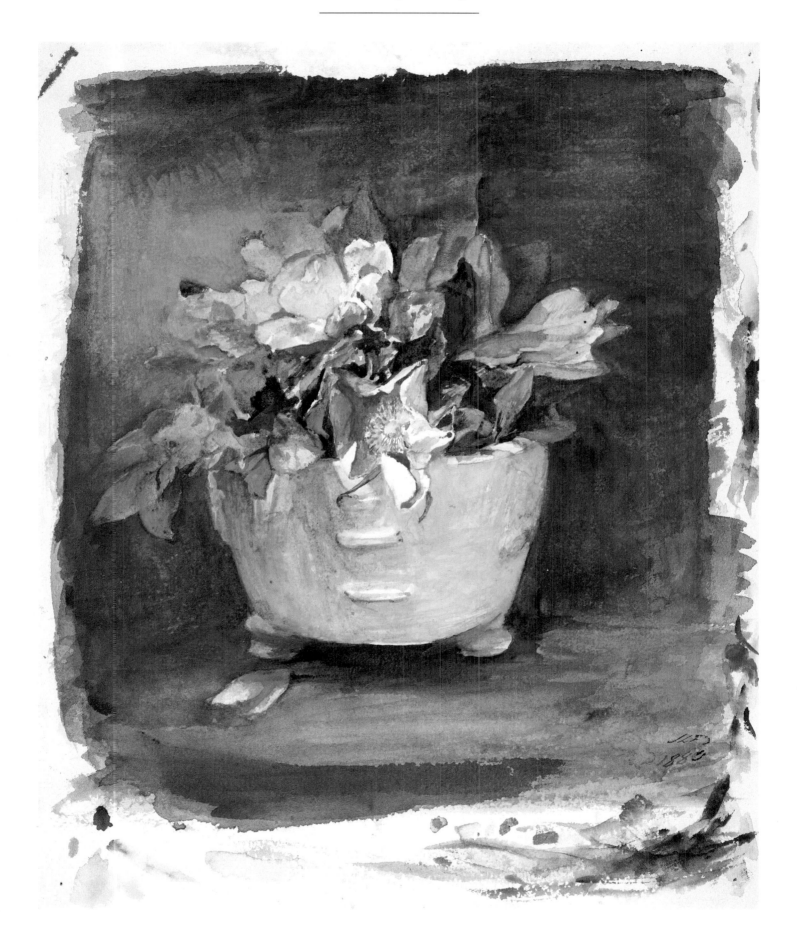

differences of approach and atmosphere. In technique they are more polished, more attentive to details and accessories. In mood they are as delicate as the oils, but somewhat less contemplative, with a richness of color that gives them a new decorative exuberance.

La Farge had always been attracted to the exotic, and this attraction took wing when he set off on two excursions, first to Japan in 1886 and then to the South Seas in 1890–91. On both journeys, watercolor served as his principal means of expression.

The Trip to Japan

In 1886 La Farge abruptly broke away from his immediate commitments and set off for Japan with his friend Henry Adams, who was in despair over the recent suicide of his wife.[91] The decision to go was made hastily, and La Farge left his affairs in confusion. Shortly before leaving he signed a contract to complete a large mural for the Church of the Ascension in New York. His patrons believed that he would go to work immediately, but instead he surreptitiously left for the Orient on the third of June, the day before the vestry voted to approve the agreement.[92] The British publisher Cassell and Company had just engaged La Farge to illustrate Percy Bysshe Shelley's "To a Skylark" for its reprint series. But La Farge cheerfully abandoned the project, stopping off in Albany to telegraph a cryptic line from the poem to the firm's New York agent: "The purple evening melts around my flight."[93] By this time La Farge was seeing little of his family, who no longer depended on him for support, and from their standpoint his departure passed almost unnoticed.

In Omaha, Adams and La Farge were met by an eager young journalist, notebook in hand, who had picked up the rumor that the pair were scouting for railroad sites in Japan. When the reporter asked their destination, La Farge beamed through his spectacles that they were in search of Nirvana. Unfazed, the youth popped back: "It's out of season."[94] Indeed, Nirvana eluded them in Japan. In many ways the trip proved a disappointment.

Not that La Farge and Adams lacked good guidance in the East: their hosts were pioneers in the appreciation of Japanese art. Ernest Fenollosa had already completed his collection of Oriental art, one of the greatest ever assembled, and had begun a systematic catalog of Japanese art treasures. William Sturgis Bigelow, a gourmet and dandy with a China-trade fortune, was acquiring Japanese bibelots by the thousands and had become immersed in the study of Tendai Buddhism. Okakura Kakuzo, their Japanese interpreter, was well versed in the Chinese classics, the paradoxes of Lao-tzu, the subtleties of the tea ceremony, and the mysteries of Zen.[95] Thus, Adams and La Farge had a unique opportunity to penetrate the inner essence of Japan. Sadly, most of their responses to the place were surprisingly superficial.

Adams, still in shock from the death of his wife, was appalled by Japan from the moment of his arrival. He was distressed by the heat and by the stench of sewage; the Japanese people reminded him of monkeys, and the Japanese horses of rats. Unwilling to give in to Japanese customs, he carried with him food, sheets, flea powder, and acid phosphate for indigestion. He brewed tea that he had brought with him from Washington, D.C., and concocted meals by pouring tins of mulligatawny soup over his boiled rice. Strangely indifferent to Japanese ideas and still floating in spiritual limbo, he spent much of his time sequestered in his room, reading with delight about the torments of the damned in Dante's *Inferno*.[96]

La Farge was more charitable in his opinions about the Japanese, but little more perceptive. Perhaps most disturbing is his failure to grasp Japanese art. Before La Farge visited the East he seems to have known Japanese art chiefly through the work of the

color printmakers and through bric-a-brac. In the Orient, he learned of the scorn with which the Japanese regarded Ukiyo-e, an opinion shared by Fenollosa. But La Farge never did learn to understand or appreciate the achievements of the earlier epochs of Japanese culture, and his comments in *An Artist's Letters from Japan* reflect disturbing lapses of taste. The less significant the art, the more he was impressed by it. For example, he devoted several chapters to the vulgarities of Nikko but dismissed the ancient wonders of Nara in scarcely more than a sentence.[97] He overlooked precisely those varieties of Japanese art that seem—at least from our modern perspective—most unique and peculiar to Japan. A major oversight, for example, was his exclusion of the art of Zen. La Farge's friend Okakura later popularized the Zen aesthetic in his masterful volume of essays, *The Book of Tea*—dedicated to La Farge. In La Farge's writings, however, it is precisely the "tea taste" in Japanese art—the monochromatic ink paintings of Sesshu and Sesson, the mystic, contemplative spareness of the Katsura palace or the Ryoanji rock garden— that are unaccountably omitted.[98]

La Farge produced little of consequence during his stay in Japan, perhaps in part because it was too brief—a mere three-month sojourn. Perhaps only one of the Japanese watercolors could be described as a masterpiece, a view of Kyoto from a vantage point near the Kiyomitsu temple (plate 30).[99] In it he worked freely and wetly, with washes of delicate color splashed over the water-soaked paper, producing the piece in a mere half-hour, between 6:30 and 7:00 on the morning of September 10. Yet he caught with surprising exactitude the specific look of the place and the moment, as the early morning mist, in soft tints of gray and lavender, hovers over the rooftops of the valley, gradually being burned off by the heat of the day. Unfortunately, most of the Japanese watercolors are far drier in effect, and in appearance rather like picture postcards. A good many of them, in fact, were executed from photographs after La Farge returned to the United States, for use as illustrations in *An Artist's Letters from Japan*. All of La Farge's large watercolors of the great Buddha at Kamakura (plate 32), for example, were painted after his return.[100]

La Farge's intellectual interest in Oriental mysticism did not easily find effective expression in visual form, as is demonstrated by a series of paintings he made of Kwannon, the Buddhist divinity of compassion, whom he showed in her feminine aspect, seated in front of a waterfall (plates 34, 74). La Farge was particularly fascinated by the Oriental treatments of this theme, which seemed to him similar to Western renditions of the Virgin Mary. While in Kyoto he examined Mokkei's famous painting of the subject in the Daitokuji temple, and in addition he carefully studied another version by Cho Densu in the Fenollosa collection.[101] In *An Artist's Letters from Japan* he reproduced a scroll of this theme by the eighteenth-century artist Okio.[102] After his return from Japan, La Farge made several oils and watercolors of Kwannon in which he reinterpreted the elements of the Japanese conception according to the canons of Western painting.

That La Farge took the theme seriously is apparent both from the number of times he returned to it and from the large scale of two of his renditions. But from the aesthetic standpoint his creations are hardly successful—in fact, they look quite silly. The problem is not simply La Farge's shortcomings as a draftsman, though that certainly contributes to the difficulty, but that the whole conception comes across as false. The paintings portray a coarse-featured model with a simpering expression. The landscape and waterfall seem an artificial studio backdrop, like the painted scenes used as backgrounds by early photographers. It is hard to take these images seriously as evocations of an Oriental goddess. La Farge's oil paintings of this subject are truly embarrassing, his watercolors only slightly more successful.

La Farge had better luck with Oriental ideas, on the whole, when he did not attempt

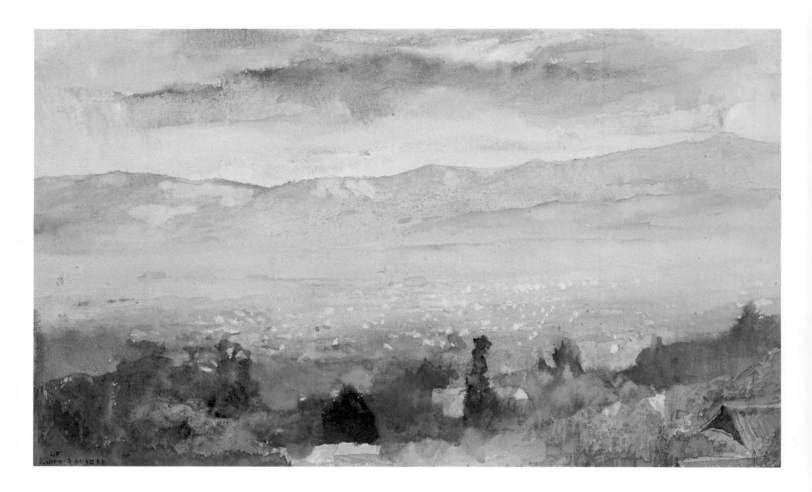

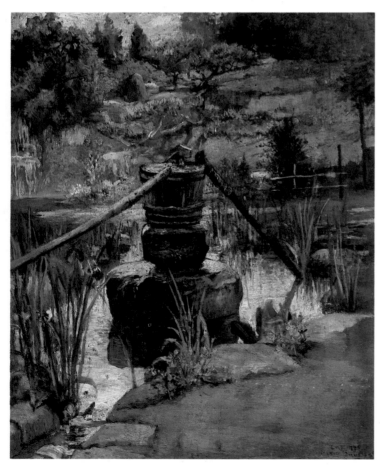

30
Sunrise in Fog over Kiyoto, 1886
(Kyoto in the Mist)
Watercolor on paper
9½ × 11⅞ in. (24.2 × 30.7 cm.)
The Currier Gallery of Art,
Manchester, New Hampshire
Gift of Clement S. Houghton
W1886.48

31
The Fountain in Our Garden at Nikko, 1886
Oil on wood
11¾ × 9¾ in. (29.9 × 24.8 cm.)
Richard M. Scaife
P1886.3

32
The Great Statue of Amida Buddha at Kamakura,
Known as the Daibutsu, from the Priest's Garden,
c. 1886
Watercolor on paper
19⁵⁄₁₆ × 12½ in. (49.1 × 31.8 cm.)
The Metropolitan Museum of Art, New York
Gift of the Family of Maria L. Hoyt, 1966
W1886.46

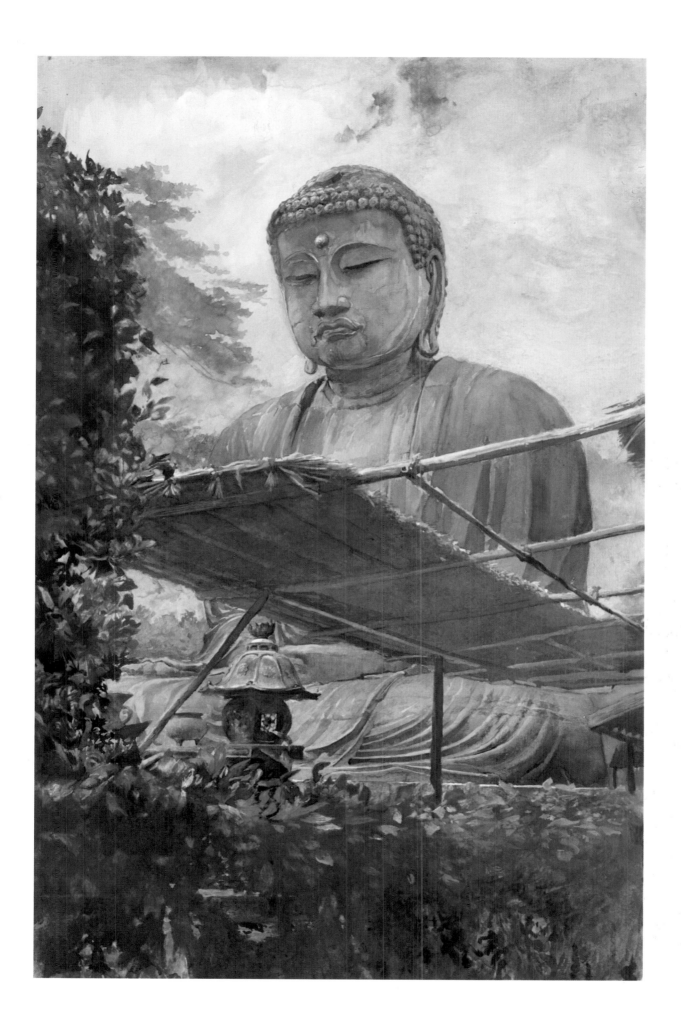

33
Augustus Saint-Gaudens
Adams Memorial, 1886–91
Rock Creek Cemetery, Washington, D.C.

to be so serious. In fact, a group of watercolors he made in 1897, a decade after his visit to Japan, on themes from Japanese folklore are delightful and recapture the bizarre inventiveness of the "fantastic" illustrations he had made in the 1860s. His scenes of an uncanny badger bellowing beside a mountain waterfall to mislead wayfarers, of a Rishi in tune with the spirit of the storm (plate 35), and of a decapitated head floating down a river (plate 36) conjure up a mood of eerie weirdness that recalls Lafcadio Hearn's wonderful ghost stories of Japan.

It was left for Augustus Saint-Gaudens to give serious expression to the mysticism of the East in the brooding memorial he created for Adams's wife in Rock Creek cemetery (plate 33). Adams conceived the project in Japan, directly inspired by Buddhist statues of Kwannon and by his conversations about Nirvana with La Farge. He gave the sculptor

34
Meditation of Kuwannon, c. 1886
(Meditation of Kwanyin)
Watercolor on paper
12¾ × 10⅜ in. (32.4 × 26.4 cm.)
Bowdoin College Museum of Art, Brunswick, Maine
W1886.62

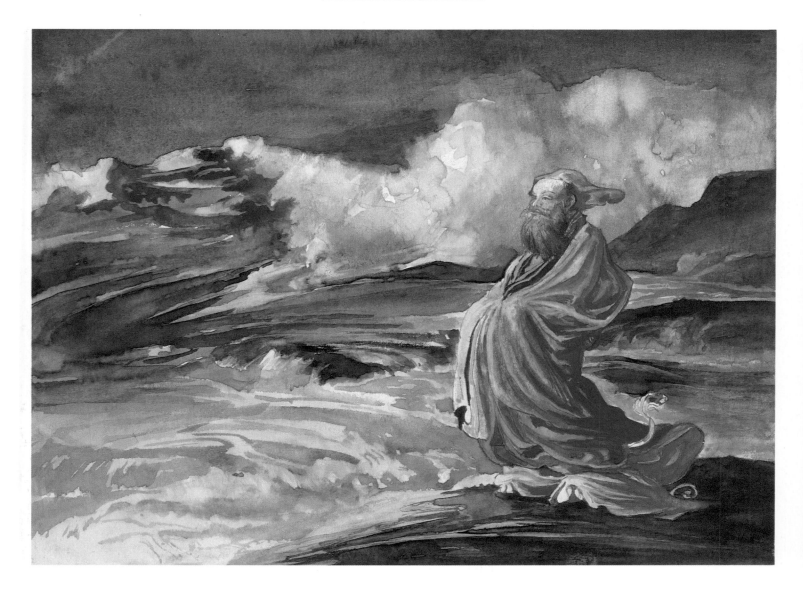

35
A Rishi Calling up a Storm, Japanese Folk Lore, c. 1897
Watercolor on paper
13 × 16⅛ in. (33 × 40.4 cm.)
The Cleveland Museum of Art, Cleveland, Ohio
Purchase from the J. H. Wade Fund
W1897.6

precise specifications for the monument—establishing the pose, suggesting that the figure be androgynous, insisting that it bear no title, and requesting that it express "the acceptance, intellectually, of the inevitable." Adams then refused to view the piece until it was completed, leaving La Farge to supervise its execution and to explain to the sculptor the Oriental concept of Nirvana.[103] The combination of La Farge's mind and Saint-Gaudens's hand resulted in a masterpiece that neither could have created on his own—an enigmatic, haunting work that stands as one of the greatest American sculptures of the nineteenth century. La Farge's role in its creation fully justifies his journey to Japan and almost excuses his inept renderings of the Kwannon theme.

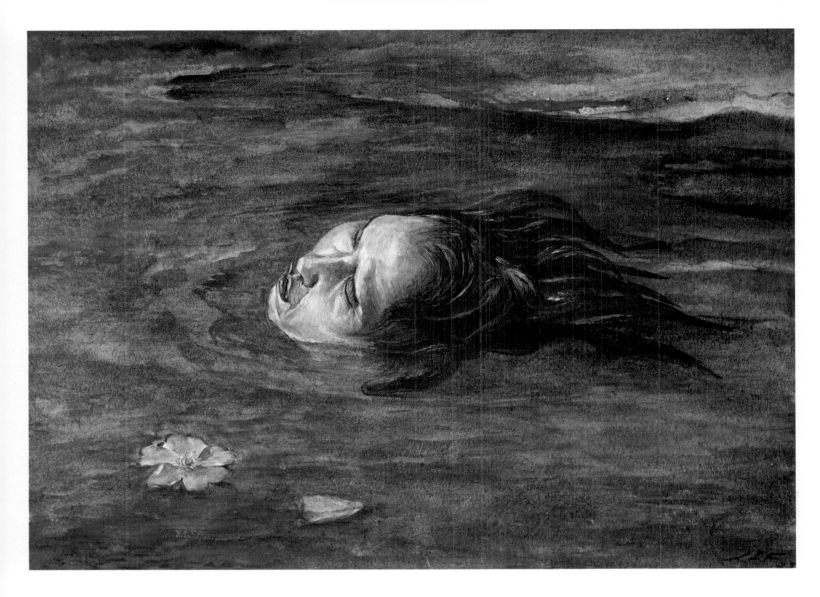

36
The Strange Thing Little Kiosai Saw in the River, 1897
Watercolor on paper
12¾ × 18½ in. (32.4 × 47 cm.)
The Metropolitan Museum of Art, New York
Rogers Fund, 1917
W1897.3

The Trip to the South Seas

Far more impressive than the Japanese watercolors are those that La Farge made four years later during a yearlong sojourn in the South Seas (1890–91).[104] Once again he traveled with Adams, who on this occasion was in a better mood, having just completed his ten-volume history of the United States. Unlike his whining letters from Japan, Adams's Polynesian correspondence evokes a sensual paradise inhabited by a noble and handsome people. His sentences thrill with the excitement of the first sight of kanakas, breadfruit, banyans, and exotic red and purple flowers; with the strangeness of the first

taste of mango; and with the wonder of fifty-foot palm trees eerily waving their long fronds in the evening wind with an almost human suggestion of distress.

For La Farge, the trip brought emotional and artistic liberation—a respite from the relentless deadlines and practical details of his decorative projects and a chance to indulge in spontaneous artistic expression. Not since the Newport years had he had a similar opportunity to devote himself without distractions to painting, and his output was impressive—several hundred richly colored watercolors, a sizable proportion of his lifetime's production in the medium.[105] La Farge's contemporaries were particularly struck by the brilliance and strangeness of his color—intense tropical purples, fuchsias, cobalts, and alizarins—which struck a note new in American painting. Significantly, Henry Adams, who never once praised the watercolors that La Farge made in Japan, wrote a number of enthusiastic descriptions of La Farge's South Sea work.

La Farge would vacillate between enthusiasm and apathetic procrastination, letting days slip by without action and then indulging in frantic bursts of activity. "I have taken to my water-colors again," Adams wrote to a friend from Samoa, "because I find that La Farge will not paint unless I make believe to do so"; and at the end of their trip Adams wrote, with a touch of exaggeration, that La Farge had not touched his watercolors since Tahiti.[106] Yet characteristically, when the time came to leave Samoa, La Farge was completely absorbed in a large figural painting, and the steamer was delayed until he stopped work on the canvas, which he abandoned still incomplete.

La Farge's watercolors varied in technique and subject matter according to the character of the islands he visited. The weakest are those of Hawaii, where he found few remnants of native life to inspire him and still had not mastered the special challenges of depicting tropical scenery. His most spirited Hawaiian sketches are those of the active volcanos (plate 37), whose steam and brimstone he rendered with an enthusiasm that brings to mind the extravaganzas of J.M.W. Turner.

Only in Samoa did La Farge reach his stride with his painting, although his successes came gradually. "La Farge is only beginning to get into the spirit of work," Adams wrote, a few weeks after their arrival. "He has done a good deal, but it has come hard. At last he is going at it with real enjoyment."[107] By the end of their sojourn Adams was writing that La Farge was doing "first-rate work" and had "made several sketches better than anything I could get him to do in Japan."[108] While Adams grew increasingly bored with the narrowness of life in Samoa, La Farge kept prolonging their stay in order to carry on with his watercolors.

In Samoa they lived with the natives, as special guests of the great chief Mata-afa, in a magnificent thatched native house in the village of Va-i-ala. Except for their contact with Robert Louis Stevenson, who had recently settled in Samoa, they saw little of Americans or Europeans. When they traveled around the Samoan islands on a *malanga*, or journey of pleasure, it was with the huge chief of Apia, Seumanu, as their guide, and a dozen other natives as rowers and bearers. At every village they would be greeted by the village virgin, entertained with dances, and presented with gifts of food (plate 38). Many of La Farge's paintings of Samoa portray the ceremonies they witnessed—for example, the ritual presentation of food at Faleu, the speechmaking at Vao-Vai, and the dancing of the hereditary assassins of King Mali-etoa at Sapapli. Others depict more mundane activities, such as spearing a fish (plate 80), beaching a canoe (plate 39), or grating pepper root to brew the intoxicating beverage kava (plate 114).[109] Almost always the Samoan watercolors concentrate on native activities and on the beauty of the human figure.

The two travelers were quite open in their pursuit of beautiful women. At a wedding feast in Va-i-ala, for example, after spotting a particularly lovely bare-breasted girl who

reminded them of an Italian madonna, they followed her home like youthful admirers, with five loaves of bread and two tins of salmon as gifts. At their urging she gave them a private performance of the *siva* (a Samoan dance) and also posed half-nude, while Adams took photographs and La Farge made sketches.[110] In indulging their desires, however, Adams and La Farge never quite abrogated the strictures of Victorian propriety. Indeed, when they visited Papasea, where the native girls slid over waterfalls in a state of semi-undress, Adams forbade La Farge to plunge in and join the fun, declaring that it would look entirely undignified.[111] They did encourage casual flirtatiousness. "Our house is a favorite place for the girls to visit," Adams exulted. "They all want to see La Farge's sketches."[112] But never, apparently, did their urges lead to actual sexual intimacy. Their hesitancy, in fact, was a subject of discussion between them. "La Farge declares," Adams noted, "that the impassible barrier is cocoanut oil."[113]

The watercolors of Tahiti have a different character than those of Samoa, for in Tahiti the native culture had been largely destroyed by the French. The aboriginal population, which stood in the eighteenth century at about a quarter of a million, had been shrunk by European diseases to fewer than ten thousand. Hence in Tahiti it was toward landscape

37
Crater of Kilauea and the Lava Bed, 1890
Gouache, watercolor, and pencil on paper
11^{15}⁄$_{16}$ × 17^7⁄$_8$ in. (30.3 × 45.4 cm.)
The Toledo Museum of Art, Toledo, Ohio
Gift of Edward Drummond Libbey
W1890.18

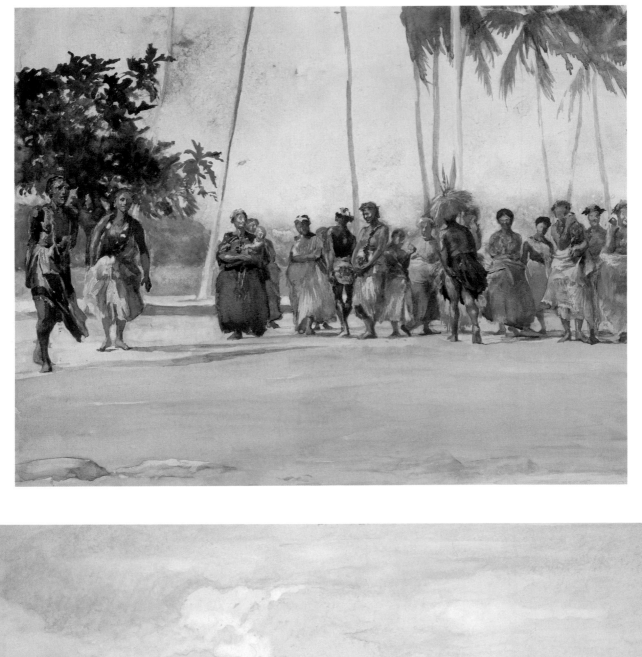

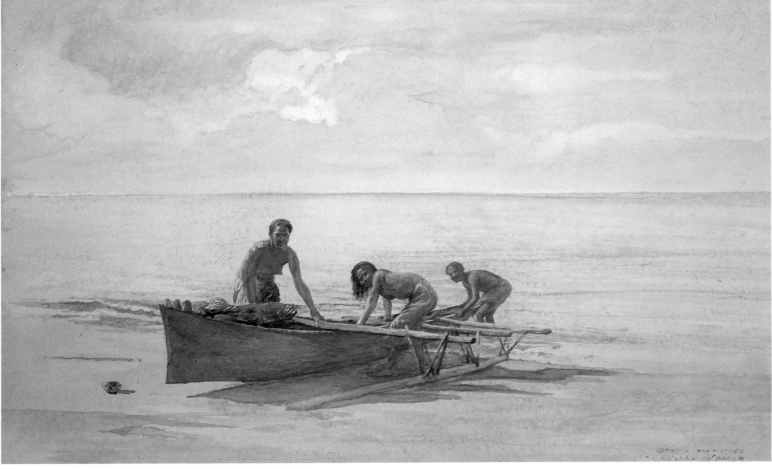

Opposite, top
38
Fagaloa Bay, Samoa, 1890. The Taupo, Faase, Marshalling the Women Who Bring Presents of Food, 1890
Watercolor on paper
12 × 14¹⁵⁄₁₆ in. (30.5 × 37.4 cm.)
The Century Association
W1890.82

Opposite, bottom
39
Women Drawing up a Canoe. Vaiala in Samoa. Otaota, Her Mother and a Neighbor, 1891
Watercolor on paper
7½ × 12¼ in. (19.1 × 31.1 cm.)
Museum of Fine Arts, Boston
William Sturgis Bigelow Collection
W1891.7

Above
40
"Hari." Bundle of Cocoanuts. Showing Tahitian Manner of Preparing and Tying Them.
Tautira, March, 1891, 1891
(Hari, or Bundle of Cocoanuts, Tahiti)
Watercolor, gouache, and ink on board
6¹⁵⁄₁₆ × 9¹³⁄₁₆ in. (17.6 × 24.9 cm.)
The Toledo Museum of Art. Toledo, Ohio
Gift of Edward Drummond Libbey
W1891.32

that La Farge directed his attention, depicting, for example, the Diadem Mountain rising up like some fairyland castle and the cliffs of Moorea, rose-hued in the sunset, floating on the turquoise ocean like great scoops of raspberry sherbet. When humans do appear, as in *Bridle Path, Tahiti* (plate 113), they remain decorative adjuncts to the natural scenery, like the sylvan and rustic figures in Claude Lorrain's pastorales.

The two spent much of their Tahitian sojourn at Tautira, on the tip of the island, with members of the native Teva family, who had ruled Tahiti in the days of Captain Cook. La Farge worked away at his painting, and both he and Adams transcribed the tales of Araii Tamai, the matriarch of the Tevas—La Farge taking down verses that were later published in an anthology of world literature, and Adams assembling the first written history of Tahiti.[114] On the verge of their departure the old lady called Adams and La Farge to her and solemnly adopted them into the Teva clan.

Their final stop was Fiji, where they were guests of the British governor Sir John Thurston, a genial botanist who entertained them at Suva, the capital, and then took them on an expedition through the rugged wilderness of the island interior. Only a decade or so before, cannibalism had still been practiced in the region. White intruders, after being killed, had had their bodies dismembered and their limbs wrapped in banana

41
Children Bathing in the Surf at the Entrance to River at Papara, Tahiti. Morning. 1891,
1891
Watercolor on paper
13¾ × 19½ in. (34.9 × 49.5 cm.)
Private collection
W1891.49

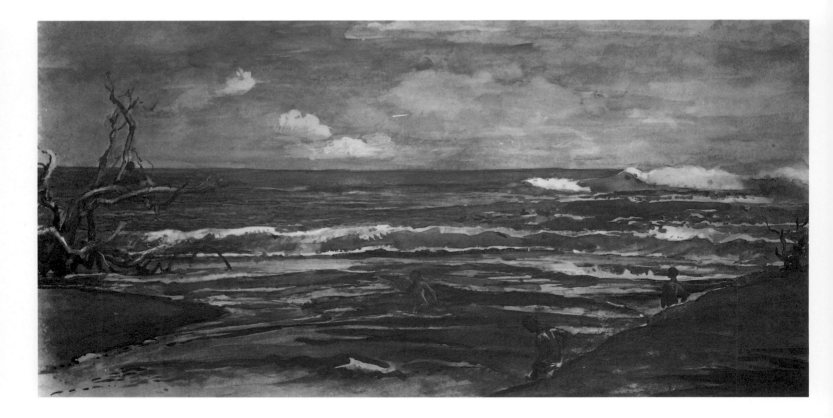

leaves and baked. They had then been served up with *Solanum anthropophagorum*, a variety of native spinach.[115] La Farge's paintings of Fiji seem to evoke this brutal past, for they are generally ominous in feeling—figure studies of men with war clubs and painted faces or landscapes depicting the primitive thatched dwellings rising out of the mist against a backdrop of rugged mountains.

La Farge painted only one large oil while he was in the South Seas—a study of Maua, a member of his boat crew, seated, half-naked, in dusky light, lost in contemplation like some savage bodhisattva (plate 42). He created his most ambitious oil of a South Sea subject after his return—the huge *After-Glow, Tautira River, Tahiti* (plate 79), which he based on a group of seven or eight watercolors that he had made on the location (frontispiece).[116] There is nothing else quite like it in La Farge's work, or indeed in American art of its epoch. Its huge scale, its bold, flat, streaky patterns of color (reminiscent of opalescent glass), and its exotic subject matter all bring to mind the work of the French Post-Impressionists. La Farge probably made the painting for a display of his work held in Paris, but in the end he did not show it there, and it was never exhibited during his lifetime.

To La Farge and Adams, the South Sea islands were the last place on earth where life and society still retained the quality of classical antiquity. To them, the fabled Golden Age lived on in Polynesia. La Farge expressed wonder that "no one had told me of a rustic Greece still alive somewhere, and still to be looked at."[117] He admired the Polynesian reverence for tradition, telling the French novelist Paul Bourget that "the savage is the original gentleman, who does everything according to custom and is unwilling to change any of his habits."[118] The travelers themselves enjoyed the illusion that they could to some degree join this performance and become actors in a nobler, simpler time. Adams observed with pleasure that La Farge, with a crown of green leaves, looked like Dante or Virgil, and he also noted with amusement that the artist's native name, "La-fa-el-e," happened to be identical with that of Raphael (the *l* and *r* being interchangeable, or rather, the *r* almost unpronounceable to the Samoans).[119]

In his South Sea watercolors La Farge expressed some of his deepest and most persistent fantasies—his dreams of a magical realm of sensuality and color. He was able to create works filled with classical feeling that also seem natural and genuine rather than false or pretentious. They seem like a fulfillment of the desires that he had sought to express in such earlier figure paintings as *The Golden Age* (plate 69).[120]

Today it is tempting to compare La Farge's watercolors to the paintings of Paul Gauguin, who arrived in Tahiti only a few days after La Farge departed. Indeed, in their brilliant color and striking compositions, La Farge's designs at times sustain the comparison. But on the whole, in fundamental respects, they belong to a different tradition, that of watercolor travel scenes such as those made in North Africa by Delacroix and Fromentin. Unlike Gauguin's paintings, which attempt general artistic statements, those by La Farge are linked to specific events and serve in a sense as illustrations supplementing the descriptions in Adams's letters. "This is not a scene from an opera nor a study for a fresco like those of Mr. Puvis de Chavannes," La Farge wrote of one design (plate 41). "It is what we saw."[121] Like so much of La Farge's best work, the paintings evoke the fleetingness of time, the transience of human life, and the impossibility of the artist's struggle to capture the passing moment.

Many of the finest South Sea works are those that were immediate and spontaneous. "La Farge once in a while," Adams observed, "apparently by accident, succeeds in pinning some momentary light or movement, which is quite untrue as statistics, but suggests poetry. His hard work over studied compositions is interesting, but does not much interest me because I have seen the original subjects, and know how little of them

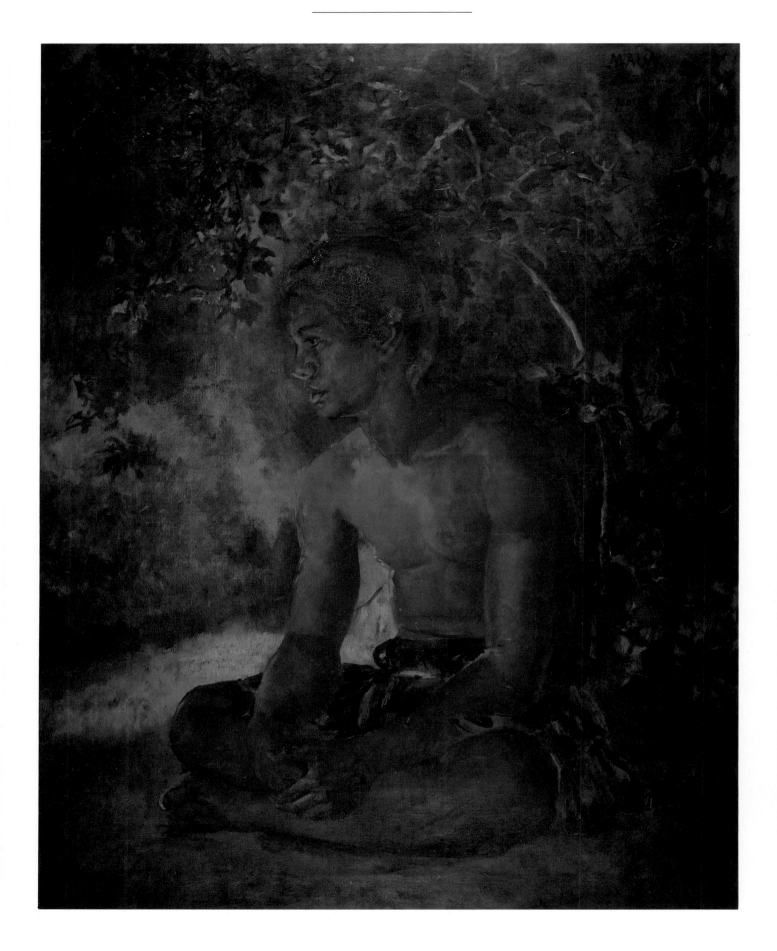

can be put on paper or panel; but now and then he gives me a light or a movement that I could not see, or could not see as he did; and these I envy him."[122]

The Late Decorative Projects

About 1886, the year of his trip to Japan, La Farge's career began a gradual change, almost comparable to the shift in his work during the 1870s. After the bankruptcy of his decorative firm in 1885 his stained glass assumed a different character. He produced fewer domestic and more ecclesiastical windows. In addition, his style grew more illusionistic, with less emphasis on the jewellike qualities of glass and more on pictorial effects. Some of his late windows are masterpieces—particularly the great *Resurrection* window in Methuen, Massachusetts, with its spectacularly colored shading (plate 158), and the wonderful peacock and floral designs he produced for Secretary of State John Hay (plates 148, 149). Much of the later glass, however, is routine, and many of the religious windows are quite maudlin.

La Farge's mural style also changed, becoming far more conventional. Unlike his work for Trinity Church, with its surprising and mentally challenging inconsistencies in the handling of pictorial space, his later murals are straightforward illusionistic scenes, treated as self-sufficient compositions. Rather than modulating an entire environment, the figures remain confined within their frames, comfortably ensconced beneath lunettes. Most of the later paintings were not executed in situ but painted on canvas in La Farge's New York studio and later attached to the wall.

La Farge's mural *The Ascension* of 1886–88 (plate 131), in the Church of the Ascension in New York, marks the transition into this later style. The painting is not easily judged from photographs, for much of its impact depends on its heroic scale and the way it dominates the architectural space. La Farge wanted to make this miracle look as natural as possible: he studied trapeze artists in circuses to learn how to represent levitation and based the background on an actual place, a mountain landscape he had sketched the year before in Nikko.[123] The figural arrangement he devised, however, is an eclectic pastiche. Floating, archaically garbed figures stand in clichéd poses from earlier religious paintings: Masaccio's *Tribute Money*, Palma Vecchio's *Assumption of the Virgin*, Raphael's *Transfiguration*, and Thomas Couture's mural *Mater Salvatoris* in Saint-Eustache in Paris.[124] While La Farge had borrowed from the past in his murals at Trinity, here the effect seems more incongruous, because he treated these borrowings not as isolated elements, which are semiotically distinct, but as a supposedly unified scene in a purportedly naturalistic setting. In making the relationship between the figures more "real," he also made it more ridiculous.

La Farge's contemporaries were ecstatic about the result, and one of them even broke into verse, publishing a sonnet about the painting in *Century Magazine*.[125] Indeed, *The Ascension* soon became La Farge's most famous and popular work. Today the painting

42
Maua, a Samoan, 1891
(Maua, Our Boatman)
Oil on canvas
47½ × 38¼ in. (120.7 × 97.2 cm.)
Addison Gallery of American Art,
Phillips Academy, Andover, Massachusetts
P1891.1

is more difficult to appreciate: one recent writer has described it as "comical in many respects."[126] Certainly the painting must be approached very differently from La Farge's purely naturalistic works, such as his Newport landscapes and floral studies and his watercolors of the South Seas.[127]

La Farge himself was certainly aware of the dangers in his handling of the subject. He wrote eloquently of the problem of history painting, which by its nature presents a falsehood, as it can never recreate a past event with absolute accuracy. Indeed, the attempt to pursue historical accuracy—to reproduce real costumes and real settings—only makes the remaining elements of fiction more misleading. In *The Ascension*, La Farge clearly sought to make the event seem real and yet to avoid any pretense of a historical record. He chose to express its inner meaning, including the cultural meanings that had accrued to it over time.[128] He deliberately made the setting not historical but indefinite.

Among the admirers of the painting was La Farge's old friend Henry James, who in *The American Scene* (1907) included an account of "penetrating in the Ascension, at chosen noon, and standing for the first time in presence of that noble work of John La Farge." James wrote:

> Wonderful enough, in New York, to find one's self, in a charming and considerably dim "old" church, hushed to admiration before a great religious picture; the sensation, for the moment, upset so all the facts. The hot light, outside, might have been that of an Italian *piazetta*; the cool shade, within, with the important work of art shining through it, seemed part of some other-world pilgrimage—all the more that the important work of art itself, a thing of the highest distinction, spoke, as soon as one had taken it in, with the authority which makes the difference, ever afterwards, between the remembered and the forgotten quest.[129]

More recently, Robert Rosenblum has written that the mural possesses "a pictorial vitality so convincing that we are almost ready to accept its impoverished repetition of older forms and symbols."[130]

Whatever the merits of the painting, however, it signals a break from the avant-garde character of much of La Farge's earlier work. The accomplishment of La Farge's early career—most notably his Newport paintings, but also much of his decoration and stained glass—was an art of personal experiment, an art that explored inner feelings and new modes of expression. The later mural paintings, on the other hand, like La Farge's popular writing on art from the same period, were self-consciously didactic. They sought to expound great moral or religious truths in a manner accessible to everyone.

Outside pressures contributed to this development. No architect of the 1890s was willing to grant La Farge the freedom to encrust every available wall surface that Richardson had given him at Trinity Church or that Herter Brothers gave him in the Vanderbilt house. Moreover, architectural styles had changed. The 1870s had been a period of eclectic movements, such as Queen Anne and Neo-Grec, which incorporated a creative and eccentric jumble of historical styles. La Farge's jarring and unusual mix of Japanese, medieval, and Renaissance motifs fit right in with the spirit of the period. By the 1890s, however, stylistic consistency had become the standard, and Beaux-Arts classicism had largely replaced the Richardsonian Romanesque. La Farge's earlier mélange of styles would have been out of place. A group of younger artists, most of them recently returned from intensive training in Paris, such as Edwin Blashfield and Kenyon Cox, eagerly turned out murals in the academic mode. Always impressionable, La Farge gradually modified his style to be more in accord with their work.

Yet La Farge and these younger muralists remained, in important respects, artists of a very different type. Most mural painters of the 1890s were conservative: Blashfield,

Cox, and their coterie were open foes of modernism and innovation. Their social ideas were rigidly authoritarian and their draftsmanship mechanical and hard. La Farge, on the other hand, was always enthusiastic about new styles, such as Impressionism and Pointillism. He corresponded with Roger Fry, Clive Bell, and Walter Pach and was himself a significant innovator. He believed that innovation could enrich artistic tradition, not conflict with it.[131] His social views were liberal and open-minded, and he was deeply curious about alien cultures and races. As an artist he was more gifted as a colorist than a draftsman.

The contrast between La Farge and his contemporaries is vividly apparent in the Minnesota State Capitol, where both he and Cox painted lunettes illustrating the principles of law. Cox chose to portray law as a naked woman holding a bridle, an emblem of

43
Adoring Angels, c. 1887
Study for mural, Church of the Ascension, New York
Watercolor on paper
8¼ × 5¾ in. (20 × 14.6 cm.)
Museum of Fine Arts, Boston
Gift of Mary W. Bartol, John W. Bartol, and Abigail Clark, 1927
W1887.4

44

The Moral and Divine Law: Moses Receiving the Commandments on Mount Sinai, 1904
Encaustic on canvas
13 × 27 ft. (4 × 8.2 m.)
Supreme Court Room, Minnesota State Capitol, St. Paul
MD1904.1

authority and coercion. She is, of course, Caucasian, as are all of Cox's figures, and the coloring is pale and cold.[132] La Farge, on the other hand, chose to depict figures from four different civilizations, of both East and West, whose activities illustrate key turning points in the development of law: Moses (plate 44), Socrates, Confucius (plate 142), and Count Raymond of Toulouse.[133] He represented law not as fixed but evolving, not as limited to one culture but gleaned from the tradition and knowledge of all peoples. His figures exemplify not a process of coercion, but a process of inquiry, dialogue, and accommodation. The color is rich and atmospheric. Rather than portraying allegories, La Farge portrayed real individuals, in poses and environments that cleverly combine an idealized quality with elements of the mundane. The settings for the figures, in fact, are not archaeologically authentic but were playfully taken from La Farge's own experience, as if to suggest the ability of the imagination to transform any place. Confucius, for example, collects legal precedents in the garden that Adams and La Farge had rented in Nikko, Japan, while Moses receives the tablets of the law on a Hawaiian volcano.[134] In short, although La Farge's compositions did become increasingly conservative, resembling more and more those by such artists as Blashfield and Cox, the spirit that impelled them remained very different.

Indeed, more humor, wit, and skepticism may reside in some of these late paintings and stained-glass designs than has usually been supposed. Surely, for example, La Farge intended an ironic statement when he memorialized Henry Clay Frick, the Pittsburgh financier, with an image of Fortune (plates 45, 160). La Farge portrayed the goddess as a giddy, disheveled, voluptuous strumpet. She balances precariously upon a wheel, her hair streaming wildly in the wind.

45
Fortune, 1901
Study for window, Frick Building, Pittsburgh
Pencil on paper
10¹⁵⁄₁₆ × 7¹⁵⁄₁₆ in. (27.8 × 20.1 cm.)
The Art Museum, Princeton University,
Princeton, New Jersey
Gift of Frank Jewett Mather, Jr.
D1901.2

Writings

Another shift that occurred around 1886 was that La Farge began to devote major effort to writing—an interest undoubtedly sparked by his contact with Henry Adams, who became much the most intimate friend of his later years. To this new field La Farge brought exceptional erudition, for he was a wide reader, absorbed at one moment in reading Plato in the original Greek and at the next in devouring the latest novel by Joseph Conrad.[135] "He is a writer by instinct and breeding," Henri Focillon observed of La Farge, "a great art critic."[136]

La Farge's first venture into print had been a landmark piece of work—an essay on Japanese art included in Raphael Pumpelly's book *Across America and Asia* (1870). This was without doubt the most perceptive account of Japanese art in its period, the first one written by a practicing artist, and the first to single out those traits of Japanese design—such as luminous color and asymmetrical composition—that were to transform Western painting dramatically.[137]

Eight years later La Farge appeared in print in an exchange of letters published by several New York newspapers. When he proposed that American wood engravings should be sent to the world's fair in Paris, he stirred up a heated exchange with the landscapist George Inness, who, remembering his own unhappy days as an apprentice wood engraver, disputed that engraving was an art.[138] The debate gave La Farge a good chance to articulate his views about the importance of the so-called minor arts. Moreover, quite

apart from the particular merits of the case, it inaugurated La Farge's practice of using newspapers to gain publicity or promote his views, a strategy that became extremely frequent in his later years.

After his trip to Japan the small trickle of La Farge's publications became a flood: he found in writing both a new form of expression and a much-needed source of income. By the time of his death he had completed seven books as well as some three dozen published essays. His books include travel accounts, a study of aesthetics, and volumes of art history and art criticism. La Farge's late writings have a somewhat different character than his early ones, for their digressions and grammatically loose phrasing are closer in character to conversation. Indeed, many of his late writings—like those of Henry James—were drafted by dictation and then subjected to successive revisions. "He wrote as he talked," Adams told La Farge's biographer Royal Cortissoz, "so that you have his conversation almost exact in his writings."[139]

La Farge's chief model as a writer was Eugène Fromentin, a gifted if minor French painter who also excelled as a writer of travelogues and art criticism. Fromentin was the first to distill into literature the sort of professional but highly personal critique of paintings that must have long been heard in artists' studios. La Farge termed Fromentin's *Les Maîtres d'autrefois* (Masters of the Past, 1876) "by far the most perfect of essays in the criticism of the art of painting," and declared: "The secret of Fromentin is accessible to everyone. We cannot all have the special eye and the poetic temper which belonged to him, but the main basis of his thought is sincerity accessible to all men;—a sincerity so great that it is possible to disagree almost entirely with some of his remarks, but, at the same time, to consider them as necessary and valuable, and to feel all the more sure of the accuracy of the critic."[140] La Farge was deeply influenced by Fromentin's breezy writing style, often presented in the form of letters. Equally, he was influenced by Fromentin's critical vantage point—that of looking at works of art from the standpoint of a painter.

To these basic ingredients of Fromentin's presentation La Farge added a good deal that was new. From the English tradition of John Ruskin he absorbed an enthusiasm for architecture and the decorative arts and a concern for moral issues. From his conversations in Japan with Fenollosa, who was deeply immersed in Hegel, Herbert Spencer, and Emersonian idealism, he picked up the belief that art expressed fundamental philosophical and cultural truths. Perhaps most interesting, from his association with William James and with such scientists as O. N. Rood, he developed an interest in the psychology of perception and its relation to the creative process. La Farge was apparently the first art critic to make extensive use of this material.[141] At a time when most American art critics were content with framing simplistic moral judgments, La Farge brought wit, subtlety, erudition, and practical experience to the analysis of the artistic process.

La Farge was often at his best in his shorter pieces, which allowed him to apply some flash of insight to a question. The topics of his articles are intriguing: the masterful early drawings of William James, the problem of representing motion in art, how to make a list of the world's greatest masterpieces, and whether there are natural limits to expression in sculpture (an essay inspired by a conversation with Auguste Rodin). His books tend to be disjointed but also contain many marvelous passages.

Considerations on Painting (1895) provides a densely reasoned treatise on aesthetics and the paradoxes of art. Even the titles of La Farge's chapters suggest bewildering difficulties: titles like "Suggestion and Intention," "Misapprehensions of Meaning," and "Maia, or Illusions." "At first I was inclined to fault him for a certain elaborate obscurity," the painter Elihu Vedder commented of La Farge. "His words hover around an idea like the perfume around a flower."[142]

An Artist's Letters from Japan (1897), though poorly organized and at times somewhat shallow, retains interest from many standpoints: as a travelogue describing La Farge's trip to Japan; as one of the first accounts of Japanese art to explore Oriental philosophy and mysticism; and as a statement of his deepest beliefs about the moral purposes of art. Lavishly illustrated by La Farge himself, it also contains an intriguing interplay between illustrations and text.

The Higher Life in Art (1908)—despite the somewhat stilted ring of its title—presents a lively and vigorous defense of the French romantic painters and the masters of the Barbizon school. William James thought it was the best of La Farge's books because it was "so concrete, simple, and unpretentious."[143] Ernst Scheyer called it, "the finest work in the history and criticism of modern French art written by an American at the turn of the century."[144] James Thrall Soby and Dorothy C. Miller praised it for "the finest appreciations of Géricault and Delacroix which have yet been published in this country."[145]

La Farge's last significant creation was a literary one, a glowing tribute inspired by the death of his old friend Winslow Homer, the one American artist he wholeheartedly admired.[146] Art historians have tended to place Homer and La Farge in opposite camps of American art, one robust and American, the other effeminate and tainted by foreign influences. But, in fact, the two men were good friends, united in their enthusiasm for progressive French painting. "If I remember more I will send more," La Farge noted at the conclusion of his eulogy, which he wrote in the midst of illness.[147] But he sent no more; he died on November 14, 1910, two weeks before his essay was published.

La Farge's Significance

La Farge's achievements are unusually challenging to interpret, for they strongly reflect his atypical background. La Farge's merging of French and American cultures yielded a distinctive set of methods and approaches, counter to the general direction of American art. Many of the striking features of his Newport paintings, for example, are fundamentally French: the free brushwork, the Romantic mood, the interest in "the sketch," and even the long descriptive titles, with their references to weather conditions and precise locations. Yet because he chose to work in America, in an environment with standards and artistic values different from those in France, La Farge produced work that did not entirely harmonize with French developments or fit easily into conventional categories.

The eccentricity of La Farge's work was abetted by his incomplete formal training, for while he often pretended to the contrary, La Farge never did go through the program of an art school or atelier. This may have hurt his technique, but it also prevented him from rigidly following French formulas. Instead, he applied traditional ideas and procedures to new problems, creating a strange hybrid art, half-French and half-American. His art from throughout his career exudes the aura not of the professional but of the gentleman dilettante. In that fact lies much of the weakness of his productions and also their charm.

While not entirely systematic, La Farge's accomplishments and innovations were the product of a consistent set of attitudes—the creations of a single artistic mind, even if an opalescent one. Certain undercurrents recur in all phases of La Farge's career: a love of the exotic, a concern with the ambiguity of sensation, and a fascination with the way that the meaning of conventional motifs may be altered by placing them in unexpected contexts. As his career advanced and he experimented with new media, La Farge continually expanded his repertoire, but his fundamental ideas remained the same. In stained glass, for example, he explored many of the same principles of color harmony that he had investigated earlier in his landscape paintings.

The critical evaluations of La Farge's work over the last century provide a fascinating

document of changing taste. During the 1860s viewers found his Newport paintings experimental and somewhat outlandish, although imbued with an intensely personal flavor. After La Farge turned to mural decoration, however, he began to receive glowing tributes. By the 1890s certain writers declared that his work possessed "the stamp of genius" and contained "celestial beauty"—although even at the height of his reputation La Farge's work was often criticized for weak draftsmanship, murky color, and obvious borrowings from the work of the old masters.[148] At the time of his death La Farge was considered an artist of enormous stature. An obituary in the *New York Tribune* bore the headline "WAS ONE OF THE GREATEST GENIUSES THIS COUNTRY EVER PRODUCED—REVIVED LOST ARTS," and the article itself described La Farge as "a universal genius who belongs to all time."[149]

Even during his lifetime, individuals differed in assessing the significance of various aspects of La Farge's work, some preferring his more intimate productions, others his ambitious academic exercises. Henry James, for example, affected in part by personal sentiment, loved most the Newport landscapes; Henry Adams found many of the South Sea watercolors delightful and spoke for the stained glass with unreserved enthusiasm; the painter Will H. Low thought most highly of the late mural paintings and admired La Farge as an exponent of the grand manner of European painting.[150]

Negative reactions to La Farge's work began to appear soon after his death. After World War I and the advent of abstract art, La Farge's work came to seem old-fashioned, eclectic, and removed from contemporary life—the product of a closed and snobbish society. As one writer put it: "La Farge is pure Newport. . . . He shows the failure of good breeding as a creative force in art."[151] Ironically, the fulsome tributes of the conservative critic Royal Cortissoz, who praised La Farge as an American old master and attacked modern art, seem to have played a major role in the devaluation of La Farge's importance.

The increase of interest in American art that began in the 1940s and boomed in the 1960s did not boost La Farge's reputation, for the painterliness of his work, its delicacy of mood, and its eclecticism fell outside the sort of sober, meticulous realism that came to be viewed as paradigmatic of the American tradition. J. C. Furnas described La Farge as "an artsy-craftsy cosmopolite, almost as rootless as an air plant," while John McCoubrey commented, "Like all American painters who tried to Europeanize their style, La Farge found only the empty shell of a historical style long since abandoned even by Europeans."[152] La Farge has never been so harshly dismissed, however, as the other academic muralists of his time, such as Blashfield or Cox, and because of his close association with other key figures in American culture, such as Richardson, Adams, and Henry James, he has often merited brief but favorable comments in survey books. Lewis Mumford, for example, wrote favorably of his achievement in his landmark study of American culture from 1865 to 1895, *The Brown Decades* (1931).[153]

La Farge has sometimes been castigated as the epitome of retrograde taste. As a muralist, he has been dismissed as an eclectic pasticheur, and some of his critical judgments—for example, some slighting remarks about Gauguin—have been held up to ridicule.[154] On the other hand, certain aspects of his work, notably the Newport landscapes, have been increasingly appreciated for their avant-garde qualities. John Canaday, for example, wrote of a 1966 exhibition of La Farge's early works:

> If it does not quite negate the judgment that La Farge was a near-genius who never quite hit the target, it does show that he came much closer to the target than we are accustomed to thinking.

Again and again, in what he said, wrote, and painted for his own satisfaction, La Farge revealed his spontaneous fascination with the kind of naturalism that in

France became the art of Courbet, then of Manet, then full impressionism, but his energies were spent in a field where naturalism had, at best, to be diluted.[155]

Such dissimilar evaluations of La Farge may appear baffling, but in fact they fairly accurately pinpoint many of the contradictions of his art, with its intriguing combination of progressive and conservative features. Although not trained in France, La Farge alone of nineteenth-century painters in America made contributions that are comparable to progressive French developments. His work exhibits many of the most forward-looking features of French art—for example, Impressionism, a love of the primitive and exotic, a decorative bent, a desire for new forms and new colors, and a wish to reevaluate the fundamental nature of expression and sensation. Remarkably, these tendencies result not from direct imitation, as in the case of the so-called American Impressionists, but from a parallel development. Indeed, La Farge's advances often preceded their closest European counterparts. He was collecting Japanese prints before Félix Bracquemond and Whistler, making plein-air landscapes before the first French Impressionist exhibition, and painting in Tahiti a year before Gauguin. Other innovations by La Farge are conceptually related to those of modernist art in France: a new school of wood engraving that eliminated outlines and depended on the optical vibration of dots and hatchures of varying densities; the invention of opalescent stained glass, which made it possible, in effect, to paint with an entirely luminous surface; and a new type of art criticism, which employed the discoveries of physiology and psychology to analyze how initial sensations are transformed into patterns of meaning.

Yet La Farge cannot be described as a modernist in any complete sense. He was a revivalist of dead or neglected art forms, such as stained glass and mural decoration, and in his art formal and technical innovations are frequently linked to an altogether conservative figural style. La Farge's progressive inclinations were invariably deflected by the intellectual setting and artistic patronage that existed in America, as well as by his own desire to forge links with the European tradition.

Paradoxically, even La Farge's conservative ideals often separated him from other American painters and endowed his work with an odd kind of originality. For example, his desire to work in one of the highest modes of the traditional French critical hierarchy, religious painting, was unprecedented in the United States. Russell Lynes once wittily described La Farge as "an eccentric conformist";[156] indeed, La Farge presents the paradox of an innovator wedded to many of the conservative strains in American culture.

Brilliant, uneven, intellectually challenging, La Farge had one of the greatest creative minds in nineteenth-century American art. It would be a mistake, however, to overrate his actual achievement. The issue is not simply the uneven technical standard of La Farge's work, the frequent marring of his artistic performance by poor draftsmanship and other indications of carelessness, incompetence, or haste. It lies also in the outmoded ideals to which he clung. At some basic level La Farge failed to recognize that contradictions actually do contradict and that the skeptical, inquiring, modernist aspects of his work were not fully compatible with conventional didactic expressions of moral platitudes and religious dogmas. In the end, La Farge's effort to accommodate himself to tradition was a failure. It was the rebels against tradition, the Impressionists and Post-Impressionists, who established a viable artistic language for the future.

Like many of his generation, La Farge never quite finessed the transition between the idealism of the early nineteenth century and the harsh realities of the twentieth. His art always conveys a sense of unfulfilled promise, and its obvious shortcomings only become more tragic when we recognize them as the failures of a genius.

NOTES

1. Henry James, *Notes of a Son and Brother* (New York and London: Charles Scribner's Sons, 1914), 85.

2. Berenson, in Ernest Samuels, *Bernard Berenson: The Making of a Connoisseur* (Cambridge, Mass.: Harvard University Press, 1979), 413.

3. Royal Cortissoz, *John La Farge: A Memoir and a Study* (Boston and New York: Houghton Mifflin Co., 1911), 13.

4. William James to Henry James, July 23, 1865, in Ralph Barton Perry, *The Thought and Character of William James*, vol. 1 (Boston: Little, Brown and Co., 1935), 221–22. The pompous mannerisms that offended William James can be imagined from a description by the artist's son John of a personal meeting with the pope. He noted: "Though the Pope conversed with me in French, I had a curious sensation that I was talking to my own father. His gestures were singularly like those of my father, particularly the characteristic one of the joined index and middle finger raised and waved paternally in the air. Little turns of expression reminded me of Father, and there was the same atmosphere, as it were, of conversation" (John La Farge, S.J., *The Manner Is Ordinary* [New York: Harcourt, Brace and Co., 1954], 273).

5. "An Artist's Lecture on Art: John La Farge Addresses an Appreciative Audience," *New York Times*, November 12, 1893, 17.

6. La Farge, S.J., *The Manner Is Ordinary*, 12.

7. Royal Cortissoz, *An Exhibition of the Work of John La Farge* (New York: Metropolitan Museum of Art, 1936), 15.

8. William James to Thomas Sergeant Perry, March 27, [1860], in Virginia Harlow, *Thomas Sergeant Perry: A Biography* (Durham, N.C.: Duke University Press, 1950), 245.

9. Henry Adams, *The Education of Henry Adams* (Cambridge, Mass.: Riverside Press, 1918), 371.

10. Viola Roseboro, "John La Farge's Conversation," typescript, c. September 1935, La Farge Family Papers, Department of Manuscripts and Archives, Sterling Memorial Library, Yale University, box 8, folder 14, 1. According to an obituary for La Farge (*Catholic World* 92 [December 1910]: 426), a distinguished writer, whose name unfortunately is not recorded, once wrote to the hostess of an informal dinner party: "The more I think of Mr. La Farge, the more wonderful he grows, and the more I appreciate the pleasure and the honor of dining with him. I never met anyone who said wicked things so gently, and I never met anyone who alternated so easily between sardonic humor and the expression of charming emotions. It is a great deal to have had one such experience, one such conversation, amid the recurrent stupidities of life."

11. Jules and Edmond de Goncourt, *Paris and the Arts: 1851–1896: From the Goncourt Journal*, ed. and trans. George J. Becker and Edith Philips (Ithaca, N.Y.: Cornell University Press, 1971), 322; Philip C. Beam, *Winslow Homer at Prout's Neck* (Boston: Little, Brown and Co., 1966), 162.

12. Frank Jewett Mather, "John La Farge—An Appreciation," in *Estimates in Art*, vol. 1 (New York: Henry Holt and Co., 1923), 242.

13. La Farge, S.J., *The Manner Is Ordinary*, 6.

14. Mather, "La Farge," 241.

15. Cortissoz, *La Farge: A Memoir*, 262.

16. James, *Notes*, 103.

17. Adams, in Arline Boucher Tehan, *Henry Adams in Love* (New York: Universe Books, 1983), 187.

18. Adams, *Education*, 370.

19. Leon Edel, *Henry James, The Untried Years: 1843–1870* (New York: J. B. Lippincott, 1953), 156.

20. La Farge, in Cortissoz, *La Farge: A Memoir*, 117.

21. James, *Notes*, 85.

22. Henry James to Mary Cadwalader Jones, December 26, 1902, James Papers, Houghton Library, Harvard University.

23. Edel, *Henry James*, 166.

24. James, *Notes*, 93.

25. Henry James, "A Landscape Painter," *Atlantic Monthly* 18 (February 1866): 182–202.

26. Adams, *Education*, 369.

27. Harry Herbert Crosby, "So Deep a Trail: A Biography of Clarence King" (Ph.D. diss., Stanford University, 1953), 278–79.

28. Adams, *Education*, 369.

29. La Farge, ibid., 370. Henry James noted the change in Henry Adams's literary style: "What a power of baring one's self hitherto unsuspected in H.A.!" (in Ernest Samuels, *Henry Adams: The Major Phase* [Cambridge, Mass.: Harvard University Press, 1964], 24).

30. James, *Notes*, 88.

31. Adams, in Cortissoz, *La Farge: A Memoir*, 212.

32. Henri Focillon, "John La Farge," *American Magazine of Art* 29 (May 1936): 311.

33. La Farge, S.J., *The Manner Is Ordinary*, 14.

34. Jean-Frédéric's career is described in T. Wood Clarke,

Emigrés in the Wilderness (New York: Macmillan Co., 1944), 165.

35. John La Farge, "Notes, Memoranda and Other Material by and about John La Farge: Recorded to Aid Royal Cortissoz in Writing His Biography," Royal Cortissoz Papers, n.d., Beinecke Rare Book and Manuscript Library, Yale University, 81. (My references are to Cortissoz's pagination.)

36. Louis Binsse's import business is listed in the New York directories for 1842–43, 1847–48, 1848–49, and 1851–52. Some of the paintings that La Farge recollected in his father's home were sold by the auction house of Nicolas Dean, New York, on January 31 and February 1, 1866 (auction catalog in the library of the Metropolitan Museum of Art, New York).

37. For La Farge's association with Gignoux, see Henry Adams, "John La Farge, 1835–1870: From Amateur to Artist" (Ph.D. diss., Yale University, 1980), 49–50.

38. La Farge, "Notes," 98.

39. James, *Notes*, 67.

40. Mather, "La Farge," 254–55.

41. Edward Waldo Emerson, "Thomas Gold Appleton," in *The Early Years of the Saturday Club* (Boston and New York: Houghton Mifflin Co., 1918), 217.

42. John La Farge, "Son of Bancroft," letter to the editor, *New York Times Saturday Review of Books and Art*, August 17, 1901, 581.

43. For an account of Hunt, see Martha J. Hoppin and Henry Adams, *William Morris Hunt: A Memorial Exhibition* (Boston: Museum of Fine Arts, 1979).

44. This costume was still in vogue at the turn of the century; it was, for example, worn by Thomas Hart Benton after his return to Paris (Thomas Craven, *Modern Art* [New York: Simon and Schuster, 1940], 340). For more about *Portrait of the Painter* and its dependence on Japanese prints and photography, see Adams, "La Farge," 185.

45. This contrast was apparent to La Farge's contemporaries. In an unpublished letter, La Farge's friend John Bancroft commented to his father on the contrast between La Farge's work and that of Frederic Church: "We have had pictures in Boston of Vedder and La Farge which have attracted a good deal of attention and met with the success that they should have found long since in New York, since I do not fear to say they are only the true painters in New York. Fashion rules otherwise, but mark their future. I would fain believe what you say about Church's *Chimborazo*, but I can hardly think that the painter who exhibited the emptiness of the falling *Niagara* and the falsities of *Cotopaxi* last winter, and whose vulgarity of mind and willful blindness to truth I have lately seen fill a small edition on canvas, should have found truth within a year" (January–March 1864, private collection, England).

46. For La Farge's interest in Japanese art, see Henry Adams, "John La Farge's Discovery of Japanese Art: A New Perspective on the Origins of *Japonisme*," *Art Bulletin* 67 (September 1985): 449–85.

47. William H. Gerdts, *Painters of the Humble Truth: Masterpieces of American Still Life, 1801–1939* (Columbia, Mo., and London: University of Missouri Press, 1981), 139.

48. For a superb account of La Farge's work in still life, see Kathleen A. Foster, "The Still-Life Painting of John La Farge," *American Art Journal* 11 (Summer 1979): 4–37, 83–84.

49. William H. Gerdts and Russell Burke, *American Still-Life Painting* (New York: Praeger Publishers, 1971), 187.

50. Wolfgang Born, *Still-Life Painting in America* (New York: Oxford University Press, 1947), 182–93; Adams, "La Farge," 253.

51. Barbara Novak, *American Painting of the Nineteenth Century* (New York: Praeger, 1969), 259. The rabatment of a painting is the bottom line of the square formed by taking the width of the painting, extending that dimension from the top corners on either side, and then connecting these two points. In other words, the rabatment is the bottom edge of the square generated by the top side of the painting. In constructing his composition, La Farge simply took this square and bisected it into smaller units—halves, quarters, and so forth. All of the major elements of the painting fall neatly either on the lines created by these bisections or on arcs generated from their crossing points.

Diagram of *Flowers in a Persian Porcelain Water Bowl,* c. 1861

52. John La Farge, *Considerations on Painting* (New York: Macmillan and Co., 1895), 22.

53. La Farge, in Cortissoz, *La Farge: A Memoir*, 112–13.

54. Elihu Vedder, *The Digressions of V.* (Boston and New York: Houghton Mifflin Co., 1910), 259.

55. This painting was discussed at some length in the first detailed account of La Farge's work; see George Parsons Lathrop, "John La Farge," *Scribner's Monthly* 21 (February 1881): 511.

56. Whistler's first Nocturne was *Nocturne in Blue and Gold, Valparaiso* (1866, National Museum of American Art, Smithsonian Institution, Washington, D.C.). La Farge apparently first heard of Whistler's work in 1862 while working on his large painting *Saint Paul Preaching,* whose white background reminded a studio visitor of Whistler's

The White Girl (La Farge, "Notes," 104). La Farge later learned more of Whistler from John Bancroft, who had known him in Paris (La Farge, "Son of Bancroft," 581). Throughout the 1860s La Farge seems to have known Whistler's work chiefly through his etchings, and the occasional similarities between his paintings and those of Whistler seem to be due more to parallels of artistic intention than to direct influence. In 1895 La Farge met Whistler in Paris, and shortly after that Whistler wrote to his sister-in-law Nellie in London to say that he had recommended that La Farge seek medical advice from her husband, Dr. William Whistler (letter 250, probably August 1895, Freer Gallery, Smithsonian Institution, Washington, D.C.; my thanks to Susan Hobbs for this reference). La Farge later met with Whistler during a visit to England, an event described in Adams, *Education*, 370–71.

57. Lloyd Goodrich, *Winslow Homer* (New York: Macmillan Co., 1944), 38.

58. Lilla Cabot Perry, "Reminiscences of Claude Monet from 1889–1909," *American Magazine of Art* 18 (March 1927): 119–25.

59. Born noted that "La Farge's flower pieces of the 'sixties are closer to contemporary French art than anything in America at the time. As a matter of fact, they are broader than those of Fantin-Latour, which they resemble at times but only vaguely" (*Still-Life Painting in America*, 41).

60. See Henry Adams, "William James, Henry James, John La Farge, and the Foundations of Radical Empiricism," *American Art Journal* 17 (Winter 1985): 60–67.

61. William James, "Does 'Consciousness' Exist?" in *The Writings of William James*, ed. John J. McDermott (Chicago: University of Chicago Press, 1977), 177.

62. Ellen B. Ballou, "Horace Elisha Scudder and the *Riverside Magazine*," *Harvard Library Bulletin* 14 (Autumn 1960): 435–36.

63. Cortissoz, *La Farge: A Memoir*, 38; Cecilia Waern, *John La Farge, Artist and Writer* (London: Seeley and Co.; New York: Macmillan and Co., 1896), 13. La Farge is mentioned in the diary of William Michael Rossetti for April 13, 1868 (William Michael Rossetti, *Rossetti Papers, 1862 to 1870* [New York: AMS Press, 1970]).

64. Sadakichi Hartmann, *A History of American Art*, vol. 2 (Boston: L. C. Page and Co., 1902; copyright 1901), 98.

65. Cortissoz, *La Farge: A Memoir*, 143.

66. Charles F. Richardson, "A Book of Beginnings," letter to the editor, *Nation* 91 (December 1, 1910): 520–21.

67. La Farge's technical procedures were well described by his son Grant. See Frank Weitenkampf, "John La Farge, Illustrator," *Print Collector's Quarterly* 5 (December 1915): 488–89.

68. For a highly critical analysis of La Farge's influence on wood engraving, see William James Linton, *The History of Wood-Engraving in America* (London: George Bell and Sons; Boston: Estes and Lauriat, 1882), 54. In *Considerations on Painting* (110), La Farge drew a parallel between the methods of the wood engraver and those of the pointillist painters. He noted of the pointillists that "their placing of colour side by side resembles the mechanism of engraving on wood, which may have given the first idea. In this case, as in the case of the little checker patterns, the little rain of dots of the wood engraver, our eye is first excited by one colour, then calmed by another; in the painting by a contrast of colour, in the engraving by a contrast of light and dark. The energies of nature, therefore—not their realities—are translated by our own energies."

69. John La Farge, *The Higher Life in Art* (New York: McClure Co., 1908), 13.

70. La Farge, S.J., *The Manner Is Ordinary*, 31.

71. John La Farge to Margaret Perry, February 20, 1860, in La Farge, S.J., *The Manner Is Ordinary*, 24.

72. Robert Berkelman, "John La Farge, Leading American Decorator," *South Atlantic Quarterly* 56 (January 1957): 27–41.

73. Cortissoz, *La Farge: A Memoir*, 156–58. La Farge's illness was probably psychosomatic, a case of what Freud termed "hysteria," now generally known as "conversion syndrome." See Adams, "La Farge," 259–64.

74. Ann Jensen Adams, "The Birth of a Style: Henry Hobson Richardson and the Competition Drawings for Trinity Church, Boston," *Art Bulletin* 62 (September 1980): 409–33.

75. For a detailed account of La Farge's work at Trinity, see H. Barbara Weinberg, *The Decorative Work of John La Farge* (1972; New York: Garland Publishing, 1977), 75–144; and H. Barbara Weinberg, "John La Farge and the Decoration of Trinity Church, Boston," *Journal of the Society of Architectural Historians* 33 (December 1974): 322–53.

76. Henry Van Brunt, *Architecture and Society: Selected Essays of Henry Van Brunt*, ed. William A. Coles (Cambridge, Mass.: MIT Press, 1969), 137. Van Brunt also noted (139): "There is a certain boldness of contradiction between the lines of the square panels and those of the archivolt which recalls the decorative methods of the Japanese."

77. Waern, *La Farge*, 36.

78. Greta, "Trinity Church, Boston," *Art Amateur* 1 (July 1879): 30.

79. Berkelman, "La Farge, Leading American Decorator," 27.

80. The specific histories of these projects have been covered by Weinberg, *Decorative Work*. Despite his high-strung temperament, La Farge had a knack for giving words of encouragement at important moments. "I don't see why you should not do as well," he once told Saint-Gaudens, when the sculptor sat in despair before the perfection of a Pisanello relief. "There is no doubt," Saint-Gaudens later proclaimed, "that my intimacy with La Farge has been a spur to higher endeavor, equal to if not greater than any other I have received" (Augustus Saint-Gaudens, edited and amplified by Homer Saint-Gaudens, *The Reminiscences of Augustus Saint-Gaudens*, vol. 1 [New York: Century Co., 1913], 162).

81. Henry Adams, *Two Novels: Democracy and Esther* (Garden City, N.Y.: Doubleday and Co., 1961), 220–21.

82. La Farge himself described his innovations in stained glass in *The American Art of Glass* (New York: J. J. Little and Co., 1893), as well as in an even more informative manuscript, "To Mr. Getz, for Mr. Bing of Paris," January 1894, La Farge Family Papers, Yale University, series IV, box 7, folder 4. Weinberg (*Decorative Work*) very fully documents La Farge's major windows, and Sean McNally has presented a selection of the major works in "Folio: John La Farge," *Stained Glass* (Fall 1985): 219–26. For an analysis of La Farge's technical innovations in glass, see Henry Adams, "The Stained Glass of John La Farge,"

American Art Review 2 (July–August 1975): 41–63; for a popular account of La Farge's stylistic development in glass, see Henry Adams, "Picture Windows," *Art and Antiques* (April 1984): 94–103.

83. John La Farge, *An Artist's Letters from Japan* (New York: Century Co., 1897), 219.

84. La Farge, *Considerations on Painting*, 39. La Farge told Viola Roseboro, "The last man who works on your window stamps it with his personality; his commonplaceness, or worse, is what he must put into your idea, more or less" (Viola Roseboro, "Conversations with John La Farge," *Catholic World* 143 [June 1936]: 290).

85. In suggesting this I am omitting Mary Cassatt and Whistler from consideration, as they worked in Europe rather than the United States. I should note also that La Farge's "modernism" coexisted with a backward-looking, historicizing tendency. In turning to stained glass as a medium he was reviving a "lost" art form.

86. One of the major features of modernism, from Impressionism to Cubism, was a progressive shift in the status of the work of art from that of a pictorial illusion to that of an object with intrinsic formal properties apart from those of representation. La Farge, in working in stained glass, directly dealt with this issue. He created "paintings" whose independent properties as objects developed a formal life of their own and demanded new principles of design. Moreover, as noted above, these formal qualities were strikingly similar to those of modernist painting in Europe. For some thoughts related to this issue, see Adams, "Stained Glass of John La Farge," 61. Interestingly, in one discussion of painting La Farge focused on the element that defines the dividing line between the painting as an object and the painting as an illusion—the frame. As he noted, "The frame decides the question—for there is no frame in nature." See La Farge, *Higher Life in Art*, 175–78.

87. The development of photography might also be interpreted as an endeavor to paint with light.

88. La Farge discussed Reynolds's failures in glass in "Windows, III" in *A Dictionary of Architecture and Building*, vol. 3, ed. Russell Sturgis (New York: Macmillan Co., 1902), col. 1075.

89. Focillon, "La Farge," 313.

90. La Farge's role in the American watercolor movement has been skillfully analyzed by Kathleen A. Foster in "Makers of the American Watercolor Movement: 1860–1890" (Ph.D. diss., Yale University, 1982), 296–339.

91. Some authors have placed the blame for Clover's suicide on her pessimistic and overbearing husband; others on the hereditary sensitivity of the Hoopers (Clover's sister also killed herself, by throwing herself in front of a train). The immediate cause of Clover's final depression was the death of her father, who had always been a close confidante. See Eugenia Kaledin, *The Education of Mrs. Henry Adams* (Philadelphia: Temple University Press, 1981).

92. The date of La Farge's departure from New York is given in Henry Adams, *The Letters of Henry Adams, Vol. 3, 1886–92* (Cambridge, Mass.: Harvard University Press, 1982), 12. The date of the vestry meeting is noted by Weinberg, *Decorative Work*, 177.

93. Adams, *Letters*, vol. 3, 12.

94. Ibid. La Farge alluded to this incident in his dedication to Adams of *An Artist's Letters from Japan*: "If only we had found Nirvana—but he was right who warned us that we were late in the season of the world."

95. For Fenollosa, see Lawrence Chisolm, *Fenollosa, The Far East and American Culture* (1927; New Haven, Conn.: Yale University Press, 1963); for Bigelow, see W. T. Councilman, "William Sturgis Bigelow," in *Later Years of the Saturday Club*, ed. M. A. de Wolfe Howe (1927; Freeport, N.Y.: Books for Libraries Press, 1968), 265–69; for Okakura Kakuzo, see Yasuko Horioka, *The Life of Kakuzo, Author of the Book of Tea* (Tokyo: Hokuseido Press, 1963). Two good accounts of Bostonian collectors in Japan are Van Wyck Brooks, *Fenollosa and His Circle* (New York: E. P. Dutton and Co., 1962); and Walter Muir Whitehill, "The Japanese Collection," in *Museum of Fine Arts, Boston. A Centennial History* (Cambridge, Mass.: Belknap Press of Harvard University Press, 1970), 101–41. Two of La Farge's guides later wrote accounts of the mysticism of the East. See Okakura Kakuzo, *The Book of Tea* (Rutland, Vt., and Tokyo: Charles E. Tuttle Co., 1956); and William Sturgis Bigelow, *Buddhism and Immortality* (Boston and New York: Houghton Mifflin Co.; Cambridge, Mass.: Riverside Press, 1908).

96. Adams, *Letters*, vol. 3, 18, 19, 22, 27, and 33; La Farge, *Letters from Japan*, 125. For a good account of Adams's reactions, see Donald Ritchie, "Henry Adams in Japan," *Japanese Quarterly* 6 (October–December 1959): 434–42; and Linnea H. Wren, "The Animated Prism: A Study of John La Farge as Author, Critic and Aesthetician" (Ph.D. diss., University of Minnesota, 1978), chap. 5, 20–21.

97. La Farge, *Letters from Japan*, 52–98, 237–38.

98. Fenollosa at this time had already castigated Hokusai's paintings as "blotchy, bad, ill-conceived, common," and praised Sesshu as "the well from which all late artists have come to drink the draught of immortality" (Ernest F. Fenollosa, *Review of the Chapter on Painting in Gonse's "L'Art japonais"*; reprinted from the *Japan Weekly Mail*, July 12, 1884 [Boston: James R. Osgood and Co., 1885], 46, 22–23).

99. Theodore E. Stebbins, Jr., *American Master Drawings and Watercolors* (New York: Harper and Row, 1976), 238.

100. Patricia Jean Lefor, "John La Farge and Japan: An Instance of Oriental Influence in American Art" (Ph.D. diss., Northwestern University, 1978), 148–49. James Yarnall has recently located a small watercolor of this subject. Signed "La Farge/Kamakura 1886," it was probably executed in Japan.

101. Ernest Fenollosa, *Epochs of Chinese and Japanese Art*, vol. 2 (New York: Frederick A. Stokes Co.; London: William Heinemann, 1913), 50, 71.

102. La Farge, *Letters from Japan*, 94.

103. Gustav Kobbé, "Mystery of Saint-Gaudens' Masterpiece Revealed by John La Farge," *New York Herald*, January 16, 1910, magazine section, 11; reprinted in the *Evening Star* (Washington, D.C.), January 17, 1910, 13. For an account of the genesis of the memorial, see Ernst Scheyer, "The Adams Memorial by Augustus Saint-Gaudens," *Art Quarterly* 19 (Summer 1956): 178–97. The critic Alexander Woollcott called the statue "the most beautiful thing ever fashioned by the hand of man on this continent." See Burke Wilkinson, *Uncommon Clay: The Life and Works of Augustus Saint-Gaudens* (San Diego, New York, London: Harcourt Brace Jovanovich, 1985), 240.

104. In addition to the works specifically cited below,

there are several brief accounts of La Farge's trip to the South Seas. These include: Louis Auchincloss, "In Search of Innocence," *American Heritage* 21 (June 1970): 28–33; James L. Yarnall, "John La Farge and Henry Adams in the South Seas" (Master's thesis, University of Chicago, 1976); and Henry Adams, "Regaining Paradise: Artist John La Farge and Historian Henry Adams Found Spiritual Renewal in the South Seas," *Art and Antiques* (March 1985): 60–65.

105. James L. Yarnall points out that La Farge retouched some of his watercolors after his return ("The Role of Landscape in the Art of John La Farge" [Ph.D. diss., University of Chicago, 1981], 365). In addition, a few of the watercolors seem to have been created in the United States. For example, La Farge apparently made a group of wash drawings from photographs to illustrate his article "A Fiji Festival," *Century Magazine* 67 (February 1904): 518–26, and he probably painted *Bridle Path, Tahiti* (plate 113) to illustrate "Passages from a Diary in the Pacific: Tahiti," *Scribner's Magazine* 30 (July 1901): 537–46, 670–84. My own impression, however, is that the bulk of the Polynesian watercolors, including those that are highly finished, were created in the South Seas—in contrast to the watercolors of Japan, which were largely made after the journey. Henry Adams's letters contain few mentions of the work La Farge made in Japan but include numerous references to the South Sea watercolors.

106. Adams, *Letters*, vol. 3, 298, 534.

107. Ibid., 394.

108. Ibid., 347, 331.

109. In writing of his own memories of the tropics, Elihu Vedder digressed to praise La Farge's watercolor *Spearing Fish, Samoa*, c. 1892 (plate 80). Vedder wrote: "I know of nothing in Art that more perfectly gives the feeling of these scenes than a sketch by La Farge of some island in the South Seas. It represents a little island, a mere patch of green; a man with a spear is wading out from it through the tranquil shallow water—and that is all, except that it is all light and floats in the very shimmer of a tropic day" (Vedder, *Digressions of V.*, 112).

110. John La Farge, *Reminiscences of the South Seas* (Garden City, N.Y.: Doubleday, Page and Co., 1912), 218; Adams, *Letters*, vol. 3, 336.

111. La Farge, *Reminiscences*, 212. For another account of Papasea, see Marie Fraser, *In Stevenson's Samoa* (London: Smith, Elder and Co., 1895), 150–61. See also Henry Adams et al., *American Drawings and Watercolors in the Museum of Art, Carnegie Institute* (Pittsburgh: Museum of Art, Carnegie Institute, distributed by University of Pittsburgh Press, 1985), 67–69.

112. Adams, *Letters*, vol. 3, 339.

113. Ibid., 398.

114. Henry Adams, *Tahiti: Memoirs of Araii Tamai e Marama of Eimeo, Teriinere of Tooarai, Terrenui of Tahiti, Tauraatua i Amo* (Washington, D.C.: privately printed, 1901); John La Farge, "Tahitian Literature," in *Library of the World's Best Literature*, ed. Charles D. Warner, vol. 24 (New York: H. A. Hill and Co., 1902), 14389–98.

115. A. B. Brewster, F.R.A.I., *The Hill Tribes of Fiji* (London: Seeley, Service and Co., 1922), 27–30.

116. For the genesis of this painting, see John E. Bullard, "John La Farge at Tautira, Tahiti," in *Report and Studies in the History of Art*, vol. 2 (Washington, D.C.: National Gallery of Art, 1968), 146–54.

117. La Farge, *Reminiscences*, 86. On the other hand, Robert Louis Stevenson had noted that the South Seas was the first place he had traveled that had never been under the rule of the Roman Empire and where he might meet men "whose fathers had never studied Virgil, had never been conquered by Caesar, and had never been ruled by the wisdom of Gaius or Papinian" (*In the South Seas* [1897; New York: Charles Scribner's Sons, 1943], 7–8).

118. La Farge, in Paul Bourget, *Outre Mer: Impressions of America* (New York: Charles Scribner's Sons, 1895), 366–70.

119. Adams, *Letters*, vol. 3, 321, 339.

120. See Henry A. La Farge, "John La Farge and the South Sea Idyll," *Journal of the Warburg and Courtauld Institutes* 7 (1944): 34–39.

121. La Farge, *Considerations on Painting*, 31, no. 98.

122. Adams, *Letters*, vol. 3, 393.

123. Cortissoz, *La Farge: A Memoir*, 164–65.

124. Mather, "La Farge," 246; Weinberg, *Decorative Work*, 179; Albert Boime, *Thomas Couture and the Eclectic Vision* (New Haven, Conn.: Yale University Press, 1980), 572.

125. Titus Munson Coan, "To John La Farge, on His Picture of the Ascension," *Century Magazine* 72 (May 1906): 79.

126. Susan Hobbs, "John La Farge and the Genteel Tradition in American Art, 1875–1910" (Ph.D. diss., Cornell University, 1974), 62.

127. For a discussion of the shift in style that this mural represents, see Henry Adams, "John La Farge and Japan," *Apollo* 119 (February 1984): 127–29.

128. La Farge's approach was thus in distinct contrast to the photographically realistic religious paintings by artists such as the English Pre-Raphaelite Holman Hunt, who actually journeyed to Palestine to record the landscape for *The Scapegoat*. In his comments to Royal Cortissoz, La Farge mentioned that he specifically rejected the notion of portraying the Judean mountains (Cortissoz, *La Farge: A Memoir*, 164).

129. Henry James, *The American Scene* (New York and London: Harper and Brothers, 1907), 90–91.

130. Robert Rosenblum, "New York Revisited: Church of the Ascension," *Art Digest* 28 (March 15, 1954): 11.

131. For La Farge's contact with Pach, see *Art Students League News* 19 (May 1966) and Pach's own recollections in *Queer Thing Painting: Forty Years in the World of Art* (New York and London: Harper and Brothers, 1938). Letters from La Farge to Fry and Bell are in the Houghton Library, Harvard University. For La Farge's interest in Impressionism and Post-Impressionism, see John La Farge, "On Painting," *New England Magazine* 38 (April 1908): 231, 240; and La Farge, "Son of Bancroft," 581. Russell Lynes has perceptively noted the contrast between La Farge's murals and those of his contemporaries in *The Art-Makers of Nineteenth-Century America* (New York: Atheneum, 1970), 421–22.

132. For a discussion of this project, see Kenneth J. Neal, "Kenyon Cox," in Adams et al., *American Drawings and Watercolors*, 103–4.

133. La Farge prepared a pamphlet describing the subject matter of his St. Paul murals to accompany the exhibitions he staged as the mural paintings were completed. A copy is in the La Farge Family Papers, Yale University.

134. Mather, "La Farge," 49; John La Farge to Russell

Sturgis, August 9, 1904, La Farge Family Papers, Yale University, cited in Wren, "Animated Prism," chap. 3, 17.

135. Cortissoz, *La Farge: A Memoir*, 253; La Farge, S.J., *The Manner Is Ordinary*, 115. Roseboro reported, "The novelist of whom I heard La Farge speak most warmly was Joseph Conrad" (La Farge Family Papers, Yale University, 3).

136. Focillon, "La Farge," 314.

137. This essay is discussed in Adams, "John La Farge's Discovery of Japanese Art," 473–79.

138. John La Farge, "American Wood-Engraving. Shall It Not Be Shown at Paris," letter to the editor, *New York Tribune*, March 16, 1878, 2; John La Farge, "American Wood-Engraving at Paris," letter to the editor, *New York World*, March 16, 1878, 5; John La Farge, "A Plea for the Engravers," letter to the editor, *New York Evening Post*, March 20, 1878, 3; George Inness, "A Plea for the Painters," letter to the editor, *New York Evening Post*, March 21, 1878, 2.

139. Cortissoz, *La Farge: A Memoir*, 233.

140. John La Farge, "Art and Artists," *International Monthly* 4 (1901): 336.

141. Ruth Berenson Katz gives a good account of La Farge's writings, with an emphasis on his scientific interests ("John La Farge as Painter and Critic" [Ph.D. diss., Radcliffe College, 1951], 156–200). See also Ruth Berenson Katz, "John La Farge, Art Critic," *Art Bulletin* 33 (June 1951): 105–18.

142. Vedder, *Digressions of V.*, 260.

143. William James to John La Farge, August 9, 1909, James Papers, Houghton Library, Harvard University.

144. Ernst Scheyer, *The Circle of Henry Adams: Art and Artists* (Detroit: Wayne State University Press, 1970), 177.

145. James Thrall Soby and Dorothy C. Miller, *Romantic Painting in America* (New York: Museum of Modern Art, 1943), 29.

146. Gustav Kobbé, "John La Farge and Winslow Homer," *New York Herald*, December 4, 1910, magazine section, 11. La Farge also discussed Homer in La Farge,

Higher Life in Art, 172. In "The Close of the Year in Art," *Independent* 50 (December 8, 1898): 1687–89, La Farge deplored the failure of American critics to recognize Homer's genius; he also praised Homer in "Speech at the Annual Banquet, American Institute of Architects, January 1905," *American Architect and Building News* 87 (January 28, 1905): 28. La Farge's enthusiasm for Homer's work is also documented by Beam, *Homer*, 108.

147. Kobbé, "La Farge and Winslow Homer," 11.

148. Hartmann, *History of American Art*, vol. 1, 183; John E. Rummell and E. M. Berlin, *Aims and Ideals of Representative American Painters* (Buffalo, 1901), 195.

149. "John La Farge Dead," *New York Tribune*, November 15, 1910, 7. Although this obituary is unsigned, it was undoubtedly written by Royal Cortissoz.

150. James, *Notes*, 101; Adams, *Education*, 371; Will H. Low, "John La Farge: A Great Artist of Strong Personality and with the Grand Style," letter to the editor, *New York Sun*, November 18, 1910, 8 (reprinted as "John La Farge: The Mural Painter," *Craftsman* 19 [October 1910–March 1911]: 337–39).

151. Jerome Klein, "La Farge Exhibit Is Pure Newport," *New York Post*, March 28, 1936.

152. J. C. Furnas, *The Americans: A Social History of the United States, 1587–1914* (New York: Putnam, 1969), 774; John McCoubrey, *American Tradition in Painting* (New York: George Braziller, 1963), 35. Theodore E. Stebbins, Jr., has declared of La Farge that "his interests were probably too varied and his approach too self-conscious to allow him true greatness as an artist" (*The Britannica Encyclopedia of American Art* [New York: Simon and Schuster, 1973], 329).

153. Lewis Mumford, *The Brown Decades: A Study of the Arts in America, 1865–1895* (New York: Harcourt, Brace and Co., 1931), 204–8.

154. Cortissoz, *La Farge: A Memoir*, 244–46.

155. John Canaday, "The Best of John La Farge," *New York Times*, May 8, 1966, section 2, 15.

156. Lynes, *Art-Makers of Nineteenth-Century America*, 417.

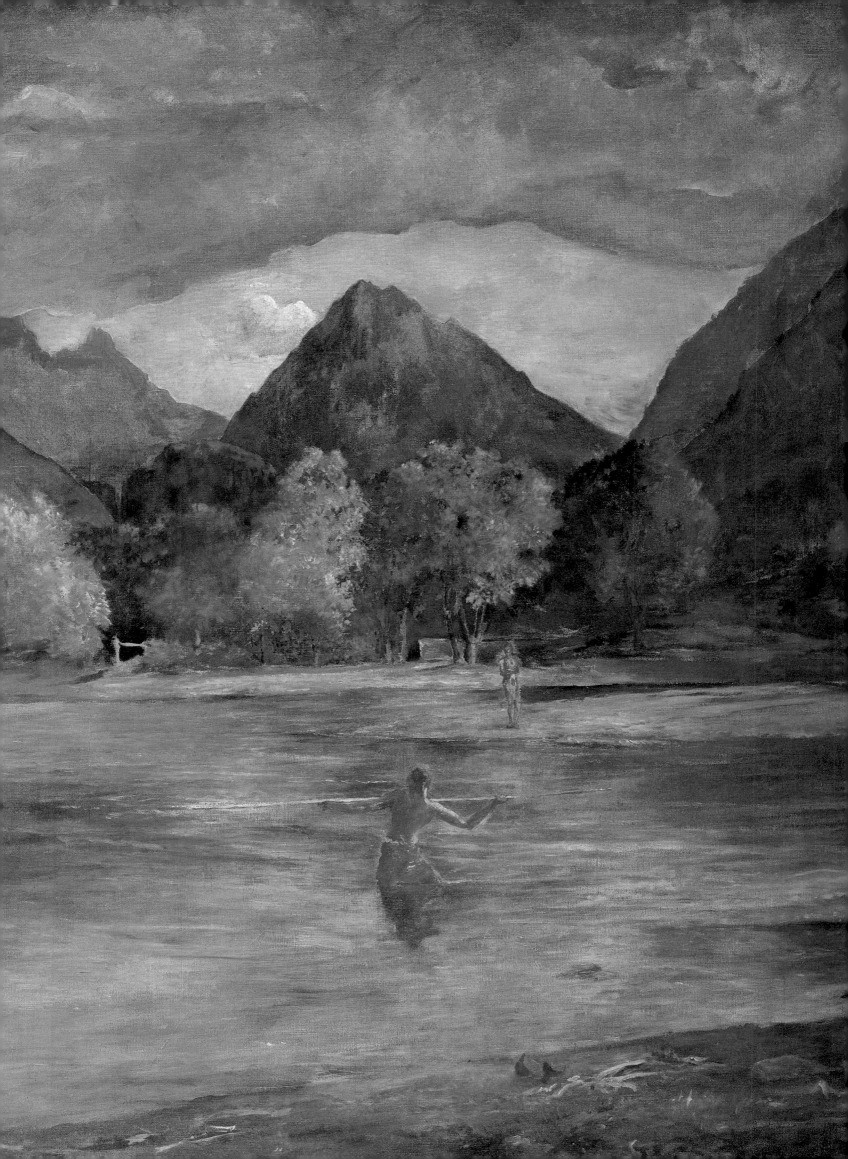

Nature and Art in the Painting of John La Farge

James L. Yarnall

46
After-Glow, Tautira River, Tahiti, c. 1895
See plate 79

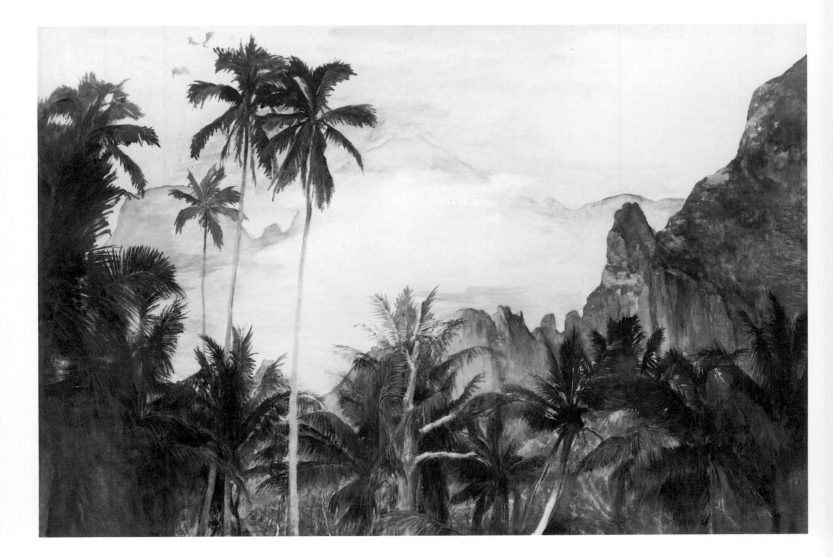

47
The End of Cook's Bay. Island of Moorea. Society Islands. 1891. Dawn, 1891
(Dawn. End of Cook's Bay. Society Island 1891)
Watercolor on paper
14½ × 22 in. (36.8 × 55.9 cm.)
The New Britain Museum of American Art, New Britain, Connecticut
Harriet Russell Stanley Fund
W1891.66

I ndeed, if one could tell what is painted from nature and what is art I should feel that the aim of my work had not been reached."[1] When these words appeared in the preface to an 1878 auction catalog of John La Farge's works, the artist was at a turning point in his career. He was about to sell off the fruits of two decades of labor: his small studies of still life and landscape, as well as early altarpieces and more recent large easel paintings. He had only recently embarked on the practice of decorative art, manufacturing his first stained-glass windows in 1875 and overseeing the interior decoration of Trinity Church in Boston soon thereafter. Ahead lay a career as a renowned decorator, illustrator, and writer, and virtual apotheosis as "our sole 'Old Master.'"[2] La Farge's simple musings on nature and art in 1878 address his past and future with equal relevance, for throughout his career, these two elements—an unflagging devotion to observing nature coupled with an encyclopedic knowledge of artistic styles and design—would be the central components of La Farge's art.

La Farge elucidated his devotion to nature when discussing easel painting shortly after the turn of the century. Generalizing somewhat, he noted that the painters of his day too frequently resorted to rote studio formulas in depicting the world around them: "The habit of the studio has so acted on modern art that the greater mass of even extraordinary successes are pictures of pictures and not pictures of Nature."[3] La Farge's own work can be regarded as an attempt to paint "pictures of Nature" that seem extensions of the world as experienced every day. When his underlying ambition to convey the vibrancy of natural appearance—whether in painting a fantastic being or capturing impressions of a landscape—is appreciated, the different genres, media, and styles that characterize the distinct stages of La Farge's career seem less disparate and disconnected.

La Farge was insistent that his interest in naturalness dated from the very outset of his career, when he criticized studio formulas even in the work of artists that he genuinely admired. For example, he pointed out that the landscape backdrops of Thomas Couture's portraits circumvented the challenge of reconciling studio and open-air painting: "I noticed how Couture painted his landscapes as a form of a curtain behind a study of the model, which in reality belonged to the studio in which it was a part, and, with the uncompromising veracity of youth, I could not understand the necessary compromises with the general truth of nature."[4] This rejection of an artificial landscape backdrop was repeated near the start of his studies with William Morris Hunt in Newport in 1859, when La Farge voiced dissatisfaction with Hunt's portraiture: "For him in general the future was merely as the past in representing figures and portraits, and he gave up the entire question of the place in which the figures lived, air and light and space."[5]

La Farge related this type of stultification to overreliance on studio teaching and formulas and a resulting tendency to paint mechanically—a pitfall he had identified and

avoided early in his career: "I was becoming more and more dissatisfied with the systems of painting which assumed some convenient way of modelling in tones that were arbitrary, and of using colour, after all, merely as a manner of decorating these systems of painted drawing."[6] La Farge saw a possible release from arbitrary formulas or "recipes" both by painting directly from nature and by applying certain scientific principles of seeing to the use of color in painting: "My youthful intolerance required the relations of colour for shadow and for light to be based on some scheme of colour-light that would allow oppositions and gradations representing the effects of the different directions and intensities of light in nature, and I already became much interested in the question of the effect of complementary colours."[7]

By freeing himself from the strictures of studio training, La Farge aspired to teach himself what he termed "realistic painting," and by learning realistic painting, he hoped to acquire the means to revivify studio art. Thus, in the spring of 1859 La Farge began sketching from nature—not just depicting landscapes but also studying still lifes and figures in settings that emphasized exposure to real "air and light and space." As La Farge described this activity: "I aimed at making a realistic study of painting, keeping to myself the designs and attempts, serious or slight, which might have a meaning more than that of a strict copy from nature. . . . I got quite sure that my many years' acquaintance with the works of art which were arrangements would be sufficient to remain in my mind while I worked in so different a way for purposes of education."[8]

La Farge's early small studies from nature (plate 48) seem just as unassuming as one would anticipate, given the artist's modest description of his program of self-instruction.

48
Boat-House. Rocks. Newport, 1859
(Old Boathouse Beach at Newport. 1859)
Oil on wood
5½ × 8¼ in. (14 × 21 cm.)
The Art Museum, Princeton University, Princeton, New Jersey
Gift of Frank Jewett Mather, Jr.
P1859.4

49
Autumn Study. View over Hanging Rock, Newport, R.I., 1868
(Bishop Berkeley's Rock)
Oil on canvas
30¼ × 25¼ in. (76.8 × 64.1 cm.)
The Metropolitan Museum of Art, New York
Gift of Frank Jewett Mather, Jr., 1949
P1868.1

50
Berkeley's or Hanging Rock, Paradise. North Wind. Autumn, 1869
Oil on wood
11 × 9 in. (27.9 × 22.8 cm.)
Private collection
P1869.6

In each study La Farge sought merely to "copy" a particular object, effect, contour, or color from the world around him. He described this activity as painting "at a blow": "Of the smaller pictures I, as far as possible, painted them at a blow, or with very little extension of time. By making careful and finished preparation—what would be called drawing—beforehand, one could do a great deal in the way of painting. Then, also, the question of using certain principles of light, by pigment, would allow one to prepare the picture in the way it would go."[9]

51
Snow Weather. Sketch, 1869
(Landscape in Snow)
Oil on wood
9⅜ × 9⁷⁄₁₆ in. (23.8 × 24 cm.)
The Art Museum, Princeton University, Princeton, New Jersey
Gift of Frank Jewett Mather, Jr.
P1869.1

These pictures were the products of careful observation and knowledge of the painter's craft acquired as much through following his instincts as through formal study with Couture and Hunt. And, although as the 1860s progressed these subtle studies grew increasingly bold in their exploration of unusual effects—such as snowstorms (plates 15, 51), fog, wind, and clouds (plate 55)—they retained a homogeneous artless simplicity. They were meant to look like nature as seen every day, not like art that was purposefully arranged or infused with symbolic meanings.

Comparing these small studies with two relatively large pictures of 1859–61—*Still Life. Study of Silver, Glass and Fruit* (plate 52) and *On the Bayou Teche, Louisiana* (plate 53)—underscores the distinction between La Farge's unpretentious sketching and his more formulaic "picture-making," as he termed easel painting. The still life emulates Dutch or French prototypes of the eighteenth and nineteenth centuries; the landscape can be regarded as an extension of the "golden" classical tradition of Claude Lorrain.[10] Such reliance on conventional composition and modeling seems finessed and artful in contrast to the general direction of La Farge's early work.

52
Still Life. Study of Silver, Glass and Fruit, 1859
Oil on canvas
16 × 20 in. (40.6 × 50.8 cm.)
Charles D. Childs
P1859.12

53
On the Bayou Teche, Louisiana, 1859–61
Oil on canvas
28 × 38 in. (71.1 × 96.5 cm.)
Mr. and Mrs. Marte Previti, New York
P1861.15

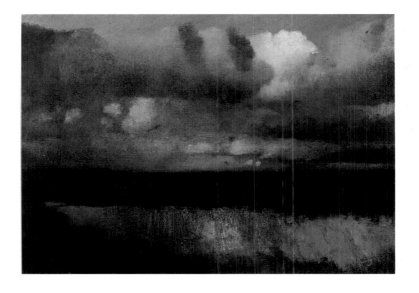

54
Clouds over Sea; From Paradise Rocks, 1863
Oil on canvas
10 × 14 in. (25.4 × 35.6 cm.)
Private collection
P1863.7

55
Study of Cloud Movement, Newport, 1865
Pencil on paper
6¾ × 3¹⁵/₁₆ in. (17.2 × 10 cm.)
Museum of Fine Arts, Boston
Gift of Major H. L. Higginson, 1911
D1865.6

56
Landscape, Newport, 1865
(Paradise Rocks, Looking South)
Pencil on paper
5¾ × 8¹/₁₆ in. (14.6 × 21.9 cm.)
Avery Architectural and Fine Arts Library,
Columbia University, New York
D1865.15

La Farge's direct study from nature did eventually lead to two landscapes—*Paradise Valley* (plate 57) and *The Last Valley—Paradise Rocks* (plate 58)—in which he applied his principles of painting from nature while avoiding conventional formulas of picturesque composition. In these monumental works, the artist expanded the tenets of his modest program of sketching to the scale of ambitious easel painting, adapting the seemingly artless compositional formats and handling of his early studies. This approach made these pictures unusual for a time in which landscape painters typically sought out the dramatic and heroic aspects of nature and painted them according to established formulas. Although La Farge was simply following his own rigorous logic rather than attempting to be different, what he accomplished in these two works was thoroughly modern in nineteenth-century terms.[11] Late in life, he was fond of discussing these paintings, and his analysis of them illuminates what he meant by "copying nature" in realistic paintings.

In *Paradise Valley*, painted in "1866–7–8," La Farge sought to reproduce a view over a pasture looking out toward the Atlantic Ocean, which lay just outside his house in the area of Middletown, Rhode Island, popularly known as "Paradise":

> My programme was to paint from nature a portrait . . . which was both novel and absolutely "everydayish." I therefore had to choose a special moment of the day and a special kind of weather at a special time of year when I could count on the effect being repeated. Hence, naturally, I painted just where I lived, within a few hundred yards from my house. I chose a number of difficulties in combination so as to test my acquaintance with them both in theory of color and light and in the practice of painting itself. I chose a time of day when the shadows falling away from me would not help me to model or draw, or make ready arrangements for me, as in the concoction of pictures usually; and I also took a fairly covered day, which would still increase the absence of shadows. That would be thoroughly commonplace, as we see it all the time, and yet we know it to be beautiful, like most of the "out-of-doors."[12]

If the main purpose of the picture was to replicate the contours of a valley in Paradise "as we see it all the time," the process of replication nonetheless involved conceptualizing, not merely copying from nature:

> I modelled these surfaces of plain and sky upon certain theories of opposition of horizontals and perpendiculars in respect to color and I carried this general programme into as many small points of detail as I could combine. I also took as a problem the question of the actual size of my painting as covering the surface which I really saw at a distance, which would be represented by the first appearance of the picture. A student of optics will understand.[13]

Paradise Valley lacks the spontaneous ease of the artist's small-scale sketches and relies on what he described as optical effects. La Farge felt that it conveyed an impression of naturalness, a point he adeptly summarized in contrasting his painting with the work of the French Impressionists:

> The main difficulty was to do all this from nature and to keep steadily at the same time to these theories without having them on the outside stick out, if I may say so, as some of my intelligent foreign friends managed to do. *In nature nothing sticks out.* They [the Impressionists] also have since worked out similar problems but they have not always insisted upon that main one, that the problems are not visible in nature. Nature, meaning in this case the landscape we look at, looks as if it had done itself and had not been done by the artist.[14]

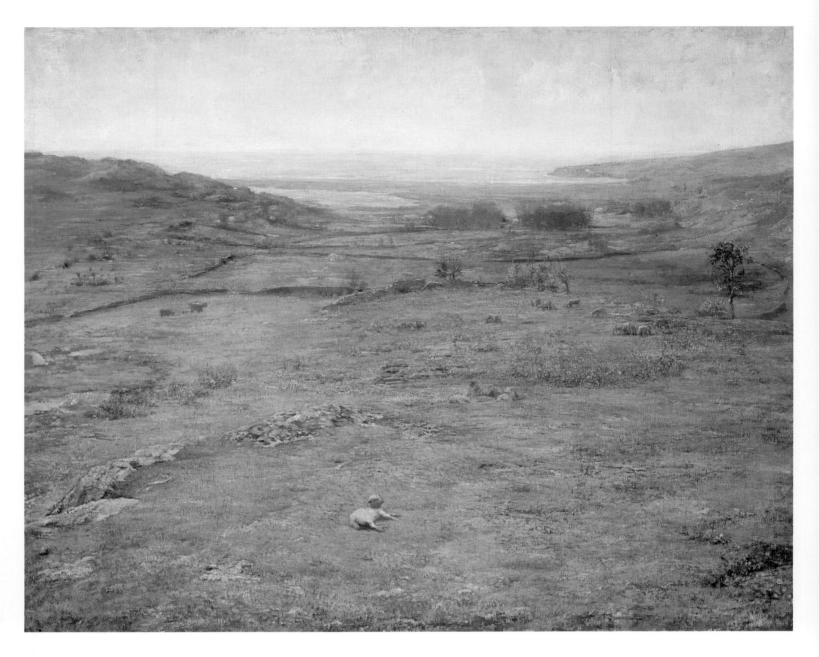

57
Paradise Valley, 1866–68
Oil on canvas
32½ × 42 in. (82.5 × 106.7 cm.)
Private collection
P1866.5

Whether or not one can agree with La Farge's claim that looking at this picture is like looking at nature, one can easily appreciate how little, in relative terms, it looks like his earlier essay in the manner of Claude. There is nothing familiar about the composition, at least from the perspective of an era preceding Impressionism, and the massing of light and dark typical of classical landscape has here been supplanted by an evenness of light bordering on blandness. Considering the picture in the context of its time, as La Farge

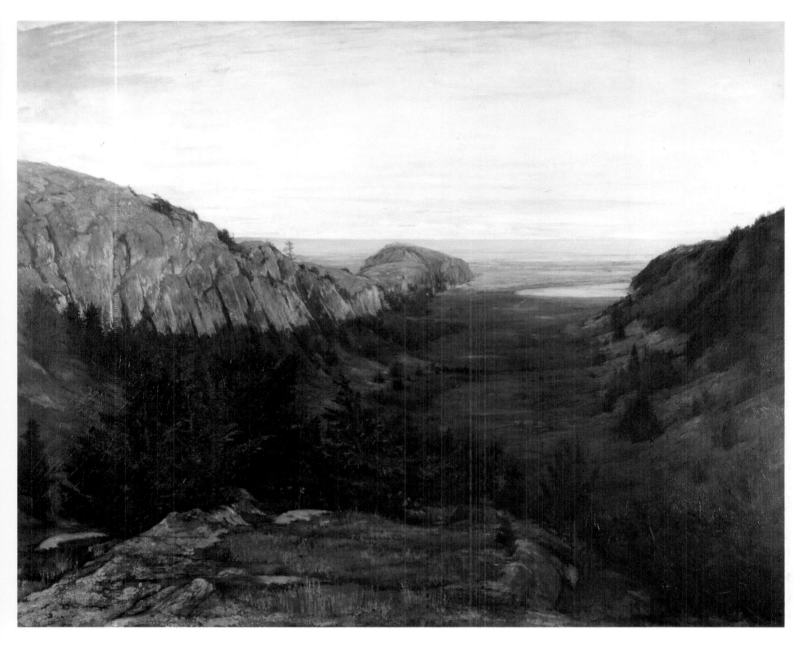

58
The Last Valley—Paradise Rocks, 1867–68
Oil on canvas
32 × 41½ in. (81.3 × 105.4 cm.)
Private collection
P1867.1

and his contemporaries did, makes it understandable why the artist thought *Paradise Valley* came closer to capturing natural effects than typical pictures of the day.

The same sort of presentation of nature in which "nothing sticks out" can be found in *The Last Valley—Paradise Rocks*, executed in 1867–68. In this case, the subject was a more colorful and diverse site (called, in fact, the "Last Valley") located high in the somewhat treacherous and now-overgrown reaches of the Paradise Hills, about a mile

from La Farge's home. This more remote location imposed certain exigencies and risks during execution, and the picture was damaged when the hut in which it was stored at the site was plundered. La Farge noted that *The Last Valley—Paradise Rocks* was "painted from nature, in the same way as the other [*Paradise Valley*], and took a very long time to paint, so as to get the same light as possible. By going very frequently,—if necessary, everyday, and watching for a few minutes, I could occasionally get what I wanted."[15]

Whereas in painting *Paradise Valley*, La Farge had selected a bland topography with few linear and lighting contrasts, for *The Last Valley—Paradise Rocks* he deliberately chose a dramatic gorge viewed at sunset, a time of day when the dual ridges of the valley would be lit in opposition, the one illuminated with the brilliance of the setting sun, the other cloaked in dusk.[16] But this view seems no more conventional than that in *Paradise Valley*, for even in reintroducing a wide range of light and dark contrasts, La Farge avoided symmetrical balance, picturesqueness, and massing. The landscape perspective is abruptly thrust toward the viewer, giving the work a distinctive sense of immediacy.

Nonetheless, as in *Paradise Valley*, La Farge again relied on elaborate conceptualizing rather than spontaneous painting from nature to execute the picture. He applied a traditional studio underpainting to establish the overall harmonies, utilizing broad masses of blue for the dark areas and red for the light ones. Maintaining the contrast of red and blue values, he carefully added details and subtle variations over a long period of time.[17] In the end, these details of the surface disappeared into an optical mixture in which "nothing sticks out"; the artist seems to have captured the real appearance of a natural site.

These monumental landscapes were the culmination of only one aspect of La Farge's early production. Another important element was what might be termed his "idealistic" paintings—works meant to express imaginative or personal meanings in portraiture, illustration, subjects from mythology and literature, and still-life compositions—which were arranged in manners meant to be highly decorative.[18] These idealistic paintings attested to the artist's desire to invest traditional studio painting with new vitality and, in their fusion of natural observation with artful stylization, they predicted the central thrust of La Farge's future artistic activity.

This fusion is apparent in an early self-portrait in which La Farge sought to circumvent the formulas of contemporary studio portraiture by representing himself in a vibrant landscape setting (plate 3). This reconciliation of an individual likeness with the depiction of real "air and light and space" was an obvious rejection of Hunt's approach. La Farge also betrayed an intention to supersede mere realism by adopting Barbizon-like stylizations and interjecting a decorative sinuosity into the play of figure and landscape.[19] This type of formulation, in which artfulness and convincingly realistic touches are carefully blended, became a prototype for his portraits throughout the 1860s, culminating in La Farge's largest and most ambitious portrait, *A Boy and His Dog* (plate 59)—a painting that derived its animated handling from Gustave Courbet's depictions of hunting life.[20]

This balance of artfulness and realism can also be detected in early works that depict

59
A Boy and His Dog, c. 1869
Oil on canvas
40 × 34 in. (101.6 × 86.4 cm.)
Private collection
P1869.4

60
Centaur, 1864
Oil on canvas
8¾ × 12⅜ in. (22.2 × 31.5 cm.)
Private collection, Washington, D.C.
P1864.10

61
The Lady of Shalott, 1862
Oil on wood
9 × 14¾ in. (22.9 × 37.5 cm.)
The New Britain Museum of American Art, New Britain, Connecticut
Harriet Russell Stanley Fund
P1862.1

popular subjects from mythology (plate 60), literature (plate 61), or history in an uncommon manner, stripping away historicizing trappings and artificialities of presentation. These pictures seldom seem highly artful, but even so they frequently employ stylistic devices or design elements derived from other works of art. For example, the buoyant depiction of the centaur Chiron carrying the infant Achilles through a verdant Newport landscape (plate 60) is a variation on a statue by William Rimmer, with whom La Farge studied anatomy in Boston in 1864.[21] Likewise, many of La Farge's magazine illustrations utilized the compositions of Japanese prints as points of departure, often in ways that barely disguise their Oriental origins (plates 62, 63).[22] La Farge indicated that such transmutation of work by other artists was a way for him to appropriate principles of good design: "From the earliest moment I have thought that it might help to refresh our minds by recalling in a new way the principles [of design] which I believe have always been more or less at the bottom of all work which is good in design whether that design be in color or not."[23] Indeed, this resourceful harnessing of the vitality in the designs of other artists,

62
Lady with a Fan, 1868
(Woman in Japanese Costume at an Easel)
India ink and Chinese white on uncut woodblock
5¾ × 4³⁄₁₆ in. (14.6 × 10.6 cm.)
The Carnegie Museum of Art, Pittsburgh
Andrew Carnegie Fund, 1918
D1868.3

63
Kaigetsudo Ando
Oiran
Full color on paper
36⅛ × 18⅛ in. (91.7 × 46 cm.)
The Cleveland Museum of Art,
Cleveland, Ohio
The Worcester R. Warner Collection

a practice that La Farge continued throughout his career, injected great diversity and hybridness into his works and seemed to fuel his imagination in picture-making.

There is something organic or instinctive in the way that La Farge moved between the worlds of art and nature, as well as in the way he refused to be bounded by any single genre or style. These points are succinctly illustrated in his paintings of the water lily, a subject he discussed fondly near the end of his life:

> Thinking again about the pictures of flowers which I used to paint, there were, besides the paintings that were studies of the flowers, and those that were painted as pictures, certain ones in which I tried to give something more than a study or a handsome arrangement. Some few were paintings of the water lily, which has, as you know, always appealed to the sense of something of a meaning—a mysterious appeal such as comes to us from certain arrangements of notes of music.[24]

The difference between La Farge's earliest studies of lilies (plates 65, 66) and the lilies of the next decade (plate 64) is not just the result of increasingly complex arrangement.[25] In the earlier studies the viewer is led to admire the light on the water, the texture of the flowers, the contrast of tones, and the subtlety of colors, while in the later pictures nature

Opposite
64
Water Lily and Linden Leaves, 1872
Oil on canvas
12 × 10 in. (30.5 × 25.4 cm.)
Mead Art Museum, Amherst College,
Amherst, Massachusetts
P1872.3

Right
65
The Last Water Lilies, 1862
Oil on wood
7¾ × 7⅝ in. (19.7 × 19.4 cm.)
Mrs. Diane Moore Field
P1862.18

Below
66
*Water-Lillies in a White Bowl—
with Red Table Cover*, 1859
Oil on wood
9½ × 11½ in. (24.1 × 29.2 cm.)
Pauline E. Woolworth
P1859.15

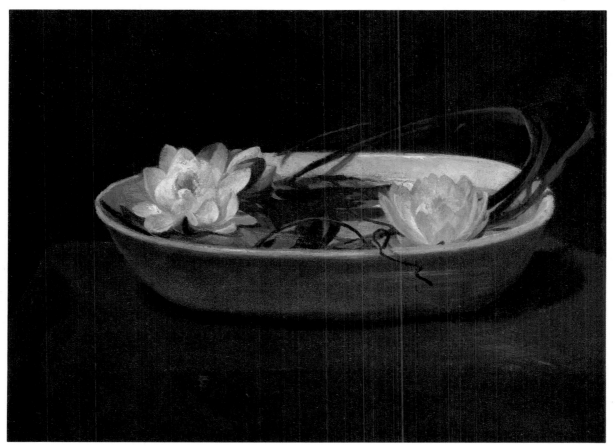

67
Virgil, 1874
Oil on canvas
42¼ × 32¾ in. (107.3 × 83.2 cm.)
Fogg Art Museum, Harvard University, Cambridge, Massachusetts
Gift of The Honorable and Mrs. Robert Woods Bliss
P1874.2

seems to be magnified and to possess a mysterious, hypnotic symbolism that cannot be easily articulated in words. Ultimately, the worlds of nature and the imagination fuse in the water lily pictures. A lily fairy (plates 96, 97) sprouting from the water seems as animated and credible as a delicate moth hovering over lily pads (plate 106).[26] In these variations on a theme, the viewer is lulled into a fantastic world where the boundaries between the real and the imaginary dissolve and the distinction between "what is painted from nature and what is art" blurs.

Judging by these early idealistic works, La Farge seems to have succeeded in his ambition to free himself from formulas as he explored many different genres. And, as the later water lily pictures demonstrate, the artist gradually seemed to drift further and further away from realism after 1870, a phenomenon aptly described by his principal biographer, Royal Cortissoz:

> If he had gone on exactly as he had begun, and, moreover, had narrowly pursued that special quality, we know just where he would have ranged himself. . . . His imagination took a wider sweep. There were too many other fields to conquer. . . . There is, therefore, something like a movement of dislocation, gradual, scarcely perceptible, but unmistakable none the less, of which one is conscious on taking leave of the early paintings.[27]

This dislocation was actually the augmentation of the tendency toward artfulness that had been subtly present in La Farge's work since the start of his career.[28] As La Farge grew increasingly interested in subjects from traditionally elevated genres of painting such as mythology and history, he began to emphasize decorative aspects such as evocative colors, majestic compositions, and painterly handling. This was most evident in several large "Decorative Panels" of the early to mid-1870s, which are staged in overtly arranged but realistically detailed natural environments (plates 67, 68).[29] The tendency toward stylization culminated in several large easel paintings of the late 1870s.

In these later works the naturalism of the 1860s has given way to an elegance derived from the old masters. La Farge did not so much abandon the careful observation of nature as subordinate all pictorial elements to decorative colors and painterly brushwork. For example, in *The Three Wise Men* (plate 130), which was set on an identifiable ridge of the Paradise Hills, La Farge emulated the tonalities and painterly flourishes of two of his great heroes, Eugène Delacroix and Théodore Chassériau, attaining an animated integration of figure and landscape.[30] This treatment recalls La Farge's praise of the sense of movement in the works of Delacroix:

> As with Rodin, who is a great example, as with Barye, Delacroix's friend, as with the Greeks, as with the greater men of all time, except the present, so Delacroix felt the unexpressed rule that the human being never moves free in space, but always, being an animal, in relation to the place where he is, to the people around him, to innumerable influences of light, and air, wind, footing, and the possibility of touching others. This is the absolute contradiction of the studio painting, however dignified, where the figure is free from any interruption, and nobody will run against it.[31]

A similar fusion of stylization with persuasive naturalnesss characterizes *The Golden Age* (plate 69), a product of the late 1870s that derived its subject and handling from Titian's *Sacred and Profane Love* (c. 1515–16; Galleria Borghese, Rome).[32] While the roseate and bluish contrasts of the painterly surface of La Farge's work clearly evoke Venetian Renaissance colorism, the artist nonetheless managed to retain a sense of real "air and light and space." In their successful appropriation of old master styles, both *The Golden Age* and *The Three Wise Men* seem consistent with La Farge's overall aesthetic program to revitalize traditional genres of studio painting. With this "grand style" of painting, he deliberately strove for the kind of believability that characterized the great traditions of art but that, to La Farge, seemed absent from the work of many of his contemporaries.

This development of an elevated manner of easel painting cannot be separated from a parallel stylistic development in La Farge's mural paintings and stained glass. Indeed, the cross-fertilization of La Farge's painting and his decorative work was completely realized

68
Decorative Panel. Seated Figure in Yellow. Study for the Muse of Painting, 1870
(The Muse of Painting)
Oil on canvas
49¼ × 38¼ in. (125.1 × 97.2 cm.)
The Metropolitan Museum of Art, New York
Gift of J. Pierpont Morgan and Henry Walters, 1909
P1870.1

69
The Golden Age, 1878–79
Oil on canvas
35⅝ × 16½ in. (90.5 × 41.9 cm.)
National Museum of American Art, Smithsonian Institution,
Washington, D.C.
Gift of John Gellatly
P1878.3

in the last major easel painting that La Farge produced around 1880, *The Visit of Nicodemus to Christ* (plate 70), which was based directly on a mural completed in 1878.[33] But, as decorative work became the mainstay of La Farge's art after the completion of Trinity Church in 1878, he virtually ceased making any other type of painting: "For nearly ten years I was obliged to give up painting, an art of which I am extremely fond, and even now [in 1894] I exercise it more as a pleasure than as a business, sometimes not getting more than four or five days in the month that I can give to painting."[34] The primary exception to this relinquishment of painting during the 1880s was La Farge's trip to Japan in 1886, which not only provided an exciting counterpoint to his arduous career as a successful decorative artist but also resulted in some of his most complexly meaningful works.[35] In addition, this trip stimulated a fresh start in La Farge's work— a sudden new blossoming of his love for painting from nature that gradually spilled over into his interest in illustration, decorative projects, and didactic easel painting and also inspired new endeavors as a writer.

La Farge's interest in visiting Japan stemmed both from his long-standing knowledge of Japanese art and from the enthusiastic reports of visitors to that country during the 1870s and 1880s. In planning for the trip, he anticipated discovering a picturesque landscape and a spiritually profound culture, anticipations that were fulfilled even as he steamed into the harbor at Yokohama in July 1886: "It is like the picture books. Anything I can add will only be filling in of detail."[36]

Filling in the details of this experience became La Farge's driving passion. At an early point in his visit he conceived of "making an analysis and memoranda" of Japanese architecture, history, culture, religion, and literature. This initial seed of an idea gradually evolved into a project to produce an illustrated travel book, which occupied La Farge sporadically for over a decade.[37] By the end of his life, he had written hundreds of pages in books, articles, and lectures on Japan and had created at least two hundred works in various media that were directly related to his experience of the country.[38]

La Farge's ambition to publish his notes and sketches of Japan influenced the way he looked at the country and its people. Although he sought greater sobriety, clarity, and realism than was common in travel illustration, many of his topographical and figural studies appropriated the stock subjects and pictorial conventions of travel illustration and of postcard photography (plates 71, 72).[39] La Farge often found conditions during travel less than conducive to concentrated study and was often unable to bring works to a requisite degree of finish. His correspondence documents that he used photographs to help him rework compositions begun on the spot and that he retouched sketches, or made copies of them, as necessary, sometimes many years after his return to New York. For example, his personal secretary wrote in 1907 to a client about to purchase one of the Japanese watercolors: "Mr. La Farge said he would like to put a few more brushes on this. He said he did it right from nature right there and he could not quite do all he wished to."[40]

Other compositions, such as wash drawings executed in 1887 and 1888 that were eventually engraved for publication, were also made entirely in New York as La Farge was bringing his travel writings together into a cohesive narrative.[41] In addition to elaborate travel views and studies of Japanese "types," he provided variety and decorative touches by executing vignettes and auxiliary illustrations that were variations on Japanese sources. In some cases (plate 73), he emulated Japanese brushwork while introducing elements of Western perspective and handling, creating a hybrid mingling of Eastern and Western techniques. In other cases, he sought to "Westernize" his artistic sources more fully in what he termed "Fantasies on Oriental Themes" or to copy his Eastern sources in all points of style in what he referred to as "Imitations of Japanese Motives or suggested

by them."[42] La Farge's Japanese work is, clearly, an unusual combination of observation and deliberation, a fascinating miscellany in which it is not always easy to distinguish between "what is painted from nature and what is art."

The experience of Japan awakened in La Farge an interest in Japanese religion and philosophy, areas in which he received extensive instruction from his hosts in Japan: William Sturgis Bigelow, a relative of Henry Adams by marriage and a practicing Buddhist, and Ernest Fenollosa, an 1874 Harvard graduate who had become a commissioner of fine arts for the Japanese emperor. La Farge also was educated in Japanese nature philosophy by Okakura Kakuzo, Fenollosa's fellow commissioner of fine arts. Although La Farge never seriously considered following Bigelow's lead in converting to Buddhism, his recollection of discussions with Okakura when the latter visited him in New York during the summer of 1888 offers some insight into the artist's interest in this religion: "During that summer my friend Okakura spent a great deal of time with me and I could paint, and then, in the intervals, we could talk about spiritual manifestations and all

70
The Visit of Nicodemus to Christ, c. 1880
Oil on canvas
41¾ × 35 in. (106 × 88.9 in.)
National Museum of American Art,
Smithsonian Institution, Washington, D.C.
P1880.4

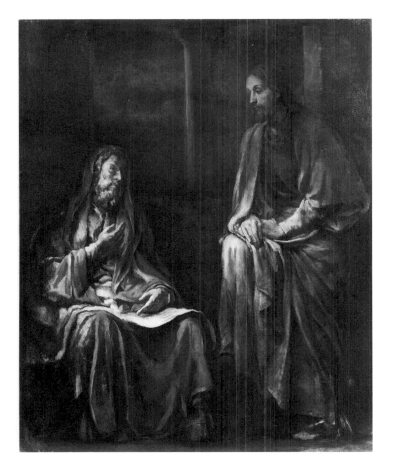

71
Avenue to the Temple of Iyeyasu, Nikko. Mid-day Study, 1886
Watercolor on paper
9½ × 11¾ in. (24.1 × 29.8 cm.)
Walters Art Gallery, Baltimore, Maryland
W1886.26

72
F. Pierdon after J. L. Crépon
Tori ou Porte Sacrée à Benten
Wood engraving from Aimée Humbert, *Le Japon illustré*
(Paris: Hachette, 1870), vol. 1, 67

73
Fisherman (Sunlight), c. 1888
(Japanese Study, Japanese Fisherman, Study of Sunlight)
Watercolor on paper
6⅝ × 5⅛ in. (16.8 × 13 cm.)
Farnsworth Museum, Rockland, Maine
W1888.15

that beautiful wonderland which they have; that is to say, the Buddhists, where again the spiritual bodies take form and disappear again, and the edges of the real and the imaginary melt."[43]

His new interest inevitably affected La Farge's use of Japanese nature imagery in his work as he strove to express his deeper personal experience of its meaning. This profound interest in Japanese nature philosophy and Oriental imagery manifested itself most explicitly in several large easel paintings, begun the year after the Japanese trip and not completed to La Farge's satisfaction until two decades later. These works attempted to express his own insights into the mysteries of Japanese nature philosophy through his role as a Western artist directing a message of spiritual discovery to a generation in which spiritual values were noticeably on the wane.

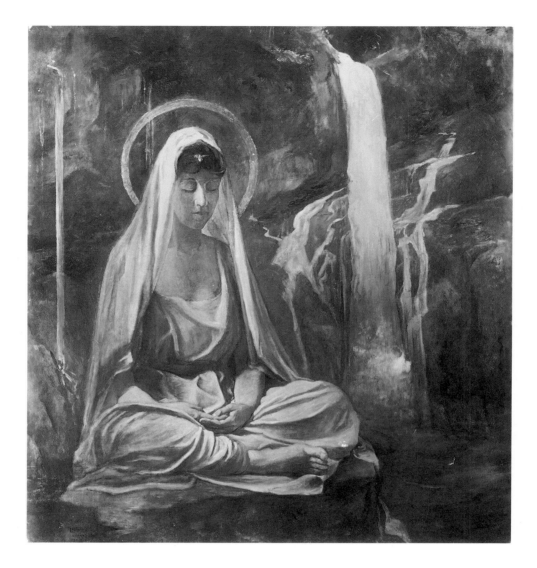

74
Kuwannon Meditating on Human Life, 1887–1908
Oil on canvas
36 × 34 in. (91.4 × 86.4 cm.)
The Butler Institute of American Art, Youngstown, Ohio
P1887.4

Several versions of the Kwannon meditating on human life (plates 34, 74) were based on an Oriental prototype in which the bodhisattva Kwannon, seated in lotus position before a waterfall, symbolizes the Eternal Feminine lost in contemplation amid the endlessly flowing waters of life, ready to offer compassion to a troubled world.[44] The artist's highly personal attraction to this imagery was based on his vivid experiences of nature in Japan: "I am continually reminded of her [the Kwannon] by the beautiful scenes about us, of which the waterfall is the note and the charm. . . . and here [at Urami-no-taki], again, the intense silence, broken by the rush of the waterfall recalled the pictures of the Kwan-on, whose meaning and whose images bring back to me the Buddhistic idea of compassion."[45] Here—as in a multitude of other works, including mural decorations (plates 141, 142) and stained glass—the waterfall evokes Japanese

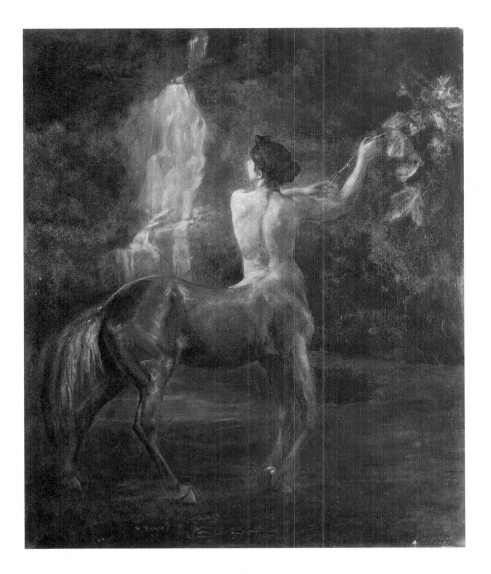

75
The Centauress, 1887
Oil on canvas
42 × 35½ in. (106.7 × 90.2 cm.)
Brooklyn Museum
P1887.1

nature philosophy not only by epitomizing the Japanese landscape but also by conveying visual rhythms that, like the sound of the waterfall, could lull the mind to meditation. Although conceding in his variations on the Kwannon to certain stylizations common to Japanese screens or handscrolls, La Farge employed Westernized spatial schemes and three-dimensional forms. Through these hybrid translations he sought to convey esoteric Oriental concepts of life, nature, and destiny in a manner that might be readily apprehended by Western eyes.[46]

A similar "translation" occurred in *The Centauress* (plate 75), a seemingly classical subject that actually fused Oriental and Western iconographies in a startling manner. Not only did La Farge set the scene in a decidedly unclassical Japanese garden, but he also seems to have endowed the human half of the centauress with the golden skin, facial

features, hairstyle, and small proportions of a contemporary Japanese woman. In this unusual melding of Western antiquity with modern Japan, the centauress seems to embody a coming apotheosis of civilization through the cultural merger of East and West, an apotheosis that Fenollosa had predicted.

As unusual as this translation of the classical past into modern Japanese terms at first appears, it in fact illustrates La Farge's intuition that his experiences in contemporary Japan somehow paralleled the Greek Golden Age. For example, he wrote: "The great Pan might still be living here, in a state of the world which has sanctified trees and groves, and associated the spirit world with every form of earthly dwelling-place. . . . Could a Greek come back here, he would find his 'soul-informed rocks,' and all that he thought divine or superstitious, even the very 'impressions of Aphrodite.' "[47] La Farge shared a pervasive nineteenth-century belief that modern man had lost touch with a natural and more elemental style of life that could still be observed in the cultures of "primitive" countries.[48] At their purest, these cultures seemed to mirror qualities of archaic Greek civilization—that time when man, nature, and art coexisted in perfect harmony. La Farge's enthusiasm for these qualities in the land, people, and culture of Japan not only accounted for the superabundance of Japanese motifs and themes in his subsequent art and writings but also provided a direct link to his similar experience of the South Seas in 1890–91.

Whereas in Japan La Farge had been stimulated to reverie about the archaic past, in the South Seas he felt that he had actually reentered "a rustic and Boeotian antiquity." The landscape was not just evocative of a Golden Age garden, it was a surrogate that seemed to equal the Greek original. Similarly, in their physiques, rituals, and daily lives, the natives seemed to be reincarnations of the ancients, not just vague reflections.

The strongest evidence of La Farge's idealizing approach is provided by his South Sea figure studies, particularly those executed in Samoa. Part of his enthusiasm was linked to the partial nudity of the natives, which permitted La Farge to study the nude in the open air without the strictures of studio lighting. His remark to his Japanese servant as he left Samoa in January 1891 sounds rather wistful: "It was like the studio, Awoki, was it not; but all fine; no need for posing?"[49] For La Farge, it had been a rare opportunity to study and portray the nude without having to resort to the artistic imagination: "And if I live to paint the subjects of the 'nude' and 'drapery,' I shall know how they look in reality."[50]

It was not only this chance to live in an open-air studio that was unique. To La Farge, it often seemed as if nature and art were one and the same in Samoa. He described the scenes before him as bringing to life passages from paintings by Nicolas Poussin, Titian, Chassériau, or Pierre Puvis de Chavannes. The ritual ceremonies that the Samoans performed outdoors reminded him of Delacroix's tableaux of Algerian women, transplanted to the South Pacific.[51] La Farge also compared the physique of Samoan males to statues of Greek athletes, while indicating that the females seemed to have stepped down from the Parthenon frieze. More generally, he noted similarities to a constellation of antique

76
Portrait of Faase, the Taupo of the Fagaloa Bay, Samoa, 1891
(A Taupo and Her Duenna Await the Approach of a Young Chief)
Watercolor on paper
19 × 15⅛ in. (48.3 × 38.4 cm.)
Daniel and Rita Fraad
W1891.18

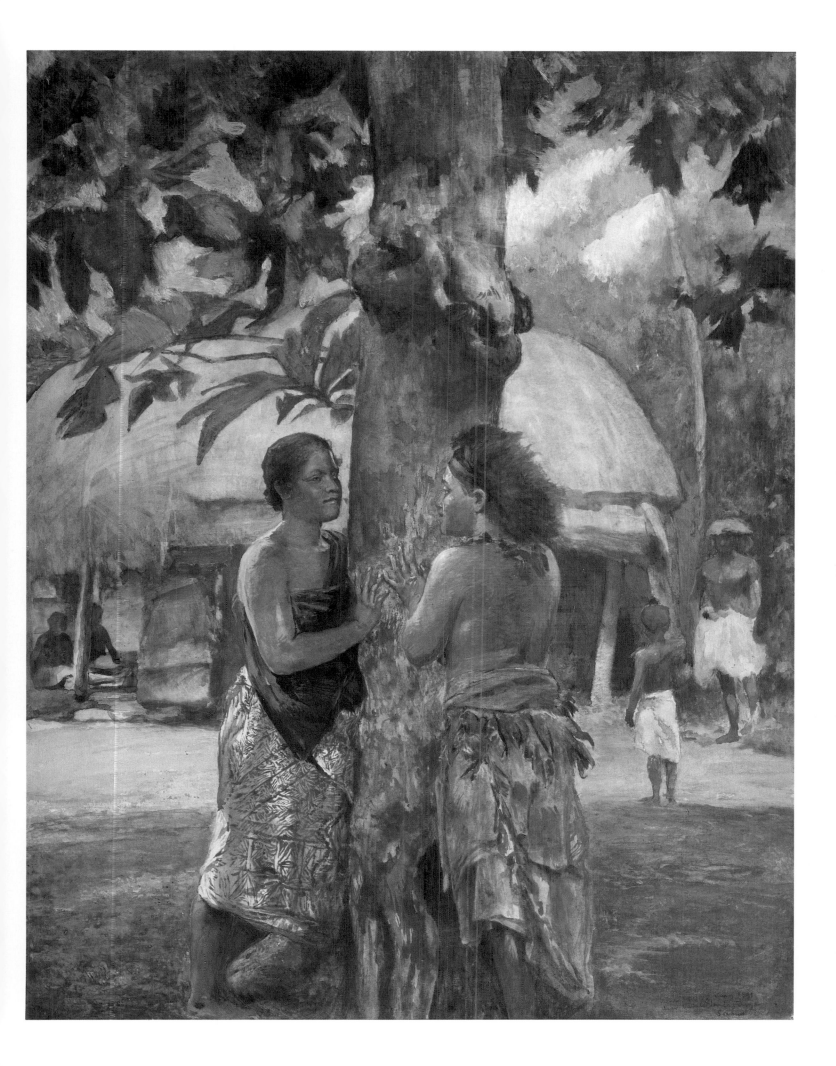

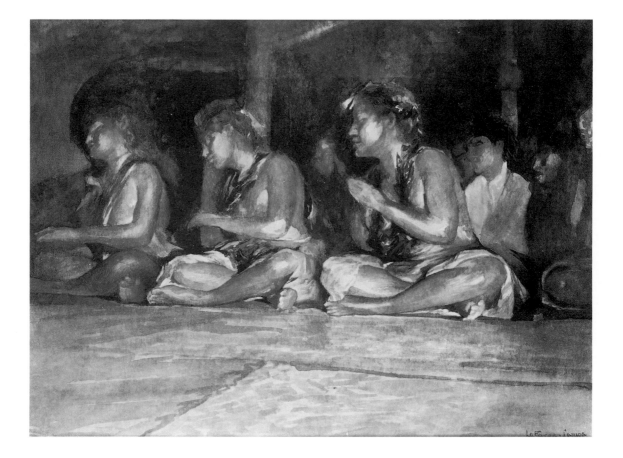

77
Samoan Girls Dancing the Seated Dance, or Siva, with Pantomime and Song.
Samoa, 1891. Night Effect, 1891
Watercolor on paper
10½ × 13½ in. (26.7 × 34.3 cm.)
Museum of Fine Arts, Boston
William Sturgis Bigelow Collection
W1891.16

sources: "Such a Boeotian set of islands as Samoa gives to the artist—the man who remembers the beauty of classical representations, the only fit recall of what he has seen in Greek sculpture, the Pompeian fresco, and the vases of antiquity."[52] This impression of art coming to life before his eyes was so strong that La Farge often felt as if he were copying from works of art rather than from nature. In many paintings there are indeed strong reminiscences of motifs from the history of art, which, if we are to believe La Farge, he painted exactly as he saw them.

Although La Farge's enthusiasm for Samoan native life was almost unbounded and he was free to paint as he wished, he found that the task was a great challenge to his own ability to capture the figure in motion. Particularly frustrating were his attempts to depict the indigenous Samoan dance, the *siva* (plates 77, 82, 83), which was performed both standing and seated, and by firelight as well as in sunlight. After much labor, La Farge found the "work either carried too far, or not far enough," the skin "too European," or the light completely elusive.[53] Even posing dancers in single movements or using photographs taken by Adams toiling "over a Kodak" to supplement on-the-spot sketches

did little to help. The finished products of these difficult endeavors seemed to the artist "stupid from their freezing into attitudes the beauties that are made of sequence."[54] He blamed much of this failure on his medium: "The only way to represent this fullness is by an underpainting carefully finished, and of course this cannot be in such a slight sketch in watercolor. Even the complications would have to be studied more carefully to see what means there would be."[55]

It was not only the *siva* dance that suffered in La Farge's depictions but virtually any subject requiring fluidity of line or spontaneity of movement. This is particularly evident in the watercolors of frolicking natives sliding down waterfalls. These "old-gold girls" had been idolized by La Farge's friend Clarence King and were one of the great treats that La Farge had anticipated painting in the South Seas (plate 78). Unconvincingly integrated into tropical torrents, they became awkward, graceless creatures, fully meriting King's derisive comment that La Farge's paintings were "without interest save to the color sense" and stripped of all the intellectual, moral, and physical resonance that had made the "old-gold girls" seem so precious to King years before.[56]

If painting the figure simultaneously enthralled and frustrated the artist, painting the landscape was relatively effortless. The volcanic mountains and soaring palms seemed to provide the ideal focus and frame for La Farge's vistas of sea, land, and sky (plate 47). The dramatic, intensely colorful natural phenomena, such as the prolonged afterglow cast on the waters after sunset, inspired a new chromatic richness that gave many works a special luminosity. But, as in the Japanese sketches, La Farge tended to look at the scenes before him through his memories of other art, depicting many stock subjects in compositions reminiscent of conventional travel illustration.

78
Lower Fall of the Papa-Seea. Fagalo Preparing to Slide the Water-Fall, 1890
Watercolor on paper
11⅝ × 13¼ in. (29.5 × 33.6 cm.)
Private collection
W1890.66

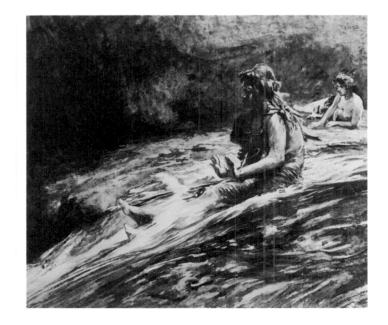

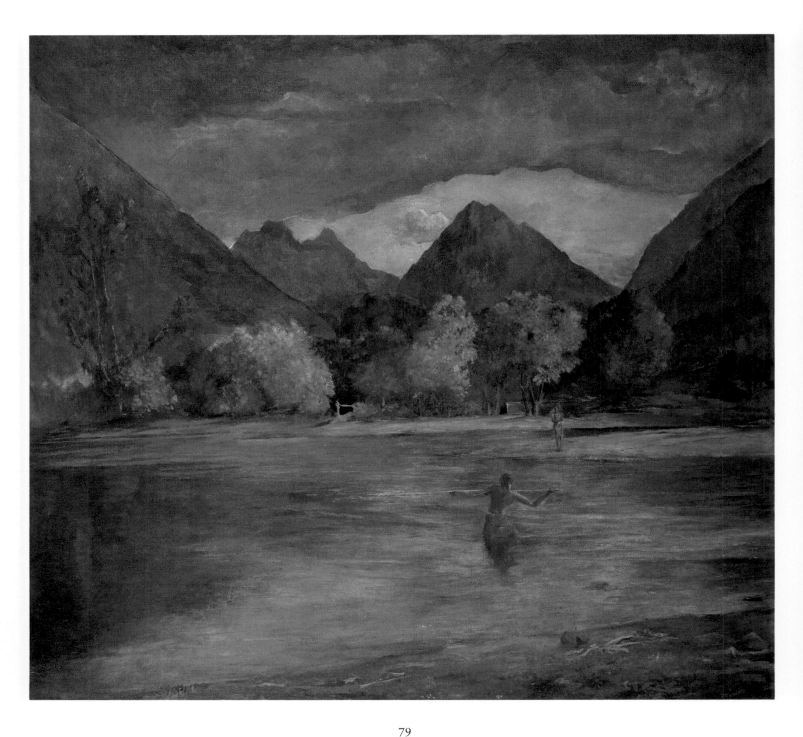

79
After-Glow, Tautira River, Tahiti, c. 1895
Oil on canvas
53½ × 60 in. (135.9 × 152.3 cm.)
National Gallery of Art, Washington, D.C.
Adolph Caspar Miller Fund
P1895.3

Henry Adams provided one of the few accounts ever written of La Farge's handling of watercolor when describing the artist's on-the-spot sketching in Hawaii: "He splashes in deep purples on deep greens till the paper is soaked with a shapeless daub, yet the next day, with a few touches, it comes out a brilliant mass of color and light. Of course, it is not an exact rendering of actual things he paints, though often it is near enough to

80
Spearing Fish, Samoa, c. 1892
Watercolor on paper
33⅜ × 29⅜ in. (84.8 × 74.6 cm.)
Addison Gallery of American Art,
Phillips Academy, Andover, Massachusetts
W1892.15

81
Charles Spitz
Spearing Fish, Samoa, c. 1885–90
Photograph
Current location unknown

surprise me by its faithfulness; but whether exact or not, it always suggests the emotion of the moment."[57] From this and other observations indicating that La Farge at times reworked watercolors at night by candlelight, it is clear that the artist needed to paint or draw from the motif only in order to capture its outlines and essential features and that he would then finish or rework sketches at his leisure. And, as in the Japanese works, many highly finished watercolors were painted both in the South Seas and after La Farge's return to New York, using various pictorial sources including annotated drawings, watercolor sketches, photographs, and books (plates 80, 81). As a result, some works that may appear to have been painted on the spot were actually produced after the fact.[58]

Like the Japanese trip, the South Sea sojourn eventually led to the production of ambitious oil paintings, the largest and most didactic being *After-Glow, Tautira River,*

Tahiti (plate 79), executed about five years after the trip and based on studies from nature, photographs, and intermediate works (frontispiece).[59] Technically, the picture is unique: its striations of shiny, vivid color seem to mimic stained glass, a fitting source for La Farge to call on in depicting the phosphorescent water segmented into jagged sections by the abrupt lines of reflected mountains. Thematically, the picture makes the most conclusive statement of La Farge's idealization of the South Sea existence—it is a virtual paean to color and light. La Farge's fascination with the family gathering sustenance from the river also pointed, by implication, to the aridity of modern Western culture, where such a harmonious relationship with nature had long since vanished.

A similar note regretting the loss of South Sea perfection was struck in three travel articles by La Farge published in 1901. These narratives not only described his discovery of a new Golden Age, but they also voiced his fear that South Sea civilization would not survive the onslaught of modernization. Seemingly motivated by this somber thought, La Farge illustrated his chronicles with especially idyllic images of native life, many of which he created around the turn of the century while preparing the articles for publication. The most idealized, *Fayaway* (plate 84), dating from a few years before this, offers a particularly pointed lesson. The picture drew its title from an episode in Herman Melville's romantic novel of life in the Marquesas Islands, *Typee* (1846): "In a moment, the tappa was distended by the breeze—the long brown tresses of Fayaway streaming in the air—and the canoe shot towards the shore . . . a prettier little mast than Fayaway was never shipped aboard any craft."[60]

82
Siva Dance at Night,
1890
(A Samoan Dance)
Watercolor on paper
7¾ × 12 in. (19.7 × 30.5 cm.)
Isabella Stewart Gardner Museum, Boston
W1890.89

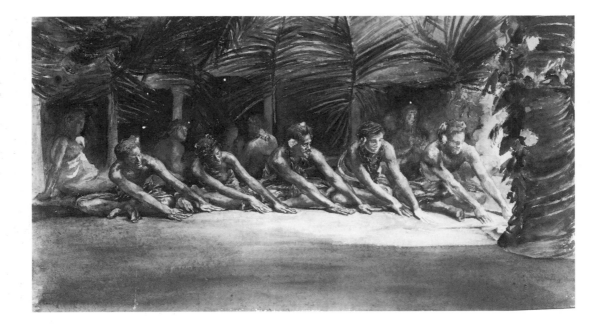

La Farge had observed similar instances of this ingenious method of waterbound propulsion in Samoa, but the picture was intended more as a demonstration of the innocence and beauty of Samoan life than as a factual record of an event. For La Farge, Fayaway also must have represented a final celebration of the nude in an "open-air studio," and he harbored a suspicion that her innocent beauty would not survive: "Shall I find Typee, shall I find it invaded by others? . . . I must return some day. But before that day I wish to have seen a Fayaway sail her boat in some other Typee."[61]

Around the same time that La Farge was preparing his articles, he also created an allegory of Autumn for rendering into stained glass that adapted Fayaway's pose and rhythms (plate 85).[62] The delicate balance between art and nature—or between allegory and nature—in this conception reveals once again the increasingly fine distinction between reality and ideality that characterized La Farge's art until the end of his career.

La Farge invested tremendous energy in a large traveling exhibition of the Japanese and South Sea pictures that he assembled in 1894 for showing the next year in both New York and Paris.[63] Entitled *Records of Travel*, the didactic show was accompanied by an elaborate catalog that used fragments of journals and letters to elucidate the pictures. Because many of the best South Sea paintings had been sold to private collectors or given to friends after La Farge's return from his trip, he found it necessary to borrow back pictures or—when owners were reluctant to lend—to make copies. The latter practice has created difficulties for scholars, since the copies are generally so exact that at times it is impossible to distinguish them from the originals (plates 82, 83).[64]

83
Siva Dance at Night, c. 1894
(Seated Siva Dance at Night)
Watercolor on paper
13½ × 22 in. (34.3 × 55.9 cm.)
The Carnegie Museum of Art, Pittsburgh
Museum purchase, 1917
W1894.10

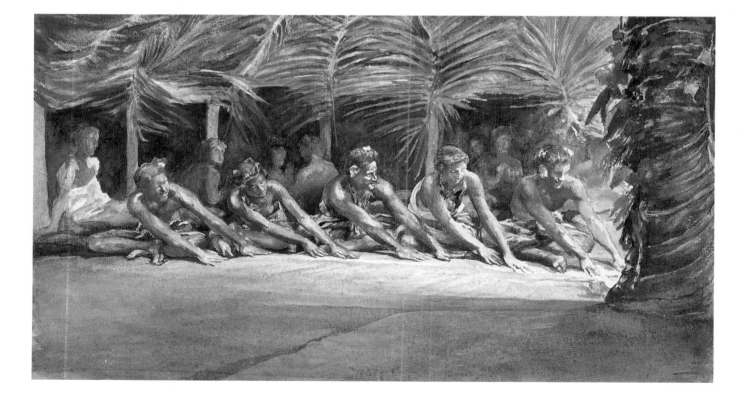

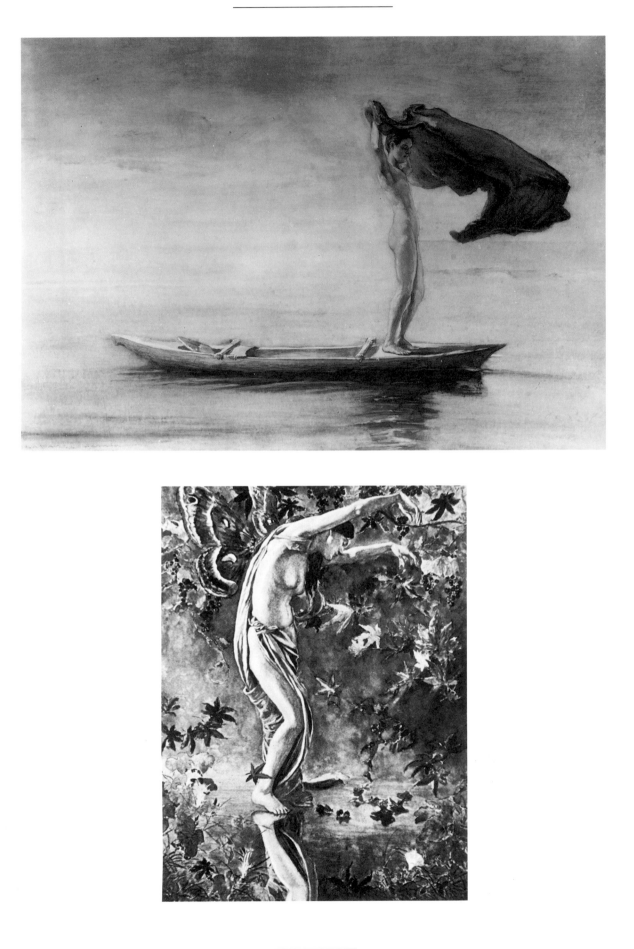

La Farge's most ambitious project resulting from his South Sea experience was a comprehensive illustrated travel book, a project derailed by the financial misfortunes that plagued the artist during the last decade of his life. He was still in the midst of negotiating for its publication, just six months before his death in November 1910, when the manuscript—along with several others and many works of art—was appropriated by his personal secretary, Grace Edith Barnes, as reimbursement for debts owed for her services.[65] Hence, La Farge's *Reminiscences of the South Seas,* published under Barnes's direction two years after his death, was at best a partial realization of this most ambitious of the artist's enterprises—and marked as well an ironic triumph of Western commercialism and the realities of twentieth-century life over La Farge's South Sea ideals.

After his death, even though La Farge was apotheosized as America's "sole 'Old Master,'" his reputation was quickly submerged beneath the impending tide of modernism. His "pictures of Nature," with their many links to the traditions of great art, held only sporadic interest for the generations that followed. Even today, the complexity of his wide-ranging production, which never focused on a single genre or style, imposes a formidable obstacle to understanding his art. But what is increasingly appreciated is the intensity of La Farge's ardent quest for truth in nature and in art, a pursuit that was aptly summed up in the concluding pages of Royal Cortissoz's biography:

> There was probably no subject of interest to man which was not of interest to him. He drank of civilization as one drinks from a bubbling spring. He knew it in those aspects which belong to antiquity, through all the long story which stretches down from Greece and Rome and the immemorial East to our own day of industrialism and politics. . . . Out of [his intellect] poured his paintings and his other works, for he was ever the artist, the maker, the man who must put his ideas into a tangible form . . . [66]

84
Fayaway, c. 1895
Watercolor on paper
14¼ × 22 in. (36.2 × 55.9 cm.)
Corcoran Gallery of Art, Washington, D.C.
W1895.2

85
Autumn Scattering Leaves, 1900
Watercolor on paper
18¼ × 13¼ in. (46.3 × 33.7 cm.)
Private collection
W1900.4

NOTES

This essay is derived from my doctoral dissertation, "The Role of Landscape in the Art of John La Farge" (University of Chicago, 1981). I wish to acknowledge the late Henry A. La Farge for providing access to his unpublished catalogue raisonné of John La Farge's work both during the writing of this dissertation and while I assisted him in preparing the catalogue raisonné for publication by Yale University Press. I also wish to thank his widow, Mary A. La Farge, who has helped continue work on this project.

1. John La Farge, in *Catalogue. The Paintings of Mr. John La Farge to Be Sold at Auction* (Boston: Peirce and Company, 1878), 2.

2. Royal Cortissoz, *John La Farge: A Memoir and a Study* (Boston and New York: Houghton Mifflin Co., 1911), 261. See also "John La Farge, Our Only 'Old Master,'" *Current Literature* 50 (January 1911): 93–96.

3. John La Farge, *The Higher Life in Art* (New York: McClure Co., 1908), 59–60.

4. La Farge, in Cecilia Waern, *John La Farge, Artist and Writer* (London: Seeley and Co.; New York: Macmillan and Co., 1896), 11–12.

5. La Farge, in Cortissoz, *La Farge: A Memoir*, 113.

6. La Farge, in Waern, *La Farge*, 12.

7. Ibid.

8. John La Farge, "Notes, Memoranda, and Other Material by and about John La Farge: Recorded to Aid Royal Cortissoz in Writing His Biography," Royal Cortissoz Papers, n.d., Beinecke Rare Book and Manuscript Library, Yale University, item 103 (cited hereafter as "Notes"; my "item" references are to the enumeration assigned to this material by the Beinecke).

9. La Farge, "Notes," item 106. La Farge made this comment specifically in reference to his works of the 1865–70 period, although it applies equally well to all the small works of the 1860s.

10. The still life is probably a copy after or variation on a Dutch or French seventeenth-century picture; see Kathleen A. Foster, "The Still-Life Painting of John La Farge," *American Art Journal* 11 (Summer 1979): 4–37, 83–84, which relates this to mainstream American still-life painting of the period. The landscape, which can be readily authenticated, represents a view of the Bayou Teche in Louisiana, a site that La Farge had visited and sketched in 1860. La Farge never explained why he produced this Claude-like composition painted in the then-popular Hudson River style; it is his only one adopting this manner.

11. See, for example, Cortissoz, *La Farge: A Memoir*, 128: "Also it was as emphatically modern as anything painted in the last quarter of the century." It should be noted that when Cortissoz adapted La Farge's notes on these pictures in *La Farge: A Memoir*, 129–31, he confused the pictures and altered many fine points of emphasis from La Farge's original description.

12. La Farge, "Notes," 113–14.

13. Ibid., item 114.

14. Ibid.

15. Ibid., item 106.

16. The artist termed this a "sunset study" when the picture was first exhibited at the Yale School of Fine Arts Annual Exhibition of 1871 (cat. no. 86) and at the Peirce and Company auction, 1878 (cat. no. 18).

17. Waern, *La Farge*, 27. The only other large landscape of this period, *Autumn Study. View over Hanging Rock, Newport, R.I.* (plate 49), has a sketchy and unfinished appearance that suggests La Farge stopped work on the picture after an initial underpainting similar to the one he described for *The Last Valley—Paradise Rocks* (plate 58). Unfortunately, La Farge never discussed the execution of *Autumn Study*, although his executrix noted after his death that "it was not one that Mr. La Farge thought well of. . . ." Grace Edith Barnes to William Macbeth, March 8, 1913, reel 2605, frame 1298, Archives of American Art, Smithsonian Institution.

18. La Farge's nascent interest in "idealistic" subjects is contrasted to his early realistic tendencies in H. Barbara Weinberg, *The Decorative Work of John La Farge* (1972; New York: Garland Publishing, 1977), 37–40.

19. The figure in the portrait was, in fact, based on an artfully posed photograph (page 238), as were other early portraits, as long noted by Henry La Farge based on family traditions and archives. See James L. Yarnall, "John La Farge's *Portrait of the Painter* and the Use of Photography in His Art," *American Art Journal* 18 (Winter 1986): 5–20. On the artfulness of this presentation, see also Weinberg, *Decorative Work*, 50.

20. La Farge subtitled this picture *A Study of Sunlight* in the catalog for his 1884 auction at Ortgies and Co. in New York (cat. no. 24). Courbet was well known in Boston beginning in 1866, when the Allston Club, to which La Farge belonged, purchased Courbet's *The Quarry*, now in the Museum of Fine Arts, Boston. See Jean Gordon, "The Fine Arts in Boston, 1815–1879" (Ph.D. diss., University of Wisconsin, 1965), 253–55, and Weinberg, *Decorative Work*, 50–51.

21. The *Centaur* was based on several drawings, including one dated "1864" by the artist that depicts the torso. This sketch was apparently done in Rimmer's studio, either from the same model as Rimmer was using while sculpting an early version of the *Dying Centaur* or else from the statue itself. The finished easel painting was noted as being for sale in an 1864 sketchbook now in the Yale University Art Gallery (1984.39.17).

22. See Henry Adams, "John La Farge's Discovery of Japanese Art: A New Perspective on the Origins of *Japonisme*," *Art Bulletin* 67 (September 1985): 449–85.

23. John La Farge to Samuel Bing, [c. 1894], La Farge Family Papers, Department of Manuscripts and Archives, Sterling Memorial Library, Yale University.

24. La Farge, in Cortissoz, *La Farge: A Memoir*, 135–36.

25. The later water lily, based on a drawing in an 1872 sketchbook, was La Farge's presentation piece for entrance into the Lotos Club, New York, that same year, suggesting that deliberate allusions to the cult of the lotos were responsible for its particular evocativeness.

26. In 1875 La Farge reused the composition of *The Spirit of the Water Lily* without the lily fairy for the frontispiece to a book of poetry published by the Lotos Club entitled *Lotos Leaves*, again suggesting that the cult of the lotos was involved with these renderings.

27. Cortissoz, *La Farge: A Memoir*, 144.

28. Weinberg, *Decorative Work*, 37–41.

29. *The Muse of Painting* was termed a "Decorative Panel" in the catalog for the auction at Ortgies in 1884 (cat. no. 18). The picture does, in fact, contain an identifiable view of the easternmost ridge of the Last Valley, and La Farge had set up a hut to house the canvas so that he could paint directly from nature, albeit a nature that he arranged by placing vines on a trellis. See Charles de Kay, "A Notable Gift to the Metropolitan Museum of Art: La Farge's 'Muse of Painting,'" *Harper's Weekly* 54 (March 12, 1910): 7. Virgil was termed a "Decorative Panel" in the catalog for the auction at Leonard's Gallery, Boston, in 1879 (cat. no. 39).

30. *The Three Wise Men* was dated "1878" when exhibited that year at the Peirce and Company auction (cat. no. 22), but was withdrawn from the sale at the last minute. It was mentioned as having just been completed nine months later in "Studio Notes," *Art Interchange* 3 (September 17, 1879): 47.

31. La Farge, *Higher Life in Art*, 59. This quote was cited by Cortissoz, *La Farge: A Memoir*, 149, where Cortissoz noted: "The principle was as to the breath of life to his own [La Farge's] work."

32. Confusion over the dating of *The Golden Age*, formerly believed to be a product of 1870 based on the partially illegible inscribed date, has been resolved through documentary evidence that the picture was executed around 1878. This is based on two primary sources: a comment in "Studio Notes," *Art Interchange* 3 (September 17, 1879): 47, that this work was reaching completion; and a photograph of the painting that originally came from La Farge's studio (now in the Yale University Art Gallery), inscribed by the artist's son with the date 1878.

33. The date of execution of *The Visit of Nicodemus to Christ* cannot be precisely determined due to lack of primary documentation. The picture was apparently not completed in time for inclusion in the Leonard's Gallery

auction of 1879, but was probably begun before La Farge's temporary cessation of painting in 1880. In 1885 this same composition served as the basis for the John Cotton Smith Memorial Window in the Church of the Ascension, New York.

34. La Farge to Samuel Bing, [c. 1894], La Farge Family Papers, Yale University, 14. La Farge first stated his intention to "devote himself entirely to decoration" in the preface to the catalog for the Leonard's Gallery auction.

35. La Farge did have at least two other quasiproductive bouts of painting during the first half of the 1880s. In 1883 he painted roughly thirty watercolors of still lifes and landscapes to sell at the Ortgies auction of his works the next year. In late 1884 or early 1885 he painted an equal number of watercolors, many of them variations on his early illustrations for the *Riverside Magazine*—and some painted on photographs of woodblocks taken before cutting—in preparation for the 1885 Moore's auction of his works. See Yarnall, "La Farge's *Portrait of the Painter*," 13–15, and Foster, "Still-Life Painting of John La Farge," 28–32.

36. John La Farge, *An Artist's Letters from Japan* (New York: Century Co., 1897), 1.

37. La Farge noted ibid., 25: "My dreams of making an analysis and memoranda of these architectural treasures of Japan were started, as many resolutions of my work are, by the talk of my companion [Henry Adams]. . . ." See also John La Farge to Henry Adams, February 16, 1887, La Farge Family Papers, Yale University. Other correspondence with Adams of this period in the La Farge Family Papers documents La Farge's involvement first with an article on Japan, "An Artist's Letters from Japan," *Century Magazine* 11 (August 1890): 566–74, and later with his far more detailed book, *An Artist's Letters from Japan*. See also Linnea H. Wren, "The Animated Prism: A Study of John La Farge as Author, Critic and Aesthetician" (Ph.D. diss., University of Minnesota, 1978), 135–39.

38. In addition to his articles and book on Japan, La Farge produced a series of lectures in 1897 on Japanese folklore and mythology that was related to a number of "Fantasies on Oriental Themes" he was producing at that time. The lectures are preserved in a typescript in the Henry La Farge Papers, New Canaan, Connecticut.

39. In the several sales of La Farge's private library, numerous travel books on Japan were recorded. His correspondence with Henry Adams in the La Farge Family Papers, Yale University, also documents the exchange of books on Japan.

40. Grace Edith Barnes to William Van Horne, November 4, [1907], Jacacci Papers, Archives of American Art, Smithsonian Institution. Other letters regarding the finishing of watercolors and the use of photographs for creating pictures are found in the La Farge-Adams correspondence for 1887, La Farge Family Papers, Yale University.

41. One of several highly finished wash drawings used to illustrate the artist's articles on Japan is inscribed on verso with the date "88" and on the mount with the note: "Jap. series," confirming the date of execution of all of these works.

42. La Farge's annual exhibitions at the gallery of Doll and Richards, his Boston dealers, frequently included these subtitles in catalogs beginning in 1898, the year after La Farge began exhibiting this particular strain of Japanese-

derived work at the New York Water Color Club.

43. La Farge, in Cortissoz, *La Farge: A Memoir*, 166. See also Van Wyck Brooks, *Fenollosa and His Circle* (New York: E. P. Dutton and Co., 1962), 41–48.

44. There are two large oil versions, the earliest being that presently in Mac Beth Gallery, New York, which was apparently begun shortly after La Farge's return from Japan. This was probably finished by 1895, when it was described by Cecilia Waern, "Some Notes on the Art of John La Farge," *Atlantic Monthly* 75 (May 1895): 693. The second oil version, today in the Butler Institute of American Art, Youngstown, Ohio, was once inscribed "La Farge/invenit 1887/1908," according to a photograph in the Peter A. Juley and Son Archives, National Museum of American Art, Smithsonian Institution (plate 74). This inscription is no longer legible. Both versions seem to have been inspired by a rendering of the Kwannon by Maruyama Okyo (1733–1795), reproduced in La Farge, *Letters from Japan*, 96.

45. La Farge, in Cortissoz, *La Farge: A Memoir*, 175, 180.

46. The concept of "translation" in this picture was explored by Waern, "Some Notes," 693, and Paul Bourget, *Outre Mer: Impressions of America* (New York: Charles Scribner's Sons, 1895), 369.

47. La Farge, *Letters from Japan*, 160.

48. The concepts of "archaism" and "primitivism" are discussed by Robert Goldwater, *Primitivism in Modern Art* (New York: Vintage Books, 1938).

49. La Farge noted this in the second of three articles on the South Seas published in 1901: John La Farge, "Passages from a Diary in the Pacific: A First Day in the South Seas," *Scribner's Magazine* 29 (June 1901): 670–84. This particular quote appears on 684. See also Wren, "Animated Prism," 148–49.

50. This passage was among the portions of La Farge's South Sea writings not published in his articles. It later appeared in his *Reminiscences of the South Seas* (Garden City, N.Y.: Doubleday, Page and Co., 1912), 272.

51. These references are scattered throughout La Farge's writings, including: *Paintings, Studies, Sketches and Drawings, Mostly Records of Travel 1886 and 1890–91 by John La Farge* (New York: Durand-Ruel Galleries, 1895), cat. nos. 27, 33, 94, and 98; Waern, *La Farge*, 97; and La Farge, "A First Day," 683.

52. La Farge, *Reminiscences*, 111. La Farge's most explicit references to specific Greek gods and figures appeared in "A First Day," 670–84.

53. La Farge, in *Records of Travel*, cat. nos. 27, 33, 94.

54. La Farge, *Reminiscences*, 119.

55. La Farge, in *Records of Travel*, cat. no. 33. See also cat. no. 97: "The paper on which I have worked, is not watercolor paper, so that corrections are extremely difficult, if not impossible; nor are washes successful, and the color rubs up, but the temptation to use anything in which drawing counts a great deal has led me away. It would also need an under-preparation, very neutral, impossible of course in a study that gives the movement."

56. King had encountered "old-gold girls" in Hawaii during the 1870s, but by 1890 La Farge and Adams found that corruption of racial purity in Hawaii had all but eliminated King's "old-gold." See discussion of King's reactions to La Farge's paintings in Evelyn de Chazeaux, trans. and intro., *Lettres des Mers du Sud*, Publication de la Société des Océanistes, no. 34 (Paris, 1974), xvii; and a letter from Henry Adams to Clarence King, March 3, 1891, cited by de Chazeaux, 291–302, in which Adams concurs with King's disappointment.

57. Henry Adams to Elizabeth Cameron, February 6, 1891, in Worthington Chauncey Ford, *Letters of Henry Adams, 1858–1891* (Boston: Houghton Mifflin Company, 1930), 407.

58. As in the case of the Japanese sketches, this process of finishing South Sea works and creating "new" ones is documented in various letters between La Farge and Adams, as well as between La Farge and other individuals. See, for example, John La Farge to Arthur Stedman, March 9, 1892, Gratz Manuscripts, Archives of American Art, Smithsonian Institution. The case of *Spearing Fish, Samoa* (plate 80) is discussed in detail in Yarnall, "La Farge's *Portrait of the Painter*," 18–19.

59. The process has been documented convincingly by E. John Bullard, "John La Farge at Tautira, Tahiti" in *Report and Studies in the History of Art*, vol. 2 (Washington, D.C.: National Gallery of Art, 1968), 146–54. Bullard proposes that this picture was painted in 1891, but it is more likely that it was executed around 1895 for use in La Farge's exhibitions of South Sea pictures. The work was listed as "unfinished" by La Farge's secretary, Grace Edith Barnes, in the catalog for the La Farge Estate Sale, American Art Association, New York, 1911, lot 599. But La Farge himself seems to have considered it finished, since he tried to sell it to William Macbeth in an undated letter [1908] in the Macbeth Papers, Archives of American Art, Smithsonian Institution.

60. Herman Melville, *Typee* (1846; New York: Dodd, Mead and Co., 1951), 144.

61. La Farge, "Passages from a Diary in the Pacific: Hawaii," *Scribner's Magazine* 29 (May 1901): 546.

62. There are numerous watercolor and pencil drawings for this window, commissioned by William C. Whitney and currently in the French Cultural Embassy at 950 Fifth Avenue, New York City. The window has been concealed behind a bookcase in recent decades but will soon be restored.

63. The exhibition was prompted by an invitation to La Farge from the French Government to display his work in a special pavilion at the Paris Salon of 1895; the offer was tendered at the urging of the dealer Durand-Ruel, who had shown some of La Farge's sketches of Japan and the South Seas in Paris in 1891. The exhibition appeared in both New York and Paris in 1895, in Cleveland in 1896, and in Chicago in 1897. At each of the two later stops, the exhibition changed slightly as pictures were sold and others were added to replace them. Fragments of this show continued to appear in Boston, New York, and elsewhere until the end of the artist's life.

64. The history of the two versions of *Siva Dance at Night* serves as a useful example of the problems encountered by the artist in obtaining pictures for his exhibition. Isabella Stewart Gardner purchased the original version in 1892; correspondence dating from 1894 in the Gardner Museum Archives indicates that La Farge implored her to lend the picture for the Paris exhibition in 1895, or, at very least, to let him copy it. The Carnegie version is the obvious result of these negotiations. In 1895 La Farge apparently also began an oil of approximately 6 by 8 feet of this same subject that was never finished, as Grace Edith Barnes

described in a letter to Robert Vose, January 15, 1912, Vose Gallery Papers, Vose Gallery, Boston. This latter picture was subsequently destroyed by fire.

65. John La Farge to William Macbeth, April 15, 1910, Macbeth Papers, Archives of American Art, Smithsonian Institution. See also a letter, John La Farge to Bancel La Farge, January 13, 1910, La Farge Family Papers, Yale University: "Beside my drawings she has also grabbed my journals of travel." In a letter from John La Farge to Mary Cadwalader Jones, July 11, 1900, La Farge Family Papers, Yale University, the artist indicates that there were proposals at this time to publish his journals, which came to nought. See also Wren, "Animated Prism," 151–52.

66. Cortissoz, *La Farge: A Memoir*, 262–63.

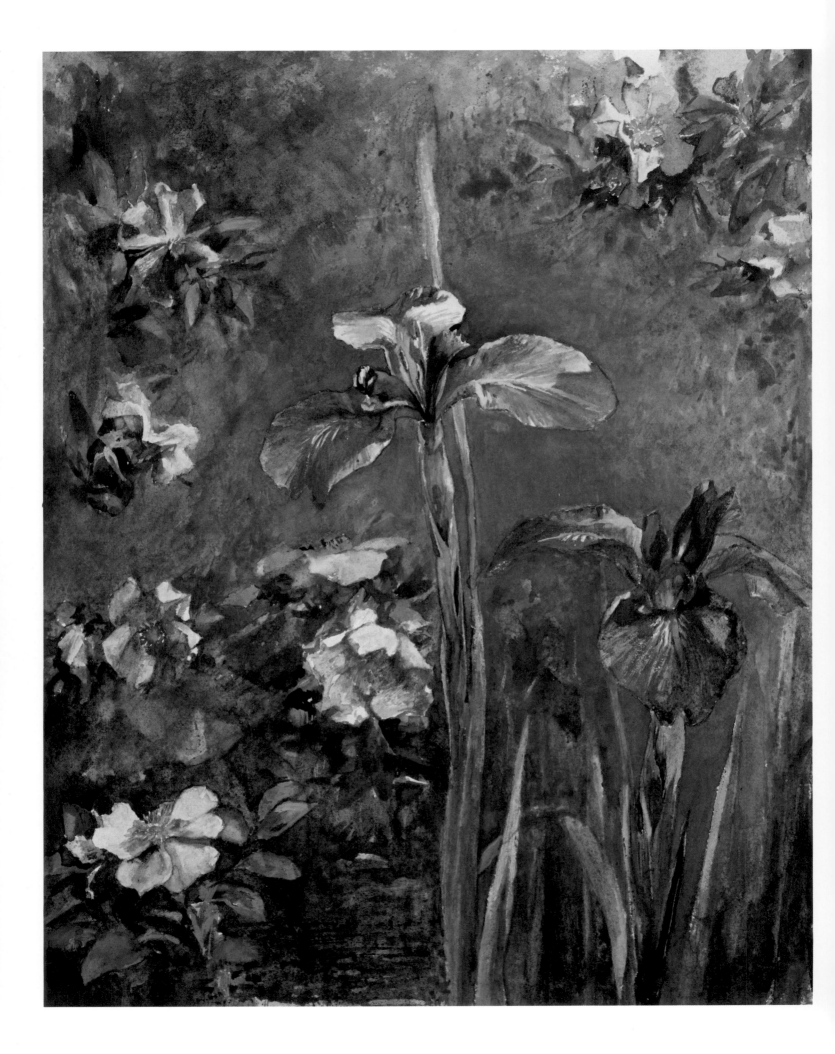

John La Farge and the American Watercolor Movement: Art for the "Decorative Age"

Kathleen A. Foster

86
Wild Roses and Irises, 1887
Watercolor on paper
12⅝ × 10⅛ in. (32.1 × 25.7 cm.)
The Metropolitan Museum of Art, New York
Gift of Priscilla A. B. Henderson, 1950, in memory of her grandfather, Russell Sturgis
W1887.13

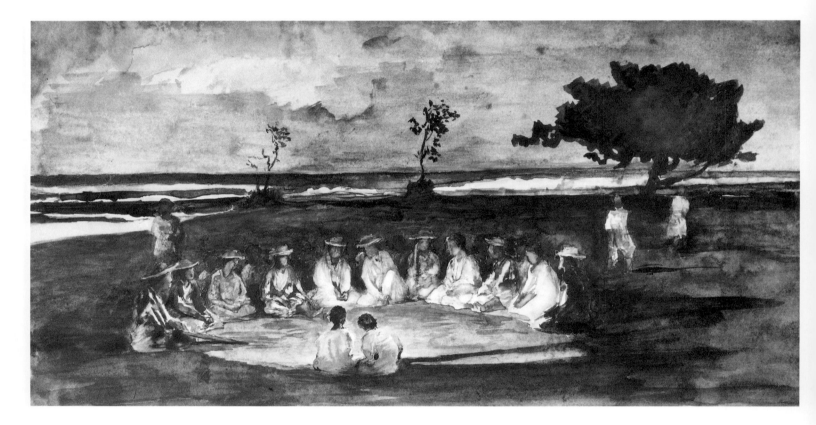

87
Himene at Papara in Front of Tati Salmon's, The Chief's House. Feb. 26th, 1891, 1891
Watercolor on paper
6¼ × 12¾ in. (15.9 × 32.4 cm.)
Private collection
W1891.26

The first medium of his youth and the favored medium of his old age, watercolor gave John La Farge some of the greatest popular successes of his maturity, in illustration and exhibition work, and helped him realize his finest achievements in stained glass and mural painting. The complexity as well as the unity of his entire career can be explored and comprehended through his watercolors, for La Farge employed no other medium with such frequency or diversity. The study of such a wide-ranging production allows appreciation of the unique aspects of La Farge's talent along with recognition of the qualities that he shared with many of his contemporaries. His accomplishment in this medium reflects upon the larger popularity of watercolor in America at this time, revealing La Farge's leadership and his eccentricity, his supremely representative yet extraordinary oeuvre.

The eccentric components of La Farge's personality were remarked early and have been celebrated often. "Among all American painters, Mr. La Farge has occupied a place apart," noted the *Art Journal*'s review of the American Water Color Society show in 1879, adding that he was "in some respects higher perhaps than anyone else."[1] The reviewer's sense of separate and higher no doubt responded to qualities in La Farge's background and temperament that colored his work as well as his demeanor. Roman Catholicism, a college degree, and patrician manners all lent an exotic air to his person; like Edgar Degas in relation to Camille Pissarro and Claude Monet, La Farge greeted his colleagues across a chasm created by differences in class, culture, and personality.[2]

Occupying a place apart in such respects, La Farge was drawn into the midst of his contemporaries by his taste for watercolor. Attracted to the medium because of its simplicity, delicacy, and a calligraphic charm he associated with Oriental art, La Farge appreciated the suggestive potential of watercolor and valued its difficulty. He remarked that oil painters had taken advantage of the popular belief in the superior representational possibilities of oil, "yet the painter of water-color exercises far more skill, must be far more resourceful, and, in the end, with his simple means, often suggests more than the oil painter is able to represent."[3] Such sentiments echoed the opinions of the founders of the American Society of Painters in Water Colors, who pressed this message into the consciousness of the American art community in the decade following the society's formation in 1866 (the name of the group was changed to the American Water Color Society in 1877). By the time the popular enthusiasm for watercolor peaked in 1882, scarcely an artist in New York chose to remain outside the society's annual exhibition, and similar clubs and watercolor shows had appeared across the United States. In this year La Farge himself (who had been elected to the society in 1868) was nominated president of the club, heading a slate of compromise candidates offered by peacemakers seeking to reunite a group splintered by the pressures of the sudden vogue for watercolors.

Respect for the elevated qualities in his work and the measure of aloofness in his manner brought La Farge into the center of this institutional turmoil.[4]

La Farge was a logical leader for the society on the basis of his work alone, for by 1882 his watercolors illustrated many qualities germane to the society's success in the previous decade. The sources of La Farge's style and technique as well as the motivation behind his choice of subject and medium were shared with many American watercolorists around 1882. Like George Inness and Thomas Moran, La Farge had learned much from the Barbizon landscape painters and J.M.W. Turner; like William Trost Richards, he had been a dedicated follower of John Ruskin in the 1850s; like Edwin A. Abbey, he shifted his allegiance from the early Pre-Raphaelites to the more decorative style of Dante Gabriel Rossetti and Edward Burne-Jones; like Winslow Homer, he was a plein-airist, a self-made Impressionist; like Abbey, he was an arts-club activist, the founder and later president of the Society of American Artists and the Society of Mural Painters, sponsor of the Society of Decorative Arts, and organizer of the Metropolitan Museum of Art. Like all of these painters (except Inness) La Farge was an illustrator; in advance of them all, he was a decorator.

Despite these traits shared with other American watercolorists of the period, La Farge was among the last to join the movement per se. His extensive activity in the medium did not begin until about 1878, when many artists returning from Europe (including his younger friends in the Society of American Artists) were also discovering the liberality of the Water Color Society's exhibitions. La Farge shared certain values with these artists,

88
Water-Fall of Urami-No-Taki, c. 1886
Watercolor on paper
10½ × 15½ in. (26.7 × 39.4 cm.)
Addison Gallery of American Art,
Phillips Academy, Andover, Massachusetts
Gift of Mr. and Mrs. Stuart P. Feld
W1886.24

89
At Naiserelangi, from Ratu Jonii Mandraiwiwi's "Yavu." July 14, 1891, 1891
Watercolor on paper
10¼ × 8¼ in. (26 × 20 cm.)
The Huntington Galleries, Huntington, West Virginia
W1891.113

such as a preference for sketches and plein-air work, not to mention a desire for more tolerant juries. But unlike these other painters, La Farge grew enthusiastic about watercolor at just the moment his activity in decorative design escalated, following the success of his work on Trinity Church, Boston, in late 1877. The simultaneous development of these two interests, both linked to the rising interest in decorative arts after the Centennial, set La Farge apart from most of his contemporaries and prepared him for a commitment to watercolor far more radical than that of even the early arrivals to the watercolor movement.

As with Louis C. Tiffany and Samuel Colman, the two other leaders of the American renaissance in the decorative arts, La Farge's increasing involvement with decoration was matched by waning interest in conventional oil painting. Watercolor exhibition pieces, watercolor travel sketches from Japan and the South Pacific (plates 88, 89, 91), and watercolor decorative designs compose the three major parts of La Farge's oeuvre in painting after 1878. The watercolors in the first two categories, while full of novel effects and observations, were consistent with traditional practice in watercolor and conventional participation in watercolor exhibitions. The third group, including all his decorative work (for stained glass, textiles, and murals), inaugurated a category that represented a major new source of energy for the American watercolor movement. These designs, which were often working sketches that later served as exhibition pieces, show La Farge at his most inventive and influential. Such work stood at the head of a large contingent of similar watercolors produced by many artists in this period, including Tiffany and Colman: designs for murals, textiles, fans, wallpaper, embroidery, and actual paintings on ceramics and furniture that burgeoned in the exhibitions, workshops, and homes of America after the Centennial.

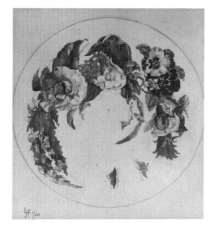

90
Study of Flowers for Embroidery, 1860
Watercolor on graph paper
9¾ × 8⅞ in. (24.8 × 22.5 cm.)
Private collection
W1860.3

"This is a decorative age," said one New York artist to his friends in the autumn of 1877. "We should do something decorative, if we would not be behind the times." Conquering the disdain of a listener who suspected "a temporary craze, a phase of popular insanity," the group's "advocate of modern principles" argued that professional artists should welcome the growth of popular interest in art and guide, by example, the work of well-intentioned amateurs. Seeking to provide a useful model in an appropriately decorative medium, the friends considered fresco, textile design, and wallpaper before falling upon a historic idea: "Let us all do tiles!" The Tile Club was born.[5]

The Tile Club's membership found watercolor techniques at the base of their new project, and their discovery reminds us that watercolor was the architect's and decorator's medium, the technique taught at the numerous new schools of industrial design, and the medium practiced by countless female amateurs who aspired to artistic homes and perhaps professional status as painters. Led by La Farge, Colman, and Tiffany, all these watercolorists contributed to the swelling exhibitions at the Water Color Society and the new Society of Decorative Arts, and their interest provoked a flood of books and articles on needlework, pottery, Oriental bric-a-brac, "aesthetic" interior decoration, and flower painting in watercolors. By 1879 *Scribner's Monthly* claimed that "the multitudes are now 'decorating' porcelain, learning the 'Kensington stitch' in embroidery, painting on satin, illuminating panels, designing and putting together curtains, making lace, drawing from the antique, sketching, daubing, etc."[6] If the "multitudes" could be united by one medium, it was watercolor. Better than any elected member of the Tile Club, La Farge, the connoisseur of Oriental art, the illustrator, the still-life painter, the designer, became a model "advocate of modern principles" for this phalanx of watercolorists with similar interests.

La Farge had begun preparing for this role in the late 1850s, for watercolor and decorative design were united in some of the earliest pieces from his professional career. In 1859 and 1860 he made several miniaturistic floral embroidery patterns for his fiancée, Margaret Perry (plate 90). His correspondence with her showed concerns that occupied La Farge for decades, such as the degree of naturalism and abstraction suited to ornamental work, the difficulty of finding materials that matched the delicacy of his intentions, and his willingness to adapt his patterns to any surface—"from slippers to a tapestry for a hall."[7]

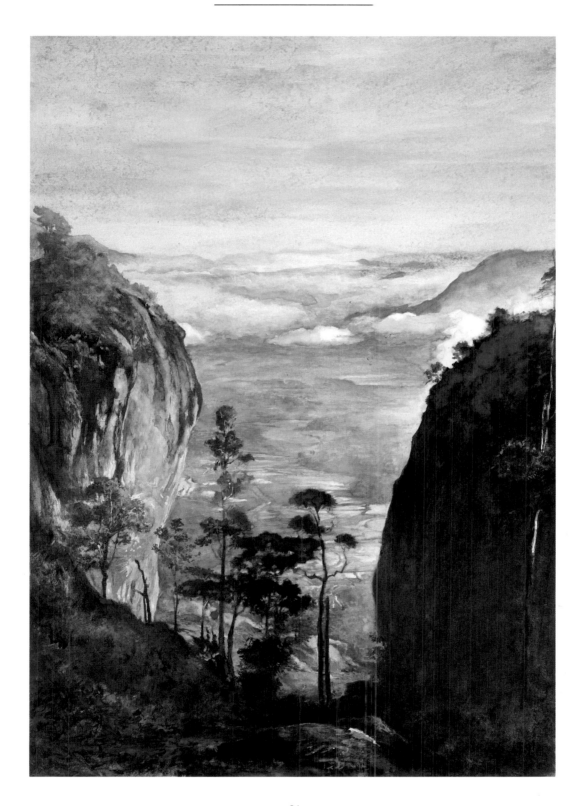

91
View near Dambula, Looking over Rice Fields, 1891
Watercolor on paper
17 × 13½ in. (43 × 34.5 cm.)
Museum of Fine Arts, Boston
William Sturgis Bigelow Collection
W1891.124

Even at this early date, La Farge turned naturally to watercolor, for he had learned the technique as a child. His maternal grandfather, who was a miniature painter acquainted with architectural drafting, gave La Farge drawing instruction when he was very young, and later, as a grammar school student, he studied briefly with "an English water color painter, who gave me thoroughly English lessons."[8] La Farge used the medium to sketch and copy old master paintings on his first trip to Europe in 1856–57, showing an amateur competence far in advance of his first experiments in oil.[9] In this respect, La Farge joined other major figures of the watercolor movement, such as Abbey, Thomas Eakins, Homer, Moran, and Richards, who had handled wash or watercolor as school-children or young professional illustrators, long before using oils.

Despite his early familiarity with the medium, La Farge, like most American painters, initially felt that watercolor was not a major medium for artistic expression. After declaring himself an artist, he moved to Newport in 1859 to study with William Morris Hunt and took up oils. When his small, intensely labored landscapes and still lifes grew too wearying, La Farge would slip back into watercolor for reassurance, although even in this medium none of his efforts before 1870 were entirely relaxed. Of the handful of watercolors extant from this period, many are studies analogous to or in preparation for

92
Perseus and Andromeda, 1868
Watercolor
9¼ × 7¼ in. (23.5 × 18.4 cm.)
Current location unknown
W1868.2

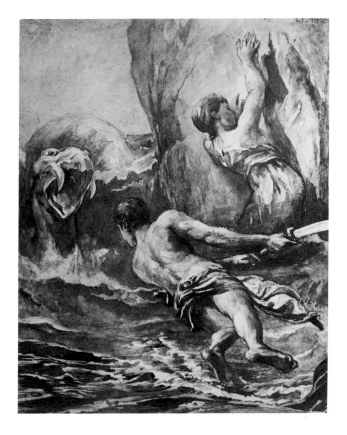

his oils, particularly snowy landscapes and sky studies. Influenced by the Barbizon and Pre-Raphaelite painters, these early watercolors share the concerns of all La Farge's outdoor work in the 1860s.[10] The rare extant figural watercolors from this decade tend to be more elaborate; a few, like *Perseus and Andromeda* (plate 92), relate to his illustrations. Others, such as *Leander, Study of Man Swimming. Twilight* (plate 93), seem to be independent inventions, often based on literary sources. Brightly colored and with fluidly painted backgrounds, these watercolors display La Farge's "thoroughly English" technique (transparent washes, with occasional mixtures of chinese white applied to dry white watercolor paper), while exhibiting neither conventional mannerisms nor sophistication. The classical themes and challenging problems of motion and foreshortening in these figural subjects show La Farge's youthful engagement with the grand European tradition, while they betray his tense and awkward moments as a draftsman.[11] Ambitious and imaginative, La Farge found himself isolated in Newport, with only the most desultory art-school experience; he could develop his watercolor technique (and his figure drawing, and his landscape studies) only through personal experimentation and practice.

The literary imagination revealed in La Farge's early figural watercolors flowered in

93
Leander, Study of Man Swimming. Twilight, 1866
(Swimmer)
Watercolor on paper
12¾ × 11⅛ in. (32.5 × 23.2 cm.)
Yale University Art Gallery,
New Haven, Connecticut
W1866.1

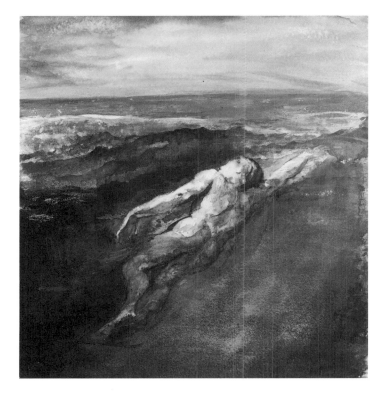

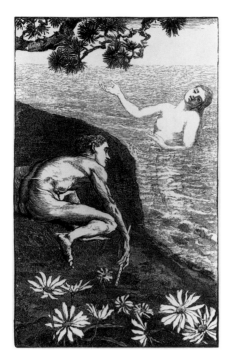

94
Song of the Siren, 1872
Illustration for *Songs from the Old Dramatists*
(1873)
Wood engraving
5¾ × 3⁹⁄₁₆ in. (14.6 × 9 cm.)
Private collection
E1873.3

95
Songs of Sorrow, 1872
Illustration for *Songs from the Old Dramatists*
(1873)
Wood engraving
5⅜ × 3⅜ in. (13.7 × 8.6 cm.)
Private collection
E1873.4

the more successful illustrations that he began in the 1860s. In conjunction with Elihu Vedder, William J. Hennessy, and F.O.C. Darley, he contributed drawings to an illustrated edition of Tennyson's *Enoch Arden*, published in Boston in 1864 (plates 21–23, pages 262, 263). At about the same time he began to develop a suite of drawings to accompany Robert Browning's poetry; prepared individual illustrations to works by Ralph Waldo Emerson, Heinrich Heine, and George Miles; and completed many compositions for the *Riverside Magazine for Young People*, including the well-known *Wolf-Charmer* (plate 16), *The Fisherman and the Djinn* (plate 20), *The Pied Piper of Hamelin* (plate 18), *The Wise Men Out of the East* (plate 129), and *The Travelers and the Giant* (plate 19), all published in 1867–68.[12] These illustrations of 1864–68 marked the maturity of La Farge's imaginative and decorative sensibilities. With a tense, active line that turned the insecurity of his drawing to expressive advantage, La Farge melded his two greatest enthusiasms, Japanese art and Pre-Raphaelite illustration, to create effects that impressed viewers as far afield as Dante Gabriel Rossetti.[13] The wood engravings after these drawings established a national reputation for La Farge that his experimental Newport landscapes had failed to win, and for years they remained in the public memory.[14]

La Farge's interest in illustration dated from the 1850s, along with his early study of Ruskin and the Pre-Raphaelites, but his serious work along such lines began after a lengthy illness in 1865–67 forced him to give up outdoor work.[15] At this moment he turned to lighter media, like pencil, crayon, and watercolor, probably because of his

96
Spirit of the Water Lily,
c. 1883
Watercolor on paper
5 × 3¼ in. (12.7 × 8.2 cm.)
Isabella Stewart Gardner Museum,
Boston
W1883.48

97
The Waterlily and the Fairy, 1872
Illustration for *Songs from the Old Dramatists*
(1873)
Wood engraving
5¼ × 3½ in. (13.3 × 8.9 cm.)
Private collection
E1873.1

fragile health and perhaps also because of his larger sense of exhaustion (or depression) following the disintegration of his first large decorative projects and the lukewarm reception given his two major landscape oils, *Paradise Valley* and *The Last Valley—Paradise Rocks* (plates 57, 58), of 1866–68. The attention to illustration may have had a financial motivation, too, for La Farge never had much success selling his easel paintings. Whatever the reasons, he suddenly began to devote most of his energy to illustration. Denying that the oil painter trod "some higher path," he asserted the importance of the illustrator, whose task "calls upon all the powers of the artist": imagination, description, expressive manipulation, suggestion, composition, line.[16] "I also tried that never in any case should these drawings be loose illustrations such as we get in books and magazines," he commented later, "but be really compositions capable, if necessary, of being made as large as any pictures are made."[17] Proving his intentions, he returned to many of these compositions years later as sources for independent exhibition pieces in oil and watercolor.

The tonal subtlety of the *Riverside* wood engravings and of four later compositions published in a volume of poetry, *Songs from the Old Dramatists* of 1873 (plates 94, 95, 97, page 264), indicates that La Farge was working on the woodblock with a brush, not the more customary pencil or pen and ink.[18] Although wash techniques would become standard practice among illustrators by the mid-1870s, La Farge's avant-garde practice in the 1860s caused a certain amount of friction between the artist and his engraver, Henry Marsh, who "of course wanted lines to engrave, not wash."[19] La Farge's refusal

to work conventionally finally pushed Marsh into moments of virtuosity that gave their collaboration "a reputation unique in the history of the art."[20] Spurred by this example, Homer and Moran soon pressed for such effects in their own illustrations.[21]

Because the technology of wood engraving before about 1875 necessitated the destruction of the drawing as it was cut by the engraver, none of La Farge's illustrations published before that time remain to demonstrate his technique.[22] Only photographs of the uncut blocks, evidently made by La Farge in order to record the images, give evidence of the actual handling of some of his earliest and best-known illustrations, such as *The Wolf-Charmer* (plates 16, 98).[23] One rare example, undisturbed on its block, is *The Triumph of Love* (plate 99), made in 1866–67 for *Songs from the Old Dramatists* but never used.[24] Painted in a near monochrome of gray, brown, and tan washes on a prepared white surface, the design attempts effects of modeling that would indeed have challenged or vexed the most skillful engraver. Those illustrations that Marsh engraved, such as *The Waterlily and the Fairy* (plates 96, 97), capture La Farge's brush gestures and graduated tones.

The block for *The Triumph of Love* was one of La Farge's two debut entries at the Water Color Society's exhibition of 1876. It appeared alongside a block of the *Bishop Hatto* design that was made earlier for *Riverside* but never published there (plate 17). Although neither entry stirred much notice,[25] they appropriately represented the type of watercolor most important to La Farge's early career and critical to the growth of the society in the mid-1870s. His decision to show the actual blocks followed a precedent established by Jasper F. Cropsey and J. Henry Hill in 1873.[26] The watercolor exhibition that year proved a turning point for the display of such illustrational material; Eakins,

98
The Wolf-Charmer, 1867
Photograph of brush drawing on woodblock
Block: 6¹⁵⁄₁₆ × 5⁷⁄₁₆ in. (17.6 × 13.8 cm.)
Boston Public Library
D1867.8

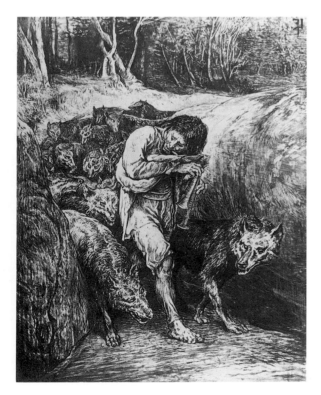

99
The Triumph of Love, 1866–67
(Love Borne Triumphant)
Wash drawing on woodblock
5⁷⁄₈ × 3⁵⁄₈ in. (15 × 9.2 cm.)
The Art Museum, Princeton University,
Princeton, New Jersey
Gift of Frank Jewett Mather, Jr.
D1866.78

Homer, and Abbey all seem to have been profoundly stimulated by this show.[27] Inspired by a large number of drawings done for reproduction in *Punch* and the *London Graphic* that appeared in a loan collection of English watercolors appended to that show, American illustrators suddenly realized that their own efforts in this genre were exhibitable. Harper's firm lost no time in following the *London Graphic*'s example and the following year submitted several drawings on wood by staff artists.

The incidence of works in the watercolor exhibitions identified as "illustrations," or labeled "on wood" or "on stone," surged after 1873, and by 1876, when La Farge sent in his first two blocks, the rising tide of illustrational work inspired the society's first designated "Black and White" gallery since 1873. The next year the Salmagundi Club sprang back to life, and within two more years their independent exhibition of all types of black-and-white work appeared. The best products of the new photographic-transfer technology, which revolutionized illustration in the late 1870s, held proud places in these shows. In 1878 Henry Marsh's engravings after La Farge's designs (executed in the old fashion, but still dazzling) were hung in the society's show near pairs of drawings and their engravings done in the new mode by Abbey and David Nichols, Moran and F. S. King. Much of this type of black-and-white work was siphoned off after 1879 by the Salmagundi shows, but illustrational material remained important to the Water Color Society's exhibitions throughout the century, just as the illustrators themselves remained central to the membership.[28] Twenty years later La Farge himself was still exhibiting work in this illustrational spirit at the society based on his travels in Japan and the South Seas.

The early celebrity of La Farge's illustrations in the 1860s, or perhaps the controversy generated by his landscapes and still lifes, had led Samuel Colman to propose him as a member of the Water Color Society in 1868. He was elected that spring, after the society's first exhibition, but he showed nothing with them until the two illustrations appeared in 1876.[29] La Farge's interest may have been dulled by many factors, including his poor health, his standoffishness, his erratic exhibition pattern, and his long visit to Europe in 1873.[30] His most successful work in wash or watercolor had been destroyed in the process of engraving, and it took him a while to realize that even the blocks had exhibition potential. But if La Farge was not painting much in watercolor at this time, neither was he productive in oil. Always a slow worker, he invested his energy during the early 1870s in very few endeavors.

La Farge's appearance at the society's exhibition in 1876 was followed by a fallow year, when he showed at none of the major New York annuals. His work on the Trinity Church decorations in Boston and the Saint Thomas Church murals in New York undoubtedly occupied all his time in 1876–77. Then, in February 1878, when Marsh sent about five of the *Enoch Arden* and *Old Dramatists* engravings to the exhibition, La Farge ventured into another progressive exhibition genre: the sketch. His one entry that year, titled simply *A Sketch*, delighted some critics and mystified others, very much as Homer's sketches had done a few years earlier. His work was described as the head and bust of an angel or spirit with butterfly wings (related, no doubt, to *The Waterlily and the Fairy*), painted quickly with gouache on tinted paper. Novel iridescent effects, part peacock and part moth, had been achieved by glazing color over gold and silver and dusting the surface with bronze powder.[31] The *Tribune*'s reviewer felt the picture was an insult to the society, "crude, unfinished, hardly begun," unfit for viewing even in the studio and altogether inappropriate to an artist of La Farge's stature.[32] *Scribner's*, on the other hand, thought the sketch was "not only curious as an experiment in materials, but supplied an imaginative element of a kind not too frequent on these walls."[33] By describing La Farge's *Sketch* as a "crude conception," containing, nevertheless, "the impression of

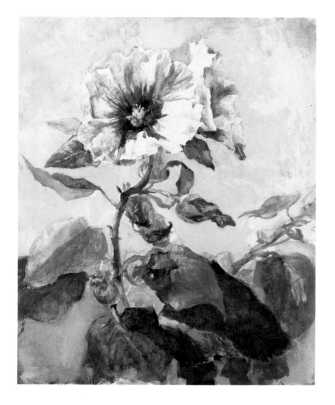

100
Study of Pink Hollyhock in Sunlight. From Nature, c. 1879
Watercolor and gouache on paper
11⅞ × 9¹¹⁄₁₆ in. (30.2 × 24.6 cm.)
The Nelson-Atkins Museum of Art, Kansas City, Missouri
Gift of James Maroney, New York
W1879.18

a soul of unusual distinction," the *Nation*'s critic conjoined the contradictory opinions of this work and exposed much of the praise of it as the expression of La Farge's already sizable cult following. "Nothing could show the peculiar mastery which this artist has over a careless public more than the fact that in this experiment, almost insulting in the largeness of the demand it makes upon the imagination, it is conceded by everybody that the thing could have been done only by an artist of talent."[34]

Even more than Homer, who attracted a similar following among aesthetes in this decade, La Farge was beginning to benefit from the growing modishness of his personal mélange of Barbizon, Pre-Raphaelite, and Japanese styles. Once incomprehensible to all but a few, his work had become more controversial by the mid-1870s, and—with the success of his prestigious Trinity Church commission—it was soon understood to be "highly intellectual, spiritual, and poetic in feeling."[35] La Farge had emerged as a leader among the progressives, who recognized in his work the aestheticism of James McNeill Whistler intermingled with the most venerable traditions of Western art.

Something in the commentary generated by his *Sketch* in 1878, or perhaps some stimulation from the exhibition itself, transformed La Farge's work in watercolor. In January 1879 he sent five watercolors to the society's show, all remarkably different from anything he had done previously. His entries surveyed all his major interests as a painter—landscape, still life, Japanese decorative art, and mural design—but with a color and detail that demonstrated new attention to technique and a new respect for watercolor as a medium suited to monumental and finished works of exhibition quality. *Chinese Pi-tong* (plate 101), his largest and most ravishing entry, "the crown of the whole exhibition"

101
Chinese Pi-tong, c. 1879
Watercolor on paper
16⅛ × 16 in. (41.2 × 40.6 cm.)
Fogg Art Museum, Harvard University, Cambridge, Massachusetts
W1879.22

to some, displayed his mastery of still life, his love of Oriental art, and his characteristic taste for "eye delighting color."[36] "Mr. La Farge has never done much for the Watercolor Society," noted the *New York Times*, "but this year he may be said to have bloomed out."[37]

His roses and his small winter landscape, *Moonrise over Snow, Study from Nature*,[38] earned widespread praise for La Farge, although some reviewers found the bric-a-brac in *Chinese Pi-tong* an unwelcome addition. For these critics, La Farge's two other still lifes, based on Japanese objets d'art, were misbegotten efforts, "much labor thrown away."[39] While some viewers perceived the connection between his well-known decorative work and these small, daintily finished pieces,[40] others were confused and disappointed: "One looked for something more than studies from a man as great as Mr. La Farge."[41] The cartoon for the mural *The Visit of Nicodemus to Christ*,[42] completed and installed in Trinity Church in 1878, served as a reference to La Farge's recent triumph in Boston, but for some this reminder cast an unfortunate light on his other watercolors, which were seen, by comparison, as "not worthy of his position." For the *Times*'s critic, the still lifes aroused "the suspicion that he is trying to be popular, instead of throwing his precept and example firmly the other way. We have too few painters who can or will follow their highest guides without thinking of what is salable or popular," complained this reviewer, "and the man who decorated Trinity Church cannot afford to paint [such] things."[43]

Indeed, La Farge could barely afford to live. His grand mural projects and painstaking landscapes had finally gained him an impressive (almost oppressive) reputation for seriousness and artistry, but he had yet to sell a painting from an exhibition.[44] Periodically on the verge of financial disaster, he had auctioned off the contents of his studio in Boston a few months earlier and was still on the lookout for sales.[45] Like Homer, he fell upon the two most successful ways to attract attention and patronage at this moment: the one-man show and sale, and the Water Color Society exhibitions. In turning to the latter, he acknowledged the energy of the watercolor movement and its cheery message to artists in a bleak economic climate: watercolors were selling.[46] So was Oriental bric-a-brac. Combining the popularity of these vogues with the strength of his own skill (and repute) as a still-life painter and decorator, La Farge produced for the show what should have been a popular success. And it worked. Although Earl Shinn thought the artist's time would have been better spent learning to draw hands and feet at the National Academy of Design, he noted in his review of the 1879 show that the "waste moments" La Farge devoted to "throwing off Oriental bric-a-brac worthy of Mohammed's heaven, and roses made of a breath or a blush" had paid off in their own way. "The roses and Oriental wares have, indeed, been selling rapidly. Mr. La Farge can no longer use his noble boast that he has never sold a picture from an exhibition," wrote Shinn. "The yellow ticket has found out the corners of his small and modest frames, and the artist can congratulate himself on being almost alone in having sold his pictures at full prices without concessions."[47]

Still in financial straits, La Farge held another auction at Leonard's Gallery in Boston later in 1879, when he tried to sell "all the available works remaining" in his studio, including many pictures he had refused to sell in 1878.[48] Thirty-seven drawings, some on wood, and twenty-one watercolors were included. Other than two embroidery designs from 1860, all of the watercolors were from late 1878 or 1879, testifying to La Farge's sudden acceleration of interest in the medium.

Most of the watercolors in the Leonard sale were floral subjects: hollyhocks, iris, camellias, apple blossoms, violets, and his famous water lilies. Twenty years of such still-life work had prepared La Farge for this new, spectacular "flowering," for this was the one subject that he could draw with genuine confidence and spontaneity. Few of these

floral watercolors contain effects that he had not attempted earlier in oil. However, the concentration on these familiar subjects completely relaxed and liberated his watercolor technique. Beginning in 1878–79 and continuing sporadically until his departure for Japan in 1886, La Farge would produce the most beautiful watercolors and some of the finest floral subjects of his career.[49] As one critic remarked in 1884, "It is on these modest water-colors that his fame, in the future, promises to rest."[50]

In a medium well suited to the depiction of translucent leaves and petals or sunlight reflected off water and glazed ceramic, La Farge achieved a remarkably suggestive naturalism. "No nearer approach has, probably, ever been made to the freshness, purity, and delicacy of texture of natural flowers," claimed an admirer.[51] At the same time, La Farge was able to accomplish calligraphic effects that complemented the Orientalism of his compositions and subjects. Without the mysterious, symbolic, and often nocturnal tone of his earlier oils, these freely painted, sunny subjects (including his well-known *Wild Roses and Water Lily—Study of Sunlight*, plate 103), approach the pure sensuousness of Impressionism, ordered by a self-conscious assertion of decorative design and color. The bright reds and greens, the strong sense of light and texture, the artful asymmetry, the contrasting densities of pigment, and the variety of handling all show an overt pleasure in the physical properties of the subject and medium.

These floral paintings are decorative in the most pleasant sense. As such, they offered encouragement and established a standard of excellence for every flower painter who showed in, or visited, the watercolor exhibitions after 1878. Judging from critical commentary and catalog listings, such artists were legion. As decorativeness became not only acceptable but chic, artists from all backgrounds began to compose overtly decorative watercolor studies, frequently based on still life or intimate landscape fragments. Thomas Moran produced his small *Study of Lotus* (4¾ by 8¾ inches; Kennedy Galleries, New York) in 1879, much in the vein of La Farge's work. Fidelia Bridges, a student of William Trost Richards, contributed her own *Water Lilies* in 1882,[52] representing a host of similar work that had made her famous in the mid-1870s. Bridges, like La Farge, demonstrated

102
Apple Blossoms. On White Ground, c. 1879
Watercolor on paper
7 × 9½ in. (17.8 × 24.2 cm.)
Museum of Fine Arts, Boston
Bequest of Mrs. Henry Lee Higginson, 1935
W1879.32

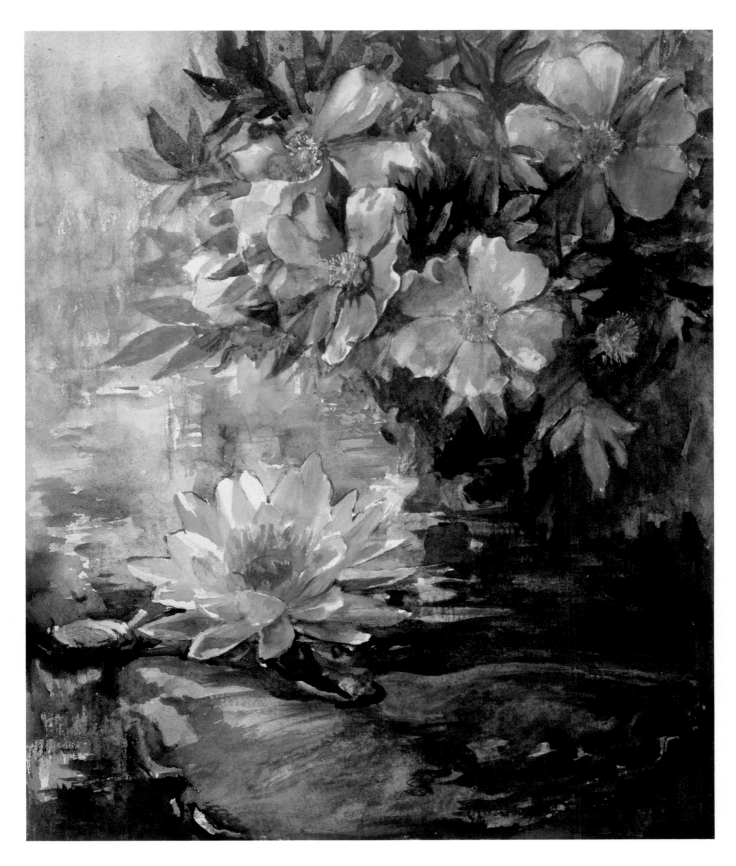

103
Wild Roses and Water Lily—Study of Sunlight, c. 1883
Watercolor on paper
10⅝ × 9 in. (27 × 22.9 cm.)
Mr. and Mrs. Raymond J. Horowitz
W1883.35

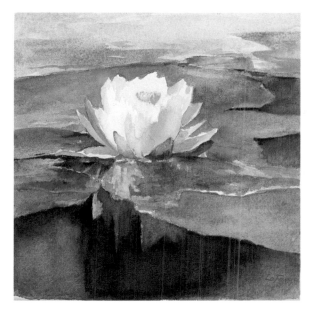

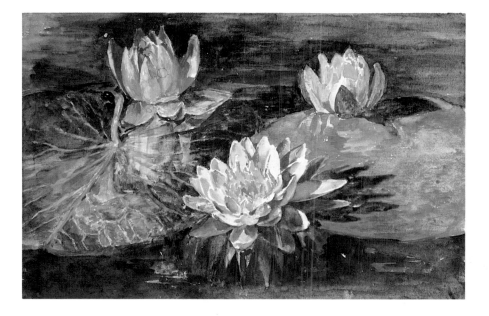

104
Water Lily in Sunlight, c. 1883
Watercolor cn paper
8¼ × 8³⁄₁₆ in. (21 × 20.8 cm.)
National Museum of Art, Smithsonian Institution, Washington, D.C.
Gift of John Gellatly
W1883.15

———————

105
Water Lilies in Black Water. Study from Nature, c. 1883
(Water Lilies. Red and Green Pads.)
Watercolor on paper
7³⁄₈ × 11¼ in. (**18.7** × 28.6 cm.)
Pauline E. Woolworth
W1883.30

———

the passage of Pre-Raphaelitism, in both England and America, from its naturalistic to its decorative phase; both artists moved from intensely detailed, Ruskinian studies to a self-consciously decorative Orientalism, with attendant asymmetry, tilted perspective, and narrow horizontal or vertical formats.[53]

The *japonaiseries* of Bridges had been cited by Earl Shinn in 1875 as examples of the major revitalization of still life "since the studios were flooded by the Japanese patterns." In particular, Shinn commented on the impact of the Japanese tendency to set plants or animals in the foreground, against a quickly drawn, very distant landscape horizon that "helps the suggestion and the escape of the mind."[54] In works by La Farge such as *Blue*

106
Water Lilies with Moth, c. 1879
(Water Lily and Moth)
Watercolor on paper
13½ × 11¼ in. (34.3 × 28.6 cm.)
Wadsworth Atheneum, Hartford, Connecticut
The Ella Gallup Sumner and Mary Catlin Sumner Collection
W1879.3

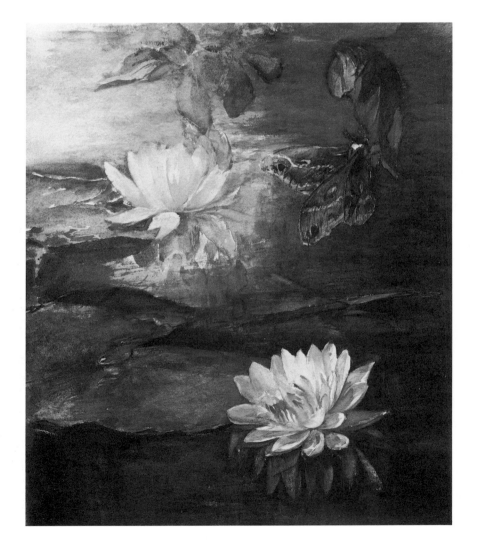

Iris. Study (plate 107)[55] and, to a lesser extent, *Water Lilies with Moth* (plate 106), the Oriental source of this compositional device became all the more obvious in watercolor, which could also emulate the calligraphic brushwork and contrasting pigment densities of Japanese ink drawing. As Whistler's work became better known in America in the 1870s (particularly after the return from Europe of artists such as Robert Blum and Alfred Brennan, who imitated Whistler's style), such Orientalisms were reinforced, merging with and eventually superseding the taste for Spanish-Italian handling.[56]

Shinn noted the emergence of this Oriental manner in Bridges's work and complimented one of her paintings in 1875 as a type of decorative picture "always comely and becoming

107
Blue Iris. Study, 1879
Watercolor on paper
10⅝ × 8⅝ in. (27 × 22 cm.)
Jerald Dillon Fessenden
W1879.12

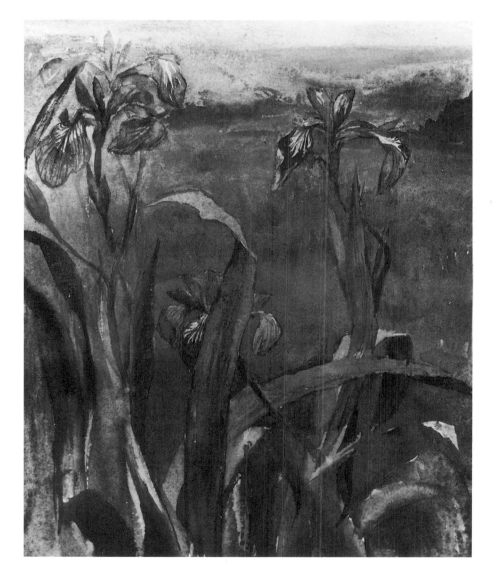

in a water-color exhibition" because it was "at first sight as purely and elegantly decorative as a good wallpaper design or a Japanese fan" and yet it yielded, at closer study, "some sentiment, lesson or poem." Shinn expanded on this topic by generalizing that "aquarelle is a method of art which goes to the adornment of homes, and it partakes largely of the spirit of a decoration or object of furniture," succeeding in proportion as it "frankly confesses" this quality and abandons to oil painting the domain of "great gallery pictures and pieces of didactic authority."[57]

Shinn's approval of this role for watercolor indicates an abrupt shift in the critical winds. After a decade spent battling condescending references to the medium as "a pretty material for lady amateurs to use in flower painting or vase-decorating,"[58] watercolor painters heard the old prejudices spoken anew, in positive tones. As talents like La Farge turned to flower painting or tile decorating, they transformed these ancient liabilities into avant-garde virtues. In watercolor art, monumentality was sacrificed for the moment, but the energetic interest of a "decorative age" was gained. In 1879 Tiffany was no doubt pleased to hear his watercolor *Among the Weeds* praised as a picture that "would glow and 'Make a sunshine in a shady place,' in any parlor as a piece of decoration."[59] Homer, judging by the Japanese attributes of his *Backgammon* of 1877 or the decorative shepherdesses of 1878, would have agreed with Shinn at this moment, too. La Farge, who insisted on the equality of *potential* expressiveness among all media, surely must have approved of the rising status of "minor" media and the new attention to decorative design. Certainly his work shows that he, like Shinn, asserted a special connection between watercolor and decoration.

A month after his second Boston sale, the 1880 annual exhibition of the Water Color Society opened without any of the "magnificent flower pieces of Mr. La Farge." In their place were several "ideal drawings in black and white,"[60] mostly lent by the artist's friend Russell Sturgis. The following two years La Farge failed to show at all, thereby defaulting his membership in the society; he would not exhibit there again until after his trip to Japan. But important things had been learned during his first years of engagement with the society. His technique was now fluent enough for any purpose. More pragmatically, he had observed the collectors crowding into the exhibition on "Buyer's Day" to acquire inexpensive art suited to domestic spaces. Continually threatened with the insolvency of his decorating firm, La Farge was not opposed to exploiting the popularity of his own earlier work by producing salable pieces aimed at the new watercolor collectors. The continuing fame of his illustrations from the 1860s and his foresight in maintaining photographs of his uncut woodblocks allowed him to execute larger watercolor replicas of his earlier compositions. The appearance of a large group of such "recent" pictures in an auction sale of 1884 betrayed the artist's need for immediate income.[61] Some of these, such as *The Halt of the Wise Men* (private collection), are actually painted over pale photographs, with the density of the gouache almost obscuring the photographic "sketch" beneath.[62] Their size, confident handling, and bright palette, consistent with La Farge's other watercolors after 1878, distinguish these new images from their black-and-white sources (see plate 96).

Apart from such special campaigns, La Farge's involvement with watercolor in the early 1880s shifted from illustration and exhibition work to decorative design. According to the auction catalog of 1879, he offered all the contents of his studio "to enable him to devote himself entirely to decoration."[63] The two Vanderbilt houses got under way in 1880, and La Farge was soon involved with their interiors (plates 136, 137) as well as with that of the Union League Club dining room, New York (plate 135). [64] By 1882, the year his name was struck from the membership rolls of the Water Color Society, he was busy supervising work on the Water Color Room in Cornelius Vanderbilt II's lavish

mansion. This house, hailed as "the most important example of decorative work yet attempted in this country," included stained glass, murals, and embroidered hangings, all designed by La Farge in watercolor.[65]

La Farge's multimedia work for the Vanderbilts, like his earlier decoration of Trinity Church (plate 24), drew upon many of the radical premises of the Arts and Crafts movement,[66] not the least of which was a fundamental dismantling of traditional media hierarchies. Stirred by the excellence of both design and craft in small pieces of Japanese bric-a-brac, La Farge remarked in 1886 that "all great periods in what we call decorative work" succeeded because there was no separation between fine art and decoration; "there was merely art to be used to fill certain spaces."[67] To La Farge, the merit or importance of a Japanese artwork lay not in its materials, but in the use of those "certain spaces." Communication succeeded according to the artist's degree of involvement in his activity and depended on infinitely diverse negotiations made between received conventions of design and fresh, personal interpretations of nature. Modern Western artists, drawn to permanent, monumental, or precious materials, foundered because they prized ends over expressive means. Their materialism, described by La Farge as an "essential snobbishness," devalued work done at a small scale, in cheap, temporary media, and it set up a system bound to frustrate artists and impoverish all artistic endeavors falling beneath the dignity of oil or stone. "The Japanese would never have invented the idea of doing poorly the work one is forced to do to live, so as to reserve vast energy for more important or influential work that might draw attention," wrote La Farge. "Our artists accept as a momentary curse the fact that to live they may have to draw patterns, or work in glass, or paint or model subsidiary ornamentation."[68]

The critique of Western, post-Renaissance art fueled by the study of medieval and Oriental culture lay at the center of the Arts and Crafts movement in England and America. It inspired a revival of interest in all the minor or decorative arts and a wave of concern over the poor quality of design and workmanship in contemporary industrial art and the decline of traditional handicraft. The English reform movement, led by A.W.N. Pugin, Ruskin, William Morris, and the founders of the South Kensington Schools for the training of young designers, provided lessons for Americans eager to improve American design. John La Farge spent half a year in England in 1873, associating with Morris, Ford Madox Brown, Rossetti, and Burne-Jones, all of whom supplied decorative designs for Morris and Company. Their example inspired La Farge's first stained-glass designs, very much in the Morris style, soon after his return.[69]

These attempts, in conjunction with a series of dining-room decorations painted in 1865 and La Farge's previous experience as a mural painter, recommended his work to H. H. Richardson, who engaged him in 1876 to coordinate the interior decoration of Trinity Church.[70] The achievement of Trinity, combined with his work in illustration and conventional easel painting, made La Farge in 1877 the most versatile practitioner of the Arts and Crafts philosophy in the United States. With an interest in decorative design that went back to his discovery of Japanese and medieval art in the 1850s, La Farge was also the first American painter to enter this field. Whistler, who completed the Peacock Room in 1877 in England, set a similar example from afar, but with less versatility and perseverance. La Farge continued such work until the end of his life. "I have always been interested in decoration," he insisted in 1894, "that is to say the appliance of art in any shape to buildings and objects made for use."[71]

La Farge's first and largest "appliance of art" came as mural decoration and, as indicated by the cartoon for *The Visit of Nicodemus to Christ* at the Water Color Society's exhibition in 1879, watercolor had become part of his mural-designing method by the time of his Boston commission.[72] La Farge also exhibited his watercolor designs for the

145

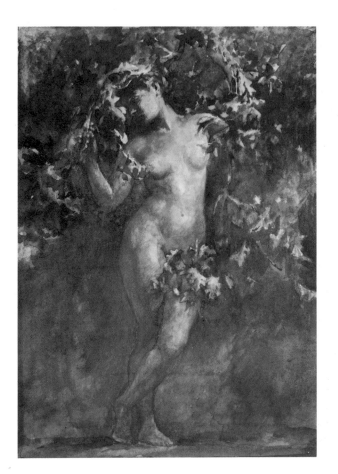

108
The Sense of Smell, 1881
Watercolor on paper
8⅞ × 6⅛ in. (22.6 × 15.3 cm.)
The Art Museum, Princeton University, Princeton, New Jersey
Gift of Frank Jewett Mather, Jr.
W1881.4

murals in the Cornelius Vanderbilt II mansion, begun sometime after this year. *The Sense of Smell* (plate 108)[73] may be one of the sketches for the vaults of the Water Color Room, which were decorated with images of the senses, an old-masterish allegorical conceit. *The Sense of Smell* shows the same watercolor technique as La Farge's still lifes of about 1880, but without the assurance of drawing. Prone to slide over details of anatomy in work like this (or the *Nicodemus* cartoon), La Farge revealed his better side—and the side that pleased his contemporaries—in the graceful composition and the brilliant blue-green color chord that dominates the image.[74]

La Farge probably designed the portieres for the Vanderbilt dining room in watercolor, although neither drawings nor curtains survive. He had not attempted embroidery design since his first, modest watercolor essays twenty years earlier, but in true Arts and Crafts spirit he ventured into ambitious textile projects without hesitation. Incorporating aspects of Japanese embroidery, Renaissance motifs, and his own naturalistic flower studies, La Farge's designs knew few constraints. The Vanderbilts' wealth put the most lavish materials at his disposal—silks, brocades, gold and silver threads and fabrics—and a

team of resourceful art needleworkers under the supervision of Candace Wheeler, the champion of American artistic embroidery, was enlisted as his collaborators. Most likely, these women worked from La Farge's watercolor designs to achieve the painterly and "iridescent" effects described by contemporary viewers.[75]

Embroidery design remained a marginal activity for La Farge because commissions like the Vanderbilts' came rarely. Still, it was one genre where his efforts may have had popular influence, for his designs were published with much praise in periodicals like the *Art Amateur*, whose readers often had both the desire and the skill to imitate this work themselves. Art magazines were proliferating in America at this time, and many included how-to articles on watercolor painting and other decorative work like china painting and embroidery, or large tear-out patterns, suitable for copying. The shimmering naturalism of La Farge's designs, so unlike the more stylized or geometrical English manner, probably had a powerful influence on the "American style" in art needlework, with its colorful, pictorial tendencies.[76]

La Farge's most admired work—stained glass—was also accessible to the public in a way that his conventional oils and watercolors could never be, although few amateurs could have participated in this technique as they could produce their own illustrations, watercolors, or embroidery. The complexity and innovativeness of La Farge's stained glass was a cause for wonder and delight, and after 1880 the majority of his patrons brought him commissions for work in this medium.[77]

109
Hollyhocks; Design for Window for J. Pierrepont [sic] *Morgan,* 1881
Watercolor on paper
8½ × 7 in. (21.5 × 17.5 cm.)
Museum of Fine Arts, Boston
Gift of Henry L. Higginson
W1881.14

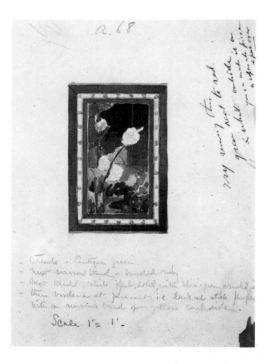

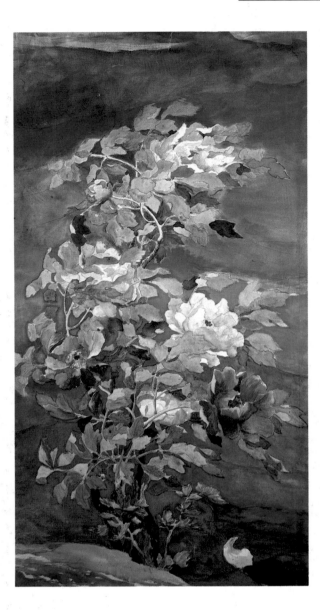

110
Peonies in a Breeze, 1890
Study for window, John Hay house,
Washington, D.C.
Watercolor on paper
37 × 19¾ in. (94 × 50.2 cm.)
Private collection
W1890.5

111
Butterflies and Foliage, 1889
Study for window, William H. White house,
Brooklyn
Watercolor on paper
10⅞ × 15⅜ in. (27.6 × 39.1 cm.)
Mr. and Mrs. Ludlow Shonnard III
W1889.8

112
Butterflies and Foliage, 1889
Window from William H. White house, Brooklyn
Stained glass
65 × 27½ in. (165.1 × 69.9 cm.)
Museum of Fine Arts, Boston
Gift of Mrs. William Emerson
G1889.3

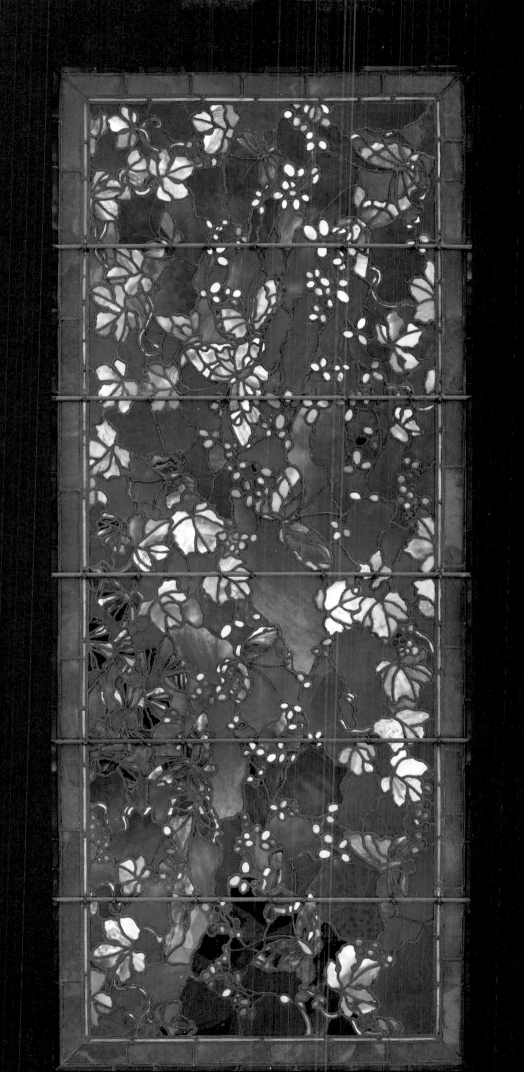

Glass surely interested La Farge more than textiles for the simple reason that he had more control over the execution of the work. Although his studio employed thirty persons by 1883, and much work had to be delegated to assistants, La Farge collaborated in every stage of the production, correcting and modifying each piece. Stained glass was also the medium best served by La Farge's skills in watercolor. Since the translucency of clean washes on white paper approximated the luminosity of stained glass better than any other medium, La Farge depended on watercolor for everything from the first tentative sketches to the elaborate cartoons that also served as exhibition pieces. A small, rather simple design like *Hollyhocks . . .* (plate 109)[78] probably translates La Farge's first mental image into visual language. Slightly larger and more finished designs must have served as guides for the coloring, plating, and painting of the window itself and later as illustrations for potential patrons or exhibition pieces, such as *Saint Elizabeth of Hungary*, which appeared at the American Water Color Society's exhibition of 1887.[79]

Effective color contrast concerned La Farge in his stained glass, as it did in his watercolors. His earliest response to medieval stained glass, which he saw in Europe in 1856, was influenced by his reading of M. E. Chevreul's comments on color harmony, and he was delighted to recognize the famous theorist's laws of harmony and contrast embodied in thirteenth-century glass.[80] For those like La Farge or Ogden Rood (a professor of optics at Columbia),[81] who were interested in the science of color, watercolor provided the most brilliant effects of reflected color-light short of actual transmitted light. Taking courage from the example of the Pre-Raphaelites and the Japanese, La Farge struggled in the 1860s for illusionistic subtlety as well as decorative color harmonies in his painting. Like one of his heroes, Théodore Rousseau, he tried to translate Japanese techniques into oil, attempting to represent "light by colors, by an arrangement of colors, an opposition of color, a concatenation of color."[82] A decade later, La Farge found these goals better served in watercolor and stained glass.[83] His floral window designs after 1878 realized, finally, the suggestive, impressionistic naturalism that had motivated his earliest landscapes and still lifes, while pushing the decorative elements dazzlingly to the fore. Modeled in color, almost without recourse to value contrast, his windows and watercolors (like the *Peonies in the Wind* for Cornelius Vanderbilt II or *Peonies in a Breeze*, plate 110[84]) unite Oriental design with sensuous Western Impressionism.

The first peonies in the wind design was contemporary with La Farge's great series of floral subjects in watercolor. His earliest surviving window (plate 145), made for H. H. Richardson's William Watts Sherman house in Newport, Rhode Island, was installed in 1878, the year his watercolors "flowered."[85] Some of these watercolor studies may have been done for windows that used floral designs, like the Watts Sherman panels, though it seems more likely that the watercolors existed independently and interacted with La Farge's glass designs as a source of inspiration. His work in both media underwent a rapid, apparently reciprocal increase in sophistication between 1878 and 1882. The watercolors resemble the windows, although they never seem to be exactly like extant glass designs, and they have a self-contained quality, as complete statements rather than preparatory studies.[86]

Although La Farge surpassed his achievements in painting by realizing the same effects *better* in glass, many of the characteristic qualities of his glass derived from his attempts to turn the medium back toward watercolor and to imitate painterly effects. Henry Adams has suggested that La Farge's use of milky gouache mixtures in his watercolors followed his use of calcitrate additives in his opalescent glass,[87] but his mixed watercolor technique surely predated his work in stained glass, and it could be argued with similar logic that his glass was emulating a taste already expressed in watercolor. The exchange between these media was not lost on La Farge's contemporaries. In the discussion that

followed the publication of the design for Vanderbilt's peony window, Mary Gay Humphreys commented that a similar window design (for the Ames residence in Boston) was "copied from a study from nature, and the freshness and exactness in detail of the study [were] repeated in the glass with as much freedom as might be shown in a watercolor painting which, in fact, it resembles."[88]

La Farge's progression from easel paintings to murals and from watercolor to stained glass seemed logical and desirable to a critic at *Harper's Weekly*. "There is a sure and comfortable prospect of employment and emolument for native painters who shall master the principles of decorative art," wrote this critic after inspecting the decorations recently completed at the Union League. "It is a significant fact that today artists like Tiffany and La Farge find it to their profit to paint walls rather than to paint canvasses, to diffuse their light through stained glass windows rather than to reflect it from a background of Whatman paper."[89]

Whether as an end in itself or as a transitional vehicle for ideas to be realized in other media, watercolor occupied a central position in La Farge's work, as it did in the decorative arts. Painting on tiles, pots, china plates, lamp shades, fans, silk, and so forth relied on watercolor techniques and often on watercolor pigments. When S.G.W. Benjamin surveyed recent tendencies in American art in 1880, he cited the popularity of the young Water Color Society as his first example of new "growth and appreciation" of the arts in America. The society's success led Benjamin naturally to the topic of decoration: "Closely associated with the movement in favor of watercolors is the rage for decorative art—including flower painting and decoration of pottery—which is now so prevalent among our cultivated circles."[90] The logic that drew Benjamin from a general statement on the growth of interest in art in America to the primacy of the watercolor movement within this expansion and then on to the alliance between watercolor and other decorative arts was exquisitely manifested in La Farge's work.

If watercolor served the most inventive and progressive aspects of La Farge's work, it also supported his most popular successes in a traditional vein. His trip to Japan in 1886 inspired an even deeper commitment to watercolor as the venerable medium of the traveling artist. The instincts of a landscape painter, illustrator, and Oriental art connoisseur, all well cultivated before he ever visited the Far East, stood La Farge in good stead throughout a long and varied production of watercolors inspired by his travels. His watercolors, reproduced in books and magazines and frequently exhibited (at the Water Color Society and elsewhere), added to the luster of La Farge's reputation as an American old master. His efforts began as documentary sketches, recording moments of natural or ethnographic interest, in the tradition of Ruskin's and Turner's travel notebooks. Worked up into more finished exhibition pieces, these subjects functioned as exquisitely realized "illustrations," such as *Young Girls Preparing Kava . . .* (plate 114), which, like his earlier work, could be independent, monumental compositions at any scale. *Bridle Path, Tahiti* (plate 113) shows the reemergence of that refined sensibility in landscape painting developed in Newport and redirected after 1867; *The Strange Thing Little Kiosai Saw in the River*[91] (plate 36) reveals the vitality, in 1897, of the literary, slightly macabre imagination that had produced the *Riverside* illustrations thirty years earlier. Less formal pieces, such as *Sunrise in Fog over Kiyoto* (plate 30), demonstrate La Farge's continuing pursuit of the Impressionist's "fleeting moment," successfully captured with the fluency and suggestive economy of a watercolor master. Throughout all these subjects, the sophisticated integration of lessons from Oriental art, now applied to the task of describing Eastern culture in a fundamentally Western mode, had an especially rich and appropriate cross-cultural effect.

Ranging from his decorative designs to the travel subjects of this period, La Farge's late watercolors summarize the talents and concerns of a lifetime. Although united by a

113
Bridle Path, Tahiti, c. 1900
Watercolor on paper
18 × 20⅛ in. (45 × 51.1 cm.)
Fogg Art Museum, Harvard University, Cambridge, Massachusetts
Gift of Edward D. Bettens to the Louise E. Bettens Fund
W1900.11

medium only recently established as important to Americans, these accomplishments underlay the exalted reputation that La Farge had earned by the turn of the century. "If America were forced to select a champion and upon his work rest her claim for artistic recognition," wrote an admirer in 1905, "that champion would undoubtedly be John La Farge."[92] Progressive in his advocacy of illustration, plein-air realism, Oriental art, and the decorative arts renaissance, but conservative in his perpetuation of the traditional forms and content of Western painting, La Farge enacted in watercolor the values that made him the champion for most artistically minded Americans in this period. Superior to his contemporaries, yet representing them well, La Farge was a leader of his culture and a servant to its best crusades.

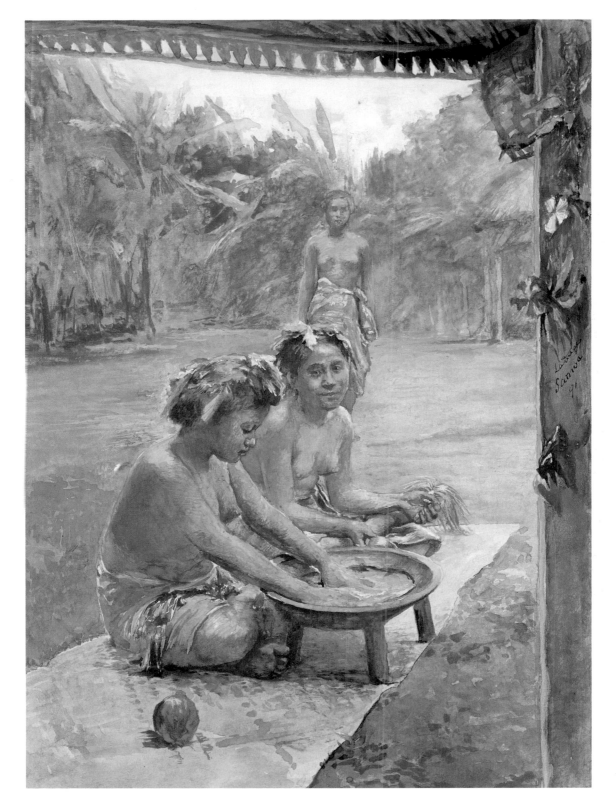

114

Young Girls Preparing Kava (the South Sea Drink). Outside of the Hut Whose Posts Are Decorated with Flowers; The Attendant, Standing in the Background Is There to Hand the Cocoanut Cup When Filled,
1891
Watercolor on paper
10⅛ × 7¾ in. (25.7 × 19.7 cm.)
Museum of Fine Arts, Boston
William Sturgis Bigelow Collection
W1891.8

This essay is an abridged and revised version of chapter 6 in my doctoral dissertation, "Makers of the American Watercolor Movement 1860–1890" (Yale University, 1982). I remain grateful for the assistance of Theodore E. Stebbins, Jr., and Jules D. Prown in directing my work at Yale. Special thanks must also go to Henry A. La Farge, who shared his unfinished catalogue raisonné with me prior to his death, and James L. Yarnall, now completing this massive work, who generously assisted my research in many ways. I am also indebted to my colleagues Henry Adams and H. Barbara Weinberg for their scholarly publications as well as many useful and cordial conversations on La Farge during the past decade.

1. Susan N. Carter, "The Water-Colour Exhibition," *Art Journal* (U.S.) 5 (1879): 94.

2. Guy Pène du Bois claimed that by the end of La Farge's life he had "scarcely a friend among painters," a condition du Bois attributed to envy and resentment elicited by La Farge's elegance and intellectualism. See Guy Pène du Bois, "The Case of John La Farge," *Arts Magazine* 17 (January 1931): 252–70ff. Even at the beginning of his career La Farge was noted for his detachment, for he rarely mixed with the other artists in the Tenth Street Studio Building in New York. His own comments on this period in the 1860s indicate his sense of a change to a more sociable pattern later; see H. Barbara Weinberg, "John La Farge—The Relation of His Illustrations to His Ideal Art," *American Art Journal* 5 (May 1973): 59. As with Winslow Homer (another fastidious and solitary type, who seems to have maintained a cordial friendship with La Farge throughout his life), the period from the early 1870s to the mid-1880s was the most gregarious time of La Farge's life. Too patrician to seek out the more bohemian haunts of the Tile Club, La Farge sparkled in conversation in more comfortable surroundings, like the Century Club. His closest associates were likely to be other professionals, and they have given accounts of his attractive and fascinating qualities. See Henry James, *Notes of a Son and Brother* (New York and London: Charles Scribner's Sons, 1914), 66–108 *passim*; Henry Adams, *The Education of Henry Adams* (Boston: Houghton Mifflin Co., 1918), 369–70.

3. La Farge, in conversation with the cartoonist W. A. Rogers, in Rogers, *A World Worth While* (New York: Harper's, 1922), 142.

4. La Farge was not elected after "the opposition" pointed out that his membership had lapsed. See Kathleen Foster, "The Watercolor Scandal of 1882: An American Salon des Refusés," *Archives of American Art Journal* 19, no. 2 (1979): 19–25.

5. William Laffan, "The Tile Club at Work," *Scribner's Monthly* 17 (January 1879): 401.

6. "Art as a Steady Diet," *Scribner's Monthly* 17 (January 1879): 439.

7. H. Barbara Weinberg, *The Decorative Work of John La Farge* (1972; New York: Garland Publishing, 1977), 262–63, n. 3. Examples of these early embroidery designs in watercolor are in the Museum of Fine Arts, Boston. These designs may correspond with items listed in the catalog of La Farge's studio sale in 1879, such as no. 11, "Four studies of flowers,—rose, camellia, pansies, begonias"; no. 16, "Decorative Flower-Piece. Circular" (both dated 1860); and no. 17, "Study of Violets" (1859). See *The Drawings, Water-Colors, and Oil-Paintings by John La Farge . . .* (Boston: Leonard's Gallery, 1879), 9–10.

8. Weinberg, "Illustrations," 55–56. The artist's own account of his childhood training is given by Royal Cortissoz, in *John La Farge: A Memoir and a Study* (Boston and New York: Houghton Mifflin Co., 1911), 58–59.

9. See, for example, *A Brittany Beadle—Sketch from Nature* (Metropolitan Museum of Art), dated 1856. Other watercolor subjects from this trip were included in the Leonard sale as items 20 and 21. Henry La Farge's catalogue raisonné lists many watercolor studies from the 1850s, often copies from old master paintings seen in Europe; only a few have been located at present.

10. See James L. Yarnall, "The Role of Landscape in the Art of John La Farge" (Ph.D. diss., University of Chicago, 1981), and his essay in this volume.

11. Another example from this period would be *Sea Nymph*, signed and dated 1859 (Museum of Fine Arts, Boston). Henry La Farge's catalogue raisonné lists several figural compositions in watercolor from the mid-1860s.

12. Most of La Farge's illustrations are discussed and many are illustrated in Weinberg, "Illustrations." Although this article focuses on the importance of decorative, ideal themes in even La Farge's earliest work, it serves as an excellent introduction to the major issues in La Farge's work before 1873. An earlier discussion of his illustrations can be found in Frank Weitenkampf, "John La Farge, Illustrator," *Print Collector's Quarterly* 5 (December 1915): 472–94; and Cortissoz, *La Farge: A Memoir*, 136–38.

13. Cortissoz, *La Farge: A Memoir*, 137–38. La Farge's involvement with Japanese art has been recognized and studied at some length, most recently by Henry Adams, in

"John La Farge's Discovery of Japanese Art: A New Perspective on the Origins of *Japonisme*," *Art Bulletin* 67 (September 1985): 449–85. Adams summarizes previous scholarship on this subject and adds much new documentation and analysis. Likewise, La Farge's long involvement with Ruskin and the Pre-Raphaelites has been widely noted; see, for example, Weinberg, "Illustrations," 67, n. 49; Cecilia Waern, *John La Farge, Artist and Writer* (London: Seeley and Co.; New York: Macmillan and Co., 1896), 27; Cortissoz, *La Farge: A Memoir*, 68–69, 97–99, 109, 137; D. H. Dickason, *The Daring Young Men* (Bloomington, Ind.: Indiana University Press, 1953), 147–48. These two important strands in La Farge's work have been analyzed in relation to his still-life painting in Kathleen A. Foster, "The Still-Life Painting of John La Farge," *American Art Journal* 11 (Summer 1979): 4–37.

14. See, for example, George Parsons Lathrop, "John La Farge," *Scribner's Monthly* 21 (February 1881): 503–16. Lathrop comments on the Japanisms in La Farge's work of the 1860s on p. 506. On La Farge's ability to capitalize on the fame of these drawings, see below, n. 61.

15. Waern claimed that La Farge took up illustration "as an amusement, and to divert his mind from suffering." Much of his work was done as he sat in bed, bolstered up with pillows. See Weitenkampf, "La Farge, Illustrator," 474; Cortissoz, *La Farge: A Memoir*, 137. Later in life, still burdened by poor health, La Farge continued this practice, "because I have found that when I was ill and could not, or thought I could not, go about or get on my steps before my painting, I would sit and do little things in size. For many of them are my best work, as they are for everybody" (Cortissoz, *La Farge: A Memoir*, 103–4). See also Weinberg, "Illustrations," 62–63; Lathrop, "La Farge," 511–13.

16. La Farge, in conversation with W. A. Rogers, in Rogers, *A World Worth While*, 141. La Farge's belief in the creative potential of illustration was revealed as early as 1860, in a letter to his fiancée, quoted by Henry Adams in "John La Farge," in *American Drawings and Watercolors in the Museum of Art, Carnegie Institute* (Pittsburgh: Museum of Art, Carnegie Institute, distributed by University of Pittsburgh Press, 1985), 65. Adams also cites Sadakichi Hartmann's opinion, voiced in 1901, that La Farge was one of the two instigators of "serious" illustration in America (64).

17. From the La Farge Family Papers, Department of Manuscripts and Archives, Sterling Memorial Library, Yale University; cited by Weinberg, "Illustrations," 68. As she notes, La Farge successfully replicated two of these compositions, *The Halt of the Wise Men* and *The Wolf-Charmer*, at a much larger scale. Many of them were also reworked in watercolor about twenty years later; see below, n. 61.

18. Cortissoz, *La Farge: A Memoir*, 143. Preparatory drawings for the *Enoch Arden* illustrations (particularly *The Mercy of Christ*, or *Enoch's Supplication* and *Enoch Alone*, catalogue raisonné nos. W1864.2 and W1864.3) show that La Farge was using brush and washes for this project in 1864; the wood engraving by J. P. Davis eliminated most traces of this procedure.

19. The conflict was recounted by the artist's son C. Grant La Farge in a letter to Frank Weitenkampf, November 24, 1914 (New York Public Library), quoted in "La Farge, Illustrator," 488–90. "When it came to the wood, the surface of the block used to be prepared with what I take

to have been some sort of Chinese White," wrote Grant La Farge. ". . . He then laid in the outline of his drawing with lead pencil as a guide. After this the drawing was made in wash with camels' hair brushes, using India Ink as a medium. There was the bone of contention between him and Henry Marsh. Of course, Marsh wanted lines to engrave, not wash." His son speculated that La Farge enjoyed the "greater freedom and flexibility in the use of the brush" and the "great delicacy and beauty of shading and values" obtained by its use. "I don't think that either he or Marsh was ever satisfied with the engraved result; but I feel pretty sure—that the very difficulty of the problem set the engraver led to qualities which could not otherwise have been obtained."

20. These engravings were praised "for subtlety, for richness of color, and for sympathetic translation of the originals." "The Old Cabinet," *Scribner's Monthly* 15 (April 1878): 889. "Such a union has rarely been known," concluded the *New York Tribune* that same year, summarizing a long description in praise of the La Farge-Marsh collaboration (February 14, 1878, 5). Another opinion that acknowledged Marsh's skill but argued against the premise of such imitative translation in wood engraving can be read in W. J. Linton, *The History of Wood-Engraving in America* (Boston, 1882), 36, 54–56; first published in the *American Art Review* 1 (1880); see especially 515–16. Despite his struggles with Marsh, La Farge was quick to defend the art of wood engraving along with other "minor" arts he espoused; see Adams, "La Farge," 66 and n. 8, with references to La Farge's newspaper debate in 1878.

21. See Foster, "Makers of the American Watercolor Movement," 49–50.

22. I have not found an explicit date for the use of photographic-transfer techniques given by the writers of this period; the date 1875 is generalized from visual material and from William M. Laffan's *Engravings on Wood by Members of the Society of American Wood Engravers* (New York: Harper's, 1887). Laffan dates the arrival of "a new and enlightened practice of the art" at "about 1875," when "the advantages of photographing the subject upon the block became apparent" (facing plate 3). Linton, in *The History of Wood-Engraving in America*, makes no mention of the onset of this technique, although he describes several works from 1877 and later as done from photographs on the block, and his description of the "new" style of imitative engraving (see above, n. 20) focuses on the period around 1875 as well. S.G.W. Benjamin, commenting on the "individuality and variety" occasioned by the new technology, noted that at "least twenty years ago designs were photographed on wood, although it is not until recent years that the practice has become common" ("Tendencies of Art in America," *American Art Review* 1 [1880]: 202).

23. See James L. Yarnall, "John La Farge's *Portrait of the Painter* and the Use of Photography in His Art," *American Art Journal* 18 (Winter 1986): 5–20. I am grateful to Dr. Yarnall for information and good conversation about La Farge's use of photography.

24. La Farge sold this block to *Scribner's* for $25 in 1879. About a year later, new photographic techniques were used to transfer the design to another block, which was cut by Timothy Cole and published in Lathrop, "La Farge," in *Scribner's* in 1881 (505; discussed 516). The engraving reversed the image but correctly transposed the inscription.

25. *Scribner's* commented that La Farge showed "two wood drawings which give with great salience two very different strains of feeling of which this artist is a master" ("Ninth Exhibition of the Water Color Society," 11 [1876]: 902); *The Independent* simply listed *Bishop Hatto* among the most interesting works in the black-and-white room ("Exhibition of Paintings in Water Colors," 28 [February 10, 1876]: 7).

26. Cropsey showed *The Epicurean*, no. 282; Hill, *Drawing on Wood*, no. 292. The Cropsey was lent by J. M. Falconer, always an instigator of progressive and influential practices at the society.

27. See Foster, "Makers of the American Watercolor Movement," 29–30 and chapters on Eakins, Homer, and Abbey.

28. On the Salmagundi Club, see ibid., chapter 5 and chapter 6, n. 35.

29. American Water Color Society minutes, May 5, 1868, Archives of American Art, Smithsonian Institution. La Farge did lend to their exhibition once before his debut in 1876: C. Troyon's *A Normandy Farm*, which appeared in 1870 (no. 420). On La Farge's reputation, see below, n. 35.

30. After entries at the National Academy of Design and Brooklyn Art Association between 1868 and 1871, La Farge appeared in no official New York exhibitions between the spring of 1871 and the spring of 1874.

31. American Water Color Society, 1878, no. 348, $50. The best description appeared in the *Tribune*, "Water-Color Society," February 14, 1878, 5. The *Tribune's* writer (probably Clarence Cook) also revealed that the sketch was hung poorly "in a dark corner," because it had been received late, from an anonymous sender ("Water-Color Society," *Tribune*, February 2, 1878, 5). The willingness of the Hanging Committee to wedge La Farge's work in at the eleventh hour demonstrates the respect or interest accorded his work by other artists; the same consideration was given to Homer in 1881.

32. "Water-Color Society," *Tribune*, February 14, 1878, 5. Again, this critic was probably Clarence Cook, who never seems to have been easy on La Farge's painting.

33. "The Old Cabinet," *Scribner's Monthly* 15 (April 1878): 888. The *Times* also praised this "odd little sketch," conceding that it was done "hastily, but with purpose" (February 2, 1878, 6).

34. Probably Earl Shinn, "Fine Arts: Eleventh Exhibition of the American Water-Color Society," *Nation* 26 (February 26, 1878): 157.

35. John F. Weir, "General Report of the Judges—Group XXVII," *Reports and Awards of the International Exhibition of 1876* (Philadelphia, 1877), 30. For an admiring estimate in 1881, see Lathrop, "La Farge," in *Scribner's*. The genesis of La Farge's critical popularity seems to have been in James Jackson Jarves's *Art Idea*, first published in 1864, but available in many later editions. La Farge also benefited from a scandal in 1874 involving the rejection of his work by the National Academy of Design despite his privileges as an Academician. The protest over his treatment by the jury focused new and sympathetic attention on his work at exactly the time his style was becoming acceptable. See Lois Fink and Joshua C. Taylor, *Academy: The Academic Tradition in American Art* (Washington, D.C.: National Collection of Fine Arts, 1975), 73–75.

36. Clarence Cook, "The American Water-Color Society," *Tribune*, February 1, 1879, 5. American Water Color Society, 1879, no. 15, illustrated in the catalog with a line drawing.

37. The *Times* reviewer added that "it need hardly be said that La Farge is *facile princeps* in the treatment of flowers. No one can find and give the expression of flower textures like him" ("Studies of the Artists," February 5, 1879, 5). Mariana Van Rensselaer agreed that the roses were "beautifully done," although she had reservations about his other work ("Recent Pictures in New York," *American Architect and Building News* 5 [March 22, 1879]: 93). Susan N. Carter, writing in the *Art Journal*, had nothing but praise for all his still lifes, noting that La Farge painted them "with a pleasure and satisfaction that communicate themselves to the spectator" (U.S. ed., "The Water-Color Exhibition," 5 [1879]: 94). More general expressions of admiration were heard in reviews that year in the *Aldine*, *Scribner's Monthly*, *Art Interchange*, and the *Nation*.

38. American Water Color Society, 1879, no. 244. The Leonard's Gallery auction catalog (Boston, 1879), no. 9, indicates this work was painted in 1878; it is now in the collection of Mrs. Greeley S. Curtis, Jr., Cambridge, Massachusetts. Cook, in the *Tribune*, found this the most "delicately felt and beautifully expressed piece of poetry among" all La Farge's entries that year ("The American Water-Color Society," March 1, 1879, 5). Likewise, the *Times* felt that "Nothing could be more exquisite than . . . 'Moonlight Over Snow,'—a little jewel of a picture, which is beautiful in its quality of winter landscape, and adds to that an unearthly effect like the colors of precious stones" (February 5, 1879, 5). A counter opinion was heard from Van Rensselaer, who alluded to La Farge's admiring followers when she noted that "Some of his worshippers assure us that in . . . *Moonlight Over Snow*, we had a landscape most poetically conceived and rendered. For myself, I have never seen Nature render himself in just that way" ("Recent Pictures in New York," 93).

39. American Water Color Society, 1879, nos. 111, 250. "It is impossible to give [the] brilliancy of glaze and richness of tint on paper; and if it could be done, what would be the use of doing?" asked Van Rensselaer, who found the results "scarcely more valuable than an elaborate bit of illumination" ("Recent Pictures in New York," 93).

40. See Carter, "Water-Color Exhibition," 94.

41. "Even in these there was that delightful richness of color and absolute harmony that make his every picture a chord perfect in itself; only one wants something more of a motive than is found in the mere striking of perfect chords" (W.M.F. Round, "Fine Arts," *Independent* 31 [March 6, 1879]: 9).

42. American Water Color Society, 1879, no. 392, *Cartoon of Painting on the Walls of Trinity Church, Boston. Nicodemus said unto himself, "how can these things be?"*

43. "Studies of the Artists," *New York Times*, 5.

44. Said Shinn, in appraising the potential in La Farge's *Sketch* of 1878, "When this sketch is developed into some striking fresco or glass-painting, the purchaser—the first buyer of any exhibition-picture by this artist—will doubtless look back on his courageous action with pleasure" ("Fine Arts," 157). Nevertheless, *A Sketch* was not sold.

45. The auction was held at Peirce and Company, in Boston, in the late fall of 1878. A report of this sale appeared in the *New York World*, November 19, 1878.

46. See table in Foster, "Makers of the American Water-color Movement," 36.

47. Earl Shinn, "The Growing School of American Water-Color Art," *Nation* 28 (March 1879): 172. A few years later La Farge commented indirectly on his own still-life subjects while discussing Oriental art: "The artist in more ordinary subjects may be wise in keeping to themes which are known to those whom he addresses and in which they can fully grasp and enjoy his success. These general themes allow a stricter individuality in the artist who uses them, when he is capable, and makes his want of individuality tolerable, and even more laudable and pleasant, when, like most of us, he has little of his own." Perhaps this is why, he mused, "the Japanese *objet d'art* never offends" ("Bric-a-Brac: An Artist's Letters from Japan," dated August 12, 1886, in *Century Magazine* 46 [July 1893]: 422). These letters were published as a book, *An Artist's Letters from Japan* (New York: Century Co., 1897).

48. Leonard's Gallery sale, December 18–19, 1879; "all the available works remaining" is quoted from the catalog.

49. I have discussed these watercolors in "Still-Life Painting of John La Farge." Henry La Farge's catalogue raisonné has located many of these paintings in contemporary collections.

50. Robert Jarvis, "Pictures by La Farge," *Art Amateur* n.s. 2 (June 1884): 13.

51. Ibid.

52. American Water Color Society, 1882, no. 392, $215. On Bridges (1835–1923), see William H. Gerdts and Russell Burke, *American Still-Life Painting* (New York: Praeger Publishers, 1971), 120; and May Brawley Hill, *Fidelia Bridges, American Pre-Raphaelite* (New York: Berry-Hill Galleries, 1981).

53. The English Pre-Raphaelites responded quickly to Japanese art in the 1860s, especially Rossetti. In the United States, La Farge began to paint Oriental bric-a-brac by 1862, if not earlier. The American Pre-Raphaelite Henry Roderick Newman also exhibited a Japanese still-life subject at the Artists Fund Society in 1867; although unlocated, this painting sounds, from its description in the *Tribune* (July 3, 1867), very much like La Farge's work in 1879.

54. Earl Shinn, "Fine Arts," *Nation* 20 (March 4, 1875): 156–57.

55. See Foster, "Still-Life Painting of John La Farge," 34.

56. On the influence of Spanish-Italian watercolor painting in the 1870s, principally in the work of Mariano Fortuny and his circle, see Foster, "Makers of the American Watercolor Movement," 30–34, 79, 228ff.

57. Earl Shinn, "Fine Arts," *Nation* 20 (February 4, 1875), 84.

58. "Art and Art-Life in New York," *Lippincott's* (June 1882): 599.

59. This comment was made in reference to American Water Color Society, 1879, no. 271 (unlocated), in Carter, "Water-Color Exhibition," 94. It is appropriate that Mrs. Carter, principal at the Cooper Union's Free Art School for Women and editor of a paperback handbook on watercolor techniques for amateurs, would be particularly sensitive to these issues.

60. S.G.W. Benjamin, "American Water-Color Society," *Art Journal* (U.S.) (1880): 93. The *Tribune* regretted that La Farge had "been able to send but little, and that little

is but small, though some of it is extremely pretty" ("Water-Color Exhibition," January 31, 1880, 5). Van Rensselaer in the *American Architect and Building News* also mentioned his "little drawings on the wood which exhibit all his indefinable charm of sentiment" ("The Water-Color Exhibition in New York," 7 [February 28, 1880]: 31). Many reviewers made no reference at all to his work that year. Such commentary (or silence) seems at odds with the list of six items that La Farge exhibited: 548. *Flowers*; 719. *Moonlight*; 720. *Frontispiece for a book on household decoration* (Cinderella); 721. *Study from Life*; 728. *Iris by the Sea*; 730. *Sphinx*. All but the first were owned by Sturgis and were hung in the corridor with the black-and-white work. Despite their titles, they may all have been book illustrations, like no. 720; James Yarnall has remarked to me that Sturgis probably bought them all at the Leonard's sale in 1879, where they were listed as "India Ink on wood."

61. See Foster, "Still-Life Painting of John La Farge," 26. The *New York Times*'s report of the Ortgies and Co. sale (April 17, 1884, 5) noted that this hurried New York sale included "pretty much all of his works that were left after the sales in Boston several years ago" (in 1878 and '79), brought to auction to relieve "embarrassment caused by his business ventures in stained glass and other decorative work." While the *Times* writer described La Farge as "a searcher in the fine arts . . . always groping ahead of the profession" and unwilling to limit himself to the production of salable work, the sale description also mentioned his "reproductions in water-colors of famous drawings on wood, published and unpublished, which have always been strong factors in Mr. La Farge's fame," such as his lily fairy design. "Recent watercolors" remarked as "especially delightful" included *Trionfo d'Amore*, *The Fisherman and the Genie*, *The Huntress* ("just done"), and *Marcella*, "a little work of great genius," depicting a seated figure in yellow and white. According to the review, these watercolors "hardly yield in beauty" to his oils. Similar references to recent copies in watercolor appeared in the *New York Times* (March 26, 1885, 3), following the Moore's Art Gallery sale, New York, March 26–27, 1885.

62. James Yarnall has located two watercolor and gouache images, painted on top of photographic prints of La Farge's earlier illustrations, including *The Halt of the Wise Men*. He discusses La Farge's use of photography in the 1860s (and later) in "La Farge's *Portrait of the Painter*."

63. Leonard's Gallery sale; see above, n. 48. This comment was repeated in "Exhibition and Sales," *American Art Review* 1 (January 1880): 129–30.

64. La Farge's decorative projects are well examined by Weinberg in her essay in this volume and in *Decorative Work*, where the Vanderbilt and Union League projects are discussed, 245–71. The Cornelius Vanderbilt II mansion, with its elaborate gallery for the display of his collection of European watercolors, marks an important moment for the American watercolor movement, too, for the wealthiest collectors had only recently begun to patronize work in this medium. See Foster, "Makers of the American Watercolor Movement," 296–97.

65. Mary Gay Humphreys, "The Cornelius Vanderbilt House, . . ." *Art Amateur* 8 (May 1883): 135; cited in Weinberg, *Decorative Work*, 256–57.

66. On La Farge, Richardson, and the reforming principles of the Arts and Crafts movement, see Weinberg,

Decorative Work, particularly the chapter "La Farge and the Decoration of Trinity Church, Boston" (subsequently published in the *Journal of the Society of Architectural Historians*, December 1975). La Farge insisted that the best training in art came from the "hand to hand teaching of the guilds," an attitude that he and Richardson probably absorbed from Ruskin (John La Farge, "On Painting," *New England Magazine* 38 [April 1908]: 232). On La Farge's "patient struggle" to convert workmen into artisans, see Anna Seaton-Schmidt, "John La Farge, An Appreciation," *Art and Progress* 7 (May 1910): 184. La Farge's involvement with progressive decorative art, as seen in the Cornelius Vanderbilt II house, is also featured in Dianne H. Pilgrim's essay, "Decorative Art: The Domestic Environment," in *The American Renaissance* (Brooklyn: Brooklyn Museum, 1979), 120–21. I have discussed at greater length the development of this aesthetic and its contradictions in American practice in "Makers of the American Watercolor Movement," 320–24.

67. La Farge, "Bric-a-Brac," 424.

68. Ibid., 423.

69. In 1889 La Farge remembered, "I had naturally taken a great interest, both in the early days and up to that date, in the English Pre-Raphaelite School begun by Ford Madox Brown and Rossetti, and at that time (in 1873) distinguished by Mr. Burne-Jones. I saw then something of their work and their methods in stained glass, and the ancient medieval glass became a subject of interest" ("On Painting," 239). Waern records La Farge's acquaintance with the Rossettis and Morris (*La Farge*, 252); but Henry Adams asserts that a meeting with Morris probably never took place ("Stained Glass of John La Farge," *American Art Review* 2 [July–August 1975]: 53). Adams's article provides an excellent overview of La Farge's work in glass, supplementing Weinberg's work. None of his early designs, planned in 1874–75, after La Farge's return to the United States, were executed (see Adams, "Stained Glass," 53, and reproductions, 56–57). Weinberg also discusses these projects in the context of La Farge's career as a decorator (*Decorative Work, passim*). La Farge quickly surpassed Morris and Company in the subtlety of his lead-line designing, plating, and use of novel glass, though Adams's criticism of the dull decoration of the firm's windows (unfavorably compared to La Farge's in "Stained Glass," 53) must be questioned by those who have seen the great Burne-Jones windows at Saint Martin's Church, Brampton, in Cumbria.

70. Lathrop, "La Farge," 503ff. Cottier and Co., a New York designing firm, was responsible for the non-figurative interior painting of Trinity Church.

71. La Farge's comment came in response to inquiries by the French Art Nouveau entrepreneur Samuel Bing (from the La Farge Family Papers, Yale University; cited by Weinberg, *Decorative Work*, 61). Bing's commentary on La Farge's art was published in France in 1895 and in Samuel Bing, *Artistic America, Tiffany Glass, and Art Nouveau*, trans. Benita Eisler (Cambridge, Mass.: MIT Press, 1970).

72. Apparently, La Farge's earliest mural sketches in watercolor (e.g., *The Three Marys*, collection Mrs. Henry La Farge) were done for the project at Saint Thomas Church, New York, in 1877, just when his watercolor work in other genres increased. Earlier studies for his projects in the 1860s were in crayon and charcoal; see Adams, "Stained Glass," 41ff. It is possible that the monochrome cartoon

The Visit of Nicodemus to Christ that appeared at the Water Color Society in 1879 was done after the mural, as a replica, although the mural was not installed in Trinity until later that spring. A gouache by this title (7 by 5 3/4 inches) annotated by the artist, "Visit of Nicodemus to our Lord. Study of Moonlight and Lamplight; also a study of one of the decorative groups in Trinity Church, Boston," also may be a study before or after the mural (*John La Farge, Oils and Water Colors* [New York: Kennedy Galleries, 1968], cat. no. 10). This gouache was sold at the Moore's sale in 1885 (no. 62). It is not clear whether or not this is the same work shown at the American Water Color Society in 1879. Although it was seemingly too small to be useful as a working drawing, La Farge did use similarly sized drawings for his stained glass, and his late mural studies are equally petite. He also made a small oil replica of *The Visit of Nicodemus to Christ* (plate 70); this recycling of a popular mural image followed his pattern of making watercolor and oil replicas of earlier illustrations.

73. See Barbara T. Ross, *American Drawings in the Art Museum, Princeton University* (Princeton: Art Gallery, Princeton University, 1976), cat. no. 72. As with *Nicodemus*, La Farge also painted an oil of this subject about four times larger, now known as *Woman Bending a Branch* (Museum of Fine Arts, Boston). See Weinberg, *Decorative Work*, 266. Given the loss of the ceiling itself when the house was demolished in 1927, it is not clear whether or not these oils and watercolors came before or after the mural. Three watercolor studies for this ceiling were exhibited at the Pennsylvania Academy of the Fine Arts in 1888. According to the Princeton catalog, their *Sense of Smell* was once owned by Tiffany. For a description and reproductions of the Vanderbilt ceiling, see Weinberg, *Decorative Work*, 256ff. The T-shaped panels in this room were designed to follow the pendentives. Evidently, the murals were done on canvas and set into the ceiling. It is unlikely that they were painted in watercolor, as Ross asserts in the Princeton catalog, no. 72.

74. See, for example, Shinn's criticisms of La Farge's drawing in "Growing School of American Water-Color Art," 172. Also in 1879, S.G.W. Benjamin characterized La Farge's drawing as "defective . . . hesitating, uncertain and feeble," but added that America had "no artist since Stuart who has shown such natural sympathy for the shades and modulations of chromatic effects" (*Art in America* [New York: Harper's, 1880; copyright 1879], 94). Benjamin's praise summarizes the admiration for La Farge as a colorist, widely held by 1879. Like his reputation as a poetic, intellectual artist and a still-life painter, this opinion seems to date to Jarves's *Art Idea* of 1864. Praise for La Farge's color and criticism of his drawing are likewise summarized by Weir in his report on the Centennial Exhibition, "General Report of the Judges. . . ," 30.

75. In a description of two floral designs for embroidery, a writer in 1882 commented on La Farge's careful methods, his elaborate cartoons and color studies ("Artistic Needlework in New York," *Art Amateur* 6 [February 1882]: 61). The Vanderbilt portieres, executed in gold and silken threads on silver cloth, were described in "Art Notes," *Art Journal* (U.S.) 8 (November 1882): 351–52. See Weinberg, *Decorative Work*, 262–63. A cartoon for one of these curtains was reproduced in the *Tribune*, February 17, 1901, 8–9. La Farge also did designs for theater drop curtains; see Ross, *Princeton*, cat. no. 77.

76. The embroidery designed by La Farge appeared in the U.S. edition of the *Art Amateur* 2 (1880): 96, 224. Candace Wheeler noted that American embroiderers quickly broke away from the South Kensington manner and took to designs with "natural flowers, following the lead of Moravian practice and flower painting, rather than decorative design" (*The Development of Embroidery in America* [New York and London, 1894; reprint, Harper and Brothers, 1921], 11).

77. Henry Adams has estimated that La Farge was responsible for about five thousand window designs ("Stained Glass," 54).

78. This window was designed for the Jenkins house, in Pennsylvania; it is now in the collection of Robert Roch, South Norwalk, Connecticut.

79. American Water Color Society, 1887, no. 257. Full-scale cartoons for the lead lines were developed for each window, but the color guide was usually just a small, sketchy watercolor that, according to the artist's grandson, Henry La Farge, "served the glassmaker and La Farge himself as a point of reference in choosing the individual pieces of glass." The margins of plate 109 are strung with annotations, perhaps instructions to his assistants or personal memoranda. The result was full of improvisation and surprise, though not as much as might be predicted, because these "little working sketches for window designs . . . came to embody coded meanings in their watercolor washes that corresponded to certain specific choices of glass." Henry A. La Farge, "Introduction," in *La Farge* (New York: Kennedy Galleries, 1968), 2–3. When the window was completed, La Farge saved the sketch, to be used as an exhibition piece (like *Saint Elizabeth of Hungary*) or reworked in another design. This practice may have been learned from the example of the Pre-Raphaelite designers, for Morris used watercolor to design his papers and textiles, and Burne-Jones made large watercolor cartoons and replicas for his window projects.

80. Cortissoz, *La Farge: A Memoir*, 87–88; see also Henry Adams, "Stained Glass," 58–61. Referring to Chevreul's famous treatise, *De la Loi du contraste simultané des couleurs* (first published in 1835 and later translated into English as *The Principles of Harmony and Contrast of Colors*), La Farge commented, "Personally I the painter have never ceased obedience to what I could understand of [Chevreul's teachings]" ("On Painting," 240).

81. Ogden Rood, a founding member of the American Water Color Society, published his influential treatise, *Modern Chromatics, with Applications to Art and Industry*, in 1879. This work supplanted, particularly for English readers, earlier works on the subject by George Field and Chevreul; translated into French, it became a bible for Georges Seurat and the Neo-Impressionists. When published, Rood's book was praised for its usefulness to painters and decorators: "Its author has worked as patiently and seriously outdoors, with sketch-book and pigments, as in his laboratory; and this earnest attention to the study of Art has enabled him more clearly to understand the needs of the painter, and more intelligently to select and describe his experiments" ("The Science of Color," *Art Journal* [U.S.] 6 [1880]: 187).

82. John La Farge, *The Higher Life in Art* (New York: McClure Co., 1908), 138.

83. Henry Adams has established the progression of La Farge's ideas from his 1860s landscapes to his stained glass, though he has not remarked the link made by watercolor in La Farge's work (see "Stained Glass," 41–63). I introduce this thesis in "Still-Life Painting of John La Farge," 33.

84. The first window from this peony design was made for the Henry G. Marquand house in Newport in 1879; it is now in the Metropolitan Museum and reproduced in color (from the wrong side of the window) in *19th-Century America* (New York: Metropolitan Museum of Art, 1970), 194. A similar design for Cornelius Vanderbilt II was published in Mary Gay Humphreys, "John La Farge, Artist and Decorator," *Art Amateur* 9 (June 1883): 13. La Farge also used this peony motif for windows for Lawrence Alma-Tadema (plate 26) and in related subjects, like the Ames windows (plates 148, 149). See Foster, "Still-Life Painting of John La Farge," 32–33. La Farge's tendency to think in color rather than in value makes his work difficult to appreciate, or even read, in black-and-white reproductions, as Henry Adams pointed out to me in conversation, September 17, 1975. The watercolor *Peonies in a Breeze* (plate 110) presents another confusing example of La Farge's tendency to rework his own designs, for it was done at least a decade after the first window made with this image. The drawing may be a fresh version from an older sketch, with new color notes, or a variant based on an earlier window.

85. Before this date La Farge's window designs seem to have been in crayon. Following the unsuccessful designs of 1874–75 (see above, n. 69), there was a hiatus in La Farge's glass designing; the new round of work (and the watercolors) began after the completion of the mural in Saint Thomas Church, in the fall of 1878. William Walton, "The Decorations of the Chancel of Saint Thomas Church, New York City," *Craftsman* (December 1905): 373.

86. As Lathrop commented in 1881, "With [La Farge] there is not that distinction between life-studies and finished paintings which is so often seen. As a rule, his slightest drawings have, therefore, the value of pictures" ("John La Farge," 515).

87. Correspondence with the author, 1976.

88. Humphreys, "La Farge, Artist and Decorator," 14. She later commented on the similarities between the streaked glass and brushwork. The Ames windows are now in the St. Louis Art Museum. By 1886 La Farge's murals, oils, and illustrations had, in the opinion of one critic, been eclipsed by his other achievements: "Few can vie with La Farge in watercolors and stained glass" (*American Art Review* 1 [November 1886]: 20).

89. "Union League Club," *Harper's Weekly* 25 (1881): 118; cited in Weinberg, *Decorative Work*, 254.

90. Benjamin, "Tendencies of Art in America," 196–97. He was also happy to see the public awaken to the "quality of color, atmospheric effect, and a dash of treatment which are peculiar to this art" because "a certain degree of culture is essential on the part of the public in order to enjoy a good watercolor painting."

91. See Kathleen Foster, *American Drawings, Watercolors and Prints*, a special issue of the *Metropolitan Museum of Art Bulletin* 37 (Spring 1980): 44.

92. The admirer, Frederick S. Lamb, also noted that "it is given to few men to express in the work of a lifetime the development of a country," as La Farge expressed American art ("John La Farge . . . ," *Craftsman* [June 1905]: 312).

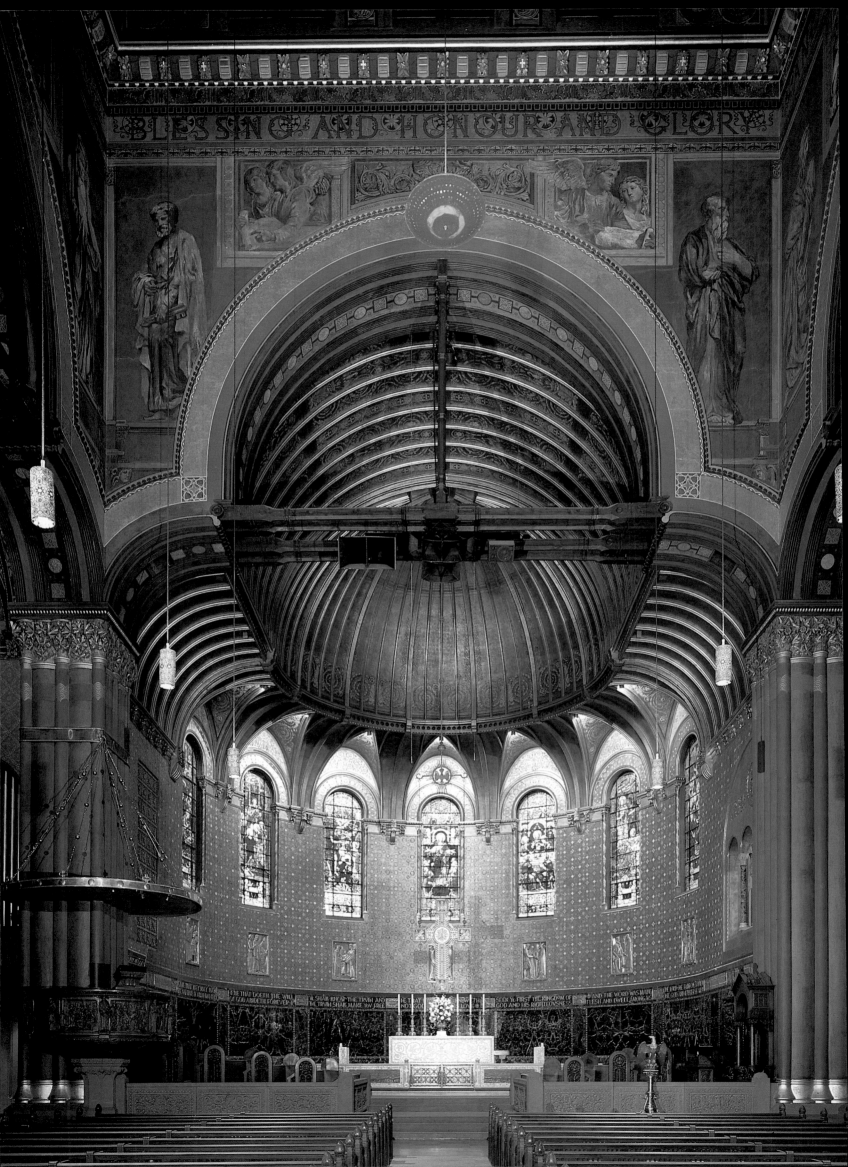

John La Farge: Pioneer of the American Mural Movement

H. Barbara Weinberg

115
Trinity Church, Boston, 1876–77
Chancel, as redecorated in 1902
MD1876.1

116
Confucius: Founder of Law and Philosophy in China, 1906
Encaustic on canvas
Dimensions unknown
Baltimore Court House, Baltimore, Maryland
MD1906.2

John La Farge was a central figure in late nineteenth-century American cultural life. He enjoyed friendships with leading intellectuals and affiliations with the most important professional groups. He was a gifted teacher, and he lectured and wrote extensively. His artistic virtuosity was remarkable, and he explored the entire spectrum of traditional subjects and an impressive range of media. Yet among La Farge's accomplishments, none appears as impressive as his mural decorations, and none—except, perhaps, his stained glass—as likely to sustain his reputation. His murals were ambitious in scale, varied and sophisticated in subject matter, and experimental in technique. They were also absolutely unprecedented in the history of American art and remain among the most significant manifestations of the American mural movement. Even more important, they vividly reflect a fundamental duality in late nineteenth-century American thought, merging a desire for affiliation with tradition with a modern respect for empirical, natural fact.

Triumphant capitalism in the period after the Civil War radically altered American taste and art. Aided by technological advances that made Europe more accessible, businessmen and financiers who had profited from the war increasingly traveled abroad and acquired a taste for European architecture and art. To demonstrate their sophistication and respectability, many of them built new homes, usually in emulation of European models, and filled them with imported art, both old and new. Eager to compete with European artists for patronage, American painters avidly pursued foreign study and assimilated European styles, especially those of the stars of the Paris Salon. Like their patrons, they esteemed eclecticism and self-consciously sought to develop a new "American" art out of the best that the world had to offer.

While many artists who returned home despaired of being able to surpass their foreign counterparts in the American art market, others found extraordinary and unparalleled opportunities. The Civil War had provoked increased industrialization and territorial expansion, which led to population growth and the demand for new governmental, religious, and social facilities. The taste that conditioned the design and decoration of the homes of the newly rich also infused new or refurbished state capitols, courthouses, libraries, clubs, and churches. American artists who could serve this taste enjoyed a heyday, a range of commissions for mural painting, architectural sculpture, and stained glass to be envied even by their French contemporaries. The climax of this movement—which has been called the American Renaissance—occurred in the decades on either side of the turn of the century, stimulated after 1893 by the display of American Beaux-Arts design and decoration at the World's Columbian Exposition in Chicago and diminishing after the completion of several major state capitols just before World War I. Its earliest manifestations are the decoration of Trinity Church, Boston, by John La Farge in 1876–

78 and the murals for the New York State Capitol Assembly Chamber by William Morris Hunt, painted in 1878–79.

La Farge and Hunt, the pioneers of the American mural movement, had also been pioneers in seeking Parisian training in the 1840s and '50s. While their successors would assimilate more orthodox Beaux-Arts styles and principles—working at the Ecole des Beaux-Arts or at the rival Académie Julian—Hunt and La Farge had studied under Thomas Couture, whose rapid, painterly, Venetian-based style revealed his disenchantment with French academic practices. La Farge in particular would consistently echo the Venetian tradition, from Giorgione to Couture and Eugène Delacroix. Although La Farge's and Hunt's pioneering mural projects were perceived as jointly exemplifying a "new dispensation of monumental art,"[1] it is La Farge's that merits primacy of place, and not only for its primacy of date. Hunt's effort was an elaboration of ideas first formulated in easel painting and then enlarged to mural scale for insertion in a room that the architect alone had designed. By contrast, La Farge's decoration of Trinity Church was conceived as a mural project in response to a particular architectural setting, and it reflected a collaboration between architect and artist as well as an integration of architecture and painting—an interaction fundamental to the developing mural movement.

While La Farge's period of study under Couture in 1856 had been brief, it coincided with the completion of Couture's decoration of the Chapel of the Virgin in the Cathedral of Saint-Eustache, Paris. La Farge seemed not to have realized the ultimate benefit of his exposure to Couture as a muralist; he spoke much more, during his student days and after, of the impression made upon him by the murals of Delacroix. He found, however, that he wished to continue training in Couture's manner once he had returned to New York and decided on a career as an artist. Going to Newport to study under Hunt in 1859, he was disappointed to find that Hunt had abandoned the practice of Couture in favor of emulating the Barbizon painter Jean-François Millet. Yet the techniques of the two French masters were similar, and Hunt's teachings and technique resembled those of Couture, despite his tendency to imitate Millet's subjects.

By June 1872, when H. H. Richardson received the commission to design Trinity Church on Copley Square in Boston's newly developing Back Bay, he had known La Farge for five or six years. It is possible that he had La Farge in mind for work at Trinity from the beginning, as one of Richardson's competition drawings indicates that he intended to ornament the interior of the church with polychrome decoration. La Farge was one of the few American painters to whom the French-trained architect was likely to have turned. La Farge had received training in the French manner, both abroad and at home, and other personal and professional factors would have made him appear well qualified to undertake the work. Aged thirty-seven in 1872 (in contrast to Hunt's forty-eight), La Farge was three years older than the architect. Born of French émigré parents and raised as a Catholic in circumstances that were economically and intellectually privileged, he possessed an unusual worldliness and sophistication. Although La Farge may not have practiced his religion in an orthodox manner and may not have experienced or expressed any especial spirituality, his extensive religious education and connections within the Catholic community would have equipped him more fully than most of his contemporaries to explore religious imagery. La Farge's studies in the liberal arts, his firsthand acquaintance with the works and techniques of French and English aestheticians and decorators, his sympathy to the art of the past and inclination toward creative eclecticism, and his friendships with American architects also would have recommended him to Richardson.[2]

During his sixteen-year artistic apprenticeship after his study under Couture, La Farge had shown a tendency toward the ideal and the decorative in a few experiments in

domestic and church decoration. Richardson had, in fact, admired one of his earliest mural projects—panels of fish and flowers painted for the dining room of the Charles Freedland house, Boston, in 1865—and had considered engaging La Farge to decorate two earlier churches.[3] La Farge had also displayed a predisposition toward the ideal and the decorative in his naturalistic landscapes and still lifes. Conversely, he would consistently draw upon the naturalistic impulse that had generated these works in interpreting ideal themes in his murals.

In the course of developing his plans for Trinity, Richardson appears to have relied on La Farge's advice to design the tower after that of the Salamanca cathedral, photographs of which La Farge supplied to the architect.[4] Some of Richardson's working drawings suggest that his initial plan for a painted interior yielded, at least for a while, to one highlighted only by stained-glass memorial windows. By the summer of 1876, however, Richardson had invited La Farge to plan a far more ambitious mural scheme than that suggested in his original competition drawing. Two important conditions affected the award of the contract to La Farge by Trinity's Building Committee: that he decorate the church cheaply and quickly. In the interest of economy, he proposed that almost all of the decoration be carried out before completion of the building, so that he and his assistants could use the contractors' stagings. The lingering effects of the Depression of 1873 permitted La Farge to employ assistants at very modest wages, and he accepted the lowest possible fee for himself. As the congregation had been homeless since its Summer Street church had burned in November 1872, La Farge agreed to plan and execute the decoration in only a bit more than four months. It was in meeting this schedule that he most fully exploited his training in Couture's quick, painterly method.

Aside from the limitations of money and time, Trinity provided a very hospitable setting for color decoration. The Romanesque style of the church, derived generally from twelfth-century Auvergnat models, made large wall and ceiling surfaces available. As these were covered by plaster, La Farge could choose color with as much freedom as he could choose forms. The only requirement was to follow Richardson's preference for red as the prevailing note. La Farge would blend precedents in much the same way that Richardson did to convey the spirit of early Christianity, a spirit consistent with the theological and aesthetic leanings of the congregation and clergy, especially those of the sophisticated and well-traveled rector, Phillips Brooks.

After engaging a firm of decorators to paint the walls and ceilings, La Farge hired artists to assist him in the figurative and the detailed ornamental work. Among those who subsequently gained repute were George Willoughby Maynard, Francis Lathrop, Augustus Saint-Gaudens, and Francis Davis Millet. The master and his assistants divided the responsibility for embellishing almost every surface of the church, working from designs that were essentially La Farge's. Their sympathetic collaboration makes identification of individual hands as problematic in Trinity's decoration as it would be in the product of any successful Renaissance or Baroque workshop. Such interdependence with assistants, who would emulate his method and manner, would characterize all of La Farge's later activity as a muralist.

The medium of almost all the painting in the church is durable, water-resistant encaustic, consisting of wax melted with turpentine, alcohol, and Venice turpentine and applied directly to the walls. La Farge's interest in this medium derived from a meeting in Brussels in 1856 or 1857 with Henry Le Strange, who had used encaustic for the ceiling in the west tower of Ely Cathedral in 1855. La Farge's confidence in the durability of the medium was confirmed during the 1956–57 restoration of Trinity, which involved little more than cleaning with mild detergent.

Contrasting with the coffered tower ceiling (plate 123), which is patterned in green

against a blue-green background, the tower walls are of a higher tint than the dull red lower walls of the church and are ornamented with two series of decorations. Adjacent to the windows are symbols of the four Evangelists, a pair of large Latin crosses painted in imitation of mosaic work, and two illuminated texts. The second series appears in the lunettes above the twelve pairs of windows and consists of scriptural scenes interpreted in early Christian motifs. Although much of this decoration can be read from the floor in only the most general way, no tower surface was denied elaborate enrichment, not only

117
First Study for Tower, Trinity Church, Boston, 1876
Crayon on paper
6¼ × 11½ in. (15.5 × 29.3 cm.)
The Art Museum, Princeton University, Princeton, New Jersey
Gift of Frank Jewett Mather, Jr.
D1876.3

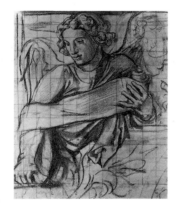

118
Angel with Scroll, 1876
Cartoon for mural, Trinity Church, Boston
Pencil and charcoal on paper
12⅝ × 10½ in. (32.1 × 26.7 cm.)
National Gallery of Art, Washington, D.C.
John Davis Hatch Collection
D1876.22

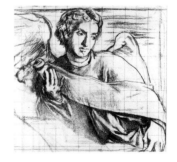

119
Angel with Scroll, 1876
(An Angel: Study for a Decoration in Trinity Church)
Cartoon for mural, Trinity Church, Boston
Charcoal on paper
13 × 13 in. (33 × 33 cm.)
Sterling and Francine Clark Art Institute,
Williamstown, Massachusetts
Gift of Mr. L. Bancel La Farge
D1876.23

for its own sake but in the interest of strengthening the architectural harmonies within the church as a whole. The blue and gold backgrounds of the lunettes, for example, contrast with the red walls of the tower, emphasize the round-arched window frames, and echo the massive arches of the lower tower. To assure the visual unity of the tower, La Farge also appears to have dictated the design of the tower windows, thus beginning his lifelong involvement with the problem of integrating stained glass with painted decoration.

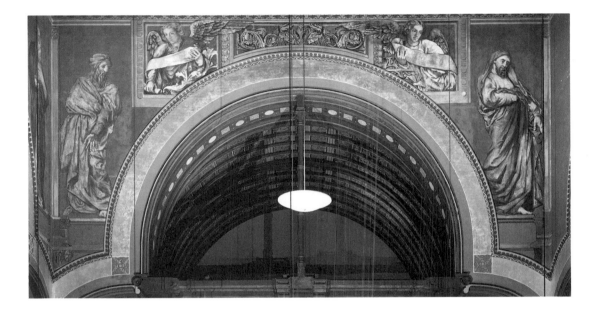

120
Trinity Church, Boston
South wall of lower tower

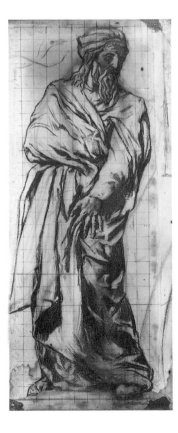

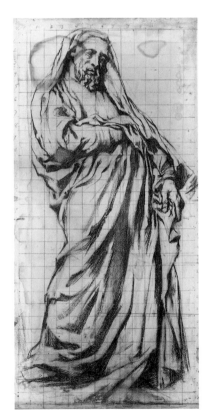

Left
121
Isaiah, 1876
Cartoon for mural, Trinity Church, Boston
Crayon on paper
28 × 13⅞ in. (71.1 × 35.2 cm.)
Sidney Ashley Chanler
D1876.6

Right
122
Jeremiah, 1876
Cartoon for mural, Trinity Church, Boston
Charcoal on paper mounted on canvas
29½ × 15½ in. (74.9 × 39.4 cm.)
Yale University Art Gallery,
New Haven, Connecticut
The Gheradi Davis Fund
D1876.7

123
Trinity Church, Boston
Tower ceiling

At a height of some sixty feet, Trinity's upper tower is divided from the lower by a corbeled cornice resting on a series of foliate and geometric friezes. These surmount a wide gold border bearing a text from Revelation in dull red Roman letters, which extends around the four sides of the tower. Below this inscribed band and over the great arches on three sides of the tower, half-length angels holding scrolls and painted in pearly shades of rose and blue occupy rectangular panels with violet backgrounds (see plates 118, 119). In the adjacent spandrels are six colossal figures of prophets and apostles that are the most conspicuous feature of the decoration (see plates 120–22). It is in the strong outlines and broad, scumbled surfaces of these figures that the influence of Couture is most apparent, as it is in the fact that they could be and were executed with extreme haste. Their isolated, floating effect, which critics disliked, must reflect La Farge's intentional effort to recall the decoration of churches from the period of early Christianity.

124
Trinity Church, Boston
Chancel and south transept

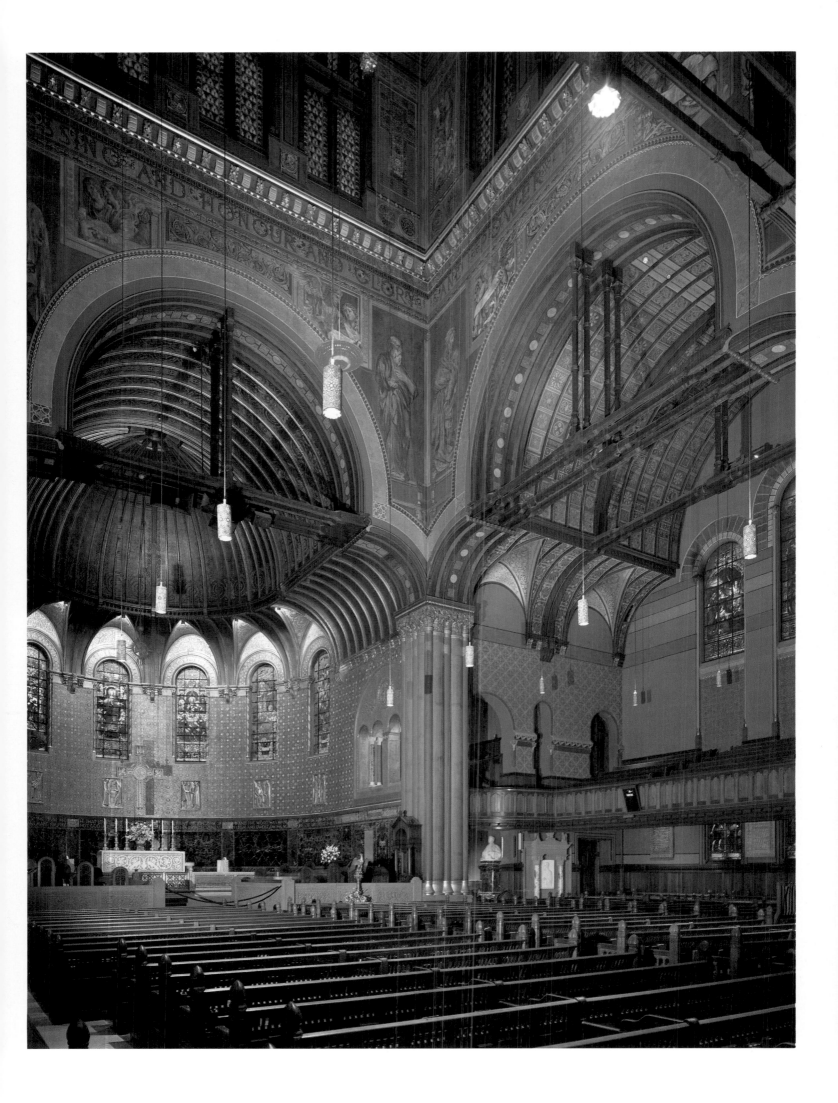

In spirit and pictorial detail the decorative scheme for Trinity's tower recalls early Christian art. Although a rigid concordance is not evident, scenes and figures illustrate correspondences between the Old and New Testaments, with concentration on themes of salvation through faith and the extension and increase of faith. The possibility of a direct relationship between the iconography of Trinity's tower and the religious philosophy of Phillips Brooks invites additional inquiry.[5]

La Farge, with his assistants, carried the richness of painted ornament in the tower into other areas of the church, such as the vaulted nave and the transept ceilings. He also devoted extensive consideration to the chancel decoration. The effect, evident in early descriptions and in photographs taken before a 1902 renovation (plate 125), must have

125
Trinity Church, Boston
Chancel in 1888

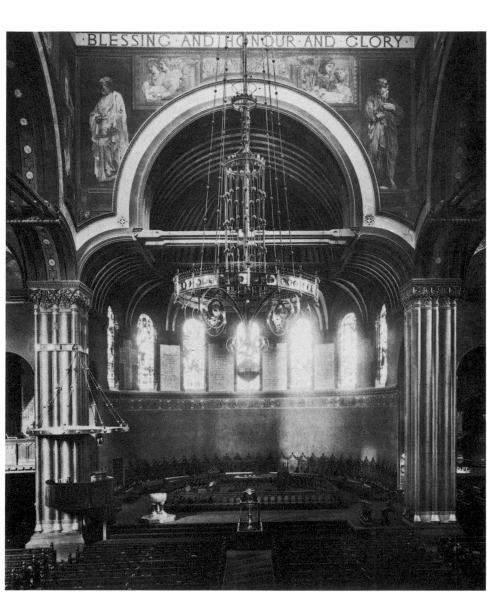

been impressive. The chancel's most striking feature was a series of six panels between the windows. In these, gold grounds set off elaborate Latin crosses (similar to those in the upper tower), extracts from the communion service, and the texts of the Lord's Prayer and the Apostles' Creed. La Farge also planned a "processional decoration" for the chancel, above the thirty-six black walnut stalls that lined the east wall. While this element of the decoration was not included in his original contract and was never undertaken at Trinity, the artist later used it for *The Nativity* and *The Adoration of the Magi* in the Church of the Incarnation, New York.

Decorative work at Trinity continued until the end of January 1877, with the last of the great tower stagings being removed on February 3, only six days before the consecration. Critics admired the interior decoration and commented on its novelty in the history of American art, its uniqueness in depending upon the efforts of artists rather than artisans, and its place as a forerunner of a new movement in religious decoration in which art and architecture would be fully integrated.[6] They noted, however, that the decoration of "Boston's Basilica" was not entirely finished. Some seemed to expect the addition of elaborate ornament to the nave. La Farge appears to have decided to limit decoration there to the aisle arches and to the clerestory level of the nave walls, where he painted two murals, as specified in his contract (plate 24).

He completed the first of these, *Christ and the Woman of Samaria at the Well*, on the north wall of the nave by October 1877 and finished *The Visit of Nicodemus to Christ* on the south wall some time between February and May 1878. These murals benefited from the extra time allowed to execute them. La Farge also brought to them his experience in painting the large murals in Saint Thomas Church, New York, which he completed concurrently. He effected a solution to the task of depicting narratives there that he then applied to the *Woman of Samaria* and *Nicodemus* murals: all of these narratives establish his mature style of mural painting, recapitulating the blend of the natural and the ideal or decorative that characterizes many of his earlier easel works. Throughout his long career as a muralist La Farge would restate his ability to express in naturalistic terms the ideal themes available in world history, religion, and mythology, to describe episodes based in fact, faith, or fantasy as if they were actually taking place. Despite their reliance on volumetric forms and the illusion of enterable space—fundamentals of a naturalistic style—La Farge's murals would preserve the integrity of the flat wall, in keeping with prevailing criteria for decoration.

Although La Farge might have wished for greater financial returns on his investment of time and effort at Trinity, he could not have hoped for more impressive professional profits. A pivotal work in the history of American church design, and in the career of its architect, Trinity also established La Farge's reputation as a major American artist and brought him other commissions for sacred and secular decoration.

In the decade following completion of the main part of his work at Trinity, La Farge was invited to provide murals for three neo-Gothic Episcopal churches in New York. These projects presented analogous problems and elicited similar solutions. As at Trinity, La Farge explored and recombined varied precedents so that his work might evoke a spiritual link with the past and appear appropriate to the architecture of each church. Additionally, he expressed ideal, even supernatural themes in naturalistic terms, mixing natural light and suggestive atmosphere. He further developed a personal mural style based on the painterly colorism of the sixteenth-century Venetians, both as he had experienced it directly and as he had seen it reinterpreted by Couture and Delacroix. He declared allegiance to that tradition not only in form and style but also in his commitment to the collaboration of artists in various media and to the coordination of the roles of artist and artisan for a unified effect.

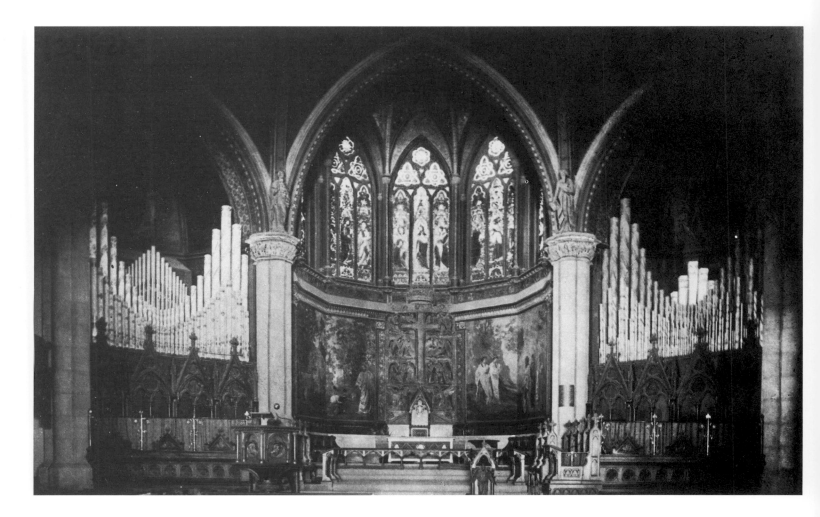

Unity and collaboration were compromised in the first of these three commissions, the decoration of the chancel of Saint Thomas Church, at the northwest corner of Fifth Avenue and Fifty-third Street (plate 126). This was the last important church designed by Richard Upjohn, America's leading interpreter of the neo-Gothic style. Although the first service was held in October 1870, funds for decorating the chancel were not available until much later, and the work was not completed until April 1878. Upjohn's retirement before the initiation of the chancel project, the general finishing of the interior before La Farge was engaged, and the contractual limitation of his work to the chancel all impeded unity.

La Farge was also handicapped by the physical attributes of the space to be decorated, including the shape of the deep polygonal chancel and the conflicting light sources. As at Trinity, he was also hampered by inadequate funds and time. William F. Morgan, the rector, dictated key elements in La Farge's plan for decorating the chancel: the subject of the Resurrection, including the specific Gospel texts, and the inclusion of a tall Latin cross and a wooden Gothic bishop's chair against the chancel wall.

Bound by all these conditions, La Farge exploited the pentagonal form of the chancel for an effect reminiscent of an early Renaissance altarpiece. In the central section, above the bishop's chair, he set the cross in a reredos of adoring angels, executed in painted plaster relief by Augustus Saint-Gaudens from La Farge's designs. He framed this panel with carved and inlaid pilasters and, at the rector's request, hung an ornate crown above the cross. The "wings" of the "altarpiece" illustrated the prescribed texts: *Christ Appearing*

126
Saint Thomas Church, New York, 1877–78
Interior before 1896
MD1877.2

127
The Three Marys, 1877
Cartoon for mural, Saint Thomas Church,
New York
Pencil on paper
12⅝ × 10¼ in. (32.2 × 25.9 cm.)
The Art Museum, Princeton University,
Princeton, New Jersey
Gift of Frank Jewett Mather, Jr.
D1877.9

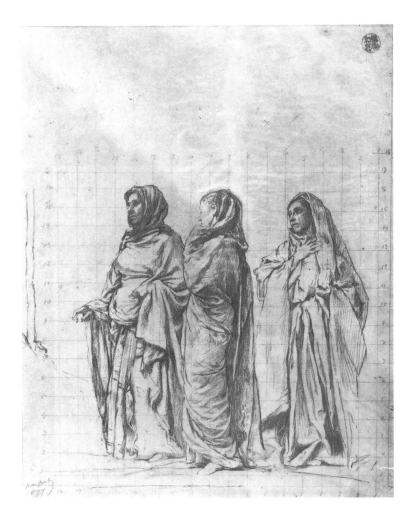

to *Mary Magdalene (Noli Me Tangere)* and *The Angel at the Tomb* in two panels at the left and the *Arrival of the Three Marys at the Tomb of Christ* at the right. La Farge executed these twelve-foot-high murals in encaustic on canvas for later application to the walls. This was the method and medium of all his mural painting subsequent to Trinity; only the Church of the Ascension mural was executed in place, albeit on canvas.

La Farge's creative eclecticism is evident in his conjoining for his own version of the Resurrection story a motif from Giotto's *Noli Me Tangere* in the Arena Chapel with a motif for the *Arrival of the Three Marys* (see plate 127) based on a well-known Byzantine ivory. The juxtaposition of the two reflects the typically varied sources and reference methods for La Farge's borrowings. For Giotto, whose works he had not seen (he first visited Italy in 1894), he relied on engravings published by the Arundel Society; the Byzantine ivory he may have studied in the Bayerisches Nationalmuseum during his trip to Munich in 1856.

To accommodate Morgan's wish to have Christ placed at the center of the Saint Thomas chancel wall, La Farge reversed the scenes and compromised the narrative and visual clarity of his original arrangement, which had treated them as a single story with two episodes. What unity is evident derives from the landscape setting, which replaced the abstract backgrounds in La Farge's sources and gave a sense of place without contradicting the flatness of the wall.

Handicaps to visual and narrative coherence notwithstanding, La Farge strove mightily for a unified effect and collaborated with artists in different media, merging responsibilities

of artist and artisan. He designed enframements for his paintings and for Saint-Gaudens's reredos and helped carve them. He obtained permission to paint over the stained-glass windows already in place in the chancel in order to integrate them with his decorative scheme. When he was disappointed with an artisan's interpretation of his design for the chancel ceiling, he repainted it himself.

The donor's funds for the Saint Thomas chancel decoration ran out before La Farge was satisfied with the ensemble. Thus, it was surely with ambivalence that he responded to the church's proposal nearly twenty years later, in 1896, that he plan alterations for the chancel he had never finished decorating. Whatever plans he devised at that time were rejected, and the renovation was carried out by another decorator. The church remained dissatisfied, and in 1904 La Farge was once again consulted regarding alterations. He proposed to put Saint-Gaudens's plaster reredos and other details into lasting materials, to rearrange the lighting, and to remove combustible materials from the chancel. Had this taken place, the fire that destroyed the church on the morning of August 8, 1905, might not have occurred. Doubtful that he could replicate the scheme, even if invited to do so, La Farge never had the chance to try. The church was rebuilt in even stricter neo-Gothic style by the architectural firm of Cram, Goodhue, and Ferguson, beginning in 1909, the year before La Farge's death.

The Church of the Incarnation was constructed at the northeast corner of Madison Avenue and Thirty-fifth Street in 1863–64. Its interior, in the Early Decorated English Gothic style, relied on memorial windows set into stenciled walls for ornament; the shallow, windowless chancel was austerely decorated with Gothic medallions and moldings. On March 24, 1882, fire damaged the church, particularly its chancel. The plans for rebuilding suggest that vestry and congregation were accepting more beautiful surroundings for worship. The prime mover was undoubtedly the rector, Arthur Brooks, the brother, travel companion, and confidant of Trinity's rector, who probably shared his theological attitudes and taste.

The rebuilding of the Church of the Incarnation began just after the fire, and the church was reopened at Christmas 1882. However, depressed business conditions and the expectation that the walls of the newly deepened chancel—designed by La Farge's son C. Grant La Farge—would settle delayed decoration. The general coloring and gilding of the chancel were finally carried out in the summer and fall of 1885, and La Farge undertook a pair of murals for the upper chancel wall the following winter (plate 128).

The name of the church dictated the themes of the murals: *The Nativity* and *The Adoration of the Magi*. La Farge had shown an interest in the Magi as early as 1868, when he depicted their journey in an illustration for the December issue of the *Riverside Magazine for Young People* (plate 129). A decade later, while he was considering a decoration incorporating the Magi for the chancel of Trinity Church, he translated that illustration into a large painting. Typically, *The Three Wise Men* (plate 130) demonstrates La Farge's habit of expressing ideal themes in naturalistic terms, setting the three kings in an identifiable Newport landscape. La Farge expanded the theme of the Magi to include the Nativity in a pair of wood engravings published in *Scribner's Monthly* in January 1881. These were simply enlarged for the curving walls of the Incarnation chancel.

As at Saint Thomas, the two chancel murals were closely linked in content and were placed, like the wings of an altarpiece, on either side of a large Latin cross. Also similar were the unified treatment of light and the exploitation of early Renaissance sources: motifs from the Nativity scenes of Giovanni Pisano's Pisa and Pistoia pulpits and Giotto's Arena Chapel *Nativity* and Peruzzi Chapel *Vision on Patmos*. Rather than the early morning light that pervaded the Saint Thomas murals, La Farge recorded nocturnal

illumination, as he had in the scene of Nicodemus and Christ at Trinity, and explored contrasts between outdoor and indoor, natural and supernatural light.

As usual, La Farge sought to harmonize his paintings with their setting, planning colors sufficiently dark and saturated to carry in the dim light of the chancel, whose half-dome ceiling was gilded and whose walls were painted a subdued blue and terra-cotta. Subsequent redecorations of the church, which lightened the chancel walls and replaced the central cross with a white marble altar, have sapped the coloristic richness of the murals. Yet the paintings reveal the maturation of La Farge's attitudes toward religious mural painting. They continue the naturalistic interpretation of religious themes in the Trinity nave and Saint Thomas murals, and in their evocative painterliness and rich Venetian colorism they anticipate the most ambitious demonstration of his personal style in *The Ascension*.

128
Church of the Incarnation, New York, 1885–86
Interior in 1912
MD1885.1A–B

129
The Wise Men Out of the East, 1868
Illustration for the *Riverside Magazine for Young People* (1868)
Wood engraving
5½ × 7 in. (14 × 17.8 cm.)
The Metropolitan Museum of Art, New York
Harris Brisbane Dick Fund, 1936
E1868.3

130
The Three Wise Men, 1878–79
(Halt of the Wise Men)
Oil on canvas
32¾ × 42 in. (83.2 × 106.7 cm.)
Museum of Fine Arts, Boston
Gift of Edward W. Hooper
P1878.2

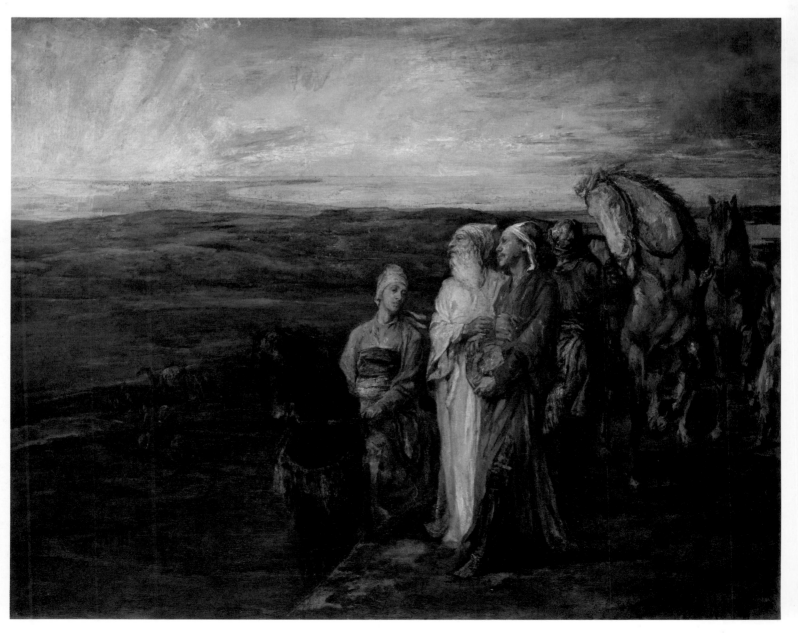

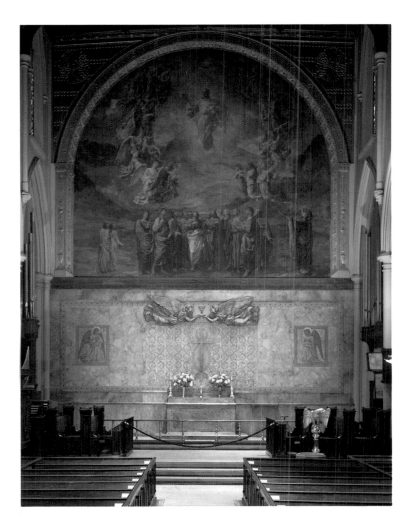

131
Church of the Ascension, New York, 1886–88
Chancel
MD1888.2

Richard Upjohn had designed the austere neo-Gothic Church of the Ascension, on the northwest corner of Fifth Avenue and Tenth Street, in 1841. By the early 1880s the negative associations of decoration with "high church" practices had softened, and other "low church" Episcopal congregations such as Trinity's had found that beautiful surroundings were not inconsistent with a simple liturgy. E. Winchester Donald, who assumed the rectorship of the Church of the Ascension in April 1882, seems to have exerted a crucial influence in allaying suspicion of beauty in the church and in mobilizing his congregation to decorate it. In 1884 the architect Stanford White was approached for advice, and in the following year a bequest from two parishioners made renovation likely. At first, it seemed desirable to deepen the extremely shallow chancel and to insert a large stained-glass window in its rear wall. It was for this that Dr. Donald initially consulted La Farge, then a neighbor on Tenth Street and already the author of a memorial window for the church. When deepening the chancel proved infeasible, a mural painting seemed the most appropriate and economical form of decoration for the flat, blank wall. La Farge, again, seemed the natural candidate to execute it. The name of the church dictated the subject, and, on June 4, 1886, the vestry resolved to contract with La Farge "for painting a picture on Canvas upon the Wall of the Chancel the subject being the Ascension of our Lord Jesus Christ" (plate 131).[7]

While La Farge had represented religious themes with supernatural implications in naturalistic terms before, the reconciliation of the ideal and the real at the Ascension was much more difficult. Here the event radically defied practical experience. La Farge's starting point was High Renaissance precedents: the grouping of apostles derived from Palma Vecchio's *Assumption of the Virgin* (c. 1506–10; Accademia, Venice) and the figure of the risen Christ from Raphael's *Transfiguration* (c. 1517–20; Vatican Museum, Rome). To these he added the figure of the Virgin Mary, alone, to the right of the composition, not only to emphasize her special intensity of feeling but to help fill the thirty-six-foot-wide wall, as the inclusion of the "two men . . . in white apparel" (Acts 1:9–11) helps to fill it at the left. La Farge then added other elements that made the portrayal of levitation as convincing as possible. These include a huge halo of angels (see plate 43)—based upon those in Couture's murals at Saint-Eustache—which seem to dissolve in and out of the opalescent clouds, and an expansive mountainous landscape that appears to support the angels and the figure of Christ.

La Farge's borrowings from the past seem to have resulted from an imaginative and fluid rather than a programmatic eclecticism. Thus, it is not surprising to find his stylistic expediency served by combining motifs from Venetian and Roman High Renaissance painting, by then fusing them with a quotation from Couture, and, finally, by juxtaposing the resulting figurative composite from the Western tradition with an Oriental setting. Indeed, La Farge found his landscape arrangement for *The Ascension* in Japan, during a three-month visit in the company of Henry Adams; they had left New York the day before the vestry of the church voted to contract for the painting.

Upon La Farge's return to New York in December 1886, practical problems, including difficulties in fastening the canvas in place, caused additional delays. La Farge must also have devoted considerable time to developing his encaustic medium, which he seems to have modified with a variety of oils and varnishes to produce an unusual opalescent, vaporous effect appropriate to the spiritual theme. He must also have collaborated with White in designing the architectural setting, which was basic to the success of the painting. The heavily gilded, deeply niched frame cuts down a bit the width of the chancel wall, echoes the Gothic character of the church in its spandrel decorations, and defines the shape of the composition while at the same time seeming to grow from it. The decorative treatment of the wall below La Farge's painting also helps to unify the chancel. A pair of flying angels, modeled in relief and bearing an upraised chalice, and two kneeling angels, depicted in mosaic, were executed by Louis Saint-Gaudens and Maitland Armstrong, respectively, in collaboration with La Farge.

Although travel and practical problems had delayed his start, La Farge proceeded rapidly once he began painting *The Ascension*, devoting only the second half of 1888 to the huge task. Upon the unveiling of the chancel on December 30, 1888, critics noted the painting's beauty and claimed a significant place for it in the history of religious art.[8] The work constitutes the fullest realization of the issues that La Farge had addressed in a decade of mural work, including visual unity, collaboration among architect and artists, and interpretation of ideal themes by simultaneous reference to the traditional and the naturalistic. It also demonstrates the full maturity of La Farge's mural style, which now possessed a character as personal and strong yet as delicate and opalescent as that of his stained glass.

Concurrently with these projects for figurative religious murals, La Farge designed more purely ornamental decoration for three churches. In the United Congregational Church, Newport, and the Brick Presbyterian Church, New York, he applied motifs derived from Romanesque and Byzantine sources to austere meeting houses. His work for the Church of Saint Paul the Apostle, New York, which extended over four decades

and included architectural counseling as well as ornamental painting and stained glass, was similarly responsive to a desire to capture the spirit of early Christianity.

The United Congregational Church of Newport, founded in 1695, had a meeting house at the corner of Spring and Pelham streets, dedicated in January 1857. The installation of Henry J. Van Dyke as pastor in March 1879 coincided with the congregation's desire to repair and repaint the interior. Although the church members' sophistication and familiarity with advances in decorative art in Boston and New York would have predisposed them to concur, it was Van Dyke who appears to have been most fully committed to beautiful adornment as well as necessary repainting. His admiration for La Farge's work, and the artist's accessibility as a Newport resident, made him the natural choice for the commission, which he undertook between February and June 1880.

La Farge decided on ornament derived from Romanesque and Byzantine sources. This was consistent with the church's plain, essentially classical architecture and with its theological tradition, which would have prohibited figurative decoration. La Farge's decorative scheme could also be realized in paint, the medium dictated by limited funds. Since the new green carpeting gave an inevitable keynote of color, he produced a "green church," alternating large plain spaces with elaborately patterned ones, the varied greens enriched and reinforced by notes of dark red and yellow. He decorated the focus of the church—the chancel wall—with a painted pedimented portico, "constructed" of pilasters and complex friezes and decorative bands and set against a background of minutely detailed ornament (plate 132). The ceilings of the nave and the galleries were decorated in patterns based on Turkish carpets, stylistically consistent with the Byzantine references elsewhere in the church and appropriate to the limited capabilities of inexperienced workmen.

132
United Congregational Church, Newport, Rhode Island, 1880
Chancel
MD1880.1

133
Brick Presbyterian Church, New York, 1883
Nave and chancel
MD1883.1

By relying on a variety of precedents that yielded a traditional and ecclesiastical effect without overtones of "popery," and accepting the practical limitations of architecture, funds, and ability of his workmen, La Farge created an unusual solution to the problem of merging American and European traditions. A modern observer might favor the simplicity of the original interior, especially now that a recent repainting in chalk blue of the plain green wall spaces makes them clash with the original patterned areas, still vivid in durable encaustic. Yet one must acknowledge La Farge's transformation of the United Congregational Church as a fascinating document of the aesthetic desires of the period.

For twenty-five years after its construction at the northwest corner of Fifth Avenue and Thirty-seventh Street, New York, the Brick Presbyterian Church possessed an austere "meeting house" interior. By the early 1880s younger members of the congregation had begun to find its severity "positively repellent."[9] Plans for renovation accelerated after the installation of Henry J. Van Dyke as rector in January 1883. La Farge had successfully redecorated his Newport church in 1880; six months after Van Dyke's installation he began a similar task at the Brick Presbyterian Church and completed it by the end of October 1883 (plate 133).

Once again La Farge found in the stark simplicity and classical proportions of an oblong hall an unrestricted field for decoration. Here he chose to apply motifs derived from Italian churches of the eighth to tenth centuries, which seemed consistent with the classicism of the church, reflected a period of simple religious belief and practice, and accorded with Van Dyke's taste and theological orientation. As at Trinity, La Farge colored the large wall surfaces a dark Pompeian red, which set off the detailed decoration of apse, cornice, ceiling, and gallery railings. This decoration consisted of a variety of designs based on abstract symbols and pure ornament. Patterns for the paneled ceiling

recalled those of the United Congregational Church and the Turkish carpets that served as sources there.

At the Brick Presbyterian Church, La Farge also experimented with varied materials to achieve a richly complex effect. He incorporated mosaic, imported from the Minton works in England and reminiscent of early northern Italian church decoration; borders of geometric relief work, gilded and inlaid with tiles; and embroideries and stained glass that he either designed or approved. Critics evaluated his accomplishment at the church for its consistency with Presbyterian theology as well as for its beauty—its warmth and richness of color, its dignity and mellowness associated with churches of the old world.[10] Measured on both scales, religious and aesthetic, it warranted high praise.

The twentieth century witnessed a reaction against the reattachment to European tradition that the late nineteenth century had avidly sought. A rebirth of interest in the unique character of American institutions and art forms, a search for what was American in American art, characterized the period between the two world wars. Following its affluent congregation uptown, the Brick Presbyterian Church abandoned its monument to the eclectic taste of the 1880s. The church was demolished, and the site developed in accord with the increasingly commercial character of Fifth Avenue. Since the late 1930s the congregation has been housed in a tasteful Georgian structure at Park Avenue and Ninety-first Street, whose interior is reminiscent in its simplicity of the undecorated Thirty-seventh Street church.

La Farge had been involved with the Church of Saint Paul the Apostle, on Ninth Avenue between Fifty-ninth and Sixtieth streets, New York, for twenty-five years before he actually began decorating it in 1884. In the late 1850s he had become friendly with Isaac Thomas Hecker, founder of the Paulist Fathers, who was instrumental in converting La Farge's wife to Catholicism in 1860. At about the same time, La Farge undertook his first large-scale religious painting, a depiction of Saint Paul preaching for the first Paulist chapel.

For reasons that have not been recorded, the painting was never placed in the chapel for which it was intended, and it is now unlocated. Nevertheless, La Farge and Hecker remained friendly. In 1876, when Hecker was planning a permanent church for the order—which would become one of the largest churches in New York—he sought La Farge's counsel. The artist's help enabled Hecker to modify the plans for the church that the architect—one Jeremiah O'Rourke—had submitted. Correspondence between La Farge and Hecker at this time (preserved in the Paulist Fathers Archives) suggests that the painter was equipped to design the architectural scheme for the church but not to execute working drawings for it. La Farge's training as an architect was hinted at by several of his contemporaries.[11] While his consultations with Hecker do not document such training, they do attest to his involvement in planning a unified architectural and decorative scheme for a religious building even before he received the contract to decorate Trinity Church in the summer of 1876.

As a result of the ongoing Depression of 1873, construction of the Paulist church progressed very slowly after the laying of the cornerstone on July 4, 1876. Gradually the design evolved from O'Rourke's Gothic scheme to one more reminiscent of an early Christian or Byzantine basilica, consistent with Hecker's taste. In the first phase of his involvement with decorating the church, which began in 1884, La Farge and his assistants painted the barrel-vaulted ceiling deep blue and covered it with stars, conveying the impression of a roofless church reminiscent of the Tomb of Galla Placidia in Ravenna. His second task, completed in 1888, was to design for the nave clerestory a series of fourteen huge stained-glass windows, based on the motif of a richly jeweled cross. Slightly later, he designed the windows on the entrance wall. These reveal an effort to modify the

pointed Gothic arches of the openings to produce a more Byzantine effect in response not only to Hecker's early desires but also to the massive Byzantine altar and baldachin, designed by Stanford White and completed in mid-1890.

The last major episode of La Farge's work at Saint Paul the Apostle was the redecoration of the chancel (plate 134), begun in 1896 as a memorial to Hecker, who had died in 1888. Here La Farge made additional efforts to Byzantinize the church in response to the style of the high altar. Five dull neo-Gothic windows, the products of London and Munich workshops, had been installed in the chancel between 1885 and 1888. Although La Farge proposed to replace all of them, a curtailment of funds appears to have dictated a compromise: retention of the three central windows and replacement of the outer two with opalescent glass that recalls mosaics in the Church of San Vitale, Ravenna. La Farge's plan to decorate the chancel wall beneath the windows with a huge depiction of angels in a landscape was also unfulfilled.

On the side walls of the chancel at the clerestory level, La Farge expanded the theme of a choir of angels that was expressed in the original chancel windows, filling tondi in the upper side walls with angelic figures in postures of adoration and prayer. This scheme, too, was realized only in part, as the result not only of financial difficulties but of the artist's recorded but unexplained clashes with members of the clergy, with the donor of the chancel redecoration, and with his son Bancel, who was an important collaborator at this time.[12]

That the Church of Saint Paul the Apostle was the only Catholic church to offer La Farge a major commmission reflects the tendency of late nineteenth-century American Catholic congregations to devote discretionary funds to parish aid—especially to the needs of burgeoning immigrant populations—rather than to enrichment of edifices. La Farge's work in the Church of Saint Paul was fraught with more frustration and unrealized intentions than any other of his decorative projects. It may have suffered more than any of his surviving church schemes as well, for much of his mural decoration, and that of others in the church, was painted over in the 1950s.

La Farge's achievements in sacred mural decoration are not matched by his accomplishments in secular settings. Although he was considered as a successor to Hunt in the decoration of the New York State Capitol Assembly Chamber and to Constantino Brumidi in the decoration of the United States Capitol rotunda, La Farge received neither commission. Few others were available in the late 1870s or '80s. La Farge's projects for secular murals in this period were limited to a clubhouse and two private mansions in

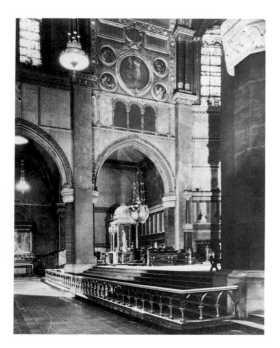

134
Church of Saint Paul the Apostle, New York,
1896–99
South wall of the chancel, before 1950
MD1899.1A–E

135
Union League Club, New York, 1880
Dining room viewed from the south end in 1896
MD1880.2

New York. Although secular mural commissions were increasingly available in the 1890s and after the turn of the century, La Farge received only three of them. When architects and their clients, emulating the Beaux-Arts style exemplified and stimulated by the 1893 World's Columbian Exposition, began to plan decorative schemes for governmental and cultural structures, they sought more strictly academic murals than La Farge was willing or able to offer. His tenacious adherence to naturalism—his preference for depicting the actual rather than the abstract—seemed to disqualify him from participation in certain major projects, such as the Chicago world's fair itself and the Library of Congress; to make him an adviser, rather than an actual participant, as in the Appellate Division Courthouse, New York; or, when he did participate, to make his work seem singularly naturalistic by contrast with its surroundings and with accompanying murals by other artists. He was, of course, far from idle as a decorator, but his energies were directed more toward stained glass than toward mural work.

La Farge had demonstrated in his religious decorations a creative eclecticism, and his flexibility in the secular sphere was also impressive. For the dining room of the Union League Club, for example, he successfully responded to his patrons' desire for a reminiscence of the Common Halls of Oxford or Cambridge with a free adaptation of the Elizabethan style (plate 135).

Having occupied two residences farther downtown since its founding in 1863, the Union League prepared in 1879 to move to a site at the northeast corner of Fifth Avenue and Thirty-ninth Street. The club was unusual in its prominence and its prosperity, in

136
Cornelius Vanderbilt II house, New York,
1880–83
Dining room
MD1881.1A–H

137
Cornelius Vanderbilt II house, New York,
1880–83
Water Color Room
MD1881.2A–H

its choosing to construct a clubhouse rather than lease quarters, and in its encouragement of art. The architects, Peabody and Stearns, placed the impressive two-story main dining room at the top of the building, with its ceiling running up into the high mansard roof. Special attention was given to the decoration of this room, whose preliminary painting and ornamental moldings were executed by Frank Hill Smith of Boston; its decoration was completed by La Farge, with the assistance of Will H. Low, in November and December 1880.

The more or less Elizabethan details of the dining room—walls wainscoted with oak and capped by a concave cornice and a steeply pitched ceiling supported by open timbers—presented substantial problems. La Farge chose gold as the unifying element of the scheme, using it as the background for scrollwork and emblematic patterns worked out in blue, green, red, and white. The north and south gables were decorated with mosaics of ultramarine glass tiles, which set off a coat of arms (at the north) and an allegory of Victory (at the south), both modeled in relief by Louis Saint-Gaudens. Finally, La Farge filled a third gable on the west side of the room with a large rose window.

Critics regarded La Farge's efforts in decorating the dining room as most successful, both absolutely and relative to other decoration in the clubhouse, even including that provided by Louis C. Tiffany in the main staircase hall.[13] Although the demolition of the Fifth Avenue quarters of the Union League Club in 1932 precludes verification of such commentary, one thing is certain. Once again, but for the first time in a secular setting, La Farge had produced a fascinating document of the late nineteenth-century American taste for elegance expressed through reference to the European tradition.

La Farge's work for the mansion of Cornelius Vanderbilt II extended and elaborated the kind of decoration he had provided in the Union League Club, demonstrating similar flexibility in combining sources; integrating paint, stained glass, and ornamented bas-relief; and cooperating with other artists. The house, one of three Fifth Avenue mansions

constructed for members of the family in 1881–82, was designed by George B. Post for the northwest corner of Fifty-seventh Street. Either Post, whom La Farge had known since the early 1860s, or Vanderbilt himself entrusted La Farge with his first documented domestic commission since the Freedland dining room in 1865. He was to oversee the decoration of the entire house and to decorate the ceilings of its dining room and "Water Color Room" (plates 136, 137). Payments to La Farge, totaling almost $100,000, were made between July 1880 and May 1883.

The dining room ceiling, measuring forty-five by twenty-three feet, was deeply coffered and divided into panels by oak beams inlaid with mother-of-pearl and by moldings accented with hammered bronze patterns. The central area was reserved for three huge skylights of pale opalescent glass and was surrounded by fourteen relief panels carved in West African mahogany and inlaid in various materials by Augustus Saint-Gaudens and his assistants after La Farge's designs. The corner panels contained heads of Apollo in gilded-bronze repoussé work, surrounded by laurel wreaths inlaid with green serpentine leaves and ivory berries and bracketed by mother-of-pearl–winged cherubs holding decorative scrolls ornamented with pearl and ivory. Other panels contained an escutcheon flanked by pairs of clasped hands, legends referring to hospitality and friendship, and representations of the sun and moon. In the ceiling at the ends of the room were pairs of panels depicting classical figures who refer to sustenance: Ceres (wheat), Pomona (fruit), Bacchus (wine), and Actaeon (meat). The dining room panels were relocated to the billiard room when the house was renovated and expanded in 1892–94; they were dispersed after the demolition of the house in 1927. Only two have been located: *Ceres* (Saint-Gaudens National Historic Site, Cornish, New Hampshire) and one of the Apollo panels (plate 138).

Connecting the dining room with the smoking room was a skylit Italianate hall, used as a small picture gallery and called the Water Color Room. It was decorated shortly after the dining room. Spanning the length of each side of the room—as if defining a

138
Head of Apollo with Erotes, 1881
Panel from the Cornelius Vanderbilt II house, New York
West African mahogany with inlays of Japanese hammered bronze, abalone and pearl shell, carved green and ivory-toned marble, and metallic gold wash
27½ × 63½ × 3½ in. (69.8 × 161.3 × 9 cm.)
Private collection
MD1881.2A

nave—were three-bay arcades, above which spaces were reserved for painted decoration. Here La Farge—now assisted by Will H. Low and Theodore Robinson—depicted allegories of the four seasons and four of the senses in T-shaped panels framed by gilded moldings. He also filled a lunette at one end of the gallery with *The Chariot of the Sun Preceded by Dawn Sprinkling Dew*, reiterating one of the motifs he had used in a tower lunette at Trinity Church; and he decorated lunettes in the side walls with images of classical goddesses and garlands of fruit and flowers. In the 1892–94 expansion of the house, La Farge's Water Color Room was moved and reconstituted as an entrance hall; none of the decorations survived the demolition of the house.

In addition to designing reliefs and paintings for the dining room and Water Color Room, La Farge planned and supervised the embroidery of decorative draperies—four sets of elaborate portieres—which excited considerable contemporary interest.[14] He also provided stained-glass windows for other rooms of the house, including a number of transoms and the second of his six versions of *Peonies in the Wind* for the drawing room, later moved to the "Persian Room" and now unlocated. The windows that La Farge executed at the same time for the house of William H. Vanderbilt (plates 146, 147), which were considerably more ambitious, are discussed by Henry La Farge in chapter 5 of this book.

The Villard Houses on Madison Avenue between Fiftieth and Fifty-first streets, New York, mark a turning point in late nineteenth-century American architecture. The three houses, unified around three sides of a court, were designed in 1883 by Joseph M. Wells of the firm of McKim, Mead, and White, in close emulation of a single and specific Roman Renaissance prototype, the Palazzo Cancelleria. The trend toward a highly disciplined eclecticism, begun with the Villard Houses, reached a climax in the unified Beaux-Arts style of the World's Columbian Exposition a decade later. A reaction against the random eclecticism of Richardson and others, designs such as that for the Villard Houses codified the diffuse yearnings of prior decades for a return to tradition. A new insistence on archaeological accuracy of the whole and its details prevailed.

Several years after the completion of the Villard Houses, the southerly section of the structure was sold to Whitelaw Reid, publisher of the *New York Tribune*. Stanford White was retained to plan the decoration of the music room—a parlor on the *piano nobile*—and La Farge (with whom White was concurrently involved at the Church of the Ascension) was engaged to fill the twenty-foot-wide lunettes in its end walls (plate 139). A sense of classical harmony pervades the high oblong room (since 1978 this has served as a luxurious cocktail lounge in the hotel that appropriated the Villard Houses as its "vestibule"). The paneled walls with relief carvings of flowers and musical symbols and the arched, delicately coffered ceiling are in white, overlaid with or highlighted by gold. Windows to one side, filled with pale, amber-toned opalescent glass, reinforce the golden effect. A shallow gallery at one end is ornamented with panels of dancers and musicians reminiscent of the reliefs of Donatello. The hemicycle above this gallery was reserved for La Farge's depiction of Drama and the space opposite, above the ornamented doors that led to the dining room, for his mural of Music.

Because of his desire to please Reid, who seems to have been an especially sympathetic client, La Farge subordinated other obligations, including his work at the Church of the Ascension, to rapidly complete the music-room murals in the fall and winter of 1887–88. Despite the High Renaissance orthodoxy of Wells's architecture and the formality of White's setting, La Farge resisted arid allegories on the designated themes. Rather than personifications—figures acting *as* "Music" or "Drama"—which an allegorical interpretation would have demanded, La Farge chose to represent ladies dressed up and playing, rather more naturalistically, *at* those arts. His designs derive from pastoral scenes

139
Whitelaw Reid house (currently Helmsley Palace), New York, 1887–88
Drama mural, music room, in 1904
MD1887.1

by such Venetian High Renaissance painters as Giorgione, with bucolic landscapes in each forming the background for what one contemporary critic characterized as "a garden masquerade."[15]

La Farge found the demands of a mural commissioned for the Walker Art Building at Bowdoin College, Brunswick, Maine, to be far less flexible than those associated with the Reid project. Participating in a program with three other artists, he was compelled to paint an allegory. That requirement notwithstanding, La Farge's predilection for the natural rather than the conventional held sway, and his mural differs substantially from those of his colleagues.

The Walker Art Building was designed by Charles F. McKim in 1891 in close emulation of Florentine Renaissance examples, notably the Cappella Pazzi and the Loggia dei Lanzi. The building is in the form of a modified Greek cross, with three galleries grouped around a domed sculpture hall. For the twelve-by-twenty-four-foot lunettes over the entrance to each gallery and over the main entrance to the building, McKim envisioned mural paintings.

In August 1892, Elihu Vedder accepted the first and, at the time, the only commission to paint such a mural, an allegory of "The Art Idea," for the lunette opposite the entrance. By spring of the following year the project was expanded to include murals for the three remaining lunettes, and invitations to undertake them were extended to La Farge, Abbott Thayer, and Kenyon Cox. Under McKim's guidance, the artists chose as the unifying theme of the decorations the artistic achievements of four great classical and Renaissance

140
Athens, 1893–98
Encaustic on canvas
12 × 26 ft. (3.6 × 7.9 m.)
Walker Art Building, Bowdoin College, Brunswick, Maine
MD1893.1

cities: Athens, Rome, Florence, and Venice. This scheme permitted the retitling of Vedder's painting to symbolize Rome; allegories of Athens (plate 140), Florence, and Venice were assigned to La Farge, Thayer, and Cox, respectively.

All four of the painters involved had studied in Paris, but only La Farge lacked training in the Beaux-Arts tradition. Vedder had worked in the 1850s under François-Edouard Picot, a member of the generation of Jean-Auguste-Dominique Ingres and a stylistic kindred spirit, and Vedder's long residence in Italy had reinforced his Neoclassical mannerisms. Both Thayer and Cox were the products of the studio of Jean-Léon Gérôme in the 1870s. Among the four allegorical murals at Bowdoin, La Farge's lacks the academic concentration on linear definition that characterizes its Beaux-Arts–based companions and stands out, instead, for its Venetian colorism and its naturalism.

La Farge's *Athens* was finally installed on the east wall of the sculpture hall in September 1898, four years after his colleagues' paintings were placed.[16] Here three monumental females, loosely adapted from Graeco-Roman types, dominate a shallow stage. A youthful woman, draped in gold below the waist, is studied by two peripheral figures. Leaning on a herm and embracing an Attic torch, she has been interpreted as the personification of Nature. To the left, Minerva, goddess of wisdom and patron of the ornamental arts and of Athens, is drawing the young woman's image. A personification of Athens looks on. Wearing the crenellated crown representing the city walls, she is seated to the right on a stone block carved with an owl, symbolic of Minerva. Although symmetrical, the grouping is far from rigid. La Farge placed his figures against a naturalistic, Giorgionesque evocation of the surroundings of the Greek capital. In contrast with the abstract backgrounds of the neighboring lunettes, this setting suggests a particular moment and locale, enlivening the allegory and linking it with La Farge's earlier landscapes and murals. Moreover, the fact that Minerva is shown not only drawing Nature but also working from life seems to be an intentional and vivid restatement of La Farge's commitment to the natural.

141
The Recording of Precedents: Confucius and His Disciples, 1903
Study for mural, Supreme Court Room, Minnesota State Capitol, St. Paul
Watercolor on paper
7⅛ × 10⅝ in. (18.1 × 27 cm.)
The Metropolitan Museum of Art, New York
Bequest of Susan Dwight Bliss, 1966
W1903.3

142
The Recording of Precedents: Confucius and His Disciples, 1904
Encaustic on canvas
13 × 27 ft. (4 × 8.2 m.)
Supreme Court Room, Minnesota State Capitol, St. Paul
MD1904.4

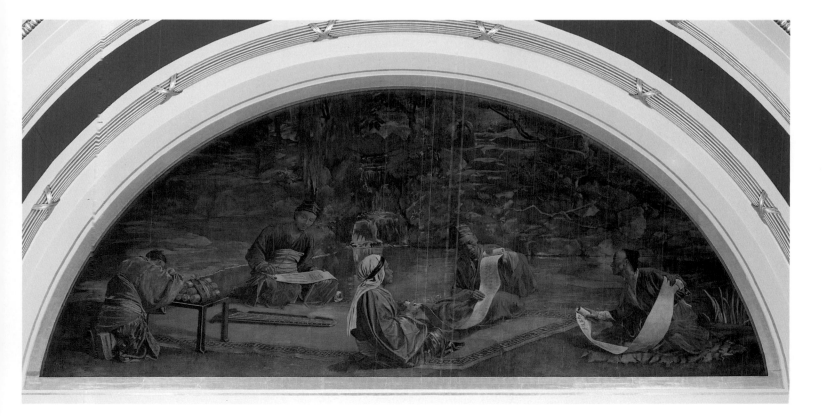

Whenever possible, La Farge avoided complex allegories in mural painting, believing, as he explained in *Considerations on Painting* (1895), that "the plastic arts . . . are not the best form for explanation and development of a moral and metaphysical notion."[17] Equally resistant to the Beaux-Arts painting style, he received only two mural commissions for governmental buildings. During the "High" Renaissance phase of the American Renaissance—the decades on either side of the turn of the century—dozens of such structures were ornamented with countless ladies in classical dress personifying any number of abstract ideas and ideals, moral and metaphysical notions. Although La Farge's age may also have limited his participation in such projects, it is notable that he addressed the two commissions that he did receive with energy, enthusiasm, and skill. These were two series of lawgivers for the Minnesota Supreme Court Room and the Baltimore Court House. As in the music room of the Whitelaw Reid house, La Farge portrayed his subjects in real rather than allegorical terms. Although both series are more formal and austere than his earlier murals, their reliance on the specific and the literal—episodes from the history of the law—is the product of his predilection for naturalism.

Cass Gilbert, the designer of the Minnesota State Capitol at St. Paul, had absorbed Beaux-Arts principles at the Massachusetts Institute of Technology and in the offices of McKim, Mead, and White. Having persuaded the Board of Commissioners for the St. Paul project to accept an elaborate decorative scheme, Gilbert entered into negotiations with some of the period's most eminent muralists early in 1903. His aim was to insure the decoration of the Supreme Court Room, the Senate Chamber, and the spandrels of the rotunda, as well as the general decorative painting of the entire interior. By the end of the year La Farge, Edwin H. Blashfield, Edward E. Simmons, and Elmer E. Garnsey, Gilbert's respective choices for these commissions, were at work.

The Supreme Court Room, at the east end of the second floor, is in the shape of a Greek cross with short arms. In the upper walls, four recessed eighteen-by-twenty-seven-foot lunettes were reserved for murals that would provide a sumptuous contrast to the simplicity of the painted and paneled walls below. Unlike his colleagues at St. Paul, who celebrated Minnesota and the western United States in allegorical terms, La Farge examined a more universal theme—justice—in a documentary manner. His plan embodied a prevailing national conception of America as heir to all of traditional culture as well as his own preferences in depicting ideal themes. Instead of portraying abstractions, he chose four biblical and historical events in the evolution of organized law to suggest the varied heritage of the American legal system. Relying on extensive research, La Farge succeeded in telling the several stories as if they were really happening, and happening in four different eras and places. The four subjects were: The Moral and Divine Law: Moses receives the Law on Mount Sinai (plate 44); The Relation of the Individual to the State: Socrates and his friends discuss the *Republic*, as in Plato's account; The Recording of Precedents: Confucius and his pupils collate and transcribe documents in their favorite grove (plates 141, 142); and The Adjustment of Conflicting Interests: Count Raymond of Toulouse swears at the altar to observe the liberties of the city in the presence of the bishops, the representatives of religious orders, and magistrates of the city.

As the St. Paul lunettes were completed, one by one, between October 1904 and November 1905, and shown in various New York exhibitions before being shipped west for installation, they were greeted with much favorable commentary.[18] The fact that La Farge had executed these paintings at the age of seventy especially pleased the artist and amazed his friends. In light of the success of his work and his pride in it, it is not surprising that, even before the St. Paul project was completed, La Farge was offered and accepted the commission for another series of murals, also based on the theme of justice, for the Baltimore Court House.

As the new courthouse, designed by Wyatt and Nolting, Baltimore architects, neared completion late in 1899, the Municipal Art Society of Baltimore planned to provide mural decoration. In November 1901 the Court House Commissioners entered into contracts for the initial decorations with Blashfield and Charles Yardley Turner. La Farge's involvement was part of the second decorative campaign, with consultations beginning as early as the summer of 1903 and the work carried out between 1905 and 1907.

La Farge's paintings were to occupy six spandrels in the upper walls of the St. Paul Street entrance vestibule, a long rectangular room designed in the Italian Renaissance style. The subjects chosen related, as did those in St. Paul, to the evolution of law. La Farge again depicted Moses and Confucius (plate 116, page 268) but reduced the number of figures and employed compositional strategies appropriate to the awkward spandrel shapes. Other variations make the Baltimore project seem rather different from that in St. Paul. For example, two obscure subjects—Lycurgus and Numa Pompilius—were included in the scheme, reflecting La Farge's certain and his patrons' possible awareness of Delacroix's depictions of them in murals in the library of the Palais Bourbon. In the most obvious imitation of particular models in his entire mural work, La Farge also drew on Delacroix's compositions in interpreting these subjects.

Mohammed and Numa Pompilius were chosen for the spandrels of the entrance wall, with Lycurgus and Confucius occupying the opposite panels of the east wall. The spandrel in the north wall is occupied by Moses, and that in the south wall by Justinian. Of all the major mural paintings that La Farge produced, the Baltimore panels are the most purely decorative, being more closely related to his early work in Trinity Church than to any intervening project. The unusual shape of the panels limited each depiction to a principal figure with one or more accessory figures, and narrative and naturalistic atmosphere are subordinated to the requirements of the spaces to be filled and their surroundings. The dark-veined golden marble of the room suggested the use of an abstract gold background.

Yet attention to decorative necessities did not divert La Farge from his persistent concern with historical actualities. He depicted a particular moment in the life of each character so that he could suggest that these episodes had really happened, and he modified the gold backgrounds with bits of landscape and architecture. Once again, as he had ever since the late 1870s, La Farge produced a major decorative scheme, conveying, insofar as possible, an abstract idea in naturalistic terms and responding as well to desires for a unified visual effect.

While La Farge's murals may not always compel rapture on the part of the modern viewer, their extreme importance in American cultural history must be acknowledged. Their tenacious naturalism reflects a unique artistic personality and acts as a foil to the tendency toward academic aridity that characterized the mural movement in the heyday of the American Renaissance. However, while La Farge's approach may have appeared old-fashioned in the Beaux Arts–dominated 1890s and the first decade of the twentieth century, it was also strikingly anticipatory of even newer attitudes toward mural painting. As artists and their patrons tired of "the customary representations, such as a group of young women in their nighties presenting a pianola to the city of New York"—as La Farge's erstwhile assistant Francis Davis Millet once put it—they turned to a more documentary mode of mural painting which echoed the empirical spirit that La Farge had always demonstrated.[19] La Farge's importance in the American mural movement consists, then, not only of his defining its beginnings in the 1870s and of his working in harmony with its developing styles without sacrificing personal predilections but also of his anticipating its ultimate expressive concerns.

NOTES

This essay is based upon my doctoral dissertation, *The Decorative Work of John La Farge* (Columbia University, 1972; New York: Garland Publishing, 1977), which I could not have written without the generous assistance and encouragement of Henry A. La Farge. I am also indebted to Barbara Novak for her guidance during my graduate studies and to the clergy, owners, and staffs of the sites of La Farge's murals for their consideration.

1. Henry Van Brunt, "The New Dispensation of Monumental Art," *Atlantic Monthly* 43 (May 1879): 633–41.

2. By the middle of 1858 La Farge had rented a room in the recently completed Tenth Street Studio Building, which Richard Morris Hunt had designed and where his own pupils were installed. Henry Van Brunt recorded George B. Post, Charles D. Gambrill, William Ware, Frank Furness, and himself as pupils in the Tenth Street Studio in 1858–59. "Richard Morris Hunt," *Journal of the American Institute of Architects* 8 (October 1947): 180–83. La Farge appears to have remained friendly with Van Brunt and Post, as well as with Hunt.

3. Richardson may have envisioned La Farge as a muralist for the Church of the Unity, Springfield, Massachusetts, for which Richardson won the competition in November 1866 and upon which he worked for several years. See Mrs. [Mariana Griswold] Schuyler Van Rensselaer, *Henry Hobson Richardson and His Works* (Boston and New York: Houghton Mifflin Co., 1888), 49, which describes Richardson's hope for "a great picture" on the church's west wall. In 1870 Richardson invited La Farge to provide "an interior painted decoration" for the Brattle Square Church, Boston. Although plans were made and an assistant engaged, "the scheme fell through," according to La Farge in a speech to "a society of young architects," quoted in Cecilia Waern, *John La Farge, Artist and Writer* (London: Seeley and Co.; New York: Macmillan and Co., 1896), 32; see also Van Rensselaer, *Richardson*, 20.

4. For the development of Trinity's design in relation to Spanish Romanesque and other sources, see Theodore E. Stebbins, Jr., "Richardson and Trinity Church: The Evolution of a Building," *Journal of the Society of Architectural Historians* 27 (December 1968): 281–98. La Farge's role in suggesting the Salamanca prototype is noted (291), as well as in Van Rensselaer, *Richardson*, 64. Royal Cortissoz quotes La Farge's recollections in *John La Farge: A Memoir and a Study* (Boston and New York: Houghton Mifflin Co., 1911), 154.

5. Collaboration between Brooks and La Farge on the plan for the tower is not specifically documented. However, the clergyman's familiarity with churches of southern France, Italy, and the Near East, including the Holy Land; his affection for the art of those churches; and his desire to express the spirit of early Christianity through decoration must have supplemented the painter's knowledge and affected the choice and placement of subjects. A specific key to the iconographic program of Trinity Church might yet be found in Brooks's extensive sermons and lectures.

6. These critical keynotes were struck even as the decoration proceeded. See, for example, ["Trinity Church, Boston—Decoration"] *American Architect and Building News* 1 (October 28, 1876): 345. Typical kudos upon the consecration appear in "Boston's Basilica," *Boston Evening Transcript*, February 6, 1877, 4. For more considered critical analysis, see Clarence Cook, "Recent Church Decoration," *Scribner's Monthly* 15 (February 1878): 570; and George Parsons Lathrop, "John La Farge," *Scribner's Monthly* 21 (February 1881): 514.

7. Minutes of the Meetings of the Vestry 3 (1870–1904), June 4, 1886, 232, Church of the Ascension, New York.

8. Its "exquisite beauty and delicacy" were said to have "held the congregation enthralled" on the day of its unveiling; James W. Kennedy, *The Unknown Worshipper* (New York: Morehouse-Barlow Co. for the Church of the Ascension, 1964), 571, citing but not specifying an older source. Within a few years, the painting's "profound impression upon the religious and artistic public" was widely acknowledged, according to Waern, *La Farge*, 47. Will H. Low admired its "subtle qualities of color, limpid and atmospheric," in "John La Farge: The Mural Painter," *Craftsman* 19 (October 1910–March 1911): 337. Ernest Knaufft noted "it is lighter, more atmospheric, more pearly in color than the altar pieces of the Old World," in "American Painting To-Day," *American Review of Reviews* 36 (December 1907): 690. Eloquent testimony to the painting's impact also appears in Henry James, *The American Scene* (New York and London: Harper and Brothers, 1907), 90–91.

9. Shepherd Knapp, *A History of the Brick Presbyterian Church, in the City of New York* (New York: Trustees of the Church, 1909), 380.

10. See, for example, Rev. Frank L. Janeway, formerly assistant at the church, in *Brick Church Record* (January 1, 1913), quoted in "The Interior of the Brick Church," *Brick Church Record* [16] (January 1, 1928): 29. Knapp

[Brick Presbyterian Church, 383 and note) quotes "a prominent New York architect" as saying "the result is probably the most beautifully decorated interior of any public building in the country."

11. See, for example, Lathrop, "La Farge," 513; quoted in Waern, La Farge, 29; and Mary Gay Humphreys, "John La Farge, Artist and Decorator," Art Amateur 9 (June 1883): 12.

12. Conflicts between La Farge and Father George Deshon, who superintended the construction of the church, are recorded in Rev. Joseph McSorley, C.S.P., to Constance Armstrong (copy of letter), October 29, 1925, Superior General's Papers, Paulist Fathers Archives, New York, and in undated notes of Rev. Theodore C. Petersen, C.S.P., in the same archives. Notes of 1925 by Rev. Henry E. O'Keefe, C.S.P., also in the Paulist Fathers Archives, record La Farge's difficulties with Caroline Locke, donor of the chancel decoration. Conversations with Henry A. La Farge, February 20, 1970, and February 23, 1972, disclosed that misunderstandings between La Farge and his son resulted in the departure of the latter from the artist's studio in the late 1890s.

13. See, for example, Mary Gay Humphreys, "Novelties in Interior Decoration: The Union League Club House and the Veterans' Room of the Seventh Regiment Armory," Art Amateur 4 (April 1881): 102; "Art Notes: The Union League Club," Art Journal (U.S.) 7 (May 1881): 160. Less enthusiastic commentary appears in "Some of the Union League Decorations," Century Magazine 23 (March 1882): 748–49.

14. See, for example, "Art Notes—Decorative Work," Art Journal (U.S.) 8 (November 1882): 351–52; "La Farge Embroideries," Art Amateur 8 (January 1883): 49. M[ary] G[ay] H[umphreys], "Some Facts about a Curtain," Art Amateur 8 (May 1883): 141.

15. Waern, La Farge, 48.

16. Delay in completion of the mural is attributable to travel by the artist; almost constant illness; supervision of the publication of Considerations on Painting in 1895 and An Artist's Letters from Japan in 1897; and an immense variety and number of commissions, including work on the chancel of the Church of Saint Paul the Apostle. Complications involving a discrepancy between the size of the painting and the size of the wall space—a problem ultimately resolved by the frame design—also delayed installation.

17. John La Farge, "Notes and Memoranda of Lessons," in Considerations on Painting (New York: Macmillan and Co., 1895): 255–56.

18. See, for example, Russell Sturgis, "The La Farge Lunettes for the Minnesota Capitol," Scribner's Magazine 37 (May 1905): 638–40; Frederick Stymetz Lamb, "John La Farge: With Examples of His Latest Work in the State Capitol, Minn., and the John Harvard Memorial, London," Craftsman 8 (April–September 1905): 312–23. Elisabeth Luther Cary, "John La Farge's Decorations at St. Paul," Scrip 1 (February 1906): 136–43; Hamilton Bell, "Recent Mural Decorations in Some State Capitols," Appleton's Booklovers Magazine 7 (June 1906): 715–25; [Royal Cortissoz], "John La Farge: His Decorations for the New Capitol at St. Paul," New York Daily Tribune, November 29, 1905, 5.

19. Millet, in Sylvester Baxter, "Francis Davis Millet: An Appreciation," Art and Progress 3 (July 1912): 640. The trend toward documentation is evident in the Governor's Reception Room of the Minnesota State Capitol, where factual renderings of particular episodes of Minnesota history offer a striking contrast to the inflated allegories of Blashfield and Simmons elsewhere in the building.

143
John La Farge in his studio, at work on *Athens*, c. 1895

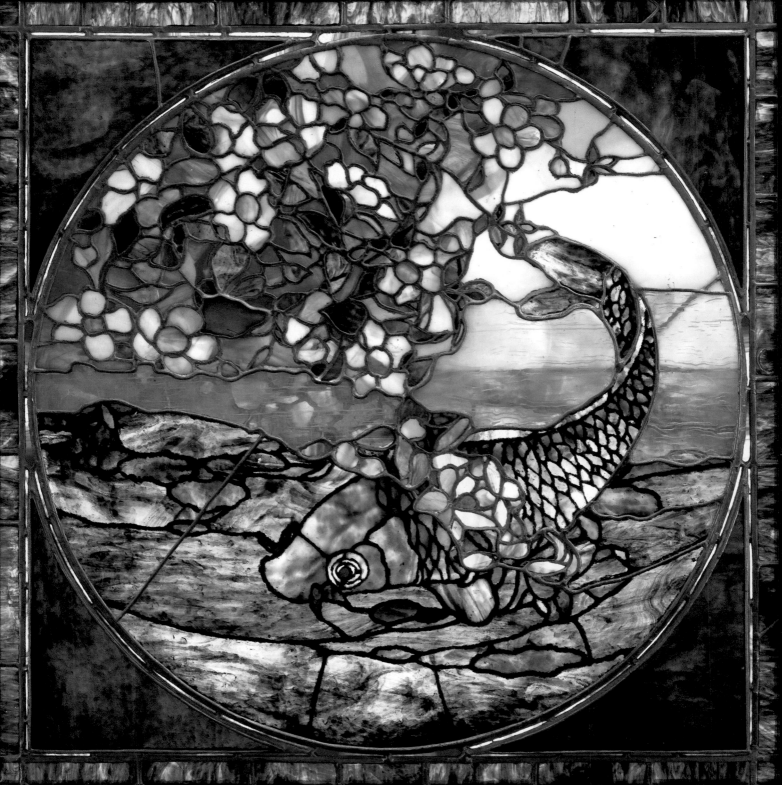

Painting with Colored Light: The Stained Glass of John La Farge

Henry A. La Farge

144
Fish and Flowering Branch, c. 1896
Window from Gordon Abbott house, Manchester, Massachusetts
Stained glass
26½ × 26½ in. (67.3 × 67.3 cm.)
Museum of Fine Arts, Boston
Anonymous gift and Edwin L. Jack Fund
G1896.5

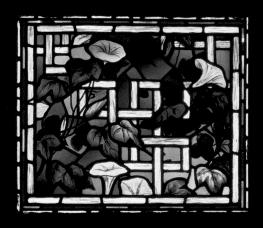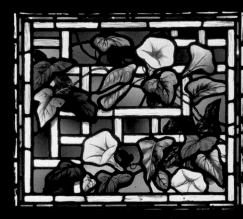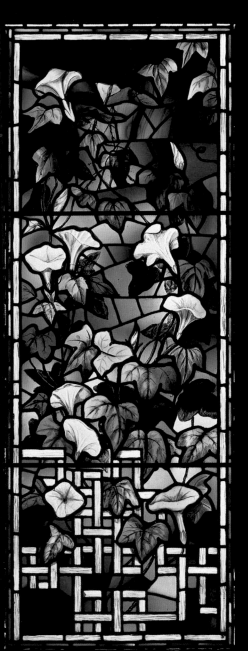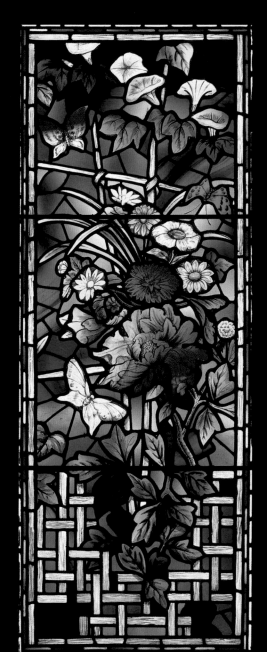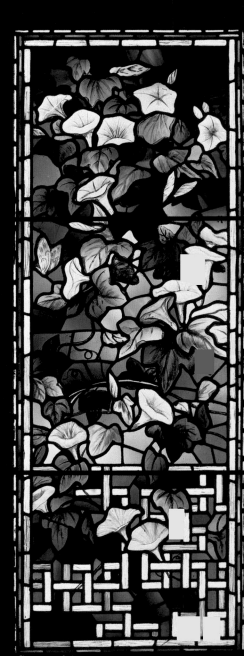

W hen John La Farge made the transition from painting to stained glass, he joined a long line of famous painters who are also known for their work in glass. From the Renaissance period alone, Raphael, Albrecht Dürer, and Lucas Cranach are only some of the names that can be connected with stained-glass windows. Even the sculptor Lorenzo Ghiberti is credited with having designed a window for the Duomo in Florence. But in the final analysis, the successful execution of such works was dependent on the master craftsmen working in the great tradition of glass descending from the twelfth and thirteenth centuries in France. So alive was that tradition still in the sixteenth century that when Pope Julius II brought to Rome a famous French master of glass, Vasari is said to have exclaimed of his work, "These are not windows but marvels fallen from the sky for the consolation of men."[1]

In 1875, when the forty-year-old La Farge took up stained glass, he found that almost nothing was left of that tradition and that practically no glass of good quality was available in this country for making windows. That he should have chosen glass as an appropriate medium of expression is both a mark of the times in which he lived and a revelation of his personality. In a period of great scientific discovery and development, with every kind of invention bringing unheard-of results, La Farge invented a new technology for stained glass. And with the restless urge to novel solutions that affected much of his work, he sought to regenerate the craft. There are approximately three hundred windows securely recorded as his work, some of which are lost; among the survivors can be counted a number of masterpieces.

La Farge's first successful window was a diverting set of lights made in 1878 for the front hall of the William Watts Sherman house in Newport, Rhode Island (plate 145). The architect, H. H. Richardson, introduced a number of adventurous decorative elements into the house and gave La Farge a completely free hand. It is not surprising that La Farge based the design of the leads on Japanese metal openwork,[2] but there is another innovation of deeper significance for his future work in glass. This was the unprecedented

145
Morning Glories, 1878
Six-panel window from William Watts Sherman house, Newport, Rhode Island
Stained glass
86½ × 72 in. (219.7 × 182.9 cm.)
Museum of Fine Arts, Boston
Gift of James F. and Jean Baer O'Gorman
G1878.2

combination of traditional pot-metal glass with pieces of translucent white opalescent glass.

For this window, La Farge had been able to find European pot-metal glass that exceeded in depth of tone anything obtainable in this country. But at about the same time, a cheap toilet article made of opalescent glass in imitation of porcelain caught his eye. He visualized the harmonious effect that the translucent material would have alongside the transparent pot-metal glass, and he delayed the progress of the window to try it. Recalling the occasion, La Farge wrote: "This I carried out by replacing certain ones of the patterns that had the ordinary pot-metal. . . . The effect of contrast of solidity with relative thinness, and the play of complementary tone suggested by the opal alongside . . . was so pleasant that I felt convinced that here was a possible new departure. . . ."[3]

La Farge first had to find someone who could produce the material, and his search led him to Thill's Flint Glass shop in Brooklyn.[4] Thill was a glassmaker from Luxembourg who was making household objects of opalescent glass for commercial use. In his shop La Farge found batches of the glass that had been rejected because of imperfections such as streaking and irregularities of tone and texture. La Farge saw in these imperfections the very qualities he needed to give vibrancy to his windows. To Thill's astonishment, he offered to buy all there was, and this was the material La Farge used for the pearly whites in the Watts Sherman window.

It was undoubtedly both from Thill and from another Brooklyn glassworker, the German-trained chemist Louis Heidt,[5] that La Farge obtained much of the glass for the so-called Derby window, made in 1879 for Richard H. Derby, of Huntington, Long Island. La Farge induced these men to experiment with colored opalescent glass and to make glass according to his specifications. The Derby window was La Farge's first window composed primarily (but not entirely) of opalescent glass. A pane taken from the window in its recent restoration has been identified as a portion of an eighteen-inch purple spun-glass disk from Thill's Flint Glass shop.[6] The window itself, with all the details of its execution, glass cutting, leading, and so forth, was assembled by La Farge in his New York studio at 51 West Tenth Street, with the help of one assistant. The date of the window is recorded in a diamond-shaped piece of glass in the center panel, which is inscribed, "This opal made/June 25, 1879."

For La Farge, the major impetus for the use of opalescent glass stemmed from the discovery of its singular properties. Describing what could be done with it, he wrote:

> The material seemed to be the proper basis for a fair venture into the use of free colour in windows, even when it was used only in small patches, alongside of the English [i.e., pot-metal] glass, whose flatness was relieved by the opal's suggestion of complementary colour—that mysterious quality it has of showing a golden yellow, associated with violet; a pink flush brought out on a ground of green. . . . Moreover, the infinite variety of modulations of [tone in] the opal glass allowed a degree of light and shade for each piece, which not only gives modeling, but also increases depth sufficiently to allow the darker spaces to melt softly into the harsh lead line.[7]

It is clear from this that La Farge had found in opalescent glass a way to obtain three-dimensional effects by shading and thus to avoid the inordinate use of stipple, which had helped cause the decline of stained glass in the eighteenth and nineteenth centuries. Stipple, consisting of a colorless iron oxide, smudges and obscures the color in glass, and thus was anathema to La Farge. In the great age of glass, the twelfth and thirteenth centuries, tones had been controlled in a primitive way simply by interspersing painted black lines in the glass, which modified light intensity or indicated facial features without clouding the color. This was the method used by La Farge in the two windows cited

above, although in a very limited way. But in *Peonies in the Wind* (Metropolitan Museum of Art), a window executed in 1879 for the house of Henry G. Marquand, in Newport, no paint whatsoever was employed.[8] The window is composed of a bewildering variety of both opalescent and pot-metal glass that is streaked, rippled, molded, pressed, and even plated. It created a sensation when exhibited in 1881 at the Museum of Fine Arts in Boston, but it also elicited some critical doubts. Martin Brimmer, director of the museum, writing to a friend, intimated that "such splendid glass as that of La Farge must lead to fine results. . . . but with a half-trained man of genius one can never be sure of anything. . . . The Marquand window is a marvel of color—but it is like a sketch of jewels, and jewels are not somehow the right material to sketch with."[9]

As with the Derby window, La Farge built the Marquand window himself, in workrooms he established at 39 West Fourth Street, off Washington Square. Nearby was the glass entrepreneur James Baker & Sons, at 20 West Fourth Street, through whom La Farge obtained a great deal of the glass for this and other early windows. An account published by Baker's grandson in 1918 gives insight into La Farge's relationship with the Baker establishment around 1880. "John La Farge was an enthusiast. I can see him yet, flinging off his coat in our office and admiring any new batch of disc glass we had received, offering to take the whole lot [of] the new glass, which was made at Thill's Flint Glass house in Brooklyn under Mr. Baker's personal supervision."[10]

Fully convinced of the possibilities of opalescent glass, La Farge proceeded to make his first figural window employing the new medium: the celebrated *"Battle" Window*, in Memorial Hall, Harvard University. The left half of the two-lancet window, consisting exclusively of pot-metal glass, had been begun in 1878 and installed in 1879. But La Farge had become dissatisfied with it and had it returned to his studio to be entirely done over at his own expense.

Contrary to the wishes of the architects, William Ware and Henry Van Brunt, who had specified single figures in all the paired lancets of the Memorial Hall windows, La Farge created a battle scene across the two lights. Avoiding the use of stipple to model the figures, he painted in translucent ceramic colors consisting of mineral oxides fused in the glass.[11] Even though the rest of the window is in glass without any paint, with modulations of tone intrinsic to the glass, the figures are entirely integrated in the design. Regarding this window, La Farge wrote:

> I used almost every variety of glass that could serve, and even metal, stones such as amethysts, and the like, and I began to represent effects of light and modulations of shadow by using the streaked glass, the glass of several colors blended, and a glass wrinkled into forms, as well as glass cast into shapes, or blown into forms. I also painted the glass very much and carefully in certain places so that in a rough way this window is an epitome of all the varieties of glass that I have seen used before or since.[12]

La Farge was now beginning to attract attention for his work in glass and to receive commissions. He also began to be imitated, and, not surprisingly, he took out a patent for the use of opalescent glass in windows in 1880.[13] That year he contracted with the decorating firm of Herter Brothers in New York to make any of the stained glass they would need for the lavish houses they were then working on. Under this contract, La Farge made glass for such clients as Samuel J. Tilden, Cyrus W. Field, Darius Ogden Mills, J. Pierpont Morgan, and William Henry Vanderbilt in New York, and John W. Doane in Chicago.[14]

By far the most important of these commissions was the glass for the William H. Vanderbilt house at 640–42 Fifth Avenue, New York. This consisted of three huge

triptychs, one on each of the landings of the grand staircase.[15] On the first landing, running through the three lights of the triptych, was a multifigured allegory, *The Fruits of Commerce*, depicting the triumphs of the Vanderbilt enterprises (plate 146). The triptych on the second-floor stair landing treated the eye to a sort of Venetian splendor (plate 147). Here the pictorialism was less obtrusive, and there was greater emphasis on the pure beauty of glass. In the left light, representing Hospitality, a kneeling figure is assisted by two cherubs carrying costly wine vessels in preparation for a banquet. The skirt of the woman is of an opalescent ruby, and her blouse is yellow glass in the shadow but white in the full light of the shoulder, against a sky of boldly shifting blue and white opalescent glass. In the right-hand light, representing Prosperity, a majestic Veronese-like figure carrying a cornucopia of coins is in a dress of golden-hued glass, skillfully adjusted to the vivid blue and white opalescent glass of the sky. The final triptych, on the third-floor landing, signified Prosperity with a scene representing the golden apples of the Hesperides.

To fulfill all the commissions now coming to him, La Farge moved his workshop to larger quarters in the Century Building, at 33 East Seventeenth Street, overlooking Union Square. The glass for the William H. Vanderbilt house was the last under the Herter contract, but in the meantime La Farge had received a contract of over $100,000 for the embellishment of the Cornelius Vanderbilt II house at Fifty-seventh Street and Fifth Avenue.[16] La Farge was given charge not only of the glass but also of work in other media, which included mural paintings, sculpture, and textiles, for which he gathered together a group of artists and craftsmen to help in the execution of his designs. For the glass, he had as helpers a seasoned glassmaker called John Calvin and a twenty-six-year-old English glazier named Thomas Wright, who had come to this country in 1880 and had worked with La Farge on the *"Battle" Window*. Both of these men would work for him until the end of his life.[17]

Most of the glass in the Cornelius Vanderbilt II house consisted of door and window transoms. Special emphasis was placed on prismatic and textural effects deriving from the various kinds of glass used, and the results reveal the exuberance of La Farge's approach to glass at this time. The many window transoms all over the house were panels of outright mosaic glass. An experimental panel that has survived comprises a variety of pressed, dropped, and molded pieces in both pot-metal and opalescent glass, in which the diversity of tone and color is heightened by the play of light striking the uneven glass surfaces.[18] For these transoms, La Farge devised a way to create a unity of style from a great variety of designs. He developed stocks of molded and pressed glass forms—rosettes, leaf and floral shapes, vases, cabochons—that could be incorporated interchangeably in different compositions. The reappearance of the same form within changing contexts produced an element of harmony combined with surprise, like a refrain in a piece of music.

La Farge was now ready to demonstrate a new peak of decorative splendor in glass.

146
The Fruits of Commerce, 1881
Triptych from William H. Vanderbilt house, New York
Stained glass
Left: 83⅜ × 39⅛ in. (211.8 × 99.4 cm.);
center and right: 83⅜ × 37⅞ in. (211.8 × 96.2 cm.)
Biltmore House, Asheville, North Carolina
G1881.1

He was commissioned to provide stained-glass windows for a baronial hall in the house of the railroad magnate Frederick Lothrop Ames, in Boston (1882). The immense hall, measuring sixty-nine by seventeen feet, paneled in carved oak under a beamed ceiling eighteen feet above the floor, was illuminated on the west by La Farge's two *Peacocks and Peonies* windows (plates 148, 149). The inner panels of these windows perpetuate in a mosaic of deep-toned glass the classic bird and flower theme of Ming dynasty painting.[19] The surrounding frame and the base are of paler glass, designed to bring light into the hall; a sparkling glass mosaic in Italian Renaissance style placed in the lunette above served as a transition from the hall paneling. The two bases in neo-Pompeian style are in trompe-l'oeil perspective to give the effect of outwardly curving parapets.

A close look at the intricate mosaic of these inner panels reveals how resourcefully and audaciously La Farge manipulated the glass (plate 150). The peacocks' tails consist of tiny chips of clear-colored glass, in a technique developed and often used by La Farge, which he called "broken jewel." The peony blossoms are each made of a single piece of

Opposite
147
Hospitalitas/Prosperitas, 1881
Triptych from William H. Vanderbilt house, New York
Stained glass
65 × 39¾ in. (165.1 × 101 cm.), each panel
Biltmore House, Asheville, North Carolina
G1881.2

See page 204, left
148
Peacocks and Peonies I, 1882
Window from Frederick Lothrop Ames house, Boston, Massachusetts
Stained glass
105¾ × 45 in. (268.6 × 114.3 cm.)
National Museum of American Art, Smithsonian Institution, Washington, D.C.
Gift of Henry A. La Farge
G1882.8

See page 204, right
149
Peacock and Peonies II, 1882
Window from Frederick Lothrop Ames house, Boston, Massachusetts
Stained glass
105¾ × 45 in. (268.6 × 114.3 cm.)
National Museum of American Art, Smithsonian Institution, Washington, D.C.
Gift of Henry A. La Farge
G1882.9

See page 205
150
Detail of *Peacocks and Peonies I*

151
Nine-Paneled Firescreen, c. 1883
Stained glass
40 × 36¼ in. (101.6 × 92.1 cm.)
The Chrysler Museum, Norfolk, Virginia
Gift of Walter P. Chrysler, Jr.
G1883.9

opalescent glass cast from a sculptured mold, so that light striking at certain angles delicately highlights the edge of petals. The rippled glass used for the deep blues of the background gives vibrancy to the setting.[20]

La Farge quickly recognized the aesthetic value of using glass of varied types and textures, which produced results so effective and entertaining when viewed close at hand, and he lost no opportunity to apply this variety to his decorative panels. Many examples have been lost, but surviving works of this kind can be cited in the *Nine-Paneled Fire-screen* (plate 151), which is composed of a random yet symmetrical arrangement of blue, green, dark amber, and mottled-white pressed-glass roundels of varying sizes. The pride that La Farge took in this piece and his fear of its being imitated is reflected in the inscription "J. La Farge, Pat. 1880," which appears on each one of the nine panels.

Even more visually intriguing is the panel of *Cherry Blossoms against Spring Freshet* (now in the Tavern on the Green, New York). In a design avowedly derived from a stylized Japanese motif, the gleaming petals of white opalescent glass stand out against rippled blue glass that simulates the rushing waters of a flooded stream. When the panel was removed from the Michael Jenkins house in Baltimore a few years ago, the forthright

152
Persian Arabesques, 1882
Window from James J. Hill house, St. Paul, Minnesota
Stained glass
34 × 50 in. (86.4 × 127 cm.)
Private collection
Lent through the Minneapolis Institute of Arts
G1882.3C

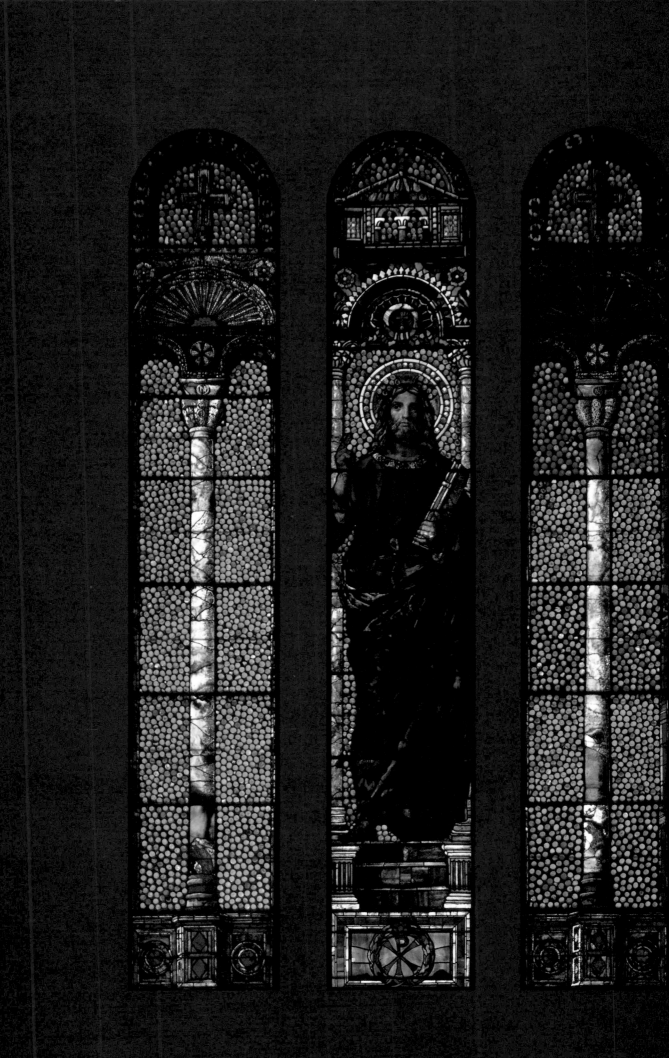

llusionism of the glass led to its being wrongly attributed to Louis C. Tiffany. But the existence of a drawing used in the design definitely established it as the work of La Farge.[21] Characteristic of La Farge is the shallow space in this panel, so aptly described by H. Barbara Weinberg as "compressed" in the plane of the glass,[22] as opposed to the deep space evoked in Tiffany's landscape windows.

In still another house panel, the famous *Fish and Flowering Branch* (plate 144), the virtuoso handling of illusionism in the glass is so personal and exuberant as to be inimitable. It was made for a gift from La Farge's son Grant to a friend, Gordon Abbott. Both men were ardent fishermen, and the explicit illusionism is full of elements evoking the excitement and pleasures of the sport. The center of attraction is the fish with its sparkling scales, a tangible presence against the variegated blue-green opalescent glass that gives viewers the feeling of looking down into deep seawater.

Among the most exquisite in pure design of La Farge's domestic glass of the early 1880s are the three delicately tinted windows for the original residence of the railroad builder James J. Hill, in St. Paul, Minnesota (plate 152).[23] The leads create flowing arabesques of plant forms, and the glass is limited in tone to a very pale green blanching almost to white, punctuated throughout by small pressed-glass golden-toned cabochon jewels. A surrounding border, in smoky-toned opalescent glass accented with sparkling rosettes, acts as counterpoint to the cool transparency of the central panel.

La Farge received a commission for the monumental west windows of Trinity Church, Boston, in 1880, three years after the church had been consecrated; but it was another three years before the windows were installed (plate 153). La Farge's first impulse for the tall, slender lancets was to break up the space with a purely ornamental treatment. An early pencil study shows the central lancet divided horizontally into superimposed sections incorporating abstract symbols and monograms and, on a lower register, a pair of small Gothic niches with standing figures (plate 154). A note by the artist alongside the study reads "perhaps better empty without figures." But Phillips Brooks, rector of Trinity, is said to have wanted something inspiring to look at while preaching. La Farge's response

153
Christ Preaching, 1883
(*Christ in Majesty*)
Stained glass
Dimensions unknown
Trinity Church, Boston
G1883.1

154
Sketch for West Windows of Nave, Trinity Church, Boston, 1883
Pencil on paper
6¾ × 4⁷⁄₁₆ in. (11.3 × 17.1 cm.)
Private collection
D1883.3

was to translate into glass the thirteenth-century portal statue of Christ in Majesty at the Cathedral of Amiens. Whether this imposing solution can be credited to the famous preacher is not known, but at least he had found in La Farge an artist able to match his spiritual aspirations with a noble rendering of an exalted devotional image, well known to the cultivated parishioners of Trinity Church. The figure of Christ, his right hand raised in benediction, fills the central lancet. The ruby red of his robe and dark blue of his mantle stand out against the blue-green mosaic background that extends into the side lancets, in a superb evocation of the sixth-century mosaic decoration of San Vitale, Ravenna. The setting becomes entirely integrated with the image of Christ by virtue of the spectacular glass, "whose astonishing brilliance," declared the French critic Samuel Bing while visiting America ten years later, "surpasses in its magic, anything of its kind in modern times."[24]

Without resorting to traditional imagery, La Farge exploited the emotive power of glass even more intensely in the *Angel of Help* (1887), in Unity Church, North Easton, Massachusetts (plates 155, 156). This remarkable window, literally a wall of glass filling the end of the west transept of the church, is a memorial to Helen Angier Ames, deceased sister of the donor Frederick Lothrop Ames, for whom La Farge had made the *Peacocks and Peonies* windows five years before. The majestic visual metaphor of the *Angel of Help* is expressed with all the resources of La Farge's new handling of glass. The jeweled sarcophagus surrounded by angels, rising above the mourners below, is composed of hundreds of fractured-glass nuggets, creating a luminous rainbowlike halo. Both that celestial vision and the very real figures below are set against a deep blue ground in La Farge's "broken jewel" technique. To elucidate the unusual theme, the standing angel below is labeled "Help" in red-glass lettering, and the two mourners are identified with the words "Need" and "Sorrow." The faces of the mourners are so individualized as to appear to be portraits.

Commissioned in 1882, the window was not completed until 1887. In January of that year La Farge wrote to his friend Henry Adams, "I am as I told you extremely fatigued. I have done the Ames window—and have suffered much from it . . ."[25] That cryptic remark was not so much a reference to problems inherent in the execution of the window as to difficulties he was having in the administration of his glass shop, the La Farge Decorative Art Company. This was a partnership organized in 1883 by a group of businessmen to provide financial support for the proliferating number of commissions La Farge was receiving. But the partnership did not prosper. La Farge, who habitually spent money on his work without regard to cost, was running deeply into debt, and he accused the company of appropriating his designs and having them executed without his control. The bitter lawsuit that ensued was settled out of court. La Farge was able to satisfy his creditors with the proceeds from an important sale of his paintings in 1884,[26] and they then returned his designs, including the watercolor modello for the Ames window. But the La Farge Decorative Art Company was now dissolved. In the midst of the controversy, La Farge's prized glassworkers John Calvin and Thomas Wright had left his company and formed the Decorative Stained Glass Co., at 46 Washington Square South, where the Ames window was finally completed.

The battle over the ownership of La Farge's designs raises a point about the way he worked. Most of these designs consisted of relatively small watercolors conveying the essence of his idea for a particular window. His mastery of watercolor made it possible to suggest his ideas in transparent washes on white paper. The watercolor served as a guide that was constantly referred to during the execution of a window. But it was only by La Farge's close supervision of the work in process, and usually by his personally choosing the glass, that his intentions could be fully realized.

La Farge consulted an intriguing and sometimes surprising range of sources for his designs—from a Ming dynasty painting for the Ames peacocks to the Amiens Christ for Trinity Church. For a large country house in Beverly, Massachusetts, belonging to Washington B. Thomas, he made a somewhat colloquial interpretation of a classical myth in the window *The Infant Bacchus* (plate 25). Within an architectural framework in neo-Pompeian style, a young woman holds a child on her shoulder, helping him to pick grapes from an arbor above. The folds of the woman's dress are sumptuously modeled in tones ranging from light orange in the highlights to somber purple in the shadows, against a translucent blue sky. This vigorous treatment of glass contrasts with the soft monochrome modeling of the flesh tones, which are rendered in photographic chiaroscuro. The contrast is curious, yet skillfully assimilated. The truth is that the window was done from a photograph. Exactly the same figural group has been discovered in a photograph recording a tableau in a family pantomime found in an album belonging to La Farge's friend, the poet and editor Richard Watson Gilder.[27]

La Farge never reconciled himself to the fact that even with the infinite variety of tones offered by opalescent glass it was still not possible to render figurative form without paint. In an attempt to overcome this difficulty, he invented a method of modeling form by joining together minute pieces of glass without leads. In his words: "The use of glass fused together in patterns without leads [is] a sort of variation of cloisonné made by joining glass [with] thin filaments of metal fused to the glass. . . . By it I have been able to model faces in much detail, bringing pieces together so small that many of them could be placed on the nail of the little finger . . ."[28] This was the method employed in *The Old Philosopher*—a window done for the Crane Memorial Library in Quincy, Massachusetts— not only for the face but for the entire piece. The source of La Farge's design was a fifth-century ivory diptych;[29] therefore he had to translate a three-dimensional image into glass. On close inspection it is clear how the face and figure are modeled by using separate pieces of glass for variations of tone, thus creating the illusion of three-dimensional form by means of colored light.

The Old Philosopher is La Farge's most successful example of cloisonné glass. But the costliness of the process and the complications caused by repeated firings forced him to abandon it almost entirely. The few later examples include his well-known *Peacock and Peonies* (1892–1908, Worcester Art Museum) and a remarkable series of panels for the author and publisher Edward W. Bok (1909). The venture into cloisonné glass, however, brought other rewards. La Farge discovered ways to manipulate the color in glass that would yield more controlled results than the accidents of texture and the prismatic effects of opalescent glass that had hitherto engaged his attention. Respecting as always the plane of the glass, he found that the new approach was fundamental to chromatic vibrancy, wherein the play of tonal harmony becomes a function of the design.

Peonies Blown in the Wind (plate 26) employs exactly the same composition as the *Peonies in the Wind* made for Marquand, but entirely new glass. The heightened intensity of tone conveys a sense of abstraction reminiscent of Henri Matisse's vivid paper cutouts. The 1886 window was commissioned by Sir Lawrence Alma-Tadema for his studio in London. The central panel of deeply glowing opalescent glass is heavily plated in certain areas to control tone, but the blossoms are of molded glass, probably cast from the same molds as the earlier version. Another window from the same period, *Butterflies and Foliage* (plates 111, 112), for the William H. White house in Brooklyn Heights, New York, shows the same trend toward color abstraction. Brilliant hues dappled on a blue ground with tonal variations produce a sparkling kaleidoscopic effect in a design derived from a Japanese brocade.

In La Farge's figurative windows of this period the heightened color becomes symbolically

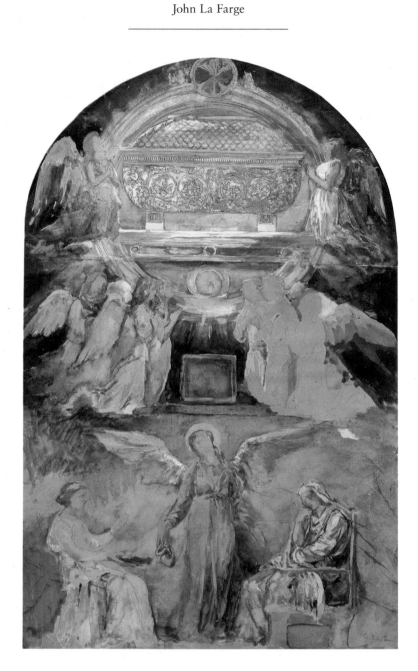

155
Charity, 1884
Study for Helen Angier Ames Memorial Window, Unity Church, North Easton, Massachusetts
Watercolor on tracing paper
18 × 11½ in. (45.7 × 29.2 cm.)
Fogg Art Museum, Harvard University, Cambridge, Massachusetts
W1884.4

156
Angel of Help, 1887
Helen Angier Ames Memorial Window
Stained glass
Dimensions unknown
Unity Church, North Easton, Massachusetts
G1887.1

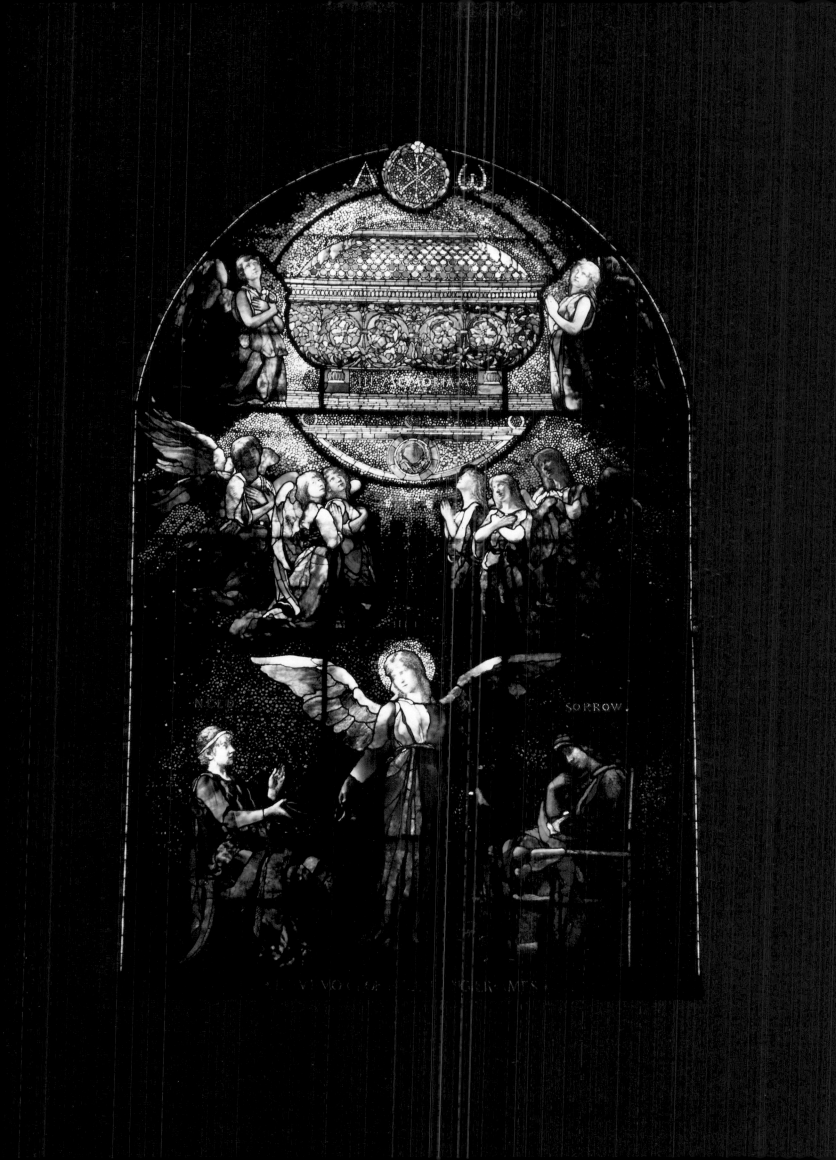

charged. In *Angel Sealing the Servants of God* (1889, Trinity Church, Buffalo), depicting the vision of Saint John the Evangelist from the Book of Revelation (chapter 7), the subject is condensed into four figures on two levels, illuminated by an unearthly light. The angel's drapery ranges from a pinkish rose in the highlights to a dark transparent violet in the shadows, mingling with the opalescent blue of the background. But his wing is of a golden tone that is carried over into the light-hued drapery of the three awestruck recipients of the mercy of God, who stand out sharply against the deep ethereal blue. This was the window that was sent to the Paris Exposition Universelle in 1889, before being installed in Trinity Church, Buffalo.[30]

In *The Good Samaritan* (1888), in the same church, the New Testament parable is depicted with a poignant sense of reality, chiefly owing to the high-keyed color. The Samaritan, in robes of richly varied wine red, supports a seminude figure on a donkey led by a boy. The group moves across the space of the two-lancet window against a background of mottled sky blue, bright yellow, yellowish green, and emerald green that vividly evokes the golden sunlight of an Impressionist landscape.

After his year spent in the South Seas (1890–91), La Farge became increasingly preoccupied with color harmony in glass. By that time glass was available in thousands of tones, so the impulse to experiment with new types of glass was no longer so urgent. La Farge could devote his energies to acquiring the best "solid and true tones" of glass he could find, for windows "where the design and the weight of color modulations were more important than any small delicacies, useless at a distance . . ."[31]

The only experimentation that La Farge continued to pursue was in cloisonné glass. In this he had been spurred on by the 1892 commission for a pair of windows for the brilliant statesman John Hay, who had been Abraham Lincoln's private secretary during the Civil War and had become a central figure in the social and political life of Washington, D.C. The architect H. H. Richardson had built contiguous houses on Lafayette Square across from the White House for Hay and his friend Henry Adams. La Farge had long known Hay, and there was between them an affinity of temperament and taste.[32] Hay had fine things in his house, including a recently acquired large painting by Sandro Botticelli, so La Farge was challenged to create something worthy of the place. At first he made an ambitious peacock window in fused and cloisonné glass; but it fell short of his expectations and had to be set aside for further work at a later date. He then made a second version in leaded glass of exactly the same design, and this is the one that was eventually placed in the house. The astonishing combinations of singing color in the packed mosaic of this window create sensations of harmony analogous to the resonant tones of chamber music.

Fifty-nine years after La Farge's death, this version of the peacock window was sold as the work of Louis C. Tiffany and appropriated to serve as the centerpiece of an exhibition of Jugendstil, at the Villa Stück, Munich, in 1969.[33] A companion window in the Hay house, which was a variation on the peonies in the wind theme (plate 162), is now in the National Museum of American Art, in Washington, D.C. Both this and the peacock window are framed in stained glass simulating the traditional mount of a Japanese hanging scroll, or kakemono.

The manipulation of tone in glass reached a climax in La Farge's great *Resurrection* window of 1894, in the First Congregational United Church of Christ, Methuen, Massachusetts (plates 157, 158). The range of tone is so wide that it is almost impossible with modern color film to record the deeper passages without overexposing the lights. It is an enormous window, measuring seventeen feet across and eleven feet high, and said to contain some eight thousand pieces of glass. The window fills the full width of the chancel of a mid-nineteenth-century Gothic Revival church. When La Farge was first

asked to do this work, he was so discouraged with the architecture that he refused the commission until a commitment was made to build a new chancel.[34] His son the architect C. Grant La Farge provided the plans for the new chancel, which was separated from the body of the church by a deeply splayed Gothic arch that focused attention on the window. In the center of the window, an almost life-size figure of Christ in brilliant white draperies and with arms outstretched ascends in a glow of light. Pairs of robed figures at either side push away dark clouds.

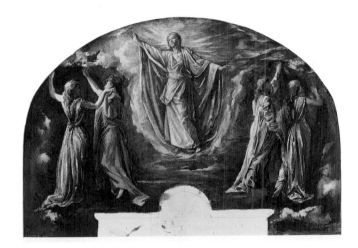

157
Resurrection, 1894
Study for Col. Henry Coffin Nevins Memorial Window,
First Congregational United Church of Christ, Methuen, Massachusetts
Watercolor on paper
19⅝ × 24 in. (14.9 × 61 cm.)
The Walters Art Gallery, Baltimore, Maryland
W1894.1

See page 216
158
The Resurrection, 1894
Col. Henry Coffin Nevins Memorial Window
Stained glass
11 × 17 ft. (3.3 × 5.2 m.)
First Congregational United Church of Christ, Methuen, Massachusetts
G1894.1

See page 217
159
Angel at the Healing Waters of Bethesda, 1898
(The Pool at Bethesda)
James Ayer Memorial Window, from Mount Vernon Church, Boston
Stained glass
133⅜ × 31⅞ in. (338.8 × 81 cm.), each panel
Worcester Art Museum, Worcester, Massachusetts
G1898.3

FOR·AN·ANGEL·WENT·DOWN·AT·A·CERTAIN·SEASON
INTO·THE·POOL·AND·TROVBLED·THE·WATER

WHOSOEVER·THEN·FIRST·AFTER·THE·TROVBLING·OF
THE·WATER·STEPPED·IN·WAS·MADE·WHOLE

La Farge was interviewed during the execution of this window and gave the following account:

The end of my work then would be in the development of design, properly so-called, within rich color by the greatest possible attention to the leads and lead-lines so that throughout the most serious element shall be felt, no matter how much covered up it may be by the wealth and richness in the *orchestration* of color. . . . [This] describes to a certain extent my later tendency [in glass], that is to say the use of leads very much, and depending upon [the choice] of glass before-hand, and not dependent upon change of modulations of color or light in the piece of glass itself. . . . The sense of study of abstract line must be strongly felt even as when in a great part of the window it is felt in a depth of color.[35]

A detail of the central figure reveals how the whites of the drapery are broken down into hundreds of individual pieces of glass varying in tone and size, with the leads defining the drapery folds. In the side figures, color of Post-Impressionist intensity ranges from pink and yellowish green, orange and cerulean in the highlights to violet and blue green in the shadows, the latter tones melting into the deep blue of the background, but with the lead lines still defining the form.

The harmonious shading and gradual transition of color—which La Farge referred to above as his "later tendency"—enormously widened the range of expression in stained glass and expanded the medium's potential far beyond anything previously attempted. There was no precedent for the sumptuous colors in the windows that La Farge's glass shop began to produce in the 1890s. An extreme example is the window *Rebecca at the Well* (1896), originally made for H. H. Richardson's Church of the Unity, in Springfield, Massachusetts. The astonishing effects of sunlight and shadow, the depth of tone, and the feeling of three-dimensional form are, however, attained at the expense of visibility. Due in part to an excessive use of plating, the window requires very strong direct sunlight to reveal the richness of the glass.

More controlled, and certainly one of La Farge's masterpieces of this period, is the *Pallas Athena* window (1898), in Sanders Theater, Harvard University. The impressive simplicity of the design reflects the more monumental figural style adopted by La Farge

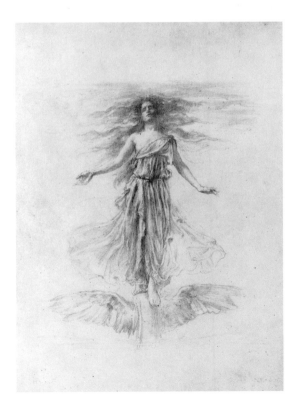

160
Fortune, 1901
(The Wheel of Fortune)
Study for window, Frick Building, Pittsburgh
Pencil on paper
10¹⁵⁄₁₆ × 7⅞ in. (27.8 × 20 cm.)
The Cleveland Museum of Art, Cleveland, Ohio
Gift of William G. Mather
D1901.3

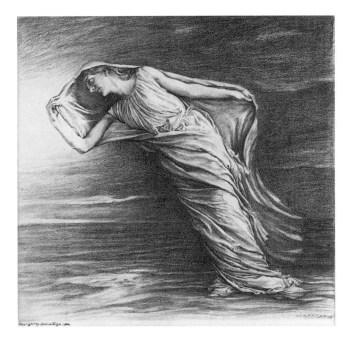

161
Dawn Comes on the Edge of Night, 1880
Design for mural (never executed),
Cornelius Vanderbilt II house
Crayon on paper
13 × 13 in. (33 × 33 cm.)
Fogg Art Museum, Harvard University,
Cambridge, Massachusetts
Gift of the Family of the late Frederick A. Dwight
D1880.3

following his first visit to Italy in 1894.[36] Through masterful management of color harmony in another window of 1898, La Farge depicted *Angel at the Healing Waters of Bethesda,* a story from the New Testament (plate 159). In a double-lancet window made for the Mount Vernon Church, Boston, the angel is shown in the right lancet leaning over the edge of the pool, about to stir the water that will heal a lame woman being helped into the pool, in the left lancet. The drama of the supernatural event centers on the angel's finger touching the still smooth water, in which his reflection is marvelously rendered. The pronounced illusionism of this window was noted by a contemporary critic, who remarked, "It is probable that there never was a window more deliberately made into a picture . . . an effect never before attempted in stained glass."[37]

La Farge's pictorialism now began to be widely imitated, often badly. But La Farge remained faithful to the magic of glass. He sought to use the inherent properties of the medium to create meaningful and symbolic imagery, wherein the glass itself serves as metaphor. An impressive example of this is the *Fortune* window, which dominates the white-marble lobby of the Frick Building in downtown Pittsburgh (see plates 45, 160). (When the window was first installed, at the opening of the building in 1902, it faced open daylight, instead of the artificial light it has today.) The theme derives from the ancient worship of the Roman goddess Fors Fortuna. Usually represented as a giver of prosperity, the goddess was often shown riding on a wheel, to indicate the fickleness of fortune.

In this window La Farge conveyed the meaning of the image by contrasting light and dark on opposite sides of the figure. The heroic female figure with red hair flaming and eyes blindfolded advances toward the spectator on a winged wheel. Her bare right breast and shoulder are in full light, the right arm and hand outstretched in a gesture of generosity; but her whole left side and arm are in deep shadow, the hand lowered as if to retract her gifts. At the top, a stormy ultramarine sky gives prominence by contrast to the dazzling head and bust of the goddess; lower down this turns into a portentous golden glow, as background to the rest of the draped figure, delicately balanced on her wheel.

The use of color to convey sensation is even more pronounced in La Farge's *Dawn Comes on the Edge of Night* (see plate 161), a window made around 1903 for the house

of New York businessman Frank L. Babbott. (The design was originally intended for one of the mural decorations in the Cornelius Vanderbilt II house but never used.) The subject comes to life in startling color unique to glass. The swooping figure wrapped in white drapery symbolizes the course of a swiftly passing moment. The deep sapphire blue sky of night shading off to paler cerulean is streaked with salmon and yellow light, while the figure stands on a brilliant emerald green ground. This explosive color calls to mind the Fauve paintings that would soon scandalize Paris.

Sixteen years after he had started the cloisonné version of the peacock window for John Hay, La Farge announced that he had finished work on it. Writing to Henry Adams in November 1907, he declared: "I had a really beautiful window almost ready just as you were here. . . . It is the window I began for Hay and tried to make in cloisonné which failed in the firing in parts. I have slowly taken it up during many months and though it may not be quite what I had hoped for then, it is both curious and I think pretty fine."[38] But to Russell Sturgis the following spring, he wrote: "Come therefore and look at a piece too dear to buy—Nothing of the kind has ever been and any one such seen anywhere on earth."[39] The ultimate result is neither a pictorial representation nor an abstraction, but the visual sensation of the subject.

In 1909, the year before he died, La Farge made a set of six small cloisonné panels for Edward W. Bok. The panels were intended to represent landmarks in the ethical development of man. In the panel depicting the love of nature—which reflected the Romanticism of the early nineteenth century—a young couple is shown looking out onto a wide landscape under a sky of marvelously varying tones. There are no lead lines to break the color transitions in the glass. The image brings to mind La Farge's dictum that "window decoration is the art of painting in air with a material carrying colored light."[40]

There is between stained glass and painting a narrow line. The main difference, as previously noted, is the dependence on highly specialized craftsmanship in creating stained glass, so that the final work is at one remove from its conception. But the very close relationship that La Farge maintained with his artisans and his active participation in every stage of the process gave his windows the distinctive stamp of his own personality.

162
Peonies in the Wind with Kakemono Borders, c. 1893
Window from John Hay house, Washington, D.C.
Stained glass
56 × 26 in. (142.2 × 66 cm.)
National Museum of American Art, Smithsonian Institution, Washington, D.C.
Gift of Senator Stuart and Congressman James M. Symington
G1893.2

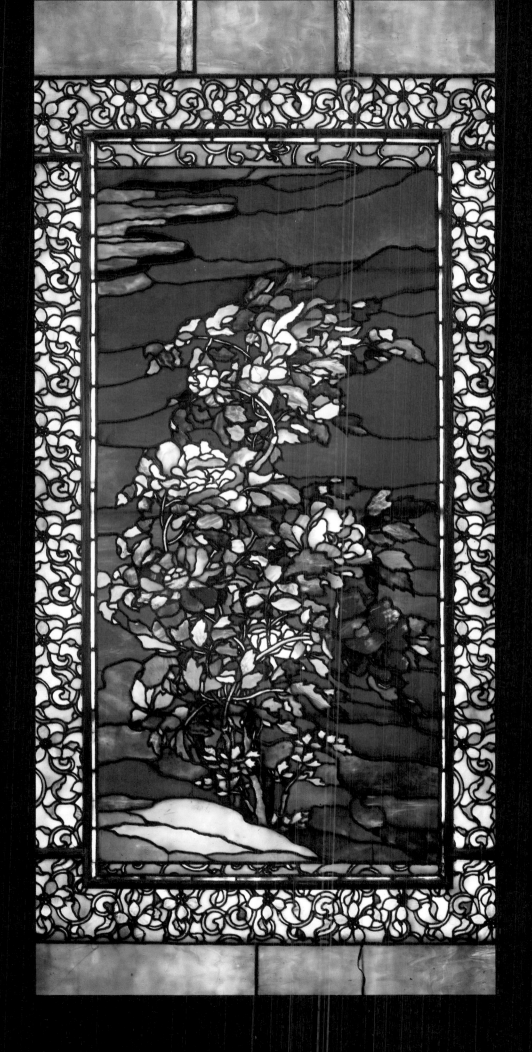

NOTES

1. Emile Mâle, "Le Vitrail français au XV et au XVI siècle," in André Michel, *Histoire de l'art*, vol. 4 (Paris: A. Colin, 1911), 788.

2. Cecilia Waern, *John La Farge, Artist and Writer* (London: Seeley and Co.; New York: Macmillan and Co., 1896), 68.

3. La Farge, quoted ibid., 53.

4. John La Farge to Thomas Gaffield, New York, March 21, 1896, La Farge Family Papers, Department of Manuscripts and Archives, Sterling Memorial Library, Yale University.

5. Charles Rollinson Lamb, "The Romance of American Glass," *Brooklyn Museum Quarterly* 16 (October 1929): 109–16.

6. Now in the collection of Mrs. Henry A. La Farge.

7. John La Farge, "Windows, III," in *A Dictionary of Architecture and Building*, vol. 3, ed. Russell Sturgis (New York: Macmillan Co., 1902), col. 1079. See also Waern, "La Farge," 53.

8. Henry G. Marquand was a distinguished art collector and second president of the Metropolitan Museum of Art.

9. Martin Brimmer to Sarah Wyman Whitman, November 10, 1881, Archives of American Art, Smithsonian Institution, Roll D-32. Whitman was a designer of stained glass.

10. James W. Baker, "An Old Timer," *Ornamental Glass Bulletin*, September 1918.

11. The vitreous amalgam was baked into the glass at high temperatures to render it permanent.

12. La Farge, in Waern, *La Farge*, 54.

13. H. Barbara Weinberg, "John La Farge and the Invention of American Opalescent Windows," *Stained Glass* 67 (Fall 1972): 4–11.

14. "Artistic Houses, Being a Series of Interviews of a Number of the Most Beautiful and Celebrated Houses in the United States," 2 vols. (New York: Appleton and Co., 1883–84).

15. Henry A. La Farge, "John La Farge's Work in the Vanderbilt Houses," *American Art Journal* 16 (Fall 1984): 31–39.

16. Ibid., 39–69.

17. "Thomas Wright Obituary," *Ornamental Glass Bulletin* 12 (March 1918): 8.

18. This experimental panel, now in the possession of Frederick L. Leuchs, Monterey, Massachusetts, is reproduced in La Farge, "Vanderbilt Houses," 67.

19. A Ming dynasty scroll painting is recorded as "Peacock and Peonies" in the catalog of La Farge's estate sale; it is believed to have served as a model for the design of these windows. See *Catalogue of the Art Property and Other Objects Belonging to the Estate of the Late John La Farge, N.A.* (New York: American Art Association, 1911), cat. no. 399.

20. For a critical estimate of the Ames windows when they were shown in New York before installation in Boston, see *New York World*, December 30, 1882.

21. This drawing is in the Museum of Fine Arts, Boston, accession no. 11.2861.

22. H. Barbara Weinberg, *The Decorative Work of John La Farge* (1972; New York: Garland Publishing, 1977), 390ff.

23. Two of the cited windows are today in the Maryhill Retreat House, Summit Avenue, St. Paul; the third is on long-term loan to the Minneapolis Institute of Arts.

24. Samuel Bing, "La Culture artistique en Amérique," 1895; *Artistic America, Tiffany Glass and Art Nouveau*, trans. Benita Eisler (Cambridge, Mass.: MIT Press, 1970), 132.

25. John La Farge to Henry Adams, January 10, 1887, La Farge Family Papers, Yale University.

26. *Important Collection of Oil and Water Color Paintings, by John La Farge of This City. To be Sold at Auction.* Ortgies and Co., New York, April 14–17, 1884.

27. The woman in the photograph has been identified as Lisa Stillman, an English friend of the Gilders, and the child in the leopardskin costume as Gilder's son Rodman, then aged six.

28. La Farge, in Waern, *La Farge*, 54.

29. Right-hand leaf of the ivory diptych, "The Muse and the Poet," in the Treasury of Monza Cathedral, northern Italy. See Joseph Sauer, *Die Altechristichle Elfenbeinplastik* (Leipzig, 1922).

30. *Official Catalogue of the United States Exhibit* (Paris: Exposition Universelle, 1889), 124. The window was awarded a medal of the first class, and La Farge received the insignia of the Legion of Honor.

31. La Farge, unpublished typescript, January 1894, La Farge Family Papers, Yale University, 10–11, box VII, folder 4. His statement was prepared at the request of Samuel Bing for his report to the French government in 1895 (see above, n. 24).

32. Seven years earlier John La Farge had been commissioned by John Hay to make a window of Saint Catherine of Alexandria to commemorate the Cleveland industrialist and railroad builder Amasa Stone (Hay's father-in-law) in

the Old Stone Church, Cleveland, Ohio. See Tyler Dennett, *John Hay, from Poetry to Politics* (New York, 1934).

33. Catalog of the International Jugendstil Exhibition, Villa Stück, Munich, 1969, cat. no. 168 (erroneously attributed to Louis C. Tiffany).

34. The window was commissioned by Julie F. Henriette Nevins, widow of Col. Henry Coffin Nevins, a wealthy Methuen cotton-mill owner.

35. La Farge, in statement prepared for Bing, La Farge Family Papers, Yale University, 11–13.

36. On his grand tour of Europe in 1856–57, La Farge had declined an invitation from his cousin, Paul de Saint-Victor, and Charles Blanc to travel to Italy that year. Reminiscing on this late in life, he wrote, "I have never known whether I did well or ill, for I cannot tell what the effect upon me might have been of the inevitable impression of the great Italian paintings seen in their own light and their native place" (Waern, *La Farge*, 12).

37. Russell Sturgis, "A Pictorial Window," *New York Evening Post*, November 7, 1898.

38. John La Farge to Henry Adams, November 19, 1907, La Farge Family Papers, Yale University.

39. John La Farge to Russell Sturgis, March 23, 1908, La Farge Family Papers, Yale University.

40. La Farge, "Window," in *Dictionary of Architecture*, vol. 3, col. 1080.

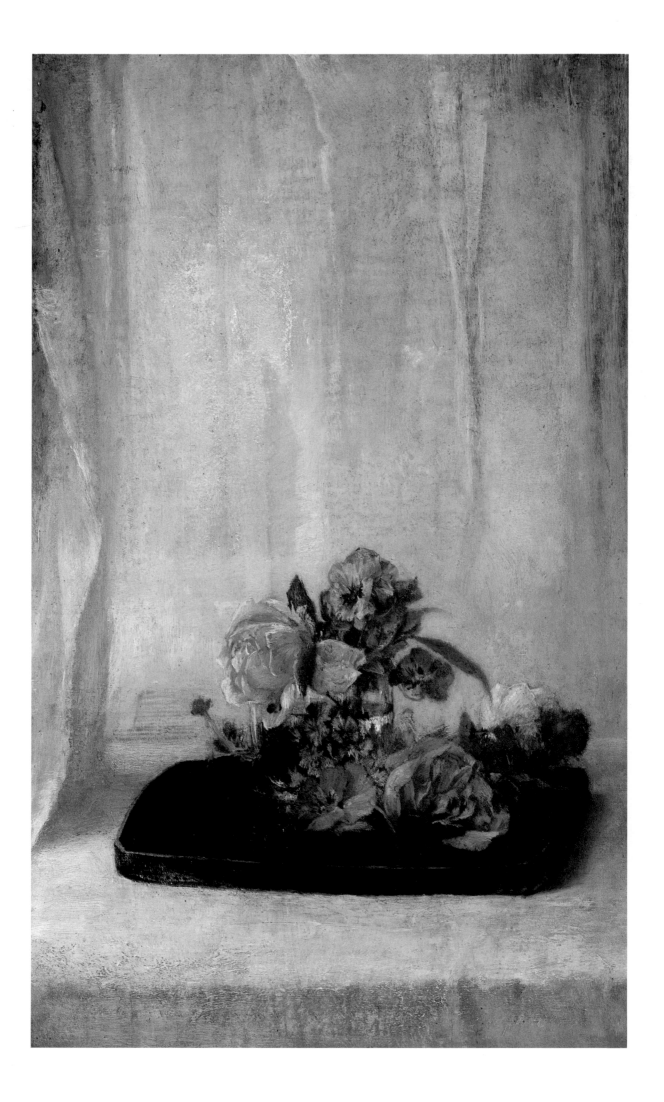

John La Farge: Aesthetician and Critic

Linnea H. Wren

163
Roses on a Tray, c. 1861
Oil on Japanese lacquered panel
19⅞ × 11¼ in. (50.5 × 28.6 cm.)
The Carnegie Museum of Art, Pittsburgh
Katherine M. McKenna Fund, 1983
P1861.4

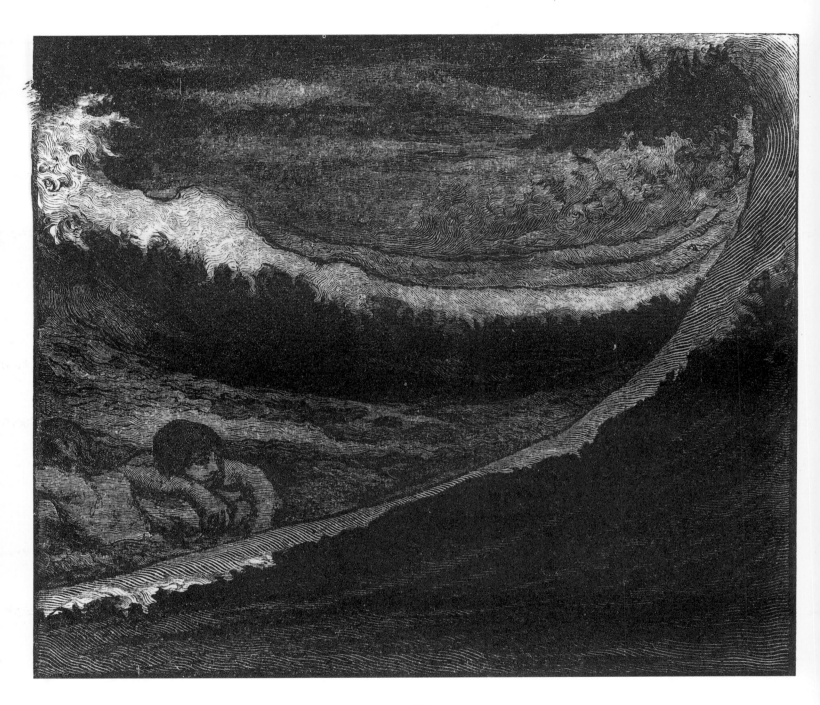

164
Shipwrecked, 1864
Illustration for *Enoch Arden* (1864)
Wood engraving
3¹⁵⁄₁₆ × 4¾ in. (10 × 10.2 cm.)
Private collection
E1864.4

Throughout his life John La Farge divided his time between the studio and the library. From the 1870s until his death his daylight hours were absorbed by his struggles to fulfill his commitments for illustrations, stained-glass designs, and mural compositions; his evenings were often occupied with his critical and aesthetic writings. As he reported wearily to a friend upon completion of his murals for the Supreme Court Room of the Minnesota State Capitol, "I am thru' my picture agony as you can see—now comes the rack of literature on which I am to be stretched."[1]

The result of La Farge's literary efforts was an impressive array of books, articles, and essays. They reveal a powerful and original thinker. He was an aesthetician and art critic who drew on a multitude of intellectual, cultural, and personal influences to evolve a philosophy of art that was admired by forward-looking contemporaries and is still surprisingly fresh today.

La Farge wrote for a variety of reasons. One of them, he confided to his friend Henry Adams, was financial. "And I make little excursions into literature which pay home expenses. So that I am still afloat—all my interests in life are just there."[2] An able lecturer and teacher, La Farge had, at infrequent intervals in the 1870s and '80s, contributed essays on art to a number of publications. In the 1890s, compelled in part by a need to augment his income, La Farge began to supply American publishing firms with a steady stream of manuscripts. Even during his final illness he worried about his uncleared debts and determined to continue the "miserable grind."[3]

Another reason that prompted his writing was La Farge's desire to capture the experiences enjoyed during his travels. Two of his books grew out of visits with Henry Adams to Japan and the South Seas. For both men, the three-month journey to Japan in 1886 was the culmination of years of interest in the Far East. Adams had long been interested in the feudal system of medieval Japan and in the social and industrial revolution of the contemporary era. La Farge had a well-developed appreciation for Japanese art. He had begun collecting it in the 1850s; a few years later he began incorporating Japanese accessories in paintings such as *Roses on a Tray* (plate 163) and began experimenting with Japanese design principles in prints such as *Shipwrecked* (plate 164). His appreciation for the simplicity, subtlety, intellectual refinement, and the beauty of color that made Japanese art "a new and fresh fountain of intellectual enjoyment" is expressed in an extended essay written by La Farge as early as 1870.[4]

La Farge and Adams were met in Japan by two Bostonians, William Sturgis Bigelow and Ernest Fenollosa. Bigelow, a doctor, had arrived in Japan in 1882 and had devoted himself to the study of Japanese language, religion, philosophy, and art. Fenollosa had been in Japan since 1878 and had taught at the Imperial University in Tokyo. His knowledge of the arts of Japan was so extensive that in 1888 he was appointed manager

of the Tokyo Fine Arts Academy and Imperial Museum. In 1890 he returned to Boston to become curator of the department of Oriental art at the Museum of Fine Arts. Under the guidance of Bigelow and Fenollosa, La Farge entrusted himself to the "full sea of new impressions" and "yielded entirely to the spirit in which I came."[5] He enthusiastically painted such luminous watercolor scenes as *Water-Fall of Urami-No-Taki* (plate 88) and *The Great Statue of Amida Buddha at Kamakura, Known as the Daibutsu, from the Priest's Garden* (plate 32).

La Farge's account of his experiences in an unfamiliar culture, accompanied by reproductions of his watercolors, was published by the Century Company, first as a series of articles in the *Century Magazine* between 1890 and 1893 and subsequently in 1897 as a volume of letters entitled *An Artist's Letters from Japan*. In this work La Farge describes the sensation of "not understanding a word of what one hears, and yet getting at a meaning through every sense,"[6] and he evoked "the piercing sound of flutes and stringed instruments" of Japanese music, "the high distinct declamation" of Japanese actors, and the "rhythmic movements" of Japanese dancers.[7] In all the arts, and throughout all aspects of society, La Farge perceived "an indefinite sadness . . . a feeling of the humility and the nothingness of man."[8]

In 1890 La Farge and Adams journeyed to the South Seas. "Beauty" and "art" became the watchwords of their voyage to Hawaii, Samoa, Tahiti, and Fiji.[9] Hawaii was pronounced "fascinating" but proved a mere "prelude" to Samoa,[10] where the two men discovered a society less defiled by Western intrusions and more faithful to its own traditions. In Samoa they met Robert Louis Stevenson; more impressive still were Araii Tamai, an old chieftess of Tahiti, and her daughter, Marau Taaroa, who enthralled them with accounts of the "old songs, superstitions and customs" of Tahiti.[11] La Farge combined the Tahitians' recollections with his own observations in his journals, and, as in Japan, responded to his visual impressions in watercolors. Three excerpts from his South Sea journals appeared in *Scribner's Magazine* in 1901, and another section appeared in the *Century Magazine* in 1904. The journal was not published in its entirety until 1912, two years after La Farge's death, when it appeared under the title *Reminiscences of the South Seas*,[12] accompanied by reproductions of his watercolors.

La Farge enjoyed a considerable reputation as a lecturer, and his most important written works emerged directly from his efforts to present his theories on art and aesthetics to a wide audience. In 1893 he was appointed instructor in color and composition at the art school of the Metropolitan Museum of Art, where he offered instruction in mural painting to prepare students to compete for the Travelling Scholarship in Mural Painting, which had recently been established in memory of the painter Jacob Lazarus. In conjunction with his instruction La Farge delivered a series of lectures in November and December 1893. Only a handful of students had enrolled in his course on painting, but approximately four hundred people attended the lectures outlining his aesthetic beliefs, which were published as *Considerations on Painting* in 1895.[13] The success of the lecture series in New York led to an invitation in 1903 to inaugurate the Scammon Lectures on Art at the Art Institute of Chicago. The six lectures, published in 1908 as *The Higher Life in Art*,[14] dealt with the Barbizon painters, who had intrigued him since he had first begun to paint.

La Farge was encouraged to write by those who admired his skill as a lecturer and teacher. Russell Sturgis, the editor of "The Field of Art" in *Scribner's Magazine*, asked La Farge to submit essays on whatever subjects interested him. Between 1898 and 1901 a series of articles by La Farge covering a wide range of topics appeared in the magazine. These subjects included contemporary artists such as Pierre Puvis de Chavannes and Auguste Rodin, art critics such as John Ruskin, and a variety of aesthetic and critical

problems ranging from "How Shall We Know the Greatest Pictures" to "The Limits of the Theatre."[15] The article on Puvis de Chavannes created a particular stir in the magazine world by including six full-color plates, the first ever published in *Scribner's*.[16] Although he eventually stopped writing for the magazine because of disagreements over appropriate subject matter for his essays, La Farge continued to work with Sturgis by contributing to two works prepared by the critic: *A Dictionary of Architecture and Building, Biographical, Historical and Descriptive* and *Ramblings among the Art Centres*.[17]

In 1901 La Farge began a series of seven articles for *McClure's Magazine*.[18] Each focused on a single painter: Michelangelo, Raphael, Rembrandt, Rubens, Velázquez, Dürer, and Hogarth. The articles, with the substitution of Hokusai for Hogarth, were published in 1903 as a single volume, *Great Masters*.[19] Between 1903 and 1908 La Farge submitted twelve more articles to *McClure's* under the general heading of "One Hundred Masterpieces of Painting," which were later published as a book with the same title.[20]

La Farge and August F. Jaccaci, the art editor of *McClure's*, became involved in 1903 in editing a set of deluxe volumes on American private art collections for the publishing house of Merrill and Baker. La Farge and Jaccaci recruited respected European and American critics to write essays on individual paintings; La Farge was, in addition, responsible for writing the introductory essays. Of the projected series, only the volume on the Isabella Stewart Gardner collection in Boston was completed, and even its publication, under the title *Concerning Noteworthy Paintings in American Private Collections*,[21] was delayed by the bankruptcy of the original publishers; it appeared in print only a year before La Farge's death. La Farge's final published work, *The Gospel Story in Art*,[22] came out posthumously in 1913.

La Farge's writings reveal his deep involvement in the complexities of aesthetics and art criticism. Yet he once confided to Henry Adams that though he had felt duty bound by a recent mural commission to read all of Plato, he had floundered at the task. "I can always enjoy him by skipping," he wrote, "but to read it right along shows me that I was never meant to follow the meanderings of philosophers."[23] Given the familiarity with philosophy and aesthetics that informed his writings, and the numerous volumes on these subjects contained in his library, the artist's statement is startling. However, La Farge added that he was disenchanted not with the entire range of philosophy but with the "system-makers"[24]—a comment that explains both his impatience with Plato and other philosophers of similar dispositions and his own originality as an aesthetician and critic.

For philosophy in general, the turn of the century was a period of unprecedented crisis. Like La Farge, an increasing number of philosophers questioned the need for an all-encompassing system of philosophy and attacked the dominant system of Hegelian Idealism. This had a profound effect on the study not only of art but of literature, religion, and many other aspects of culture. The ideas that La Farge offered in place of a system indicate his originality, his practicality, and his common sense. Rejecting the speculative approach favored by his age, he resisted the temptation to enter the realm of metaphysics and relied instead upon "the result of some twenty-three years of observation and reflection."[25] In other words, his approach was Socratic rather than Platonic, rooted in practical concerns rather than intellectual abstraction. If the method struck many of his more traditionally minded contemporaries as difficult and unsatisfying, it anticipated to an astonishing degree much current philosophical practice.

One of his critics was La Farge's own son, the Jesuit priest John La Farge. In his view, which missed the radical nature of his father's thought, La Farge had not deliberately rejected the idea of constructing an aesthetic system as much as he had "never thought of placing his philosophic ideas in a systematic form, for he was essentially discursive and 'occasional,' in writing as well as reading." Indeed, the younger La Farge was

convinced that his father's lack of system was more apparent than real. "There was a clear logical structure beneath the casual form," he insisted.[26] Its precise nature, he argued, conformed with the *"philosophia perennis,* the tradition of Aristotle and St. Thomas Aquinas."[27] It is understandable that the younger La Farge, who occupied a prominent place in the Catholic intellectual life of his own time, should want to establish his father firmly in the same Catholic tradition. But while the elder La Farge professed Catholicism throughout his life, he did not always fit easily into its intellectual tradition.

His son was mistaken not only in his assertion that Thomistic philosophy lay behind his father's thinking on aesthetic matters; he was mistaken also in attributing his father's lack of system to the demands of style and the necessities of occasion. John La Farge was unsystematic because he quite consciously chose to be so. In an article in the *International Monthly,* he quoted disapprovingly Ruskin's remark that "with time, also the vain abstractions of philosophers, through which they decided for artists what should be the rule and the law, have ceased to interest us, as we begin to feel more distinctly how little most of these theorists really felt of art and how little interest they really took in it."[28]

As a young man La Farge had deeply admired Ruskin for "having said things every decent painter knew in his heart—for the first time in such great English."[29] He retained his respect for Ruskin's prose style but came to disagree sharply with the critic's analysis of why so many aestheticians were unable to deal with specific works of art. La Farge argued that it was not the lack of aesthetic temperament that had brought those who philosophize about art into disrepute, but their attempts to systematize everything at the expense of the concrete example; if a specific work of art could not be fitted into their scheme, it was simply discarded. "I can hardly think," La Farge continued, "that it was from any exertion of mind that mere abstract theories concerning art became tiresome to us, the public; it seemed as if faith in getting truth handed to us in one given block had diminished, and that the doctrines led nowhere in particular and were continually undermined by the examples offered."[30]

The title of La Farge's major work on aesthetics, *Considerations on Painting,* suggests his aversion to conducting any large-scale inquiry into aesthetics. He did not try to develop a comprehensive theory for all of art or attempt to define a single criterion for all art criticism. He did what he could do best: he wrote about the paintings that he knew and the practices that he shared as an artist. He was attempting, "by the use of examples, and by appealing to [his] own experience . . . by taking the facts one by one . . . to get our theory along with our facts."[31] The resulting approach was, as La Farge recognized, "perhaps not very deep, perhaps limited at once in its applications, but quite comprehensible in all parts."[32] The lack of any sophisticated tradition of aesthetic thought indigenous to America may have made it easier for La Farge. To a large extent, he could define his own questions, rather than being forced to deal with questions raised in an unsympathetic philosophical context. Unlike Kant and Hegel, he was not coerced by his intellectual environment into thinking that he must be a generalizer and speak for all the arts.

But it was not just La Farge's temperament, time, and place that led to his small-scale, practical approach to aesthetic issues. He also wanted to remain within his own competencies: "such [are] my own experiences . . . they give to me the only proof of accuracy in any other man's remarks, because they unfold the very nature and basis of our judgments & must be accounted for."[33] More fundamentally, he was motivated by his belief in the priority of practice over theory. La Farge's deep conviction that "the principles of art are the practices of the best artists" was opposed to much in the Western aesthetic tradition, yet it was confirmed by his knowledge of traditions in other cultures. In his article "Art and Artists," he wrote:

I am reminded just here of some talks I once had with a Japanese Imperial Commissioner, who was engaged in an attempt to rebuild some of the practical arts of his country by means of a school. . . . I was delighted at some of his explanations of the methods to be followed. With us Westerners it would have been natural to establish a system of instruction; a corps of professors who would have to learn the theories which they were afterwards to profess and apply; and perhaps a corps of young beginners of promise or obedience who would begin to learn afresh from these theoretic views. With my Oriental a part of the mechanism was based on the idea . . . that the arts lived in certain men. He told me that there still existed older men, thrown out of the practice of their arts, who earned livings in other ways, and that his very simple programme was to find some man who had been a most successful practitioner, and have him establish the practice again, and with it, incidentally, the theory for each different branch of these minor arts. The immediate success which attended his experiments and the influence of this renovation on outsiders justified the correctness of his very simple view.[34]

What precisely did La Farge mean by "the practices of the best artists"? He did not mean their specific techniques; he warned against elevating the habits of individual artists into principles of art, since they varied widely according to personality, period, and place. In his view, it would be absurd to insist that there was only one proper method of creating a work of art. "On the contrary," he argued, "each real man, whether he be as great as Raphael or small as one of the lesser Dutch painters, had made his own laws and built the structure in which he lives."[35] Thus, the hexameter that served as the means for Homer's expression could not be adopted as the standard of poetry, and the pyramid that served as the basis for Raphael's compositions could not be mandated as the pattern for painting.[36] Indeed, since the "definitions of art are established by what [artists] have done," it would always be possible for masters like Michelangelo and Velázquez to redraw "the geography. . . of art."[37] Therefore, La Farge believed that theoreticians could never discover "a fixed equation that shall cover every problem of painting . . . a general nostrum to be applied at once."[38] The question "What is art?" must be answered not by enunciating principles but by examining works, and the answers must necessarily be as diverse as the works themselves. "For," La Farge concluded, "there are no foreknown limits of art; all that we know of the laws of art comes from the works of certain men which established these limits."[39]

The principles of art then, for La Farge, were to be discerned by analyzing the work of great artists; it is what they did that defines the nature of art and beauty. But this, as he acknowledged, can provide only a multiplicity of complex, unsystematic, sometimes contradictory, and always provisional principles. He recognized, in much the same way as Hume had earlier, that aesthetics had much more to do with the education of taste than with the development of a philosophical system.

Not surprisingly, the proposals La Farge made in his major work on aesthetics, *Considerations on Painting*, were not intended to be systematic and definitive. Indeed, he argued simultaneously for two viewpoints that his more systematically inclined contemporaries would have immediately labeled incompatible. For La Farge not only subscribed to the Romantic attitude that art is personal and that the artwork is the product of the psyche of the individual creator, he also admitted to the Hegelian notion that art is impersonal and that the work of art is, in some sense, an expression of the zeitgeist. As a result of this unlikely combination of beliefs, La Farge avoided total commitment to either theory and was thus saved from being carried away into extreme positions by the momentum of a system. He simply took from each theory what seemed to him to be

true, using as the final touchstone his own knowledge of the history and practice of art. In so doing, he created a surprisingly compelling approach.

La Farge's Romantic side is quite evident in his discussion in *Great Masters* of Michelangelo's ceiling in the Sistine Chapel. Its importance, he suggested, "is not only one of technical beauties but arises from its being one of the greatest and most important stretches, upon which an artist has been able to express what is in reality himself."[40] The emphasis here was on art as an expression of the artist's personality, and La Farge also claimed to see in the early work of Michelangelo the same haughtiness that marked his nature.[41] Although La Farge did not believe that this simple kind of relationship always obtained, art was, in some manner or other, supposed to bring one into contact with its creator. About a painting of Delacroix's that depicts lions drinking, he wrote: "Those animals . . . that drink are not merely a lion drinking, they are a beast lapping water; they are the animal indulging itself, the animal getting its necessary supply; they are Delacroix refreshing himself as he laps the water through the beast. He is playing this action. It is not the copy of the beast, the observation of a naturalist, it is the observation of the higher division of animated nature, recognizing in the lower form that side which he can understand, and clothing it in the vision of the eye."[42]

For La Farge, the distinction between good and bad art depended not solely on an artist's skill or technique but on the sentiment expressed, whether willingly or not, by his art. He claimed, quoting Eugène Fromentin, that "any work of art which has been deeply felt by its maker is also naturally well painted." A good painting was "the result of powerful conviction, the expression of the [artist's] own sentiment, a co-ordination of the memories of sight in a personal equation." In artists of the first rank the aesthetic processes are "intimately connected with a personal sentiment." In the work of their imitators, however, these processes had become divorced from sentiment and reduced to mechanical exercises. The results were, in consequence, second-rate.[43] La Farge condemned the works of Delacroix's inferior rivals, for instance, because "these works, however important, however the make of strong minds and good eyes, are not creations from within."[44]

This capacity of art to reveal the sentiments of the artist justified for La Farge a further range of critical judgments. Since it was never entirely possible to separate an individual work of art from the "personal equation" of the artist, he considered it appropriate to apply to works of art certain categories more normally used to characterize the moral and intellectual worth of individuals.[45] "In reality," he wrote, "the art of painting . . . gives most indubitable testimony of the moral state of the painter at the very moment that he uses his brush."[46] Thus in great art, "we are addressed by something beyond what is physical; we are addressed by something that is moral, and the list of names of the makers of great works would always be a list of minds of great moral quality."[47]

The moral quality of the artist could be perceived in his art, La Farge believed, only if the artist was willing to display his total personality. For La Farge, great art and sincere art became all but synonymous. Raphael's portraits, he wrote, "testify to a prodigious sincerity"; in Dürer's self-portraits, "there is in the expression a degree of sincerity which is the great mark also of all that he has done"; Rembrandt's "sincerity of mind and love of nature show through all the earlier work."[48] The lack of sincerity, La Farge argued, was what made second-rate works offensive, particularly those whose purpose seemed to be a mere display of technical virtuosity.

In expounding such views, La Farge was, of course, drawing on a late eighteenth- and early nineteenth-century Romantic legacy, which had become one of the commonplaces of his own time. His originality lay, as has been pointed out, in his combining this emphasis with a decidedly Hegelian strain. For as emphatically as he stressed the importance

of the artist's sentiment, he refused to view art, its subject matter, and its significance, as purely idiosyncratic—the implications of Romanticism carried through to their logical conclusion. La Farge denied that the meaning of a work of art was totally private, that it issued solely from the individual consciousness of its creator. A meaning that could be apprehended only by its author was no meaning at all. "Most of the work done to embody the feelings of the moment . . . loses its meaning later."[49]

La Farge believed that a host of impersonal factors, transpersonal issues, and deep cultural forces entered into the production of a work of art. "In the progress of [an individual's] life at first there is the instinct, the inherited disposition; then the accumulated memories of images which give him a language for his sentiment. The tendency to translate these by the hand describes the destiny of the painter." The painter gained insight and strength by enriching himself with these memories and by carrying in his consciousness and in his thought-life something transcendental, determined not by himself but by his history. "Each man has succeeded in turn," wrote La Farge, "to the sum of memories accumulated in him by his ancestors and himself." A familiarity with his cultural heritage helped the artist create "a world of memories which dispense him from reflective action, and become as a habit, that he may be fully free when the time comes for action. This free world that he creates escapes the chances of the exterior world in which he lives." La Farge rejected the pure Romantic view of creativity and warned against attempting to break completely with the past by trying to produce something entirely new. "In his work the real man forgets himself and any small pride—clearly or obscurely feeling that to try to find originality is a sure way of losing one's way."[50]

The originality of great art, then, had to be firmly rooted in tradition. In the great masterpieces of Michelangelo, La Farge wrote, originality "is based on the previous work of Italy back to the obscurest intentions of the Middle Ages. The half-expressed desires of earlier sculptors are here completed. So intimate is the connection that the student, as he goes through the many details, will call the memories of earlier fragments inspired by a similar intensity."[51] In the same vein, he roundly disagreed with Leonardo's reputed description of Giotto as a painter without precedents. No one, La Farge was convinced, "has beginnings from himself alone."[52] For La Farge, great art was indebted not simply to the individuality of the artist but also to the great "Ideas" of a culture. "These works of men which we study or admire," he wrote, "contain, in some mysterious way, the informing principle which shaped them."[53] This principle kept alive the impersonal and transcendental aspects of art.

La Farge identified these impersonal elements primarily in terms of national traditions and characteristics. Spanish religious paintings, he wrote in *Great Masters*, "are some of the truest expressions of religious feeling produced by art. They may not suit the taste of today, or the sentiments of a more intellectual or more refined habit of mind, but if ever the sentiment of the people was reflected in art, it is there in the paintings of the Spaniards."[54] On the other hand, he believed that no English artist could paint religious subjects; he wrote in his article on Hogarth, "it might, therefore, be pardonable, as by a race instinct, that Hogarth should have failed in his religious stories."[55] Nationality could be a limitation, as in the case of Hogarth and Dürer. Of the latter, La Farge commented: "The German side of his work is its limitation. The national or race side of any work of art is its weakness. What is called German is probably nothing more than a form of less lengthy civilization. The reason of the superiority of Italian expression in art is the extreme antiquity of its origins, which for thousands of years have never been aimed at a national, but, on the contrary, at a general human expression."[56] The positive influence of Italy was reiterated in La Farge's description of Leonardo's following "a long-beaten path of art in a manner so Italian, so indicative of both the faith and the affections of

the people, that we realize what a national art can be."[57]

The influences of the age in which an artist lived also played an important role. Hogarth could be understood, La Farge argued, only by recognizing that his genius belonged "essentially to the eighteenth century's middle strength, to ideas unaffected by the inquiries, the sentiments, the agitations which closed the century, and are prolonged into today."[58] Rubens was cited as another example: "Of all men who have expressed themselves in the art of painting, Rubens had the widest sympathy for the whole of life. In his own works are reflected the attempt of that age to unite all divergencies, and to break down the lines which often separate the more spiritual demands from the natural enjoyment of nature and art, and the common likings of man."[59]

It was in order to explore the subtle relationship between the personal and the cultural elements in art that La Farge introduced the quite modern notion of "the ordinary grammar of the art of painting." Art and spoken language were analogous, he explained, in that neither could possibly exist as a "lawless game": both were forms of expression and therefore subject to the limits that this implied. "Art is a language," maintained La Farge, "a language made on purpose for the thought it tries to express." And like any language, art had a "grammar"; it had rules that determined how the individual artist expressed his convictions and how his audience understood them. The artist could no more be "absolutely free-minded in the way he reproduces things" than the orator could be in the way he said things. "It is as if we said: We shall be free in the use of words, and if necessary, put in words of other languages,—any which seem neater, Japanese, Chinese, French; and as these cannot meet all cases, we shall invent them as we go along."

In recognizing these impersonal aspects of painting—the "words" and the "grammar"—La Farge circumscribed the activity of the artist. "The artist has only the choice of the language he has learned and which he has modified to some extent. That language may be more or less stilted, heroic, idyllic, epic, or commonplace; he can only ride the ride that is brought to him by Fate."[60] Far from limiting originality, this apparent curtailment of freedom made originality and creativity possible. Words and grammatical rules must be public property, for that is what makes them a possible means of communication. In art, as in language, La Farge recognized, "we assemble these different parts that constitute our speech, and use them for that form of communication which is best suited to our individual capacities."[61] One result was continuity of style and motif. Discussing medieval portraits of the Madonna, La Farge observed that "of course, they resemble the earliest ones in the Catacombs, but they already testify to the increase of the respect for the Mother of Christ. With the natural necessity of using previous expressions, which rules absolutely the ways of speech of man, whether in words or writing or the arts of the hand, the types of many of these early works recall, even through their unsuccessful efforts, the Junos and Athenes just disappearing from common sight."[62]

By understanding art as a form of language, La Farge articulated a conceptual scheme that allowed him to avoid both the Romantic extreme of naive expressionism and that of Hegelian Idealism, which made the artist simply the unconscious instrument of his culture and era. His notion of the ordinary "grammar" of painting prefigured a similar concept that later played a key role in the works of Ludwig Wittgenstein. But while the shared terminology may be accidental, there is no doubt that La Farge's overall approach to aesthetic issues and particularly his insistence that theory must be grounded in practice is in harmony with the methods and goals of the philosophy advocated by Wittgenstein.

La Farge concluded that only a synthesis of personal and impersonal factors could explain how a painting worked and what made a painting great. Art, he explained, fused the personal, which was free and new, and the impersonal, which was old and given,

and thereby escaped from the tyranny of the moment so that it could be understood beyond its immediate context. "The forms of art," according to La Farge, "are not affected by fashion, which belongs to the few, and the record of human life is, therefore, deeper and more continuous."[63] Great art certainly spoke of the moment but also transcended it. He used Hogarth as an example: "For this re-entering into the past, such a work as Hogarth's is a great help. Unlike most artists he builds his pictures out of the more transitory materials of politics and nationalism. The average heart of his time and place beats strongly in his pictures; their purpose and their morality seem at first sight limited to the use of the moment only, and it is only through the man's power—what we call genius—that the eternal truth lurks all through the smaller transient facts he liked to produce."[64]

Thus La Farge refused to choose between interpreting art as either a product of the individual's creativity or a reflection of social pressures. It was not that either view had no truth at all for La Farge, it was rather that neither view had all the truth. Art is too complex to be explained so simply, and understanding it should require effort, patience, and time. If painting were a form of propaganda with a message open to every observer, it would not need to be pondered. "A man giving [in art] even what all expect, sometimes goes very far beyond, and his own record of memories will only be understood as other people's memories accumulate. He will be a constant reminder of there being something more."[65]

This essay is a revision of a chapter from my doctoral dissertation, "The Animated Prism: A Study of John La Farge as Author, Critic, and Aesthetician" (University of Minnesota, 1978). I would like to acknowledge the contributions to my study made by Melvin Waldfogel and the late Donald Torbert.

1. John La Farge to Mary Cadwalader Jones, n.d., La Farge Family Papers, Department of Manuscripts and Archives, Sterling Memorial Library, Yale University.

2. John La Farge to Henry Adams, June 4, 1908, La Farge Family Papers, Yale University.

3. John La Farge to Henry Adams, May 21, 1898, La Farge Family Papers, Yale University.

4. John La Farge, "An Essay on Japanese Art," in Raphael Pumpelly, *Across America and Asia* (New York: Leypoldt and Holt, 1870), 202.

5. John La Farge, *An Artist's Letters from Japan* (New York: Century Co., 1897), 17.

6. La Farge, *Letters from Japan*, 3.

7. Ibid., 18, 21.

8. Ibid., 98.

9. Harold Dean Cater, ed., *Henry Adams and His Friends* (Boston: Houghton Mifflin Co., 1947), 200.

10. Henry Adams, *Letters of Henry Adams*, ed. Worthington C. Ford, vol. 1, *1858–1891* (Boston: Houghton Mifflin Co., 1920), 413.

11. Adams, *Letters*, vol. 2, *1892–1918*, 35. Adams also wrote a volume devoted exclusively to Tahitian folklore, *Tahiti: Memoirs of Araii Tamai e Marama of Eimeo, Teriinere of Tooarai, Terrenui of Tahiti, Tauraatua i Amo*, which was privately printed by Adams in Washington, D.C., in 1901, and published under the nominal authorship of Marau Taaroa.

12. John La Farge, *Reminiscences of the South Seas* (Garden City, N.Y.: Doubleday, Page and Co., 1912).

13. John La Farge, *Considerations on Painting* (New York: Macmillan and Co., 1895).

14. John La Farge, *The Higher Life in Art* (New York: McClure Co., 1908).

15. John La Farge, "How Shall We Know the Greatest Pictures?" *Scribner's Magazine* 24 (August 1898): 253–56; "The Limits of the Theatre," *Scribner's Magazine* 25 (April 1899): 509–12; "Concerning Painters Who Would Express Themselves in Words," *Scribner's Magazine* 26 (August 1899): 254–56; "On Coloring Statuary and Architecture," *Scribner's Magazine* 27 (June 1900): 765–68; "The American Academy at Rome," *Scribner's Magazine* 28 (August 1900): 253–56; "Puvis de Chavannes," *Scribner's Magazine* 28 (December 1900): 672–84, 29 (June 1901): 607–81, 30 (July 1901): 69–83. One article was published posthumously: "The Teaching of Art," *Scribner's Magazine* 49 (February 1911): 178–88. La Farge was also the coauthor, with William C. Brownell, of "Two Recent Works by Rodin" in *Scribner's Magazine* 23 (January 1898): 125–28. A longer discussion of Ruskin appeared under the title "Ruskin, Art and Truth" in *International Monthly* 2 (July–December 1900): 510–35.

16. Frank Luther Mott, *A History of American Magazines*, vol. 4 (Cambridge, Mass.: Harvard University Press, 1957), 726.

17. Russell Sturgis, *A Dictionary of Architecture and Building, Biographical, Historical and Descriptive* (New York: Macmillan Co., 1902). Russell Sturgis, Kenyon Cox, and John La Farge, *The Booklover's Reading Handbook to Accompany the Reading Course (III) Entitled: Ramblings among the Art Centres* (Philadelphia: Booklover's Library, 1901).

18. John La Farge, "Michelangelo," *McClure's Magazine* 18 (December 1901): 99–112; "Raphael," *McClure's Magazine* 18 (February 1902): 309–22; "Rembrandt," *McClure's Magazine* 18 (April 1902): 502–14; "Rubens," *McClure's Magazine* 19 (June 1902): 159–73; "Velasquez," *McClure's Magazine* 19 (October 1902): 497–513; "Dürer," *McClure's Magazine* 20 (December 1902): 129–42; "Hogarth," *McClure's Magazine* 20 (April 1903): 584–98.

19. John La Farge, *Great Masters* (New York: McClure, Phillips and Co., 1903).

20. John La Farge, "One Hundred Masterpieces of Painting," *McClure's Magazine* 22 (December 1903): 148–63; 22 (February 1904): 351–56; 22 (April 1904): 579–86; 23 (July 1904): 298–305; 23 (September 1904): 491–97; 23 (October 1904): 595–603; 24 (December 1904): 195–205; 24 (February 1905): 401–7; 24 (March 1905): 529–38; 28 (February 1907): 437–44; 30 (January 1908): 339–45; 32 (December 1908): 135–44. John La Farge, *One Hundred Masterpieces of Painting* (Garden City, N.Y.: Doubleday, Page and Co., 1912). In 1909 Doubleday, Page and Co. had published La Farge's *The Ideal Collection of the World's Great Art*.

21. August F. Jaccaci, ed., *Concerning Noteworthy Paintings in American Private Collections*, with an introduction by John La Farge (New York: August F. Jaccaci Co., 1909).

22. John La Farge, *The Gospel Story in Art* (New York:

Macmillan Co., 1913).

23. John La Farge to Henry Adams, March 16, 1907, La Farge Family Papers, Yale University. La Farge was referring to his commission for the Minnesota State Capitol. The lunette entitled *The Relation of the Individual to the State* was based on a theme from Plato's *Republic*.

24. John La Farge to Henry Adams, March 4, 1907, La Farge Family Papers, Yale University.

25. John La Farge to Sylvester Ross Koehler, August 12, 1879, Sylvester Ross Koehler Papers, George Arent Research Library for Special Collections, Syracuse University, Syracuse, New York.

26. John La Farge, S.J., "The Mind of John La Farge," *Catholic World* 140 (March 1935): 704.

27. Ibid., 705.

28. La Farge, "Art and Artists," 340.

29. La Farge to Margaret Perry, February 20, 1860, La Farge Family Papers, New-York Historical Society.

30. La Farge, "Art and Artists," 341.

31. La Farge, *Considerations on Painting*, 76.

32. Ibid.

33. John La Farge to Mary Cadwalader Jones, November 4, n.d., La Farge Family Papers, Yale University.

34. La Farge, "Art and Artists," 354.

35. La Farge, *Great Masters*, 83.

36. La Farge, *Considerations on Painting*, 227.

37. La Farge, *Great Masters*, 26, 28.

38. La Farge, *Considerations on Painting*, 67.

39. La Farge, *Great Masters*, 26.

40. Ibid., 31.

41. Ibid., 14.

42. La Farge, *Higher Life in Art*, 19–20.

43. La Farge, *Considerations on Painting*, 22, 27, 27, 37.

44. La Farge, *Higher Life in Art*, 20.

45. La Farge, *Considerations on Painting*, 22.

46. Ibid., 11.

47. La Farge, *One Hundred Masterpieces*, xxix.

48. La Farge, *Great Masters*, 79, 198, 104.

49. La Farge, *Considerations on Painting*, 30.

50. Ibid., 40, 67, 41, 38–39.

51. La Farge, *Great Masters*, 33–34.

52. La Farge, *Gospel Story*, 278.

53. La Farge, *Considerations on Painting*, 9.

54. La Farge, *Great Masters*, 177.

55. La Farge, "Hogarth," 597.

56. La Farge, *Great Masters*, 214.

57. La Farge, *Gospel Story*, 150.

58. La Farge, "Hogarth," 595.

59. La Farge, *Great Masters*, 133.

60. La Farge, *Gospel Story*, 6.

61. La Farge, *Considerations on Painting*, 8.

62. La Farge, *One Hundred Masterpieces*, 308.

63. Ibid, viii.

64. La Farge, "Hogarth," 595.

65. La Farge, *Considerations on Painting*, 152.

John La Farge posing for the *Portrait of the Painter*, c. 1859
Photograph from glass-plate negative
Yale University Art Gallery, New Haven, Connecticut
Gift of Frances S. Childs in memory of Henry A. La Farge

CHRONOLOGY

James L. Yarnall with Mary A. La Farge

1835

March 31—John Lewis Frederick Joseph La Farge born on Beach Street, New York, the eldest child of John Frederick La Farge (1786–1858) and Louisa Josephine Binsse de Saint-Victor (1817–1895), wealthy and cultured French émigrés.

Late 1830s

Resides in vicinity of Washington Square, New York. Receives bilingual education with strong emphasis on literature and culture as well as strict Roman Catholic religious training.

Early 1840s

Receives first lessons in drawing, from his maternal grandfather, Louis Binsse de Saint-Victor (1778–1844).

1845

Receives first lessons in watercolor, from an "English water color painter," while attending Columbia Grammar School. Paints *Dead Bird* (Yale University Art Gallery), his earliest known watercolor.

1849

Carefully copies engravings and other works of art (a dated sketchbook is in Yale University Art Gallery).

1850–51

Attends Mount Saint Mary's College, Emmitsburg, Maryland.

1851–52

Attends Saint John's College, New York (the present Fordham University).

1852–53

Returns to Mount Saint Mary's College and graduates in June 1853.

1854–55

Studies law in New York. Studies painting in New York with a "French painter" (perhaps Régis-François Gignoux. Becomes acquainted with George Inness. Learns about Barbizon School art and purchases lithographs and other reproductions in that style. 1855—awarded master's degree from Mount Saint Mary's College. Probably reads M. E. Chevreul's treatise on optics and perception for first time.

Paints his first known oil painting, a self-portrait dated "1854/1855" (private collection).

1856–57

April 7, 1856—departs for Le Havre, France, on steamship *Fulton* with brothers Henry (1839–1890) and Alphonse (1840–1889). Welcomed in Paris by his mother's family, including her first cousin, the well-known critic Paul de Saint-Victor (1827–1881), who introduces him into literary circles. Enrolls briefly in the studio of Thomas Couture, who advises him to copy in the Louvre; registers to copy there. Meets and models for Pierre Puvis de Chavannes. Deeply impressed by the works of Eugène Delacroix and Théodore Chassériau. May 1856—travels to Belgium, where he sketches from nature and learns about encaustic painting from Henry Le Strange. June 1856—visits relatives in Brittany. July 1856 and/or July 1857—travels to Denmark and executes copy of Rembrandt's *Christ and the Disciples at Emmaus* in Copenhagen. By August 1856—returns to Brittany. Spends remainder of trip copying from old masters or sketching from nature in Paris, Belgium, Munich, Dresden, and Switzerland; cancels planned trip to Russia to return to Paris. Fall 1857—called back home by news of his father's illness; stops en route at the Manchester Art Treasures Exhibition in England. Resumes law studies in New York.

1858

By middle of year—rents a studio, which he will retain throughout his life, in the newly opened Tenth Street Studio Building at 51 West Tenth Street, New York. Studies painting, although apparently practices law for a living. Meets the architects Richard Morris Hunt, Henry Van Brunt, William Ware, and Richard Gambrill. June 26—father dies.

1859

Spring—relocates to Newport, Rhode Island, in order to study painting in the studio of William Morris Hunt on Church Street; among his fellow students are William James, Henry James, and Thomas Sergeant Perry. Summer—begins independent study of both landscape and still-life subjects from nature. By this time is acquainted with Japanese art. Becomes romantically involved with Tom Perry's sister, Margaret Mason Perry (1839–1925), a granddaughter of Commodore Oliver Hazard Perry and grandniece of Commodore Matthew Galbraith Perry. Complications ensue because of her Episcopalian background; La Farge tries

unsuccessfully to convince her to convert to Catholicism. October—paints an important self-portrait (plate 3) set on the grounds of his family's country house at Glen Cove, Long Island, New York. Begins illustrations (never published) for Robert Browning's *Men and Women*, experimenting with photographic reproductive methods. December—Perry family departs for Porter plantation in Louisiana for five months.

1860

January—begins correspondence with Margaret Perry after hearing that she has other suitors. April—visits the Bayou Teche, Louisiana, and becomes engaged to Margaret. Around May—returns via family house at Glen Cove. Suffers an illness that he describes as malaria, "which for many years hung over me." By July—returns to Newport. Works on a large altarpiece, *Saint Paul Preaching at Athens*, commissioned by Rev. Isaac Thomas Hecker, founder of the Paulist Fathers; it was not completed until 1863 and never used by the Paulist Fathers. October 15—marries Margaret Perry in Newport. November 7—she is formally converted to Catholicism and baptized by Father Hecker in New York. La Farge is elected to honorary membership in the Century Club, New York.

1861

March—purchases residence on corner of Bull Street and Mount Vernon Court in Newport. Summer—rents cottage at Howard Farm on Paradise Road in the nearby town of Middletown, Rhode Island, a section of the coast known as Paradise. Begins to paint and experiment with color theory. Begins productive period of painting still lifes in oil.

1862

January—birth of first son, Christopher Grant (1862–1938), later a very successful architect. April—La Farge first exhibits at the National Academy of Design, New York. Paints an important portrait of Henry James (plate 4) and a major still life, *Agathon to Erosanthe, Votive Wreath* (plate 9). Begins two panels of the Virgin and Saint John (location unknown) for a Crucifixion triptych commissioned by Saint Peter's Church, New York (project abandoned in 1863 before execution of central Crucifixion panel).

1863

John Chandler Bancroft takes up residence in Paradise, where the La Farge family continues to summer. La Farge imports Japanese prints with Bancroft through A. A. Low, president of the New York Merchant's Association, who summers in Newport. November—birth of first daughter, Emily (1863–1919).

1864

April 14—forced to flee Mount Vernon Court house to escape creditors; relocates to Ellis Street in Roxbury, Massachusetts. Studies anatomy in Boston with William Rimmer. Fall—for a Christmas gift-book edition of Alfred, Lord Tennyson's *Enoch Arden* designs illustrations in a style influenced by Japanese and Pre-Raphaelite illustration. Begins illustrations for Henry Wadsworth Longfellow's *The Skeleton in Armor* (worked on through 1866; never published). October—sells Mount Vernon Court house. First

Left to right: Margaret Perry La Farge,
Mrs. Louis La Farge, Louis La Farge,
John La Farge (seated), Thomas Sergeant Perry, and
Aimée La Farge (in foreground with dog), c. 1860–61
Photograph from lost daguerreotype
Yale University Art Gallery, New Haven, Connecticut
Gift of Frances S. Childs
in memory of Henry A. La Farge

exhibits at the Brooklyn Art Association. Commissioned by architect Henry Van Brunt to prepare a set of still-life panels to decorate the dining room of the Charles Freedland house, 117 Beacon Street, Boston (executed 1865; never installed). Unrecorded date—birth of son Raymond, who died within two years (inconclusively documented).

1865

Relocates more permanently to Paradise, where he and family reside on Paradise Avenue until 1871, at times spending winters "in various rented houses in the town [Newport]." October—onset of a serious illness that lasts at least until 1867, believed by the artist to have been lead poisoning. September or October—birth of son John Louis Bancel (1865–1938; known as Bancel), later an artist and his father's studio assistant.

1866

Begins first major landscape painting, *Paradise Valley* (plate 57), painted in the backyard of Paradise Avenue house and completed in 1868. Paints second important wreath picture, *Wreath of Flowers* (plate 1). December—first auctions off part of his extensive personal library in New York, purportedly to raise funds for travel to Europe. First exhibits with the Allston Club in Boston.

1867

Begins second major landscape painting, *The Last Valley— Paradise Rocks* (plate 58), painted from a ridge in the Paradise Hills overlooking Bishop Berkeley's Rock. Begins a series of illustrations for the *Riverside Magazine for*

Margaret Perry La Farge, 1870s
Photograph from lost daguerreotype
Yale University Art Gallery, New Haven, Connecticut
Gift of Frances S. Childs
in memory of Henry A. La Farge

Young People, the last of which is completed in 1870.
September—birth of daughter Margaret (1867–1956).

1868

Begins third major landscape painting, *Autumn Study.
View over Hanging Rock, Newport, R.I.* (plate 49), which
is never brought to a high degree of finish. His mother
remarries and moves to Shrub Oak, near Peekskill, New
York, where he paints occasionally in subsequent years.
Birth of a stillborn child. Visits brother Frank (1847–
1876) in Colorado, where Frank had been sent to recover
from tuberculosis; while there, paints watercolors of the
Garden of the Gods near Pike's Peak. Elected member of
the American Society of Painters in Water Colors (later
called American Water Color Society).

1869

Paints *A Boy and His Dog* (plate 59), depicting Dicky
Hunt, son of architect Richard Morris Hunt. Paints *Sleeping
Beauty* (destroyed by fire before 1911), a large canvas of
his wife asleep and clad in a Japanese robe, which is
ridiculed when exhibited at the National Academy of Design.
July—birth of son Oliver Hazard Perry (1869–1936). La
Farge elected a member of the National Academy of Design.
Serves on the Provisional Committee to set up the Metro-
politan Museum of Art. First exhibits in regular exhibitions
at the Century Club, New York.

1870

Paints first of several "Decorative Panels," *The Muse of
Painting* (plate 68). Publishes "Essay on Japanese Art" in
Raphael Pumpelly's *Across America and Asia*. February—
birth of a stillborn child. New York address listed as the
YMCA, Twenty-third Street and Fourth Avenue.

1871

First exhibits at the Yale School of the Fine Arts. Appointed
university lecturer on composition in art at Harvard College.

1872

Newport address listed as "Lovie's, Mann Avenue" in
Newport proper. From this point on, resides largely in New
York or Boston. depending on commissions, staying in
various men's clubs and temporary rental accommodations
while his family remains in Newport. Summer—first exhibits
with London Society of French Artists, group sponsored
by the Parisian dealer Durand-Ruel. Joins the Lotos Club,
New York. Illustrates Abbey Sage Richardson's *Songs from
the Old Dramatists*. Lectures on Ruskin at Harvard College;
his talks are interrupted by illness. Unrecorded date—birth
of son Joseph Raymond, who apparently died in infancy
(inconclusively documented).

1873

March—wife purchases with her inheritance a house at
10 Sunnyside Place, Newport, which remains the family
residence until daughter Margaret dies in 1956. La Farge
departs for Europe, stopping in Cuba en route. Visits with
the Pre-Raphaelites for "some five or six months," meeting
Sidney Colvin, Ford Madox Brown, Dante Gabriel Rossetti,
and Edward Burne-Jones. Summer or fall—exhibits *The
Last Valley—Paradise Rocks* and other works with the
London Society of French Artists. Visits French cathedrals
at Amiens and other sites. Visits Puvis de Chavannes again
in Paris. Completes oil painting, *The Story of Psyche* (Scripps
College).

1874

January—returns from Europe, perhaps around the time
of the birth of his daughter Frances Aimée (1874–1951).
The Last Valley—Paradise Rocks is shown at the annual
exhibition of the French Salon. On commission from Ware
and Van Brunt, makes first designs for stained glass for
Memorial Hall at Harvard (window only half-completed,
considered a "botch" by La Farge, and never installed).
Completes oil painting, *Virgil* (plate 67). March—first
exhibits at the Boston Art Club.

1875

Rents a studio in Booth's Building, Twenty-third Street and
Sixth Avenue, New York. Provides frontispiece to *Lotos
Leaves*, a book of poetry published by the Lotos Club.
Serves on founding committee of the Museum School of
the Museum of Fine Arts, Boston. First exhibits at the
Union League Club in New York. Helps organize a painting
exhibition at Cottier's Gallery that results in founding of
Society of American Artists. Manufactures first stained-
glass windows. Unrecorded date—birth of daughter Aimée,
who died shortly after birth.

1876

March—first exhibits with the American Society of Painters
in Water Colors at the National Academy of Design in
New York. Summer—consults on decoration of Trinity
Church, Boston, and begins drawings for project. Septem-
ber—oversees execution of mural decorations for Trinity,
assisted by Augustus Saint-Gaudens and Francis Davis
Millet, among others. Awarded medal at Philadelphia Cen-

tennial Exposition for *The Last Valley—Paradise Rocks*. March—*Paradise Valley* is shown at the National Academy of Design. September—Alice Sturgis Hooper purchases *Paradise Valley* for three thousand dollars when it is consigned to Doll and Richards, Boston, the firm that later becomes La Farge's primary dealer. Begins Edward King Tomb with Augustus Saint-Gaudens (installed in Newport's Island Cemetery in 1878).

1877

February—completes major phase of work at Trinity Church (plate 115). Spring—receives commission to provide three-panel reredos paintings for the chancel of Saint Thomas Church, New York (plate 126), with cross and adoring angels sculpted by Saint-Gaudens. By October—completes first panel of the reredos; completes large mural painting, *Christ and the Woman of Samaria at the Well*, for Trinity Church. Continues to experiment with stained glass.

1878

March—participates in first exhibition of the Society of American Artists and is elected as the twelfth member. April—completes other Saint Thomas reredos panels. By May—completes second large mural for Trinity Church, *The Visit of Nicodemus to Christ*, which serves as the basis for an oil painting of the same title (plate 70). Borrows *Paradise Valley* from Alice Hooper to lend to the Exposition Universelle in Paris. Completes oil painting, *The Three Wise Men* (plate 130). November—holds an extremely successful and highly publicized auction of his works at Peirce and Co., Boston, selling off his early small Newport landscapes and still lifes, along with *The Last Valley—*

Paradise Rocks, *A Boy and His Dog*, and *Sleeping Beauty*. Begins oil painting, *The Golden Age* (plate 69), a picture still on his easel in late 1879. Makes windows including opalescent glass for William Watts Sherman house in Newport (plate 145). Newport studio address listed as 28 Prospect Hill Street, in downtown section. Begins period of extensive use of watercolor.

1879

At New York studio exhibits a major window based on Renaissance prototypes for the residence of Dr. Richard H. Derby, Huntington, Long Island, his first window made with predominantly opalescent glass. December—holds a successful auction of works at Leonard's Gallery, Boston, selling recent watercolor still lifes along with major oil paintings such as *Virgil*, *The Shepherd and the Sea*, and *The Three Wise Men*. Establishes his own glass manufacturing shop at 39 West Fourth Street, New York; retains studio in Tenth Street Studio Building, where a great deal of decorative work is done. Designs a peony window for the house of Henry G. Marquand in Newport, the first of numerous versions of this subject in glass.

1880

February—receives commission for decoration of United Congregational Church, Newport, a project completed by June (plate 132). February—receives a patent for his "opal" glass, the first patent for opalescent glass issued in the country. February—birth of son John (1880–1963), later the Rev. John La Farge, S.J., an eminent Catholic priest and writer. July—receives contract for decoration of Cornelius Vanderbilt II house at 1 West Fifty-seventh Street,

John La Farge warming his feet during the painting of Trinity Church, Boston, 1876
Ferrotype
Yale University Art Gallery, New Haven, Connecticut
Gift of Frances S. Childs
in memory of Henry A. La Farge

on Fifth Avenue, New York (plates 136, 137). November—receives contract to provide decorations for the dining room of the new Union League Club, New York (plate 135), with sculptural work by Augustus Saint-Gaudens, a project completed in November and December. Contracts with the decorating firm of Herter Brothers, New York, to make stained glass for their commissions.

1881

January—second auction held in New York of books from his library. February—first major article on La Farge, by George Parsons Lathrop, published in *Scribner's Magazine*. March—small exhibition of his stained glass held at the Museum of Fine Arts, Boston. Designs *The Fruits of Commerce* window (plate 146) for William H. Vanderbilt's New York residence at 640–42 Fifth Avenue. By fall—begins decoration of the dining-room ceiling in Cornelius Vanderbilt II house, with sculptural work by Augustus Saint-Gaudens.

1882

October—completes *"Battle" Window* in Memorial Hall, Harvard University; it was installed in 1879, then redone by La Farge with opalescent glass in 1882. Designs Baker Memorial for the Channing Memorial Church, Newport. Completes dining-room ceiling and begins Water Color Room in the Cornelius Vanderbilt II house, working primarily in the Tenth Street Studio Building, assisted by Theodore Robinson and Will H. Low, among others. May and June—awarded contracts for portieres for the Cornelius Vanderbilt II dining room and Water Color Room, with execution overseen by Mary E. Tillinghast. Provides stained-glass decorations for the Frederick Lothrop Ames house, the first Boston residence to rival the sumptuousness of New York Gilded Age mansions.

1883

March—the *Christ Preaching* (commonly known as *Christ in Majesty*) window (plate 153) installed at Trinity Church, Boston. June—begins redecoration of Brick Presbyterian Church, New York (plate 133); work completed by the end of October. Summer—works on *The Shepherd and the Sea* in Newport. August—exhibits *The Golden Age* and *A Boy and His Dog* at the Munich International Exhibition. September—cost overruns on Vanderbilt dining room and Water Color Room place him deeply in debt. October—forms a consortium called the La Farge Decorative Art Company, with Mary E. Tillinghast as manager; company locates in the Century Building, overlooking Union Square at 33 East Seventeenth Street, New York. Makes *The Old Philosopher* window for the Crane Memorial Library, Quincy, Massachusetts, his first window to use the "cloisonné" technique of fusing glass. Designs *Virgil and Homer* window for Harvard Memorial Hall.

1884

April—auction of works held at Ortgies and Co., New York, including many watercolors painted on photographs of his earlier illustrations. Designs *Vision of Saint John the Evangelist* window for Trinity Church, Boston, one of his most unusual pictorial stained-glass windows. Finishes *The Infant Bacchus* window (plate 25) for the Washington B. Thomas house, Beverly, Massachusetts. Completes the *Saint Paul Preaching at Athens* window for Saint Paul's

Episcopal Church, Stockbridge, Massachusetts. Begins decoration for the Church of Saint Paul the Apostle, New York, commissioned by Father Hecker, a project occupying him off and on for the next fifteen years.

1885

January—La Farge Decorative Art Company dissolves due to legal and financial disputes between La Farge and his business partners. Soon after, La Farge enters into agreement with John Calvin and Thomas Wright to manufacture stained-glass windows from his designs. February—receives contract from architect George Heins (husband of La Farge's sister, Aimée) for chancel decoration of the Church of the Incarnation, Madison Avenue, New York (plate 128). By spring—completes altarpiece for the Church of the Incarnation. March—auction of works held at Moore's Art Gallery, New York, including many watercolor copies of works sold the previous year at Ortgies and Co. April—legal disputes erupt over designs and photographs that La Farge took with him when the La Farge Decorative Arts Company folded. His highly publicized arrest follows; dispute is ultimately settled out of court. Executes additional stained-glass decorations for the Frederick Lothrop Ames house in Boston.

1886

June 3—leaves with Henry Adams on cross-country trip to catch steamer to Japan. June 4—commission for mural in Church of the Ascension, New York (plate 131), approved by the vestry. June 12—departs from San Francisco. July 3—arrives in Yokohama. Visits Tokyo, Nikko, Kamakura, Yokohama, Kyoto, Gifu, Kambara, and Miyanoshita before departing from Yokohama in early October. October 20—arrives in San Francisco. December—arrives back in New York.

1887

January—completes the Helen Angier Ames Memorial Window (plate 156) for Unity Church, North Easton, Massachusetts. Completes set of chapel windows for the Caldwell house in Newport. Begins versions of the Kwannon meditating on human life (plates 34, 74) and *The Centauress* (plate 75), completed near the end of his life. Begins murals for music room of Whitelaw Reid house at 455 Madison Avenue, New York (plate 139). October—purchases a studio on Champlin Street in Newport. Late in year—completes *Music* mural for the Reid house. First exhibits with the Architectural League of New York.

1888

Early in the year—completes *Drama* mural for the Reid house. By summer—technical problems impeding the painting of the mural for Church of the Ascension are resolved, and the mural is completed in the late fall. Begins large group of stained-glass windows for Trinity Church, Buffalo, New York. Completes clerestory windows for the Church of Saint Paul the Apostle, New York.

1889

Completes *"Watson" Window* (actually the Sherman and Van Daltsen Memorial) for Trinity Church, Buffalo. *"Watson" Window* receives first-class medal and La Farge receives French Legion of Honor citation at Exposition Universelle in Paris. Completes windows for the Parish House of Christ

Church, Springfield, Massachusetts. Designs several memorial windows for the Church of the Ascension, New York.

1890

January—first one-man exhibition/sale held at Doll and Richards, Boston. April—one-man exhibition held at Reichard and Co., New York. "An Artist's Letters from Japan" serialized in *Century Magazine* (completed in 1893). Completes ambitious set of windows for the First Unitarian Church, Detroit. Receives honorary LL.D. from Mount Saint Mary's College. August—departs for San Francisco with Henry Adams for start of tour of the South Seas. August 29—steamer arrives in Honolulu. Visits and paints Kilauea volcano, the Great Pali, and other famous sites on Hawaii. Late September—departs for Samoa by steamer. October 5—arrives at Tutuila and remains until early the next year on various Samoan islands while painting scenes of native life; visits Robert Louis Stevenson.

1891

January 28—leaves Samoa. February 4—arrives in Tahiti. Paints numerous views of landscape. June 4—leaves Tahiti on the steamer *U.S.S. Richmond*, about a week before Paul Gauguin arrives. June 16—arrives in Fiji. June—a small selection of South Sea and Japanese watercolors is exhibited in a group show of American art at Durand-Ruel's gallery in Paris, having been forwarded from New York by the artist's son, Bancel. July 15—leaves Fiji. Late July—stops over in Sydney, Australia, before departing for Ceylon and Java around August 3. Returns to New York via Paris and London.

1892

Completes many ambitious South Sea works based on sketches, photographs, and other visual aids.

1893

Appointed instructor in color and composition at Metropolitan Museum of Art, sponsored by the Lazarus Fund. November—begins series of six lectures, "Considerations on Painting," at the Metropolitan Museum. Receives contract for the *Athens* mural at Bowdoin College, Brunswick, Maine (plate 140). Canvas for *Athens* prepared and underpainting laid in, primarily by Bancel.

1894

Completes *Resurrection* window for the First Congregational Church in Methuen, Massachusetts (plate 158). Visits Italy for first time. Copies South Sea works that have been sold to private collectors for use in his projected *Records of Travel* exhibition. Lectures on Ruskin in Buffalo.

1895

Records of Travel exhibition organized; one version shown at Doll and Richards, Boston, in February; expanded version shown by Durand-Ruel New York during late February and March and at Paris Salon du Champ de Mars in March and April. Repeats "Considerations on Painting" lectures in Philadelphia and publishes book of same title. Lectures in Boston. Designs numerous memorial windows for Judson Memorial Church, New York. Wife and family spend year with him in New York at 65 Clinton Place, a house rented from Richard Watson Gilder. La Farge's mother dies.

1896

Designs Cable Memorial Windows for Trinity Episcopal Church, Rock Island, Illinois. Designs skylight for Cornelius Vanderbilt's Newport mansion, "The Breakers." Executes large oil versions of several South Sea watercolors. Receives commission for chancel mural decoration of the Church of Saint Paul the Apostle (plate 134). Receives honorary M.A. from Yale University. December—*Records of Travel* exhibited at the Picture Exhibition Society in Cleveland.

1897

January and February—*Records of Travel* exhibited at the Art Institute of Chicago. Focuses on watercolor production of "Japanese Fantasies" and "Variations on Oriental Themes." Makes windows for the house of James J. Hill, St. Paul. Makes windows for Wells College, Aurora, New York. *An Artist's Letters from Japan* published by the Century Company. Serves as juror for Annual Exhibition at the Carnegie Institute, Pittsburgh.

1898

September—*Athens* mural installed at Bowdoin College, four years behind schedule. Edwin Booth Memorial Window installed in the Church of the Transfiguration, New York. *Angel at the Healing Waters of Bethesda* window installed in Mount Vernon Church, Boston (plate 159). Prepares illustrations for Henry James's *Turn of the Screw*. La Farge's son and primary studio assistant, Bancel, marries Mabel Hooper (1875–1944), daughter of an avid collector of La Farge's work, Edward Hooper, and soon after leaves his father's employ.

1899

Visits France with Henry Adams, including trip to Chartres Cathedral. Delivers commencement address at Yale University. Designs set of chancel windows for Church of the Blessed Sacrament, Providence, Rhode Island. Leaves mural decoration in Church of Saint Paul the Apostle incomplete due to problems with the patron, finances, and his health.

1900

Designs windows for chapel of Wellesley College, Wellesley, Massachusetts. Serves as juror for Annual Exhibition at the United States Commission of the Paris Exposition of 1900.

1901

March—third sale of La Farge's personal library held in New York. "Passages from a Diary in the Pacific" serialized in *Scribner's Magazine*. "Great Masters" serialized in *McClure's Magazine* (continuing through 1903). Serves as juror for the Carnegie Institute. Receives honorary LL.D. from Yale University. Awarded medal at the Pan-American Exposition, Buffalo.

1902

Completes *Fortune* window for Frick Building, Pittsburgh. Completes *Spring* and *Autumn* windows for William C. Whitney's residence at Westbury, Long Island (never installed in that house).

1903

Delivers six Scammon Lectures on the Barbizon School at

John La Farge, 1890s
Photograph
Yale University Art Gallery, New Haven, Connecticut
Gift of Frances S. Childs
in memory of Henry A. La Farge

Art Institute of Chicago. Scammon Lectures serialized in *McClure's Magazine*. "One Hundred Masterpieces" serialized in *McClure's Magazine* (continuing through 1908). *Great Masters* published by the McClure Company. Receives commission for Supreme Court Room murals, Minnesota State Capitol, St. Paul (plates 44, 142); submits color studies in November. December—signs over legal title of Champlin Street Studio, Newport, to Grace Edith Barnes in payment for debts for her services as personal secretary.

1904

Publishes "A Fiji Festival" in *Century Magazine*. Receives honorary LL.D. from Princeton University. Awarded medal at the St. Louis Exposition. October—completes first of the Minnesota State Capitol murals.

1905

Completes John Harvard Memorial Window, Southwark Cathedral, London. By summer receives commission for Baltimore Court House murals (plate 116). August 8—Saint Thomas Church is destroyed by fire, distressing La Farge with the loss of what he considers some of his best decorative work. November—completes the last of the Minnesota State Capitol murals.

1906

By end of year—four of the Baltimore Court House murals installed. *Saint Paul Preaching at Athens* windows installed at Columbia University Chapel. Executes windows for Bloomingdale Reformed Church, New York.

1907

Paints last large-scale oil painting, *The Wolf-Charmer* (private collection), a version of an 1867 illustration from *Riverside Magazine*. Last two Baltimore Court House murals installed.

1908

February—first sale of La Farge's collection of Orientalia held in New York. *The Higher Life in Art* (based on the 1903 Scammon Lectures) published by Macmillan.

1909

March—second sale of La Farge's collection of Orientalia held in New York. Designs set of cloisonné panels on the history of civilization for the publisher and author Edward W. Bok. Installs *Welcome* window for Mrs. George T. Bliss, New York (now in Metropolitan Museum of Art). In conjunction with August F. Jaccaci, first of several projected volumes of *Concerning Noteworthy Paintings in American Private Collections* published by August F. Jaccaci Co. (project collapses after first volume). *The Ideal Collection of the World's Greatest Art*, edited by La Farge, published by Doubleday. Awarded a medal by the Architectural League of New York.

1910

April—suffers nervous collapse but denies in the press that he is seriously ill. November 14—dies in Butler Memorial Hospital, Providence, Rhode Island. Buried in Greenwood Cemetery, Brooklyn, in La Farge family mausoleum.

1911

January—major retrospective exhibition at the Museum of Fine Arts, Boston. February—fourth sale of La Farge's personal library held in New York. March—La Farge estate sale, with Grace Edith Barnes as executrix, held at the American Art Galleries in New York. November—one-man exhibition held at Vose Gallery, Boston. Royal Cortissoz's biography, *John La Farge: A Memoir and a Study*, published by Houghton Mifflin.

MAJOR EXHIBITIONS AND SALES

James L. Yarnall with Amy B. Werbel

This listing includes all one-man shows and major presentations of the artist's work. It excludes the sales of La Farge's collection of Orientalia and of his personal library. Only works by La Farge are cited; some exhibitions and auctions also included works by other artists. Original copies or photostats of the catalogs cited are on file with the Henry La Farge Papers, New Canaan, Connecticut. Information regarding the 1911 and 1936 exhibitions at the Museum of Fine Arts, Boston, is recorded in the museum's "Loan Book" of 1910–11 (Office of the Registrar) and in the "1936 La Farge-Homer Show" file (Paintings Department), respectively.

1878

Peirce and Company, Boston, November 19–20. 44 oils. *Catalogue. The Paintings of Mr. John La Farge, to Be Sold at Auction.* 8 pages, with prefatory letter from La Farge to the gallery's proprietor and descriptive texts by the artist for some of the works.

1879

Leonard's Gallery, Boston, December 18–19. 53 oils, 21 watercolors, 37 drawings. *The Drawings, Water-Colors, and Oil-Paintings by John La Farge. To Be Sold at Auction.* 12 pages, with brief preface by the proprietor.

1884

Ortgies and Co., New York, April 14–17. 44 oils, 27 watercolors, 20 drawings. *Important Collection of Oil and Water Color Paintings, by John La Farge of This City. To Be Sold at Auction.* 28 pages, with descriptive texts by artist for some works. *Supplementary Catalogue of Water Colors, by John La Farge. To Be Sold at Auction.* 10 pages, with 29 watercolors and 1 drawing, descriptive texts by the artist for some works, and errata for primary Ortgies catalog.

1885

Moore's Art Gallery, New York, March 26–27. 2 oils, 84 watercolors, 2 pastels, 9 drawings. *Catalogue of a Collection of Oil and Water Color Paintings, by John La Farge.* 32 pages, with descriptive texts by the artist for some of the works.

1890

Doll and Richards, Boston, January 25–February 6. 13 oils, 4 encaustics, 58 watercolors, 5 pastels, 8 drawings. *Catalogue of Drawings, Watercolors, and Paintings by Mr. John La Farge on Exhibition and Sale.* 8 pages.

Reichard and Co., New York, April 15–May 1. 9 oils, 4 encaustics, 61 watercolors, 2 pastels, and 20 drawings. *Catalogue of Drawings, Water Colors, and Paintings by Mr. John La Farge, N.A.* 11 pages.

St. Louis Exposition, dates unknown. 8 oils, 4 encaustics, 49 watercolors, 22 drawings, 8 of undetermined media. *Catalogue of the Art Collection of the St. Louis Exposition and Musical Hall Association Seventh Annual Exhibition.* 95 pages, with 17 pages devoted to La Farge.

1892

Doll and Richards, Boston, March 25–April 6. 2 oils, 2 encaustics, 57 watercolors, 19 drawings. *Catalogue of Drawings, Watercolors, and Paintings by Mr. John La Farge on Exhibition and Sale.* 9 pages.

1893

Doll and Richards, Boston, March 10–22. 5 oils, 49 watercolors, 1 drawing. *Catalogue of Water Color and Oil Paintings by Mr. John La Farge on Exhibition and Sale.* 6 pages.

1895

Doll and Richards, Boston, February 14–20. 1 oil, 66 watercolors. *Exhibition and Private Sale of Paintings in Water Color and Oil from the South Sea Islands and Japan.* 10 pages, with introductory note by the proprietors.

Durand-Ruel, New York, February 25–March 5. 8 oils, 218 watercolors, 1 drawing, 21 of undetermined media. *Paintings, Studies, Sketches and Drawings, Mostly Records of Travel 1886 and 1890–91 by John La Farge.* 71 pages, with preface by the artist and descriptive texts by the artist for some of the works.

Salon de 1895, Champs de Mars, Paris, March–April. 2 oils, 128 watercolors. *Etudes, esquisses, dessins: Souvenirs et notes de voyage (1886 et 1890–91) par John La Farge, traduction du catalogue américain.* 48 pages, with preface by the artist and descriptive texts by the artist for some of the works. 209 works are listed; those not in the exhibition are bracketed.

1896

Doll and Richards, Boston, February 14–26. 3 oils, 3 encaustics, 37 watercolors. *Exhibition and Private Sale of Paintings in Water Color and Oil Chiefly from South Sea Islands.* 6 pages.

Gallery of the Picture Exhibition Society, Cleveland, December 23–January 5, 1897. 4 oils, 1 encaustic, 69 watercolors, 6 drawings, 2 lithographs, 4 of undetermined media. *Catalogue. Paintings, Studies, Sketches and Drawings, Mostly Records of Travel 1886 and 1890–91, by John La Farge.* 6 pages.

1897

Art Institute of Chicago, January 26–February 21. 4 oils, 1 encaustic, 67 watercolors, 6 drawings, 3 of undetermined media. *Catalogue. Paintings, Studies, Sketches and Drawings, Mostly Records of Travel 1886 and 1890–91, by John La Farge.* 7 pages.

Wunderlich and Co., New York, March–April. 3 oils, 45 watercolors, 2 drawings. *Catalogue of Works by John La Farge.* This catalog is documented only by a handwritten transcription that Henry A. La Farge made of it around 1934; the location of any original copy is unknown.

1898

Doll and Richards, Boston, March 18–30. 3 oils, 1 encaustic, 38 watercolors, 10 drawings, 5 of undetermined media. *Exhibition and Private Sale of Paintings in Water Color Chiefly from South Sea Islands and Japan.* 6 pages.

Pratt Institute, Brooklyn, October 14–November 5. 125 watercolors, 200 drawings. *Exhibition of Two Hundred Pencil Drawings, Fifty Sketches in Color for Stained Glass and Seventy-Five Water Color Studies by Mr. John La Farge.* 2 pages, with facsimile of letter from La Farge discussing the selection of pictures.

1901

Montross Gallery, New York, January 24–February 23. 13 oils, 6 encaustics, 118 watercolors, 13 drawings, 1 mosaic. *Catalogue of Works by John La Farge.* 12 pages.

Carnegie Institute, Pittsburgh, March 27–April 10. 10 oils, 4 encaustics, 105 watercolors, 9 drawings. *Catalogue of Works by John La Farge.* 10 pages.

1902

Doll and Richards, Boston, November. 16 watercolors, 5 drawings. *Exhibition and Private Sale of Water Color Paintings by Mr. John La Farge, Mr. Childe Hassam, Miss Lucy S. Conant.* 3 pages.

1904

Doll and Richards, Boston, February 26–March 16. 2 oils, 6 encaustics, 91 watercolors, 2 drawings, 1 of undetermined media. *Exhibition and Private Sale of Pictures, Drawings and Sketches by Mr. John La Farge.* 5 pages.

1907

Doll and Richards, Boston, February 21–March 5. 6 oils, 1 encaustic, 69 watercolors. *Catalogue of Works by John La Farge.* 24 pages, with descriptive texts by the artist for some of the works.

Macbeth Gallery. New York, November 27–December 12. 7 oils, 31 watercolors. *Exhibition of Pictures by John La Farge.* 4 pages.

1909

M. Knoedler and Co., New York, February 15–27/March 1–13. 3 oils, 2 encaustics, 94 watercolors, 8 drawings, 2 of undetermined media. *Exhibition of Glass, Oil and Water Color Paintings and Sketches by John LaFarge, N.A.* 2 variant editions of this catalog exist, with the differing dates noted above. 3 pages.

Doll and Richards, Boston, March 18–April 1. 3 encaustics, 47 watercolors, 4 drawings, 7 of undetermined media. *Catalogue of Oil and Water Color Paintings and Sketches by John La Farge, N.A.* 3 pages.

1910

Anderson Art Galleries, New York, March 8. 5 oils, 2 encaustics, 23 watercolors. *Illustrated Catalogue of Important Paintings . . . from Private Collections.* 7 pages.

Doll and Richards, Boston, March 18–30. 1 encaustic, 39 watercolors, 1 watercolor by La Farge and Will H. Low, 1 drawing. *Paintings and Drawings by John La Farge.* 3 pages.

1911

Museum of Fine Arts, Boston, January 1–31. Over 175 works, including 39 oils, 123 watercolors, 13 drawings, and 1 stained-glass window. "La Farge Memorial Exhibition." No catalog.

American Museum of Natural History, New York, February. 96 works, mostly watercolors from the South Seas were lent; only 31 seem to have been exhibited. Title of exhibition unknown. No catalog.

American Art Association, New York, March 24–31. Over 920 lots, including 5 oils, 7 encaustics, 112 watercolors, 3 watercolors by La Farge and Will H. Low, 11 casts, 29 pieces of stained glass, 173 drawings, 16 portfolios of drawings, 26 engravings. *Catalogue of the Art Property and Other Objects Belonging to the Estate of the Late John La Farge, N.A.* 97 pages, with brief prefatory note by Grace Edith Barnes and descriptive texts based on the artist's notes for some of the works.

Vose Gallery, Boston, November 13–25. 5 oils, 3 encaustics, 78 watercolors, 2 portfolios of watercolors, 2 watercolors by La Farge and Will H. Low, 8 drawings, 2 portfolios of drawings, 2 portfolios of engravings, 1 set of four engravings, 1 engraving by C. A. Powell after La Farge, 4 of undetermined media. *Exhibition of Paintings, Water Colors and Drawings by the Late John La Farge.* 8 pages, with biographical preface by R. C. and N. M. Vose.

University of Chicago, December 5–12. Over 100 works. "Studies, Sketches, and Paintings by John La Farge." No catalog.

1914

Vose Gallery, Boston, March 25–April 11. Approximately 60 works. "Works of John La Farge." No catalog.

1923

Ferargil Galleries, New York, February. 6 oils, 1 encaustic, 22 watercolors, 6 stained-glass windows, 6 wood engravings. *Watercolors, Stained Glass, and Oil Paintings by John La Farge.* 4 pages.

1931

Wildenstein and Co., New York, March. 7 oils, 25 watercolors. *Loan Exhibition of Paintings by John La Farge and His Descendants.* 2 pages.

1936

Metropolitan Museum of Art, New York, March 23–April 26. 26 oils, 4 encaustics, 2 murals, 38 watercolors, 4 stained-glass windows, unrecorded number of drawings, sketchbooks, woodcuts, and illustrated books. *An Exhibition of the Work of John La Farge.* 94 pages, with preface by H. E. Winlock, 16-page essay by Royal Cortissoz, and 74 illustrations.

Museum of Fine Arts, Boston, June 25–August 2. Over 33 works, including 29 watercolors, 1 drawing, 1 engraving, and 2 works of undetermined media. "Prints and Drawings by Winslow Homer and John La Farge." No catalog.

1948

Macbeth Gallery, New York, April 26–May 15. 23 oils, 15 watercolors. *John La Farge, 1835–1910, Loan Exhibition.* 2 pages, with 1 illustration.

1950

Columbia University, New York, June 1–October 1. 46 drawings, 3 sketchbooks. "Forty-six Unpublished Drawings of John La Farge." 3 pages, with unsigned introduction.

1956

Assumption College, Worcester, Massachusetts, December 7–January 4, 1957. 5 oils, 17 watercolors, 1 stained-glass window. *J. La Farge, 1835–1910.* 3 pages, with prefatory note by John La Farge, S.J., and 1 illustration.

1966

Graham Gallery, New York, May 4–June 10. 25 oils, 2 encaustics, 27 watercolors, 5 drawings, 1 stained-glass window. *John La Farge.* 9 pages, with checklist, brief unsigned introduction by Henry A. La Farge, and 2 illustrations.

1967

Toledo Museum of Art, Toledo, Ohio, December 3–January 7, 1968. 1 oil, 50 watercolors and drawings. *John La Farge, Drawings and Watercolors.* 21 pages, with essay by Katharine C. Lee and 20 illustrations.

1968

Kennedy Galleries, New York, January 24–February 14. 7 oils, 18 watercolors. *John La Farge, Oils and Watercolors.* 25 pages, with illustrated checklist, brief chronology, essay by Henry A. La Farge, and 25 illustrations.

1973

Columbia University, New York, September 11–November 1. 45 drawings. *Drawings by John La Farge, Collection of Avery Architectural Library.* 2 pages, with essay by H. Barbara Weinberg.

1978

Peabody Museum, Salem, Massachusetts, February 1–May 1. 4 oils, 48 watercolors, 8 drawings. *Exhibition of Paintings, Watercolors, and Drawings by John La Farge (1835–1910) from His Travels in the South Seas, 1890–1891.* 15 pages, with checklist, essay by Henry A. La Farge, and 1 illustration.

CURRENT LOCATIONS OF
JOHN LA FARGE'S DECORATIVE WORKS

Henry A. La Farge with James L. Yarnall and
Mary A. La Farge

This list excludes works in private collections or commercial galleries. The numbers beginning *G* (for glass) or *MD* (for mural design) refer to the forthcoming catalogue raisonné. The first four digits of the catalogue raisonné numbers refer to the year during which primary production of the work took place.

Albany, New York

Cathedral of All Saints
Angels in Adoration, rose window. G1887.3

Asheville, North Carolina

Biltmore House
The Fruits of Commerce, window from William H. Vanderbilt house, New York. G1881.1

Hospitalitas/Prosperitas, window from William H. Vanderbilt house, New York. G1881.2

Putti, window from William H. Vanderbilt house, New York. G1881.3

Aurora, New York

Administration Building, Wells College
Aurora, Class of 1885 Memorial Window. G1896.19; completed 1897

Ornamental transom windows. G1896.20; completed 1897

Baltimore, Maryland

Baltimore Court House Vestibule
The Great Lawgivers of History: Confucius, Justinian, Lycurgus, Mohammed, Moses, and *Numa Pompilius,* spandrel murals. MD1906.1A–F; completed 1907

Emmanuel Church
The Baptism of Christ, baptistry window. G1902.5

Two ornamental baptistry windows. G1902.6A–B

Boston, Massachusetts

Museum of Fine Arts
Butterflies and Foliage, window from William H. White house, Brooklyn. G1889.3

Fish and Flowering Branch, window from Gordon Abbott house, Manchester, Massachusetts. G1896.5

The Infant Bacchus, window from Washington B. Thomas house (later Henry P. Kidder house), Beverly, Massachusetts. G1882.36; completed and installed 1884

Morning Glories, window from William Watts Sherman house, Newport, Rhode Island. G1878.2

Peonies Blown in the Wind, window from Sir Lawrence Alma-Tadema's studio, London. G1886.1

Trinity Church
Overall decorative scheme, including tower and spandrel figures. MD1876.1A–L; completed spring 1877

Christ and the Woman of Samaria at the Well, mural. MD1877.1; completed late 1877

Christ Preaching (commonly known as *Christ in Majesty*), window. G1883.1

Presentation of the Virgin (after Titian), Julia Appleton McKim Memorial Window. G1888.1

The Resurrection, Mary Love Boott Welch Memorial Window. G1902.4

Twelve ornamental tower windows. G1877.1A–L

The Vision of Saint John the Evangelist, George Nixon Black and Marianne Black Memorial Window. G1884.7

The Visit of Nicodemus to Christ, mural. MD1878.1; completed by May 1878

Trinity Church Parish House
Parable of the Wise Virgin, Gertrude Parker Memorial Window. G1885.3

Brooklyn, New York

Administrative Center, Pratt Institute (formerly Frederick S. Pratt house)
Five armorial windows. G1898.11A–E

Brooklyn Museum
Adoration, mural intended for the Church of Saint Paul the Apostle, New York, but never installed there. MD1899.3

Adoration, mural intended for the Church of Saint Paul the Apostle, New York, but never installed there. MD1899.4

Hospitalitas, window from Herbert T. Pratt house, Brooklyn. G1906.4; completed and installed 1907

Brunswick, Maine

Walker Art Building, Bowdoin College
Athens, mural. MD1893.1; completed 1898

Buffalo, New York

Trinity Church
Angel Sealing the Servants of God, Anna M. Sherman and Gretchen Van Daltsen Memorial Window (also known, incorrectly, as the *"Watson" Window*). G1889.2

The Ascension, Harriette Cornelia Howard Memorial Window. G1886.6

Cross, rose window. G1886.8

The Good Samaritan, Thomas F. Rochester Memorial Window. G1888.3

The Lord Is My Shepherd, Sarah Mercer Hazard Memorial Window. G1888.2

The Magi and the Heavenly Sign, Jerry Radcliffe and Ariadne Webster Radcliffe Memorial Window. G1886.3

The Nativity, James Platt and Mary Elizabeth White Memorial Window. G1886.2

Resurrected Christ and the Magdalen, Stephen Van Rensselaer Watson Memorial Window. G1886.5

Saint James and the Risen Christ, James C. Harrison Memorial Window. G1886.7

The Transfiguration, Rev. Edward Ingersoll Memorial Window. G1886.4

Cambridge, Massachusetts

Fogg Art Museum, Harvard University
When the Morning Stars Sang Together (after William Blake), stained-glass panels for Judge William G. Peckham, Madison, New Jersey. G1898.10

Memorial Hall, Harvard University
"Battle" Window, Class of 1860 Memorial Window. G1882.1; redone by the artist to replace his earlier window (1878) of the same design

Cornelia Mater Gracchorum, or *Cornelia, Mother of the Gracchi*, Class of 1859 Window. G1891.1; based on a design by the artist first submitted in 1875

Virgil and Homer, Class of 1880 Window. G1883.3

Sanders Theater, Harvard University
Pallas Athena, Cornelius Conway Felton Memorial Window. G1898.2

Chattanooga, Tennessee

Hunter Museum of Art
Spring and *Autumn*, windows from George Foster Peabody house, Bolton Landing, Lake George, New York. G1896.10A–B

Chicago, Illinois

Second Presbyterian Church
The Ascension, John T. Crerar Memorial Window. G1896.3 (destroyed by fire in 1902 and reconstructed by other artists)

Cleveland, Ohio

Calvary Presbyterian Church
Eucharistic Cross and Vine, apse windows. G1892.3A–C

Old Stone Church
Saint Catherine of Alexandria, Amasa Stone Memorial Window. G1885.4

Presbyterian Church
Belief in the Resurrection, Stephen Vanderburg Harkness Memorial Window. G1892.2

Detroit, Michigan

Detroit Institute of Arts
Abou Ben Adhem, John J. Bagley Memorial Window, from First Unitarian Church, Detroit. G1890.4

Faith and Hope, Charles Merrill Memorial Window, from First Unitarian Church, Detroit. G1890.2

The Ministering Angel, Royal Clark Remick Memorial Window, from First Unitarian Church, Detroit. G1890.3

First Unitarian Church
The Good Knight, Albert Grenville Boynton Memorial Window. G1899.1

Fall River, Massachusetts

Saint Patrick's Convent
Saint Elizabeth of Hungary, window from chapel of Caldwell house, Newport, Rhode Island. G1887.5

Saint John the Evangelist, window from chapel of Caldwell house, Newport, Rhode Island. G1887.6

Sistine Madonna (after Raphael), window from chapel of Caldwell house, Newport, Rhode Island. G1887.4

Two decorative windows, from music room of Caldwell house, Newport, Rhode Island. G1896.8A–B

Garrison, Maryland

Saint Thomas Episcopal Church
The Resurrection, Samuel H. Tagart and Sallie Mifflin Tagart Memorial Window. G1892.1

Greensboro, North Carolina

Weatherspoon Art Gallery, University of North Carolina
Jeweled panel, stained glass from Cornelius Vanderbilt II house, New York. G1881.24

Jenkintown, Pennsylvania

Church of Our Saviour
The Annunciation, Mary Scott Newbold Memorial Window. G1907.1

Kansas City, Missouri

Temple of the Congregation B'nai Jehudah
Ten pairs of "Jewish History" windows. G1908.4A–P

Lake Mohegan, New York

Saint George's Chapel
Floral panel, Charles A. Girault Du Vivier Memorial Window. G1908.3

Saint George, George Lewis Heins Memorial Window. G1908.2

Tabernacle, John Frederick La Farge and Louisa Binsse La Farge Memorial Window. G1908.1

Lexington, Massachusetts

Museum of Our National Heritage
Christ and the Pilgrims, Mr. and Mrs. William G. Means Memorial Window, from Mount Vernon Church, Boston. G1897.4

London, England

Southwark Cathedral (formerly Saint Saviour's Church)
The Baptism of Christ, John Harvard Memorial Window. G1905.2; destroyed in World War I and reconstructed by other artists

Medford, Massachusetts

Grace Church
Rebecca at the Well, Ellen Shepherd Brooks Memorial Window. G1886.9

Methuen, Massachusetts

First Congregational United Church of Christ
The Resurrection, Col. Henry Coffin Nevins Memorial Window. G1894.1

Middletown, Rhode Island

Saint Columba's Chapel
Saint Columba, Mary Devlin Booth Memorial Window. G1885.7

Minneapolis, Minnesota

Minneapolis Institute of Arts
Persian Arabesques, window from James J. Hill house, St. Paul, Minnesota. G1882.3C

Munich, Germany

Villa Stück Museum
Peacock and Peonies with Kakemono Borders, window from John Hay house, Washington, D.C. (mistakenly attributed to Louis C. Tiffany). G1893.1

Natchez, Mississippi

Trinity Episcopal Church
The Ascension, window. G1883.6

New Haven, Connecticut

Saint Anthony Hall, Yale University
Saint Anthony, window. G1896.9

Newport, Rhode Island

"The Breakers" (formerly Cornelius Vanderbilt II house)
Skylight. G1896.7

Channing Memorial Church
Christ Leading the Soul, Richard Baker, Jr., and Alice Baker Memorial Window. G1882.2

Saint Barnabas and the Virgin, Rev. Barnabas Bates Memorial Window. G1881.39

Newport Historical Society
Waterlilies, transom from Walter S. Langley house, Newport. G1883.8

United Congregational Church
Overall decorative scheme. MD1880.1

Five pairs of geometric clerestory windows; those on the south side were damaged by hail in April 1894 and restored by other artists. G1880.1

New York, New York

American Academy and Institute of Arts and Letters
Evening, stained-glass panel. G1880.7

Morning, stained-glass panel. G1880.6

Cathedral Museum, Cathedral of Saint John the Divine
The Boy Samuel, Frank Clark Gilmore Memorial Window, from Parish House, Christ Church Cathedral, Springfield, Massachusetts. G1889.9

The Centurion, James G. Benton Memorial Window, from Parish House, Christ Church Cathedral, Springfield, Massachusetts. G1889.10

Magdalen at the Tomb of Christ, Daniel Putnam Crocker Memorial Window, from Parish House, Christ Church Cathedral, Springfield, Massachusetts. G1889.8

The Trial of Job, William Jones Memorial Window, from Parish House, Christ Church Cathedral, Springfield, Massachusetts. G1889.11

Church of Saint Paul the Apostle
Adoring Angels, murals on upper north wall of sanctuary. MD1899.2A–D. The *Angel of the Sun* that these angels surround is by William Harris Laurel, following La Farge's design. La Farge's version of this subject was not installed due to disputes with the patron; it is now in the Staten Island Museum. Two other *Adoration* figures intended for the lower sanctuary walls are now in the Brooklyn Museum.

Angel of the Moon surrounded by *Adoring Angels*, murals on upper south wall of sanctuary. MD1899.1A–E

Design of baptistry (in conjunction with architect George Heins). MD1896.1

Five ornamental façade windows. G1889.1A–E

Fourteen clerestory nave windows with jeweled-cross motifs. G1888.4A–G, .5A–G

Two chancel windows with architectonic motifs. G1897.6A–B

Vaulted ceiling, mural. MD1884.1

Church of the Ascension
The Ascension, mural with sculptural embellishment by Louis Saint-Gaudens and frame by Stanford White. MD1888.2.

The Good Shepherd, Robert E. Coxe Memorial Window. G1910.1

The Presentation in the Temple, Francis Leland and Euphrasia Anguilar Leland Memorial Window. G1889.13

The Three Marys, Emily Martin Southworth Memorial Window. G1889.14

The Visit of Nicodemus to Christ, John Cotton Smith Memorial Window. G1885.8

Church of the Incarnation
Actor Contemplating Mask, Edwin Booth Memorial Window. G1898.1

The Adoration of the Magi and *The Nativity*, murals forming a single altarpiece. MD1885.1A–B

Christ Calling Peter and John, Captain John Riley Memorial Window. G1885.2

In the House of the Lord, George W. Smith Memorial Window. G1885.1

Columbia University Chapel
Saint Paul Preaching at Athens, apse windows. G1906.1

French Cultural Embassy (formerly Payne Whitney house)
Autumn, window made for William C. Whitney house, Westbury, Long Island, New York, but never installed there. G1902.3

Helmsley Palace Hotel (formerly Whitelaw Reid house)
Drama, lunette mural in Gold Room (formerly music room). MD1888.1

Music, lunette mural in Gold Room (formerly music room). MD1887.1

Judson Memorial Church
Angel Musician, Helen Elizabeth Wood Memorial Window. G1895.12

The Centurion, James Knott Memorial Window. G1895.5

Christ the Shepherd, Edward Abiel Stevens Memorial Window. G1895.11

Cross, Josephine Bigler Crow Memorial Window. G1895.10

The Infant Mary, Lily Holme Bryant Memorial Window. G1895.3

The Infant Samuel, David Malcolm Kinmouth Memorial Window. G1895.2

Mater Dolorosa, Delphine Antisdel Memorial Window. G1895.13

Saint Anthony, John B. Walton and Rebecca A. Walton Memorial Window. G1895.4

Saint George, Georgina Van Aken Memorial Window. G1895.6

Saint John the Evangelist, Charles Evans and Martha Scriven Evans Memorial Window. G1895.7

Saint Paul, memorial window (name of patron illegible). G1895.8

Saint Peter, John Dowling Memorial Window. G1895.9

Saint Stephen, George Dana Boardman Memorial Window. G1895.1

Maxwell's Plum Restaurant
Cornucopia and Wreaths, decorative transoms from Frederick Lothrop Ames house, Boston. G1882.13

Metropolitan Museum of Art
Greek cross stained-glass panel. G1883.12

Grotesques, stained-glass lunette from Cornelius Vanderbilt II house, New York. G1881.10

Peonies in the Wind, window from Henry G. Marquand house, Newport, Rhode Island. G1879.2

Welcome, window from Mrs. George T. Bliss house, New York. G1908.5; completed 1909

National Arts Club (formerly Samuel Tilden house)
Stained-glass vestibule doors in entrance hall. G1880.8

Tavern on the Green Restaurant
Cherry Blossoms against Spring Freshet, window from Michael Jenkins house, Baltimore (misattributed to Louis C. Tiffany). G1881.27

Newton, Massachusetts

Grace Church
Adoring Figure, Lizzie Shinn Memorial Window. G1894.4

Scroll, Mary Endicott Pond Memorial Window. G1894.3

Norfolk, Virginia

Chrysler Museum
Nine-Paneled Firescreen, stained glass. G1883.9

North Easton, Massachusetts

Unity Church
Angel of Help, Helen Angier Ames Memorial Window. G1887.1

Wisdom with Youth and Old Age, Oakes Ames, Oakes Angier Ames, and Oliver Ames Memorial Window. G1901.1

Philadelphia, Pennsylvania

First Methodist Episcopal Church
Rose window, Adams Family Memorial Window. G1898.4

First Unitarian Church
Isaiah (after Michelangelo), Samuel Morse Felton and Cornelius Conway Felton Memorial Window. G1891.2

Pennsylvania Academy of the Fine Arts
Hollyhocks and Morning Glories, window from Thomas Grover house, Canton, Massachusetts. G1884.3

Trompe l'Oeil Curtain, sash window from Thomas Grover house, Canton, Massachusetts. G1884.4

Philadelphia Museum of Art
Spring, window made for William C. Whitney house, Westbury, Long Island, New York, but never installed there. G1902.2

Samuel S. Fleisher Art Memorial
Apelles, or *Painting*, panel from Edward W. Bok house, Merion, Pennsylvania. G1909.1

Pan and Nymph, or *Music*, panel from Edward W. Bok house, Merion, Pennsylvania. G1909.3

Sakia Muni Sitting under the Bo Tree, or *Wisdom*, panel from Edward W. Bok house, Merion, Pennsylvania. G1909.2

Pittsburgh, Pennsylvania

Frick Building
Fortune, window. G1902.1

Portland, Maine

Emmanuel Chapel, Cathedral of Saint Luke
Madonna and Child (also known as the *Codman Madonna*), mural enframed by angels by other artists. MD1903.1

Poughkeepsie, New York

Vassar College Chapel
Angels, Class of 1890 Memorial Window. G1905.4

The Crown of Life, Mary Elizabeth Bowen Memorial Window. G1905.3

Ruth and Naomi, Mabel Foos Knott Memorial Window. G1905.5

Providence, Rhode Island

Church of the Blessed Sacrament
Angel of Adoration, Michael McGann and Catherine McGann Memorial Window. G1899.2

Angel of Adoration, Sarah Sears Currin Memorial Window. G1899.3

Angel of Adoration, window. G1899.5

Angel of Adoration, window. G1899.6

Large and small rose windows. G1899.7A–B

Ornamental window. G1899.4

Maddock Alumni Center, Brown University
Staircase windows with architectonic and landscape motifs. G1882.4.

Saint John's Cathedral
The Wise Virgin, Mary Mackie Paine Memorial Window (originally located in cathedral; now installed in stairwell leading to balcony in cathedral library). G1884.11

Quincy, Massachusetts

Crane Memorial Library
Angel at the Tomb, Benjamin Franklin Crane Memorial Window. G1890.5

Crinkle-glass window. G1883.34

Decorative window. G1883.5

The Old Philosopher, window. G1883.4

Rhinebeck, New York

Church of the Messiah
Angel of the Resurrection, Susan Watts Street Memorial Window. G1898.5

Rock Island, Illinois

Trinity Episcopal Church
Christ Meeting His Mother at the Temple, Mary Jane Cable Memorial Window. G1896.2

The Walk to Emmaus, Philander Lathrop Memorial Window. G1896.1

St. James, Long Island, New York

Saint James Episcopal Church
Scroll, James Clinch Memorial Window. G1881.32

Sword and Helmet, Charles Nicoll Clinch Memorial Window. G1884.10

St. Louis, Missouri

First Presbyterian Church
Isaiah (after Michelangelo), William McMillan Memorial Window. G1905.1

St. Louis Art Museum
Flowering Cherry Tree and Peony, window from Frederick Lothrop Ames house, Boston. G1882.11

Hollyhocks, window from Frederick Lothrop Ames house, Boston. G1882.10

St. Paul, Minnesota

Supreme Court Room, Minnesota State Capitol
Episodes in the History of Law: Confucius, Moses, Raymond of Toulouse, and *Socrates*. MD1904.1–4

St. Petersburg, Florida

Museum of Fine Arts
Peonies in the Wind, window manufactured as a shop experiment for testing color and glass texture. G1889.5

Salem, Massachusetts

First Church
Faith and Charity, Francis and Martha Peabody Memorial Window. G1893.3

Scranton, Pennsylvania

Westminster Presbyterian Church
Christ and the Samaritan Woman, Harriet Whiton Storrs and William R. Storrs Memorial Window. G1903.3

Southampton, Long Island, New York

Sacred Hearts of Jesus and Mary Church
Saint John the Baptist, John R. Brady Memorial Window. G1894.2

Saint Andrew's Dune Church
The Harpist, Louise Miller Howland Memorial Window. G1884.8

Madonna and Child, Julia Bryant Howland Memorial Window (extensively altered during restoration). G1898.9

Springfield, Massachusetts

George Walter Vincent Smith Art Museum
Christ between the Apostles John and Paul, Walter Farnsworth, Elizabeth Loring Young Farnsworth, Rev. Charles James Bowen, Leonard Ware, and Sarah Howard Minns Ware Memorial Window, from Church of the Unitarian Society, Amherst, Massachusetts. G1889.12

Rebecca at the Well, James Bliss Rumrill and Rebecca Pierce Rumrill Memorial Window, from Church of the Unity, Springfield. G1896.4

Staten Island, New York

Staten Island Museum
Angel of the Sun, mural intended for the Church of Saint Paul the Apostle, New York, but never installed there. MD1899.2E

Stockbridge, Massachusetts

Saint Paul's Episcopal Church
The Annunciation, William Ellery Sedgwick Memorial Window. G1887.2

Saint Paul Preaching at Athens, Rev. Samuel P. Parker Memorial Window (extensively altered during restoration). G1884.6

Tannersville, New York

Onteora Club Church
Eucharistic Cross and Angels, Fanny G. Russell Memorial Window. G1896.6

Tuxedo Park, New York

Saint Mary's-in-Tuxedo
Belief in the Resurrection, Griswold N. Lorillard Memorial Window. G1890.6

Victoria, British Columbia

Maltwood Memorial Museum of Historic Art, University of Victoria
Translucent glazed door from William Watts Sherman house, Newport, Rhode Island. G1878.5

Washington, D.C.

National Museum of American Art, Smithsonian Institution
Peacocks and Peonies I, window from Frederick Lothrop Ames house, Boston. G1882.8

Peacock and Peonies II, window from Frederick Lothrop Ames house, Boston. G1882.9

Peonies in the Wind with Kakemono Borders, window from John Hay house, Washington, D.C. G1893.2

Wellesley, Massachusetts

Wellesley College Chapel
Poetess upon the Tower of Ivory, Angie Lacey Peck Memorial Window. G1900.2

Semita Certe, or *The Path*, Helen A. Shafer Memorial Window. G1900.1

West Chester, Pennsylvania

Church of the Holy Trinity
Three Holy Women, Catherine Schuyler Bolton and Abby Jacobs Katharine Schuyler Chambers Memorial Window. G1889.7

West Roxbury, Massachusetts

Emmanuel Episcopal Church
The Harpist, Katherine Wallen Lyon Dana and Katherine Cooper Lyon Memorial Window. G1897.9

Williamstown, Massachusetts

Thompson Memorial Chapel, Williams College
Abraham and an Angel, James Abram Garfield Memorial Window, from Old Chapel, Williams College. G1882.7

Winter Park, Florida

George D. and Harriet W. Cornell Fine Arts Center Museum, Rollins College
Hollyhocks, window. G1881.29

Worcester, Massachusetts

Worcester Art Museum
Angel at the Healing Waters of Bethesda, James Ayer Memorial Window, from Mount Vernon Church, Boston. G1898.3

Peacock and Peonies, window made for John Hay house, Washington, D.C., but never installed there. G1892.4

LENDERS TO THE EXHIBITION

Addison Gallery of American Art,
Phillips Academy, Andover, Massachusetts

The Art Museum, Princeton University,
Princeton, New Jersey

Avery Architectural and Fine Arts Library,
Columbia University, New York

Beinecke Rare Book and Manuscript Library,
Yale University, New Haven, Connecticut

Bowdoin College Museum of Art,
Brunswick, Maine

The Carnegie Museum of Art, Pittsburgh

The Century Association

Sidney Ashley Chanler

Charles D. Childs

Frances S. Childs

The Chrysler Museum, Norfolk, Virginia

Sterling and Francine Clark Art Institute,
Williamstown, Massachusetts

Mr. and Mrs. Willard G. Clark

The Cleveland Museum of Art

Corcoran Gallery of Art, Washington, D.C.

The Currier Gallery of Art, Manchester,
New Hampshire

Denver Art Museum

Detroit Institute of Arts

Jerald Dillon Fessenden

Mrs. Diane Moore Field

Fogg Art Museum, Harvard University,
Cambridge, Massachusetts

Daniel and Rita Fraad

Mr. and Mrs. Raymond J. Horowitz

The Huntington Galleries, Huntington,
West Virginia

Mr. and Mrs. John M. Liebes

Margaret H. Lloyd

The Metropolitan Museum of Art, New York

The Minneapolis Institute of Arts

Museum of Fine Arts, Boston

National Gallery of Art, Washington, D.C.

National Museum of American Art,
Smithsonian Institution, Washington, D.C.

The Nelson-Atkins Museum of Art,
Kansas City, Missouri

The New Britain Museum of American Art,
New Britain, Connecticut

Private collections (7)

Richard M. Scaife

Mr. and Mrs. Ludlow Shonnard III

The Toledo Museum of Art, Toledo, Ohio

Mr. and Mrs. Glenn Verrill

The Walters Art Gallery, Baltimore, Maryland

Pauline E. Woolworth

Yale University Art Gallery,
New Haven, Connecticut

CHECKLIST OF THE EXHIBITION

The organization of the checklist follows that of the exhibition, with works grouped by subject or type. The order within each category is chronological, and, where more than one work is listed for a given year, alphabetical within the chronology. Every effort has been made to use the title given to the work when it was first exhibited or sold; any title by which a work may be familiarly known, or by which it was previously known, is given in parentheses. Each entry includes the number that the work has been assigned for the forthcoming catalogue raisonné. In those numbers, *P* refers to oil painting or encaustic, *W* to watercolor or gouache, *D* to drawing, *E* to engraving, and *G* to stained glass. The first four digits of the catalogue raisonné number refer to the year during which primary production of the work took place.

Early Works

Still Lifes

1
Still Life. Study of Silver, Glass and Fruit, 1859
Oil on canvas
16 × 20 in. (40.6 × 50.8 cm.)
Charles D. Childs
P1859.12
Illustrated page 86

2
Water-Lillies in a White Bowl—with Red Table Cover,
1859
Oil on wood
9½ × 11½ in. (24.1 × 29.2 cm.)
Pauline E. Woolworth
P1859.15
Illustrated page 97

3
Flowers in a Persian Porcelain Water Bowl, c. 1861
(Flowers on a Windowsill)
Oil on canvas
24 × 20 in. (61 × 50.8 cm.)
Corcoran Gallery of Art, Washington, D.C.
Anna E. Clark Fund, 1949
P1861.3
Illustrated page 27

4
Roses on a Tray, c. 1861
Oil on Japanese lacquered panel
19⅞ × 11¼ in. (50.5 × 28.6 cm.)
The Carnegie Museum of Art, Pittsburgh
Katherine M. McKenna Fund, 1983
P1861.4
Illustrated page 224

5
Agathon to Erosanthe, Votive Wreath, 1861
Oil on canvas
23 × 13 in. (58.4 × 33 cm.)
Private collection
P1861.10
Illustrated page 23

6
Calla Lily, 1862
Oil on wood
9³⁄₁₆ × 15¾ in. (23.3 × 40 cm.)
The Art Museum, Princeton University,
Princeton, New Jersey
Gift of Frank Jewett Mather, Jr.
P1862.13
Illustrated page 20

7
The Last Water Lilies, 1862
Oil on wood
7¾ × 7⅝ in. (19.7 × 19.4 cm.)
Mrs. Diane Moore Field
P1862.18
Illustrated page 97

8
Hollyhocks, c. 1863
(White Hollyhocks)
Encaustic on wood
34 × 15¾ in. (86.4 × 40 cm.)
Mr. and Mrs. John M. Liebes
P1863.9
Illustrated page 22

9
Shell and Flower, 1863
(Cactus Flower in an Oyster)
Encaustic on wood
7¹³⁄₁₆ × 9¹¹⁄₁₆ in. (19.8 × 24.6 cm.)
Jerald Dillon Fessenden
P1863.11
Illustrated page 25

10
Flowers in Japanese Vase, 1864
Oil on wood covered with gold leaf
18¼ × 14 in. (46.4 × 35.6 cm.)
Museum of Fine Arts, Boston
Gift of Louise W. and Marian R. Case
P1864.2
Boston only
Illustrated page 24

11
Wreath of Flowers, 1866
(Greek Love Token)
Oil on canvas
24⅛ × 13⅛ in. (61.1 × 33.3 cm.)
National Museum of American Art,
Smithsonian Institution, Washington, D.C.
Gift of John Gellatly
P1866.1
Illustrated page 6

(Still lifes continue with number 54.)

Landscapes

12
Bayou Teche, Louisiana. Study for Values. I, 1860
Pencil on paper
2¾ × 5¹⁄₁₆ in. (7.1 × 12.8 cm.)
Bowdoin College Museum of Art, Brunswick, Maine
D1860.38

13
Bayou Teche, Louisiana. Study for Values. II, 1860
Pencil on paper
2¾ × 4⁵⁄₁₆ in. (7.1 × 11.6 cm.)
Bowdoin College Museum of Art, Brunswick, Maine
D1860.39

14
Wooded Landscape on the Bayou Teche, Louisiana,
1860
Oil on wood
9 × 12 in. (22.9 × 30.5 cm.)
Margaret H. Lloyd
P1860.9

15
Clouds over Sea; From Paradise Rocks, 1863
Oil on canvas
10 × 14 in. (25.4 × 35.6 cm.)
Private collection
P1863.7
Illustrated page 87

12
Bayou Teche, Louisiana. Study for Values. I, 1860

13
Bayou Teche, Louisiana, Study for Values. II, 1860

16
Landscape, Newport, 1865
(Paradise Rocks, Looking South)
Pencil on paper
5¾ × 8¹⁄₁₆ in. (14.6 × 21.9 cm.)
Avery Architectural and Fine Arts Library,
Columbia University, New York
D1865.15
Illustrated page 88

17
Snow Storm, 1865
(Tree in Snowstorm)
Oil on wood
16½ × 12 in. (42 × 30.5 cm.)
Mr. and Mrs. Glenn Verrill
P1865.1
Illustrated page 29

18
Study of Cloud Movement, Newport, 1865
Pencil on paper
6¾ × 3¹⁵⁄₁₆ in. (17.2 × 10 cm.)
Museum of Fine Arts, Boston
Gift of Major H. L. Higginson, 1911
D1865.6
Illustrated page 88

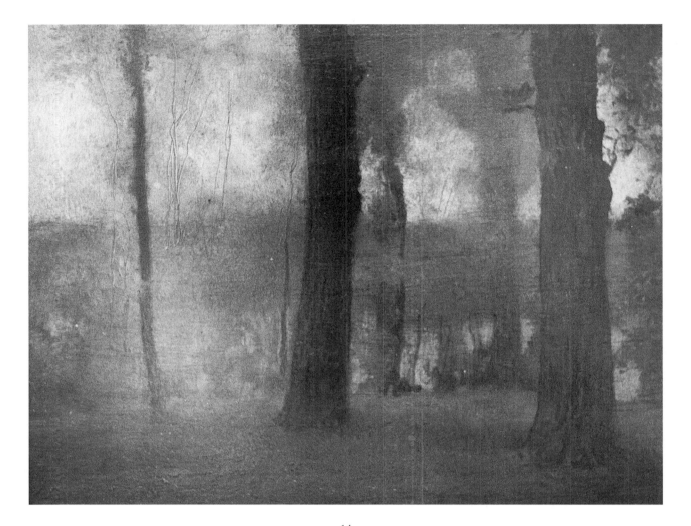

14
Wooded Landscape on the Bayou Teche, Louisiana, 1860

19
Autumn Study. View over Hanging Rock, Newport, R.I.,
1868
(Bishop Berkeley's Rock)
Oil on canvas
30¼ × 25¼ in. (76.8 × 64.1 cm.)
The Metropolitan Museum of Art, New York
Gift of Frank Jewett Mather, Jr., 1949
P1868.1
Illustrated page 83

20
Snow Weather. Sketch, 1869
(Landscape in Snow)
Oil on wood
9⅜ × 9⁷⁄₁₆ in. (23.8 × 24 cm.)
The Art Museum, Princeton University,
Princeton, New Jersey
Gift of Frank Jewett Mather, Jr.
P1869.1
Illustrated page 85

21
Paradise Rocks—Study at Paradise. Newport, R.I.,
c. 1883
(Green Hills and Pool)
Watercolor on paper
8 × 9⁷⁄₁₆ in. (20.3 × 24 cm.)
The Metropolitan Museum of Art, New York
Bequest of Susan Dwight Bliss, 1966
W1883.23
Washington, D.C., and Pittsburgh only
Illustrated page 46

22
Study at Berkeley Ridge or Hanging Rock, c. 1883
(Rocks at Newport)
Watercolor on paper
10½ × 13 in. (26.7 × 33 cm.)
Museum of Fine Arts, Boston
Bequest of Mrs. Henry Lee Higginson, 1935
W1883.24
Illustrated page 45

Portraits and Figures

23
Portrait of a Seated Boy [Garth Wilkinson James],
c. 1859–60
Oil on canvas
19⁹⁄₁₆ × 15½ in. (49.7 × 39.4 cm.)
Denver Art Museum
Helen Dill Collection
P1859.23

24
The Lady of Shalott, 1862
Oil on wood
9 × 14¾ in. (22.9 × 37.5 cm.)
The New Britain Museum of American Art,
New Britain, Connecticut
Harriet Russell Stanley Fund
P1862.1
Illustrated page 94

25
Portrait of Henry James, the Novelist, 1862
Oil on canvas
20½ × 13½ in. (52.1 × 34.3 cm.)
The Century Association
P1862.3
Washington, D.C., and Pittsburgh only
Illustrated page 15

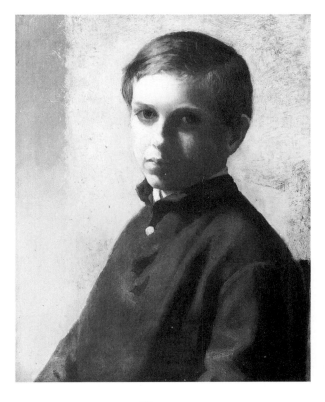

23
Portrait of a Seated Boy [Garth Wilkinson James],
c. 1859–60

26
Hilltop, c. 1862
Oil on canvas
24 × 13 in. (61 × 33 cm.)
Museum of Fine Arts, Boston
William Sturgis Bigelow Collection
P1862.14
Illustrated page 28

27
Father Baker, 1863
Pencil on paper
5⅞ × 4 in. (13.8 × 10.2 cm.)
The Art Museum, Princeton University,
Princeton, New Jersey
Gift of Frank Jewett Mather, Jr.
D1863.7

28
T[homas] S[ergeant] Perry Talking with John Bancroft,
1865
Pencil on paper
7¾ × 5¹¹⁄₁₆ in. (19.7 × 14.5 cm.)
Frances S. Childs
D1865.5

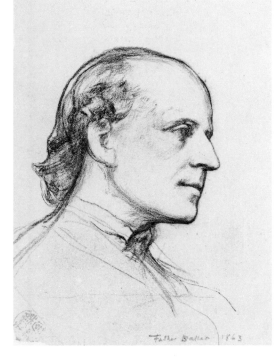

27
Father Baker, 1863

29
Child in Bedsheet, c. 1866–67
Drawing from a sketchbook
Pencil on paper
5½ × 7¾ in. (14 × 19.7 cm.)
Royal Cortissoz Papers
Collection of American Literature
Beinecke Rare Book and Manuscript Library,
Yale University, New Haven, Connecticut
D1867.37

28
T[homas] S[ergeant] Perry Talking with John Bancroft,
1865

29
Child in Bedsheet, c. 1866–67

Illustrations

30
The Children, 1864
Illustration for *Enoch Arden* (1864)
Wood engraving
3⁷⁄₁₆ × 3¹⁵⁄₁₆ in. (8.7 × 10 cm.)
Private collection
E1864.1
Illustrated page 262

31
Enoch Alone, 1864
Illustration for *Enoch Arden* (1864)
Wood engraving
3⅞ × 3¼ in. (9.8 × 8.3 cm.)
Private collection
E1864.6
Illustrated page 35

32
Enoch's Supplication, 1864
Illustration for *Enoch Arden* (1864)
Wood engraving
3³⁄₁₆ × 3¹¹⁄₁₆ in. (8.1 × 9.4 cm.)
Private collection
E1864.8
Illustrated page 262

33
The Island Home, 1864
Illustration for *Enoch Arden* (1864)
Wood engraving
3¹³⁄₁₅ × 3¼ in. (9.7 × 8.3 cm.)
Private collection
E1864.5
Illustrated page 35

34
The Lovers, 1864
Illustration for *Enoch Arden* (1864)
Wood engraving
3¹⁵⁄₁₆ × 3⅛ in. (10 × 7.9 cm.)
Private collection
E1864.2
Illustrated page 262

35
Philip and Annie in the Wood, 1864
Illustration for *Enoch Arden* (1864)
Wood engraving
3⁵⁄₁₆ × 3¹⁵⁄₁₆ in. (10 × 10 cm.)
Private collection
E1864.3
Illustrated page 262

36
The Seal of Silence, 1864
Illustration for *Enoch Arden* (1864)
Wood engraving
3¹⁵⁄₁₆ × 2⁹⁄₁₆ in. (10 × 6.5 cm.)
Private collection
E1864.9
Illustrated page 263

30
The Children, 1864

34
The Lovers, 1864

32
Enoch's Supplication, 1864

35
Philip and Annie in the Wood, 1864

37
Shipwrecked, 1864
Illustration for *Enoch Arden* (1864)
Wood engraving
3¹⁵⁄₁₆ × 4 in. (10 × 10.2 cm.)
Private collection
E1864.4
Illustrated page 226

38
The Solitary, 1864
Illustration for *Enoch Arden* (1864)
Wood engraving
3¹⁵⁄₁₆ × 3⅜ in. (10 × 8.6 cm.)
Private collection
E1864.7
Illustrated page 35

39
Bishop Hatto and the Rats, 1866
Illustration for the *Riverside Magazine for Young People*
(never published there)
Wood engraving
7 × 5½ in. (17.8 × 14 cm.)
The Metropolitan Museum of Art, New York
Rogers Fund, 1921
E1866.2
Illustrated page 32

40
The Fisherman and the Djinn, 1866–67
Illustration for the *Riverside Magazine for Young People*
(1868)
Wood engraving
6¾ × 5⅜ in. (17.2 × 14.3 cm.)
The Metropolitan Museum of Art, New York
Harris Brisbane Dick Fund, 1936
E1868.2
Illustrated page 34

41
The Triumph of Love, 1866–67
(Love Borne Triumphant)
Wash drawing on woodblock
5⅞ × 3⅝ in. (15 × 9.2 cm.)
The Art Museum, Princeton University,
Princeton, New Jersey
Gift of Frank Jewett Mather, Jr.
D1866.78
Illustrated page 134

42
The Pied Piper of Hamelin, 1867
Illustration for the *Riverside Magazine for Young People*
(1868)
Wood engraving
6¾ × 5⅜ in. (17.2 × 13.7 cm.)
The Metropolitan Museum of Art, New York
Harris Brisbane Dick Fund, 1936
E1868.1
Illustrated page 33

43
The Wolf-Charmer, 1867
Illustration for the *Riverside Magazine for Young People*
(1867)
Wood engraving
6¹⁵⁄₁₆ × 5³⁄₈ in. (17.5 × 13.7 cm.)
The Metropolitan Museum of Art, New York
Rogers Fund, 1921
E1867.1
Illustrated page 31

44
Lady with a Fan, 1868
(Woman in Japanese Costume at an Easel)
India ink and Chinese white on uncut woodblock
5¾ × 4³⁄₁₆ in. (14.6 × 10.6 cm.)
The Carnegie Museum of Art, Pittsburgh
Andrew Carnegie Fund, 1918
D1868.3
Illustrated page 95

45
The Travelers and the Giant, 1868
(The Giant)
Illustration for the *Riverside Magazine for Young People*
(1869)
Wood engraving
7 × 5½ in. (17.8 × 14 cm.)
The Metropolitan Museum of Art, New York
Rogers Fund, 1921
E1869.1
Illustrated page 34

46
The Wise Men Out of the East, 1868
Illustration for the *Riverside Magazine for Young People*
(1868)
Wood engraving
5½ × 7 in. (14 × 17.8 cm.)
The Metropolitan Museum of Art, New York
Harris Brisbane Dick Fund, 1936
E1868.3
Illustrated page 176

47
Song of the Siren, 1872
Illustration for *Songs from the Old Dramatists* (1873)
Wood engraving
5¾ × 3⁹⁄₁₆ in. (14.6 × 9 cm.)
Private collection
E1873.3
Illustrated page 132

48
Songs of Feeling, Songs of Thought, 1872
Illustration for *Songs from the Old Dramatists* (1873)
Wood engraving
5¼ × 3½ in. (13.3 × 8.9 cm.)
Private collection
E1873.2

36
The Seal of Silence, 1864

48
Songs of Feeling, Songs of Thought, 1872

49
Songs of Sorrow, 1872
Illustration for *Songs from the Old Dramatists* (1873)
Wood engraving
5⅜ × 3⅜ in. (13.7 × 8.6 cm.)
Private collection
E1873.4
Illustrated page 132

50
The Waterlily and the Fairy, 1872
Illustration for *Songs from the Old Dramatists* (1873)
Wood engraving
5¼ × 3½ in. (13.3 × 8.9 cm.)
Private collection
E1873.1
Illustrated page 133

Subject Paintings

51
*Decorative Panel. Seated Figure in Yellow. Study for the
Muse of Painting,* 1870
(The Muse of Painting)
Oil on canvas
49¼ × 38¼ in. (125.1 × 97.2 cm.)
The Metropolitan Museum of Art, New York
Gift of J. Pierpont Morgan and Henry Walters, 1909
P1870.1
Illustrated page 100

52
The Golden Age, 1878–79
Oil on canvas
35⅝ × 16½ in. (90.5 × 41.9 cm.)
National Museum of American Art,
Smithsonian Institution, Washington, D.C.
Gift of John Gellatly
P1878.3
Illustrated page 101

53
The Three Wise Men, 1878–79
(Halt of the Wise Men)
Oil on canvas
32¾ × 42 in. (83.2 × 106.7 cm.)
Museum of Fine Arts, Boston
Gift of Edward W. Hooper
P1878.2
Illustrated page 176

Later Still Lifes

54
Apple Blossoms, c. 1878
Oil on wood
10¾ × 5¼ in. (27.3 × 13.1 cm.)
Private collection, Boston
P1878.4
Illustrated page 26

55
Blue Iris. Study, 1879
Watercolor on paper
10⅝ × 8⅝ in. (27 × 22 cm.)
Jerald Dillon Fessenden
W1879.12
Illustrated page 143

56
Apple Blossoms. On White Ground, c. 1879
Watercolor on paper
7 × 9½ in. (17.8 × 24.2 cm.)
Museum of Fine Arts, Boston
Bequest of Mrs. Henry Lee Higginson, 1935
W1879.32
Illustrated page 139

57
Study of Pink Hollyhock in Sunlight. From Nature,
c. 1879
Watercolor and gouache on paper
11⅞ × 9¹¹⁄₁₆ in. (30.2 × 24.6 cm.)
The Nelson-Atkins Museum of Art,
Kansas City, Missouri
Gift of James Maroney, New York
W1879.18
Illustrated page 136

58
Wild Roses in a White Chinese Porcelain Bowl, 1880
Watercolor on paper
10¹⁵⁄₁₆ × 9¹⁄₁₆ in. (27.8 × 24.5 cm.)
Museum of Fine Arts, Boston
Bequest of Elizabeth Howard Bartol, 1927
W1880.2
Illustrated page 47

59
Water Lilies in Black Water. Study from Nature, c. 1883
(Water Lilies. Red and Green Pads.)
Watercolor on paper
7⅜ × 11¼ in. (18.7 × 28.6 cm.)
Pauline E. Woolworth
W1883.30
Illustrated page 141

60
Water Lily in Sunlight, c. 1883
Watercolor on paper
8¼ × 8³⁄₁₆ in. (21 × 20.8 cm.)
National Museum of American Art,
Smithsonian Institution, Washington, D.C.
Gift of John Gellatly
W1883.15
Illustrated page 141

61
Wild Roses and Water Lily—Study of Sunlight, c. 1883
Watercolor on paper
10⅝ × 9 in. (27 × 22.9 cm.)
Mr. and Mrs. Raymond J. Horowitz
W1883.35
Washington, D.C., only
Illustrated page 140

62
Wild Roses and Irises, 1887
Watercolor on paper
12⅝ × 10⅛ in. (32.1 × 25.7 cm.)
The Metropolitan Museum of Art, New York
Gift of Priscilla A. B. Henderson, 1950,
in memory of her grandfather, Russell Sturgis
W1887.13
Washington, D.C., and Pittsburgh only
Illustrated page 122

Japan and the South Seas

Japanese Subjects

63
The Fountain in Our Garden at Nikko, 1886
Oil on wood
11¾ × 9¾ in. (29.9 × 24.8 cm.)
Richard M. Scaife
P1886.3
Illustrated page 50

64
Sunrise in Fog over Kiyoto, 1886
(Kyoto in the Mist)
Watercolor on paper
9½ × 11⅞ in. (24.2 × 30.7 cm.)
The Currier Gallery of Art, Manchester, New Hampshire
Gift of Clement S. Houghton
W1886.48
Illustrated page 50

65
*The Great Statue of Amida Buddha at Kamakura,
Known as the Daibutsu, from the Priest's Garden*, c. 1886
Watercolor on paper
19⁵⁄₁₆ × 12½ in. (49.1 × 31.8 cm.)
The Metropolitan Museum of Art, New York
Gift of the Family of Maria L. Hoyt, 1966
W1886.46
Washington, D.C., and Pittsburgh only
Illustrated page 51

66
Meditation of Kuwannon, c. 1886
(Meditation of Kwanyin)
Watercolor on paper
12¾ × 10⅜ in. (32.4 × 26.4 cm.)
Bowdoin College Museum of Art, Brunswick, Maine
W1886.62
Illustrated page 53

67
Water-Fall of Urami-No-Taki, c. 1886
Watercolor on paper
10½ × 15½ in. (26.7 × 39.4 cm.)
Addison Gallery of American Art,
Phillips Academy, Andover, Massachusetts
Gift of Mr. and Mrs. Stuart P. Feld
W1886.24
Illustrated page 126

68
The Strange Thing Little Kiosai Saw in the River, 1897
Watercolor on paper
12¾ × 18½ in. (32.4 × 47 cm.)
The Metropolitan Museum of Art, New York
Rogers Fund, 1917
W1897.3
Washington, D.C., and Pittsburgh only
Illustrated page 55

69
A Rishi Calling up a Storm, Japanese Folk Lore, c. 1897
Watercolor on paper
13 × 16⅛ in. (33 × 40.4 cm.)
The Cleveland Museum of Art, Cleveland, Ohio
Purchase from the J. H. Wade Fund
W1897.6
Illustrated page 54

South Sea Subjects

70
Crater of Kilauea and the Lava Bed, 1890
Gouache, watercolor, and pencil on paper
11¹⁵⁄₁₆ × 17⅞ in. (30.3 × 45.4 cm.)
The Toledo Museum of Art, Toledo, Ohio
Gift of Edward Drummond Libbey
W1890.18
Illustrated page 57

71
*Fagaloa Bay, Samoa, 1890. The Taupo, Faase,
Marshalling the Women Who Bring Presents of Food*,
1890
Watercolor on paper
12 × 14¹⁵⁄₁₆ in. (30.5 × 37.4 cm.)
The Century Association
W1890.82
Illustrated page 58

72
*At Naiserelangi, from Ratu Jonii Mandraiwiwi's "Yavu."
July 14, 1891*, 1891
Watercolor on paper
10¼ × 8¼ in. (26 × 20 cm.)
The Huntington Galleries, Huntington, West Virginia
W1891.113
Illustrated page 127

73
*Children Bathing in the Surf at the Entrance to River at
Papara, Tahiti. Morning. 1891*, 1891
Watercolor on paper
13¾ × 19½ in. (34.9 × 49.5 cm.)
Private collection
W1891.49
Illustrated page 60

74
"Hari." Bundle of Cocoanuts. Showing Tahitian Manner of Preparing and Tying Them. Tautira, March, 1891, 1891
(Hari, or Bundle of Cocoanuts, Tahiti)
Watercolor, gouache, and ink on board
6¹⁵⁄₁₆ × 9¹³⁄₁₆ in. (17.6 × 24.9 cm.)
The Toledo Museum of Art, Toledo, Ohio
Gift of Edward Drummond Libbey
W1891.32
Illustrated page 59

75
Himene at Papara in Front of Tati Salmon's, The Chief's House. Feb. 26th, 1891, 1891
Watercolor on paper
6¼ × 12¾ in. (15.9 × 32.4 cm.)
Private collection
W1891.26
Illustrated page 124

76
Maua, a Samoan, 1891
(Maua, Our Boatman)
Oil on canvas
47½ × 38¼ in. (120.7 × 97.2 cm.)
Original size: 52 × 38½ in. (132.1 × 97.8 cm.)
Addison Gallery of American Art,
Phillips Academy, Andover, Massachusetts
P1891.1
Illustrated page 62

77
Portrait of Faase, the Taupo of the Fagaloa Bay, Samoa, 1891
(A Taupo and Her Duenna Await the Approach of a Young Chief)
Watercolor on paper
19 × 15⅛ in. (48.3 × 38.4 cm.)
Daniel and Rita Fraad
W1891.18
Illustrated page 109

78
Samoan Girls Dancing the Seated Dance, or Siva, with Pantomime and Song. Samoa, 1891. Night Effect, 1891
Watercolor on paper
10½ × 13½ in. (26.7 × 34.3 cm.)
Museum of Fine Arts, Boston
William Sturgis Bigelow Collection
W1891.16
Boston only
Illustrated page 110

79
View near Dambula, Looking over Rice Fields, 1891
Watercolor on paper
17 × 13½ in. (43 × 34.5 cm.)
Museum of Fine Arts, Boston
William Sturgis Bigelow Collection
W1891.124
Boston only
Illustrated page 129

80
Women Drawing up a Canoe. Vaiala in Samoa. Otaota, Her Mother and a Neighbor, 1891
Watercolor on paper
7½ × 12¼ in. (19.1 × 31.1 cm.)
Museum of Fine Arts, Boston
William Sturgis Bigelow Collection
W1891.7
Boston only
Illustrated page 58

81
Young Girls Preparing Kava (the South Sea Drink). Outside of the Hut Whose Posts Are Decorated with Flowers; The Attendant, Standing in the Background Is There to Hand the Cocoanut Cup When Filled, 1891
Watercolor on paper
10⅛ × 7¾ in. (25.7 × 19.7 cm.)
Museum of Fine Arts, Boston
William Sturgis Bigelow Collection
W1891.8
Boston only
Illustrated page 153

82
Entrance to Tautira River, Tahiti, c. 1893
Watercolor on paper
13⅜ × 21⅜ in. (33 × 54.3 cm.)
Mr. and Mrs. Willard G. Clark
W1893.1
Illustrated page 2

83
Siva Dance at Night, c. 1894
(Seated Siva Dance at Night)
Watercolor on paper
13½ × 22 in. (34.3 × 55.9 cm.)
The Carnegie Museum of Art, Pittsburgh
Museum purchase, 1917
W1894.10
Illustrated page 115

84
After-Glow, Tautira River, Tahiti, c. 1895
Oil on canvas
53½ × 60 in. (135.9 × 152.3 cm.)
National Gallery of Art, Washington, D.C.
Adolph Caspar Miller Fund
P1895.3
Illustrated page 112

85
Bridle Path, Tahiti, c. 1901
Watercolor on paper
18 × 20⅛ in. (45 × 51.1 cm.)
Fogg Art Museum, Harvard University,
Cambridge, Massachusetts
Gift of Edward D. Bettens to the Louise E. Bettens Fund
W1901.3
Illustrated page 152

Studies for Decorative Projects

86
Angel with Scroll, 1876
Cartoon for mural, Trinity Church, Boston
Pencil and charcoal on paper
12⅝ × 10½ in. (32.1 × 26.7 cm.)
National Gallery of Art, Washington, D.C.
John Davis Hatch Collection
D1876.22
Washington, D.C., and Pittsburgh only
Illustrated page 166

87
Angel with Scroll, 1876
(An Angel: Study for a Decoration in Trinity Church)
Cartoon for mural, Trinity Church, Boston
Charcoal on paper
13 × 13 in. (33 × 33 cm.)
Sterling and Francine Clark Art Institute,
Williamstown, Massachusetts
Gift of Mr. L. Bancel La Farge
D1876.23
Illustrated page 166

88
First Study for Tower, Trinity Church, Boston, 1876
Crayon on paper
6¼ × 11½ in. (15.5 × 29.3 cm.)
The Art Museum, Princeton University,
Princeton, New Jersey
Gift of Frank Jewett Mather, Jr.
D1876.3
Illustrated page 166

89
Isaiah, 1876
Cartoon for mural, Trinity Church, Boston
Crayon on paper
28 × 13⅞ in. (71.1 × 35.2 cm.)
Sidney Ashley Chanler
D1876.6
Illustrated page 167

90
Jeremiah, 1876
Cartoon for mural, Trinity Church, Boston
Charcoal on paper mounted on canvas
29½ × 15½ in. (74.9 × 39.4 cm.)
Yale University Art Gallery, New Haven, Connecticut
The Gheradi Davis Fund
D1876.7
Illustrated page 167

91
Oak Leaves, 1877

91
Oak Leaves, 1877
Study for King Monument, Newport, Rhode Island
Crayon on paper
7⅝ × 7¹⁄₁₆ in. (19.3 × 17.9 cm.)
The Art Museum, Princeton University,
Princeton, New Jersey
Gift of Frank Jewett Mather, Jr.
D1877.21

92
The Three Marys, 1877
Cartoon for mural, Saint Thomas Church, New York
Pencil on paper
12⅝ × 10¼ in. (32.2 × 25.9 cm.)
The Art Museum, Princeton University,
Princeton, New Jersey
Gift of Frank Jewett Mather, Jr.
D1877.9
Illustrated page 173

93
Dawn Comes on the Edge of Night, 1880
Design for mural (never executed),
Cornelius Vanderbilt II house
Crayon on paper
13 × 13 in. (33 × 33 cm.)
Fogg Art Museum, Harvard University,
Cambridge, Massachusetts
Gift of the Family of the late Frederick A. Dwight
D1880.3
Illustrated page 219

94
Charity, 1884
Study for Helen Angier Ames Memorial Window,
Unity Church, North Easton, Massachusetts
Watercolor on tracing paper
18 × 11½ in. (45.7 × 29.2 cm.)
Fogg Art Museum, Harvard University,
Cambridge, Massachusetts
W1884.4
Illustrated page 212

95
Adoring Angels, c. 1887
Study for mural, Church of the Ascension,
New York
Watercolor on paper
8¼ × 5¾ in. (20 × 14.6 cm.)
Museum of Fine Arts, Boston
Gift of Mary W. Bartol, John W. Bartol, and
Abigail Clark, 1927
W1887.4
Illustrated page 65

96
Butterflies and Foliage, 1889
Study for window, William H. White house, Brooklyn
Watercolor on paper
10⅞ × 15⅜ in. (27.6 × 39.1 cm.)
Mr. and Mrs. Ludlow Shonnard III
W1889.8
See number 109
Illustrated page 148

97
Resurrection, 1894
Study for Col. Henry Coffin Nevins Memorial Window,
First Congregational United Church of Christ,
Methuen, Massachusetts
Watercolor on paper
19⅝ × 24 in. (14.9 × 61 cm.)
The Walters Art Gallery, Baltimore, Maryland
W1894.1
Illustrated page 215

98
Fortune, 1901
Study for window, Frick Building, Pittsburgh
Pencil on paper
10¹⁵⁄₁₆ × 7¹⁵⁄₁₆ in. (27.8 × 20.1 cm.)
The Art Museum, Princeton University,
Princeton, New Jersey
Gift of Frank Jewett Mather, Jr.
D1901.2
Illustrated page 67

99
Fortune, 1901
(The Wheel of Fortune)
Study for window, Frick Building, Pittsburgh
Pencil on paper
10¹⁵⁄₁₆ × 7⅞ in. (27.8 × 20 cm.)
The Cleveland Museum of Art, Cleveland, Ohio
Gift of William G. Mather
D1901.3
Illustrated page 218

100
*The Recording of Precedents: Confucius and His
Disciples,* 1903
Study for mural, Supreme Court Room,
Minnesota State Capitol, St. Paul
Watercolor on paper
7⅛ × 10⅝ in. (18.1 × 27 cm.)
The Metropolitan Museum of Art, New York
Bequest of Susan Dwight Bliss, 1966
W1903.3
Washington, D.C., and Pittsburgh only
Illustrated page 189

101
Confucius: Founder of Law and Philosophy in China,
1905
Study for mural, Baltimore Court House,
Baltimore, Maryland
Watercolor on paper
5¾ × 11½ in. (14.6 × 29.2 cm.)
Detroit Institute of Arts
Founders Society Purchase, Merrill Fund
W1905.1

101
Confucius: Founder of Law and Philosophy in China, 1905

Stained Glass

102

Morning Glories, 1878
Six-panel window from William Watts Sherman house,
Newport, Rhode Island
Stained glass
86½ × 72 in. (219.7 × 182.9 cm.)
Museum of Fine Arts, Boston
Gift of James F. and Jean Baer O'Gorman
G1878.2
Only two of the six panels of the window are included in
the exhibition.
Illustrated page 196

103

Peacocks and Peonies I, 1882
Window from Frederick Lothrop Ames house,
Boston, Massachusetts
Stained glass
105¾ × 45 in. (268.6 × 114.3 cm.)
National Museum of American Art,
Smithsonian Institution, Washington, D.C.
Gift of Henry A. La Farge
G1882.8
Illustrated page 204

104

Peacock and Peonies II, 1882
Window from Frederick Lothrop Ames house,
Boston, Massachusetts
Stained glass
105¾ × 45 in. (268.6 × 114.3 cm.)
National Museum of American Art,
Smithsonian Institution, Washington, D.C.
Gift of Henry A. La Farge
G1882.9
Illustrated page 204

105

Persian Arabesques, 1882
Window from James J. Hill house, St. Paul, Minnesota
Stained glass
34 × 50 in. (86.4 × 127 cm.)
Private collection
Lent through The Minneapolis Institute of Arts
G1882.3C
Illustrated page 207

106

The Infant Bacchus, 1882–84
Window from Washington B. Thomas house (later Henry
P. Kidder house),
Beverly, Massachusetts
Stained glass
89⅛ × 44⅞ in. (226.4 × 114 cm.)
Museum of Fine Arts, Boston
Gift of W. B. Thomas
G1882.36
Illustrated page 42

107

Nine-Paneled Firescreen, c. 1883
Stained glass
40 × 36¼ in. (101.6 × 92.1 cm.)
The Chrysler Museum, Norfolk, Virginia
Gift of Walter P. Chrysler, Jr.
G1883.9
Illustrated page 206

108

Peonies Blown in the Wind, 1886
(Peony in the Wind)
Window from studio of Sir Lawrence Alma-Tadema,
London
Stained glass
60½ × 46⅞ in. (153.7 × 119.1 cm.)
Museum of Fine Arts, Boston
Purchased from General Funds
G1886.1
Illustrated page 43

109

Butterflies and Foliage, 1889
Window from William H. White house, Brooklyn
Stained glass
65 × 27½ in. (165.1 × 69.9 cm.)
Museum of Fine Arts, Boston
Gift of Mrs. William Emerson
G1889.3
See number 96
Illustrated page 149

110

Peonies in the Wind with Kakemono Borders, c. 1893
Window from John Hay house, Washington, D.C.
Stained glass
56 × 26 in. (142.2 × 66 cm.)
National Museum of American Art,
Smithsonian Institution, Washington, D.C.
Gift of Senator Stuart and
Congressman James M. Symington
G1893.2
Illustrated page 221

111

Fish and Flowering Branch, c. 1896
Window from Gordon Abbott house,
Manchester, Massachusetts
Stained glass
26½ × 26½ in. (67.3 × 67.3 cm.)
Museum of Fine Arts, Boston
Anonymous gift and Edwin L. Jack Fund
G1896.5
Illustrated page 194

SELECTED BIBLIOGRAPHY

Henry Adams

Unpublished Manuscript Material

La Farge Family Papers, Department of Manuscripts and Archives, Sterling Memorial Library, Yale University. Contains letters to John La Farge and the correspondence of his son Bancel La Farge and of his grandson Henry A. La Farge.

La Farge Family Papers, New-York Historical Society. Contains La Farge's letters to his fiancée, Margaret Perry, and La Farge family correspondence and papers.

Henry La Farge Papers, New Canaan, Connecticut. Contains materials collected by Henry A. La Farge, James L. Yarnall, and Mary A. La Farge while compiling the forthcoming catalogue raisonné of John La Farge's works. This material will be transferred to the Department of Manuscripts and Archives, Sterling Memorial Library, Yale University, New Haven, Connecticut, following publication of the catalogue raisonné.

Royal Cortissoz Papers, Collection of American Literature, Beinecke Rare Book and Manuscript Library, Yale University. Contains materials compiled by Cortissoz to aid in writing his biography of La Farge, including correspondence with La Farge, La Farge's unfinished memoir, and notes of meetings and conversations with La Farge.

By John La Farge (arranged chronologically)

"An Essay on Japanese Art." In Raphael Pumpelly, *Across America and Asia*. New York: Leypoldt and Holt, 1870, 195–202.

"American Wood-Engraving. Shall It Not Be Shown at Paris." Letter to the editor. *New York Tribune*, March 16, 1878, 2.

"American Wood-Engraving at Paris." Letter to the editor. *New York World*, March 16, 1878, 5.

"A Plea for the Engravers." Letter to the editor. *New York Evening Post*, March 20, 1878, 3.

"Notes and Comments—II." *North American Review* 141 (October 1885): 399–400 [proposal for Grant's tomb].

"Style and Monument." *North American Review* 141 (November 1885): 443–53.

"An Artist's Letters from Japan." *Century Magazine* 39 (February 1890): 483–91; 39 (March 1890): 712–20; 39 (April 1890): 859–69; 40 (May 1890): 195–203; 40 (August 1890): 566–74; 40 (September 1890): 751–59; 40 (October 1890): 866–77; 42 (July 1891): 442–48; 46 (July 1893): 419–29; 46 (October 1893): 571–76.

The American Art of Glass, To Be Read in Connection with Mr. Louis C. Tiffany's Paper in the July Number of the "Forum," 1893. [New York: J. J. Little and Co., 1893].

Considerations on Painting: Lectures Given in the Year 1893 at the Metropolitan Museum of New York. New York: Macmillan and Co., 1895.

An Artist's Letters from Japan. New York: Century Co., 1897.

Hokusai: A Talk about Hokusai, the Japanese Painter, at the Century Club, March 28, 1896. New York: William C. Martin Printing House, 1897.

"Two Recent Works by Rodin." *Scribner's Magazine* 23 (January 1898): 125–28. Coauthored with William C. Brownell.

"How Shall We Know the Greatest Pictures?" *Scribner's Magazine* 24 (August 1898): 253–56.

"The Close of the Year in Art." *Independent* 50 (December 8, 1898): 1687–89.

"The Limits of the Theatre." *Scribner's Magazine* 25 (April 1899): 509–12.

"Sargent, the Artist." *Independent* 51 (April 27, 1899): 1140–42.

"Concerning Painters Who Would Express Themselves in Words." *Scribner's Magazine* 26 (August 1899): 254–56.

"Critical Introduction." In *The Works of William Hogarth*, edited from the texts by John Nichols, George Stevens, and Samuel Ireland, with . . . a chronological *catalogue raisonné* by Austin Dobson. 5 vols. Philadelphia: George Barrie and Son, 1900.

"On Coloring Statuary and Architecture." *Scribner's Magazine* 27 (June 1900): 765–68.

"Ruskin, Art and Truth." *International Monthly* 2 (July–December 1900): 510–35.

"The American Academy at Rome." *Scribner's Magazine* 28 (August 1900): 253–56.

"Puvis de Chavannes." *Scribner's Magazine* 28 (December 1900): 672–84.

"A History of Japanese Art." Review of *Histoire de l'art du Japon*, 1900. *International Monthly* 3 (1901): 590–96.

"Delacroix: A Ten-Minute Talk." In *The Booklover's Reading Handbook to Accompany the Reading Course (III) Entitled Ramblings Among the Art Centres*, by Russell Sturgis, Kenyon Cox, and John La Farge. Philadelphia: Booklover's Library, 1901, 57–65.

"Art and Artists." *International Monthly* 4 (1901): 335–58, 466–90.

Review of *Hokusai, the Great Japanese Artist*, by C. J. Holmes. *New York Times Saturday Review of Books and Art*, April 20, 1901, 269–70.

"Passages from a Diary in the Pacific." *Scribner's Magazine* 29 (May 1901): 537–46; 29 (June 1901): 670–84; 30 (July 1901): 69–83.

"Japanese Plays." Review of *Japanese Plays and Playfellows* by Osman Edwards. *New York Times Saturday Review of Books and Art*, May 18, 1901, 353.

"Son of Bancroft." Letter to the editor. *New York Times Saturday Review of Books and Art*, August 17, 1901, 581.

"Michelangelo." *McClure's Magazine* 18 (December 1901): 99–112.

"Tahitian Literature." In *Library of the World's Best Literature*, vol. 24, edited by Charles D. Warner. New York: H. A. Hill and Co., 1902, 14389–98.

"Windows, III." In *A Dictionary of Architecture and Building*, vol. 3, edited by Russell Sturgis. New York: Macmillan Co., 1902, cols. 1067–92.

"Raphael." *McClure's Magazine* 18 (February 1902): 309–22.

"Rembrandt." *McClure's Magazine* 18 (April 1902): 502–14.

"Rubens." *McClure's Magazine* 19 (June 1902): 159–73.

"Velasquez." *McClure's Magazine* 19 (October 1902): 497–513.

"Durer." *McClure's Magazine* 20 (December 1902): 129–42.

Great Masters. New York: McClure, Phillips and Co., 1903.

"Hogarth." *McClure's Magazine* 20 (April 1903): 584–98.

"The Painting of the Ascension." *New York Herald*, April 5, 1903, second literary section, 1–2.

"Barbizon School." *McClure's Magazine* 21 (June 1903): 115–29; 21 (October 1903): 586–99.

"One Hundred Masterpieces of Painting." *McClure's Magazine* 22 (December 1903): 148–63; 22 (February 1904): 351–56; 22 (April 1904): 579–86; 23 (July 1904): 298–305; 23 (September 1904): 491–97; 23 (October 1904): 595–603; 24 (December 1904): 195–205; 24 (February 1905): 401–7; 24 (March 1905): 529–38; 28 (February 1907): 437–44; 30 (January 1908): 339–45; 32 (December 1908): 135–44.

"Clarence King." In *Clarence King Memoirs*. New York and London: G. P. Putnam's Sons for the King Memorial Committee of the Century Association, 1904, 187–97.

"A Fiji Festival." *Century Magazine* 67 (February 1904): 518–26.

"Speech at the Annual Banquet, American Institute of Architects, January 1905." *American Architect and Building News* 87 (January 28, 1905): 28–29.

"A Review of Mr. Russell Sturgis's Last Book *[A Study of the Artist's Way of Working in the Various Handicrafts and Arts of Design]*." *Architectural Record* 19 (March 1906): 199–205.

"The Decoration of Our Public Buildings." *Scrip* 1 (August 1906): 355–57.

The Higher Life in Art: A Series of Lectures on the Barbizon School of France Inaugurating the Scammon Course at the Art Institute of Chicago. New York: McClure Co., 1908.

"On Painting." *New England Magazine* 38 (April 1908): 229–40.

"Mr. La Farge's Health." Letter to the editor. *New York Daily Tribune*, October 28, 1908, 7.

"Mr. John La Farge Praises a Mural." *New York Herald*, November 22, 1908, literary and arts section, 3.

"The Collection of Mrs. John Lowell Gardner." In *Concerning Noteworthy Paintings in American Private Collections*, edited by August F. Jaccaci. New York: August F. Jaccaci Co., 1909, 1–253.

The Ideal Collection of the World's Great Art. Garden City, N.Y.: Doubleday, Page and Co., 1909.

"The Minor Arts." *New England Magazine* 40 (May 1909): 330–38. Reprinted as *The Minor Arts*. Boston: Museum of Fine Arts, 1924.

"Mr. La Farge on Glass Art." Letter to the editor. *New York Herald*, August 20, 1909, 8.

"Charles F. McKim." Letter to the editor. *New York Daily Tribune*, September 25, 1909, 7.

"A New Side of Prof. James." Letter to the editor. *New York Times*, September 2, 1910, 8.

Letter about Winslow Homer in Gustav Kobbé, "John La Farge and Winslow Homer." *New York Herald*, December 4, 1910, magazine section, 11.

"The Teaching of Art." *Scribner's Magazine* 49 (February 1911): 178–88.

One Hundred Masterpieces of Painting. Garden City, N.Y.: Doubleday, Page and Co., 1912.

Reminiscences of the South Seas. Garden City, N.Y.: Doubleday, Page and Co., 1912.

The Gospel Story in Art. New York: Macmillan Co., 1913.

"William Hogarth," in *Hogarth's Rejected and Suppressed Plates*. New York: privately printed for members of the Fraternity of Odd Volumes, 1913, 1–22.

"The Toy of Art." Letter to the editor (dated January 7, 1884). *Golden Book Magazine* 8 (September 1928): 406.

About John La Farge (arranged alphabetically)

Catalogs for La Farge's major exhibitions are cited on pages 246–48.

Adams, Henry. "Letter to the Editor." *Art Bulletin* 56 (December 1974): 625–26.

———. "The Stained Glass of John La Farge." *American Art Review* 2 (July–August 1975): 41–63.

———. "John La Farge, 1835–1870: From Amateur to Artist." Ph.D. diss., Yale University, 1980.

———. "A Fish by John La Farge." *Art Bulletin* 62 (June 1980): 269–80.

———. Review of *The Decorative Work of John La Farge*, by H. Barbara Weinberg. *Journal of the Society of Architectural Historians* 39 (December 1980): 332–33.

———. "John La Farge's 'Roses on a Tray.'" *Carnegie Magazine* 57 (January–February 1984): 10–14.

———. "John La Farge and Japan." *Apollo* 119 (February 1984): 120–29.

———. "Picture Windows." *Art and Antiques* (April 1934): 94–103.

———. "John La Farge." In *American Drawings and*

Watercolors in the Museum of Art, Carnegie Institute. Pittsburgh: Museum of Art, Carnegie Institute, distributed by the University of Pittsburgh Press, 1985, 64–69.

———. "Regaining Paradise: Artist John La Farge and Historian Henry Adams Found Spiritual Renewal in the South Seas." *Art and Antiques* (March 1985): 60–65.

———. "John La Farge's Discovery of Japanese Art: A New Perspective on the Origins of Japonisme." *Art Bulletin* 67 (September 1985): 449–85.

———. "William James, Henry James, John La Farge, and the Foundations of Radical Empiricism." *American Art Journal* 17 (Winter 1985): 60–67.

———. "John La Farge's 'Study of Pink Hollyhock in Sunlight.'" *Calendar of Events* (Nelson-Atkins Museum of Art, Kansas City), January 1987, 2.

Auchincloss, Louis. "In Search of Innocence: Henry Adams and John La Farge in the South Seas." *American Heritage* 21 (June 1970): 28–33.

Berenson, Ruth. "John La Farge: America's Old Master." *Art and Antiques* 5 (May–June 1982): 48–55.

Berkelman, Robert. "John La Farge, Leading American Decorator." *South Atlantic Quarterly* 56 (January 1957): 27–41.

Bing, Samuel. *Artistic America, Tiffany Glass, and Art Nouveau.* Translated by Benita Eisler; introduction by Robert Koch. Cambridge, Mass.: MIT Press, 1970. First essay originally published in 1895 as "La Culture artistique en Amérique."

Born, Wolfgang. *Still-Life Painting in America.* New York: Oxford University Press, 1947.

Bullard, John E. "John La Farge at Tautira, Tahiti." In *Report and Studies in the History of Art*, vol. 2. Washington, D.C.: National Gallery of Art, 1968, 146–54.

Bye, Arthur. *Pots and Pans.* Princeton: Princeton University Press, 1921.

Canaday, John. "The Best of John La Farge." *New York Times*, May 8, 1966, section 2, 15.

Cary, Elizabeth Luther. "John La Farge and the Old 'Riverside.'" *Lamp* 27 (September 1903): 122–27.

———. "The Art of John La Farge." *Putnam's Magazine* 7 (April 1910): 770–79.

Clark, T. M. "The Decoration of Trinity Church, Boston." Letter to the editor. *Nation* 26 (January 31, 1878): 77.

Cook, Clarence. "Recent Church Decoration." *Scribner's Monthly* 15 (Feburary 1878): 569–76.

Cortissoz, Royal. *John La Farge: A Memoir and a Study.* Boston and New York: Houghton Mifflin Co., 1911.

Cox, Kenyon. "Two Specimens of La Farge's Art in Glass." *Burlington Magazine* 13 (June 1908): 182–85.

Danes, Gibson. "William Morris Hunt and His Newport Circle." *Magazine of Art* 43 (April 1950): 144–50.

"Death of John La Farge." *New York Evening Post*, November 15, 1910, 6.

"Debts May Eat Up La Farge's Estate." *New York Times*, December 28, 1910, 3.

Dewing, Maria Oakey. "Flower Painters, and What the Flower Offers to Art." *Art and Progress* 6 (June 1915): 255–62.

Dreiser, Theodore. "The Making of Stained Glass Windows." *Cosmopolitan* 26 (January 1899): 243–52.

du Bois, Guy Pène. "The Case of John La Farge." *Arts Magazine* 17 (January 1931): 252–70, 276–77.

Focillon, Henri. "John La Farge." *American Magazine of Art* 29 (May 1936): 311–39.

Foster, Kathleen A. "The Still-Life Painting of John La Farge." *American Art Journal* 11 (Summer 1979): 4–37, 83–84.

———. "Makers of the American Watercolor Movement: 1860–1890." Ph.D. diss., Yale University, 1982.

Gerdts, William H. *Painters of the Humble Truth: Masterpieces of American Still Life, 1801–1939.* Columbia, Mo., and London: University of Missouri Press, 1981.

Gerdts, William H., and Burke, Russell. *American Still-Life Painting.* New York: Praeger Publishers, 1971.

"Greta." "Trinity Church, Boston." *Art Amateur* 1 (July 1879): 30–31.

Haywood, Ira N. "From Tahiti to Chartres: The Henry Adams-John La Farge Friendship." *Huntington Library Quarterly* 21 (August 1958): 345–58.

Hobbs, Susan. "John La Farge and the Genteel Tradition in American Art, 1875–1910." Ph.D diss., Cornell University, 1974.

Humphreys, Mary Gay. "Novelties in Interior Decoration: The Union League Club House and the Veterans' Room of the Seventh Regiment Armory." *Art Amateur* 4 (April 1881): 102–3.

———. "The Cornelius Vanderbilt House: Decorations of the Dining-Room, Water-Color Room and Smoking Room." *Art Amateur* 8 (May 1883): 135–36.

———. "John La Farge, Artist and Decorator." *Art Amateur* 9 (June 1883): 12–14.

———. "Talks with Decorators: John La Farge on the Re-Decoration of the American 'Meeting House.'" *Art Amateur* 17 (June 1887): 16, 18.

Inness, George. "A Plea for the Painters." Letter to the editor. *New York Evening Post*, March 21, 1878, 2.

James, Henry. "On Some Pictures Lately Exhibited." *Galaxy* 20 (July 1875): 89–97.

Jarves, James Jackson. *The Art Idea.* New York: Hurd and Houghton, 1864.

Jarvis, Robert. "A Medley of Church Decoration." *Art Amateur* 10 (December 1883): 13.

"John La Farge Explains Remarks." *New York Tribune*, January 31, 1909, 9.

"John La Farge's Stained Glass." *New York Herald*, November 3, 1879, 8.

Katz, Ruth Berenson. "John La Farge as Painter and Critic." Ph.D. diss., Radcliffe College, 1951.

———. "John La Farge, Art Critic." *Art Bulletin* 33 (June 1951): 105–18.

King, Pauline. *American Mural Painting*, Boston: Noyes, Platt and Co., 1902.

Kobbé, Gustav. "Mystery of Saint Gaudens' Masterpiece Revealed by John La Farge." *New York Herald*, January 16, 1910, magazine section, 11.

———. "John La Farge and Winslow Homer." *New York Herald*, December 4, 1910, magazine section, 11.

La Farge, Henry A. "John La Farge and the South Sea Idyll." *Journal of the Warburg and Courtauld Institutes* 7 (1944): 34–39.

———. "John La Farge, A Reappraisal." *Artnews* 65 (May 1966): 29–31, 58–60.

———. "The Early Drawings of John La Farge." *American Art Journal* 16 (Spring 1984): 4–37.

———. "John La Farge's Work in the Vanderbilt Houses." *American Art Journal* 16 (Fall 1984): 30–70.

———. "John La Farge and the 1878 Auction of His

Works." *American Art Journal* 15 (Summer 1985): 4–34.

La Farge, John, S.J. "Review of *John La Farge: A Memoir and a Study*, by Royal Cortissoz." *America* 5 (May 27, 1911): 150–52.

———. "The Mind of John La Farge." *Catholic World* 140 (March 1935): 701–10.

———. "La Farge and the Truth." *America* 52 (March 30, 1935): 586–88.

———. "Notes on the La Farge Exhibit." *America* 55 (May 2, 1936): 83–84.

———. "The Spirit of John La Farge." *Stained Glass* 39 (Winter 1944): 107–15.

———. "Henry James's Letters to the La Farges." *New England Quarterly* 22 (June 1949): 173–92.

———. *The Manner Is Ordinary*. New York: Harcourt, Brace and Co., 1954.

"La Farge Left $599 Here." *New York Times*, June 17, 1914, 1.

La Farge, Mabel. "John La Farge: The Artist." *Commonweal* 22 (May 3, 1935): 7–10.

Lamb, Charles Rollinson. "How an American Stained Glass Window Is Made." *Chautauquan* 29 (September 1899): 514–21.

Lanes, Jerrold. Review of exhibition at Kennedy Galleries. *Burlington Magazine* 110 (March 1968): 169.

Lantz, Emily Emerson. "Murals Adorning Baltimore Court House." *Art and Archeology* 19 (May–June 1925): 259–64.

Lathrop, George Parsons. "John La Farge." *Scribner's Monthly* 21 (February 1881): 503–16.

Lee, Katherine C. "John La Farge, Drawings and Watercolors." *Toledo Museum News* 11 (Winter 1968): 2–22.

Lefor, Patricia Jean. "John La Farge and Japan: An Instance of Oriental Influence in American Art." Ph.D. diss., Northwestern University, 1978.

Low, Will H. "John La Farge: The Mural Painter." *Craftsman* 19 (October 1910–March 1911): 337–39.

Mather, Frank Jewett. "John La Farge—An Appreciation." In *Estimates in Art*, vol. 1. New York: Henry Holt and Co., 1923, 241–65.

McNally, Sean. "Folio: John La Farge." *Stained Glass* (Fall 1985): 219–26.

Meehan, Thomas F., ed. "Schoolboy Letters between John La Farge and His Father." *United States Catholic Historical Society Records and Studies* 18 (1928): 74–112.

———. "Some Records of the La Farge Family." *United States Catholic Historical Society Records and Studies* 18 (1928): 113–20.

"Memories of New York's 'Quartier Latin' Centre in Tenth Street Studio." *New York Herald*, March 2, 1913, magazine section, 7.

"Meticulous Mandarin." *Time* 87 (June 3, 1966): 64.

Mumford, Lewis. *The Brown Decades: A Study of the Arts in America, 1865–1895*. New York: Harcourt, Brace and Co., 1931.

———. "The Art Galleries." *New Yorker* 12 (April 18, 1936): 52–55.

Murals in the Baltimore Court House. Baltimore: Munder-Thomsen Co., 1912.

Obituary—John La Farge. *Catholic World* 92 (December 1910): 423–26.

Perry, Thomas Sergeant. "Colour Decoration in Amer-

ica." *Architect* (London) 18 (October 20, 1877): 210–11.

Richardson, Charles F. "A Book of Beginnings." Letter to the editor. *Nation* 91 (December 1, 1910): 520–21.

Richie, Donald. "Henry Adams in Japan." *Japan Quarterly* 6 (October–December 1958): 434–42.

Riordan, Roger. "American Stained Glass—First Article." *American Art Review* 2 (1881): 229–34.

———. "American Stained Glass—Second Article." *American Art Review* 2 (1881): 6–11.

———. "American Stained Glass—Third Article." *American Art Review* 2 (1881): 59–64.

———. "The Use of Stained Glass." *Art Amateur* 12 (May 1885): 130–32.

Roseboro, Viola. "Said by John La Farge." *Golden Book Magazine* 3 (March, November 1926): 320–21, 689–92; 7 (May 1928): 647–50.

———. "Conversations with John La Farge." *Catholic World* 143 (June 1936): 287–91.

Rosenblum, Robert. "New York Revisited: Church of the Ascension." *Art Digest* 28 (March 15, 1954): 11, 29.

Saint-Gaudens, Augustus. *The Reminiscences of Augustus Saint-Gaudens*. Edited and amplified by Homer Saint-Gaudens. 2 vols. New York: Century Co., 1913.

"St. Thomas's Chancel." *New York World*, October 28, 1877, 4–5.

Sargent, Irene. "Trinity Church, Boston, as a Monument of American Art." *Craftsman* 3 (March 1903): 329–40.

Scheyer, Ernst. "The Adams Memorial by Augustus Saint-Gaudens." *Art Quarterly* 19 (Summer 1956): 178–97.

———. *The Circle of Henry Adams: Art and Artists*. Detroit: Wayne State University Press, 1970.

Sherman, Frederic Fairchild. "Some Early Oil Paintings by John La Farge." *Art in America* 8 (February 1920): 85–91.

Strahan, Edward [Earl Shinn]. *Mr. Vanderbilt's House and Collection*. 4 vols. Boston, New York, Philadelphia: George Barrie, 1883–84.

Sturgis, Russell. Review of "Considerations on Painting." *Architectural Record* 6 (October–December 1896): 230–32.

———. "The Booth Memorial Window." *New York Evening Post*, June 10, 1898, 6.

———. "The Booth Memorial Window." Letter to the editor. *New York Evening Post*, June 30, 1898, 6.

———. "A Pictorial Window." *New York Evening Post*, November 7, 1898, 4.

———. "John La Farge." *Scribner's Magazine* 26 (July 1899): 3–19.

———. "The La Farge Lunettes for the Minnesota Capitol." *Scribner's Magazine* 37 (May 1905): 638–40.

"Talks with Decorators: John La Farge on the Redecoration of the 'Meeting House.' " *Art Amateur* 17 (July 1887): 40.

"Trinity Church, Boston: The Decoration of Its Interior by Mr. John La Farge." *New York World*, February 24, 1877, 5.

Van Brunt, Henry. "The New Dispensation of Monumental Art." *Atlantic Monthly* 43 (May 1879): 633–41.

Van Dyke, John C. *American Painting and Its Tradition*. New York: Charles Scribner's Sons, 1919.

Vedder, Elihu. *The Digressions of V.* Boston and New York: Houghton Mifflin Co., 1910.

Waern, Cecilia. "Some Notes on the Art of John La

Farge." *Atlantic Monthly* 75 (May 1895): 690–93.

———. *John La Farge, Artist and Writer*. London: Seeley and Co.; New York: Macmillan and Co., 1896.

Weinberg, H. Barbara. *The Decorative Work of John La Farge*. Ph.D. diss., Columbia University, 1972; New York: Garland Publishing, 1977.

———. "The Early Stained Glass Work of John La Farge (1835–1910)." *Stained Glass* 67 (Summer 1972): 4–11.

———. "John La Farge and the Invention of American Opalescent Windows." *Stained Glass* 67 (Fall 1972): 4–11.

———. "A Note on the Chronology of La Farge's Early Windows." *Stained Glass* 67 (Winter 1972–73): 12–18.

———. "John La Farge—The Relation of His Illustrations to His Ideal Art." *American Art Journal* 5 (May 1973): 54–73.

———. "John La Farge's *Peacock Window*." *Worcester Art Museum Bulletin* 3 (November 1973): 1–12.

———. "The Work of John La Farge in the Church of St. Paul the Apostle." *American Art Journal* 6 (May 1974): 18–34.

———. "The Decoration of the United Congregational Church." *Newport History* 47, part 1 (Winter 1974): 109–20.

———. "John La Farge and the Decoration of Trinity Church, Boston." *Journal of the Society of Architectural Historians* 33 (December 1974): 322–53.

———. "La Farge's Eclectic Idealism in Three New York City Churches." *Winterthur Portfolio* 10 (1975): 199–228.

———. "John La Farge's *Peonies Blown in the Wind*." *Pharos* (journal of the Museum of Fine Arts, St. Petersburg, Florida) 13 (July 1975): 2–11.

Weitenkampf, Frank. "John La Farge, Illustrator." *Print Collector's Quarterly* 5 (December 1915): 472–94.

"Wood Engravings as Works of Art." *Nation* 26 (March 28, 1878): 218.

Wren, Linnea H. "The Animated Prism: A Study of John La Farge as Author, Critic and Aesthetician." Ph.D. diss., University of Minnesota, 1978.

Yarnall, James L. "John La Farge and Henry Adams in the South Seas." Master's thesis, University of Chicago, 1976.

———. "The Role of Landscape in the Art of John La Farge." Ph.D. diss., University of Chicago, 1981.

———. "John La Farge's 'New England Pasture Land.' " *Newport History* 55, part 3 (Summer 1982): 79–91.

———. "John La Farge's 'The Last Valley,' " *Newport History* 55, part 4 (Fall 1982): 130–42.

———. "Tennyson Illustration in Boston, 1864–1872." *Imprint, Journal of the American Historical Print Collectors Society* 7 (Fall 1982): 10–16.

———. "John La Farge's 'Paradise Valley Period.' " *Newport History* 55, part 1 (Winter 1982): 1–25.

———. "John La Farge's *Portrait of the Painter* and the Use of Photography in His Work." *American Art Journal* 18 (Winter 1986): 5–20.

Young, Mahonri Sharp. "John La Farge: A Revaluation." *Apollo* 81 (January 1965): 40–45.

Zug, George Breed. "Contemporary Mural Painting." *Chautauquan* 50 (April 1908): 229–47.

INDEX

PHOTOGRAPHY CREDITS

All photographic material was obtained directly from the collection indicated in the caption, except for the following (plate numbers refer to illustrations in text, page numbers to those in checklist): *Architectural Record, Great American Architects Series,* no. 3 (July 1896): pl. 135; E. Irving Blomstrann: pls. 47, 61; Scott Bowron, New York: pls. 4, 38; Charles H. Caffin: pl. 140; Conservation Institute, Oberlin College, Oberlin, Ohio: pl. 59; Dartmouth College Photographic Service Collection: pl. 90; Abe Dulberg, New York: pls. 146, 147; Jim Goodnough: pl. 65; Courtesy Graham Gallery and Doris Bry, New York: pl. 8; Beverly Hall, New York: p. 259; *House Beautiful* 15 (May 1904): pl. 139; Hughes Company, Baltimore: pl. 116, p. 268; Shepherd Knapp: pl. 133; Henry A. La Farge: pls. 16, 50, 78, 85, 132, 136, 137, 154; Massachusetts Historical Society: pl. 5; Sean McNally, Ridgewood, N.J.: pls. 117, 121; Gary Mortensen: pls. 44, 141, 142; Otto Nelson: p. 260 (top); Paulist Fathers' Archive: pl. 134; J. Newton Perkins: pl. 128; Mark Sexton: pl. 57; Joseph Szaszfai: pl. 93; Jerry L. Thompson: pl. 33; Everard M. Upjohn: pl. 126; John D. Woolf: pls. 24, 115, 120, 123–25, 153, 158; *World's Work* 21 (March 1911): pl. 143; James L. Yarnall: pls. 60, 81.